The Art and Craft of Motion Pictures

25 Movies to Make You Film Literate

Vincent LoBrutto

An Imprint of ABC-CLIO, LLC

Santa Barbara, California • Denver, Colorado

Library of Congress Cataloging-in-Publication Data

Names: LoBrutto, Vincent, author.
Title: The art and craft of motion pictures : 25 movies to make you film literate / Vincent LoBrutto.
Description: Santa Barbara, California : Praeger, an imprint of ABC-CLIO, LLC, [2019] | Includes bibliographical references and index.
Identifiers: LCCN 2019014437 (print) | LCCN 2019018930 (ebook) | ISBN 9781440839191 (ebook) | ISBN 9781440839184 (print :alk. paper)
Subjects: LCSH: Motion pictures—Production and direction.
Classification: LCC PN1995.9.P7 (ebook) | LCC PN1995.9.P7 L63 2019 (print) | DDC 791.4302/32—dc23
LC record available at https://lccn.loc.gov/2019014437

ISBN: 978-1-4408-3918-4 (print)
 978-1-4408-3919-1 (ebook)

23 22 21 20 19 1 2 3 4 5

This book is also available as an eBook.

Praeger
An Imprint of ABC-CLIO, LLC

ABC-CLIO, LLC
147 Castilian Drive
Santa Barbara, California 93117
www.abc-clio.com

This book is printed on acid-free paper ∞
Manufactured in the United States of America

To
Karen Cooper
Elgin Movie Theater
William K. Everson (1929–1986)
John Hanhardt
Henri Langlois (1914–1977)
Jonas Mekas (1922–2019)
Museum of Modern Art Department of Film
Charles Reynolds (1932–2010)
Richard Roud (1929–1989)
Frank Rowley
Dan Talbot (1926–2017)
The Thalia Movie Theater
Jud Yalkut (1938–2013)
For helping me become film literate and more film literate at a time when I needed it the most.

Contents

Acknowledgments ix

Introduction xiii

Chapter 1 Editing Choreography in an Autobiographical Film: *All That Jazz* 1

Chapter 2 The Ultimate Period Film: *Barry Lyndon* 14

Chapter 3 The Origin of the Creative Jump Cut: *Breathless* 27

Chapter 4 Surrealism David Lynch Style: *Eraserhead* 36

Chapter 5 Nonfiction, Diary, Essay Filmmaking, and Editing as a Magician's Tool: *F for Fake* 45

Chapter 6 Remakes: *The Flight of the Phoenix* (1965), *Flight of the Phoenix* (2004) 54

Chapter 7 The Documentary as an Investigative Tool: *Gimme Shelter* 67

Chapter 8 Time and Space: *Hiroshima Mon Amour* 75

Chapter 9 Fantasy as Reality: *King Kong* (1933) 85

Chapter 10 Destruction of the Well-Made Hollywood Movie: *The Last Movie* 96

Chapter 11 The Adult Film as Art Film: *The Lickerish Quartet* 106

Chapter 12 Birth of the Independent Cinema: *Little Fugitive* 121

Chapter 13 Parallel Storytelling, Character Connections: *Magnolia* 131

Chapter 14 Mental State as Narrative: *Memento* 143

Chapter 15 Teamwork On and Off the Screen: *Our Daily Bread* 159

Chapter 16 Tempo, Content, and Directorial Style: *Pickpocket* 166

Chapter 17 Nonlinear Structure: *Pulp Fiction* 172

Chapter 18 The Camera as Instigator: *Seconds* 183

Chapter 19 The Graphic Novel Comes Cinematically
 Alive: *Sin City* 191

Chapter 20 The Perfect Silent Film: *Sunrise* 205

Chapter 21 Tatami Camera Style: *Tokyo Story* 213

Chapter 22 The Tall Tale: *The Treasure of the Sierra Madre* 224

Chapter 23 The Essential Road Movie: *Two-Lane Blacktop* 232

Chapter 24 The 45 Minute and 56 Second Shot: *Wavelength* 240

Chapter 25 Stranger in a Strange Land: Exploring the
 Possibilities of the Detective Film: *Witness* 250

Glossary 257

Bibliography 271

Index 277

Acknowledgments

I want to thank my original editor, Anthony Chiffolo, for suggesting a further exploration of the film canon. He was also helpful in finalizing the list of 25 films within. Kevin Downing took over the project and shares my love of the movies. He also carefully shepherded the project through the publishing process. My sincere thanks to everyone at ABC-CLIO.

All my love and admiration to my late parents Rose and Anthony LoBrutto for their unconditional support, for bringing me to the movies and for being my "first producer" in the fullest sense of that notion. My son Alexander Morrison has engaged in a lifelong seminar about the cinema with me. My daughter-in-law Sharon Morrison knows most of what there is to know about television, its aesthetics, and analysis, which has influenced my study of motion pictures.

I've sat at the edge of our bed interviewing my grandson Noah and watched shows with him, all the while gaining valuable information about his perceptions. My granddaughter Callie Rose is too young to take to the movies now, but I sure look forward to the day when I can. My daughter Rebecca Roes continues to teach me about tenacity and commitment to study. My son-in-law Jürgen Roes teaches me it doesn't matter so much how much you say, but what you say, and how you say it. My wife Harriet Morrison is the best movie-going companion a guy could ever ask for, and I always look forward to the in-depth discussions afterwards. She is the first reader of all of my manuscripts. Harriet is a true life partner; my love and respect for her grows endlessly.

I'm now in my sixth decade as a perpetual student of film. I express my gratitude to those who helped me become film literate. Everett Aison has provided steadfast encouragement and inspiration for 40 years, first in New York at the School of Visual Arts and then during stimulating phone calls from Washington State where he relocated. The late Gary Carey taught me lessons about the art of film criticism and the dramaturgy of theatre. He was

also my thesis advisor when I wrote a full-length study of Sam Peckinpah, which remains unpublished but planted a seed that did grow. The late William K. Everson introduced me to the masterpieces of film history. The late Charles Reynolds presented *Paths of Glory* to a 20-year-old who just couldn't stop thinking about Stanley Kubrick. The late Jud Yalkut, the fine experimental filmmaker, gave Zen lessons on the art of Stan Brakhage, Kenneth Anger, and Michael Snow (whose masterwork *Wavelength* is discussed in this book) and introduced our class to Carolee Schneemann, who screened her legendary *Fuses* on a memorable day in the early 1970s. My appreciation goes out to the late Gene Stavis for his cinema salon and private tutoring in the history of film. Kudos to Blackhawk Films for making cinema classics available for study on 8mm, Super 8mm, and 16mm back in the day and for providing material for personal and early editing experiments conducted in the basement of our family home. David Weber was my high school film teacher and was there at the beginning when it mattered most. I am indebted to all of the editors, production designers, sound creators, cinematographers, and directors I have interviewed over the years. They have truly provided master classes in the art and craft of the cinema.

My appreciation for what I have learned from watching films extends to each and every movie experience, but especially to a select group of filmmakers who through their works were my greatest teachers. They include Michelangelo Antonioni, Stan Brakhage, Robert Bresson, John Cassavetes, Werner Rainer Fassbinder, Jean-Luc Godard, Alfred Hitchcock, Stanley Kubrick, Martin Scorsese, King Vidor, and Orson Welles. PBS has provided a lifetime of archival treasures as well as many important special programs celebrating the cinema. *Million Dollar Movie* allowed me to see Hollywood classics like my beloved *King Kong* (1933) (see Chapter 9) in many encore broadcasts in a week's time, reinforcing that a good film not only holds up but continues to reveal its jewels with each viewing. Charles Champlin's television cinema series in the 1970s solidified my belief that film was truly an art. Richard Schickel's *The Men Who Made the Movies* began my lifelong love affair with the films of King Vidor and contributed to my knowledge of John Ford, Alfred Hitchcock (Gene Stavis was associate producer on the Hitchcock episode), Frank Capra, and others.

Jonas Mekas personally sold me my copy of Brakhage's *Metaphors on Vision*, and his dedication to the art of film has motivated my passion for experimental film. In the two classes he taught that I attended before he was fired because of the loud voices of the ignorant, Jack Smith taught me that conflict between music and image is a valuable cinematic concept. During my salad days there were revival theaters that furthered my understanding. They included the Regency, Thalia, and Elgin theaters. Dan Talbot's New Yorker Theater was a university in New Wave and revolutionary films of the 1960s and 1970s. The film program at the Museum of Modern Art was my

second home during my film school years. The Whitney Museum and Anthology Film Archives broadened my perspective of film history. The New York Cultural Center educated me about the B movies of Don Siegel and adult films of Russ Meyer. The New York Film Festival provided an ongoing exposure to cutting-edge world cinema and the honor of seeing many filmmakers speak about their work in person. *Film Forum* continues to be a home for the gourmet delicacies of filmmaking.

Three film critics who have had the greatest influence on my thinking about film are Manny Faber, Stanley Kauffmann, and Jonathan Rosenbaum. My heartfelt appreciation to American Cinema Editors (ACE) for making me a Special Member of their fine and vital organization and bestowing on me the honor of associate editor of their magazine *CinemaEditor* and the prestigious Robert Wise Award. The magazine allowed my master classes to continue with every interview and encounter I have with filmmakers. So many publications nurtured my insatiable thirst for film knowledge. The most influential in my early years were *Filmmaker's Newsletter, Film Culture, American Cinematographer*, and *Take One*. Before Borders and Barnes and Noble— Cinemabilia, Gotham Book Mart, 8th Street, Strand, and St. Mark's bookshops were havens for readers and collectors of film literature. Joe Franklin was an inspiration by spreading his infectious, unconditional love of the cinema on his daily television shows and on specials in which he presented motion picture greats, like his memorable *King Kong* broadcast, that was annotated with invaluable information at the end of each segment. Editor/director Arthur Ginsberg provided "graduate studies" during on-the-job training in the film-stimulating years I worked with him. Writer and critic Peter Tonguette is a phone friend who is smart well beyond his years about all things filmic. He has always been supportive and helpful in his advice and insights.

As always, especially for a book on film education, my respect and eternal thanks to all my colleagues at the School of Visual Arts Department of Film, Video and Animation where I was a student from 1970 to 1974. I thank all the students who have attended my classes as a teacher there over the past two and a half decades. In my *The Art of Editing* and *American Maverick Filmmakers* classes, students help to illuminate the heart of the filmmaking process. My thanks and admiration to everyone at the former Film/Video/Arts for creating a vital institution for the study of independent film. The Mount Vernon Library continues to be an invaluable archive for my research. My respect and thanks to the entire staff of this wonderful archival sanctuary of learning.

Lastly my gratitude to all who write on the subject of the cinema and continue to feed my insatiable curiosity and fuel my spirit by keeping me informed, film literate, and on a steady course to spread the word.

Introduction

The purpose of this book is to educate filmgoers and those interested in the medium about the art, craft, and language of motion pictures. Film continues to be a venue for entertainment, knowledge, and understanding of aesthetics, narrative, and human endeavor.

A person is considered well read when they are familiar with a wide range of literature and the elements that make a book a book. They are familiar with story, character, narrative, tone, atmosphere; the mechanics of sentence structure, grammar, and the use of a period or full stop, comma, colon, semicolon; and a variety of literary devices and techniques. They are familiar with a range of genres and styles, and authors and books from many places in the world.

To become more film literate is a similar undertaking, but for a film, movie, or motion picture, whichever term is employed, other notions and aspects must be taken into account. The majority of people have seen motion pictures either for the story, the art and craft, or to be entertained. Now that motion pictures can be seen in a movie theater, on television or a home theater, computer, phone, or other digital devices, there is more opportunity to engage in the experience. The current movie watcher is more familiar with cinema terms and elements than 50 years ago, but a surface impression is not knowledge. Being literate is understanding and empowerment at a meaningful level. What films teach us is the mission of this book. Understanding the specifics in motion pictures—story, character analysis, narrative, genre such as film noir or Western, crafts such as cinematography or editing—will facilitate literacy enormously. How all the elements interact to create a total cinematic experience is key. *The Art and Craft of Motion Pictures: 25 Movies to Make You Film Literate* examines 25 significant films, each of which has a specific value to study.

As a longtime teacher of the art and craft of motion pictures, I have observed that most people know more about motion pictures than they realize. The

cinema embraces a codified language that is familiar on the surface, but each aspect has expressive elements concerning this enormously powerful medium that demands a closer look. To become more film literate involves a total engagement with the moving image and its ability to communicate narrative and emotion.

The 25 chapters that follow are organized in alphabetical order by film title. *The Art and Craft of Motion Pictures: 25 Movies to Make You Film Literate* will serve as a tutorial on the complex inner workings of a film as well as the technology and cinematic language employed. The choice of films represents a wide range of cinematic works. There are many directors, genres, and motion picture worlds to explore on the road to film literacy. The chapters each contain a section that investigates the film in cinematic terms, identified as **Narrative and Cinematic Analysis**. Here shot-by-shot elements will be presented to demonstrate the way the movie is shot and edited, with explanation and insights into how they tell a particular cinematic story. This provides a further guide into the language and rhythm of the film.

Becoming film literate can also be fun—inspirational, challenging, and even spiritual—enjoy the trip and get ready for a lifetime of enlightened cinematic experiences.

Note: Words that appear in **bold** can be found in the glossary along with useful terms that apply to the art and craft of motion pictures. At the end of each chapter are lists of films to see for further knowledge and books to read for further education.

Vincent LoBrutto, October 2018

Editing Choreography in an Autobiographical Film

All That Jazz

All That Jazz is a musical with intricate song and dance numbers choreographed in the iconic style of director Bob Fosse. The film dissects every part of the dancer's body, which maintains often-changing tempos. There are also nonmusical **sequences** that help drive the narrative in a different way. The protagonist, film director Joe Gideon, has pushed his health to the maximum with his carousing and womanizing, as well as his unhealthy lifestyle including smoking incessantly. Gideon is in **postproduction** on a motion picture and preparing a large-scale stage musical (both of which reference real Fosse works), while he carries on affairs and relationships with women and deals with a beautiful angel-of-death character. Gideon has a heart attack, is hospitalized, and sees his life pass before him in the form of a theatrical extravaganza of which he is the star.

On Broadway, the choreographer wields great power over the content of a musical. Director and choreographer Gower Champion dominated old-fashioned musical comedies for 20 years, from 1960 with *Bye Bye Birdie* to 1980 with *42nd Street*. He was a craftsman who may never have created a distinctive personal style like some others, but his legacy is solid in the history of the contemporary American musical. His traditional approach that developed over the decades led the way to great experimentation for others. In the arts the mavericks who experiment with the nature of their craft use the norm as a platform for discovery.

Director and choreographer Jerome Robbins revolutionized the field of contemporary American musicals in 1957 with *West Side Story*, applying his

theory that whoever controlled the movement controlled the content. Movement was always a part of the American musical, but Robbins merged character, story, and movement to present the narrative of a show. Bob Fosse developed a distinctive and angular style of **choreography** that he used to reconstruct and deconstruct the work of the writer and other collaborators. He was known for his show-stopping numbers inspired by vaudeville[1] and burlesque.[2]

Bob Fosse was a dancer, choreographer, stage director, film director—and yes, a man who smoked too much, caroused too much, had a bad heart, and was an unrelenting ladies' man. *All That Jazz* (1979) is an **autobiographical film** because the lead character Joe Gideon, played by Roy Scheider, was a dancer, choreographer, stage director, film director—and yes, an unrelenting ladies' man who smoked too much, caroused too much, and had a bad heart—but Bob Fosse refused to acknowledge that the film was about him.

Choreography is the art and practice of designing and arranging sequences where motion and form of dancers are specified. The choreographer creates these designs and instructs the dancer and dance troupe how to execute the movement along with the music and the emotion of the theatrical narrative.

Film editors do many things, least among them cut things out of a movie. It is an art that depends on what the screenwriter wrote, the director directed, and the actors acted as well as the contributions of the **production designer**, costume designer, composer, **sound designer** and **special effects** artists. They are very dependent on the director and the director of photography, how the film was shot, and how the rhythms within the shots long or short were composed. Even within these constraints the film editor has the power to act as a choreographer, structuring sequences, controlling the frame, rhythm. and order within a scene, sequences, acts, and the entire film itself. On *All That Jazz* the master editor Alan Heim (*Network* [1976], *Valmont* [1989], *Billy Bathgate* [1991]) had a master choreographer as a director, and together they found the exciting and unique **structure** of *All That Jazz*.

Alan Heim once innocently made a mistake and experienced in full Fosse's anger when anyone mentioned that *All That Jazz* was about him. One day Fosse and Heim were in the editing room working when the editor unknowingly said something to the effect of, "Bob in this scene when YOU . . ." (the capital letters are for recreating the way Fosse reportedly heard the word). Bob Fosse demanded Heim stop the editing machine and attacked him verbally, shouting words to the effect of "You think this picture is about me?" Heim didn't know what to do. He contemplated quitting, but thankfully the situation calmed down and business was continued.

The relationship between Fosse and Heim began on Fosse's 1974 **biopic** *Lenny* in which Dustin Hoffman[3] played the legendary dirty-mouth, First-Amendment-challenging comedian Lenny Bruce. On that film there was much rearrangement of shots and scenes during the editing process, and

when interviewed by the author Heim referred to him and Fosse as "kindred spirits." Heim would win the coveted Oscar for best editing on *All That Jazz* as well as the BAFTA award[4] for best editing, and the American Cinema Editors (ACE) Eddie award, a singularly important achievement in that it is decided solely by the editors in that hallowed organization. In 2012 when the **Motion Picture Editors Guild** compiled a list of best edited films of all time, *All That Jazz* was fourth behind *Apocalypse Now*, *Citizen Kane*, and *Raging Bull*. A best edited film has to do with the editor's ability to tell a story with the selection of shots and when they begin and end. Narrative storytelling is as much a part of good editing as it is a part of good screenwriting, film directing, and cinematography along with the participation of other film crafts. The cuts in a best edited film come in at the right place and end at the right time.

The screenplay for *All That Jazz* was written by Fosse and Robert Alan Arthur, who was also one of the film's producers. *Lenny*, the Fosse film before *All That Jazz*, was based on a play by Julian Barry, who wrote the screenplay that had a **narrative** that moved back and forth in the life of the tortured comedian. Heim had experience in this kind of shifting time narrative to suit the tangled experience Lenny Bruce lived in his short life. Liking those results, Fosse and Arthur worked hard to incorporate this technique into *All That Jazz*. They took a lot of what Fosse and Heim had worked out in the editing room for *Lenny* and actually wrote these ideas into the *All That Jazz* script. When they tried to make editorial changes, they found it was a little harder to be as free and spontaneous with the material as on *Lenny* because on that film it was the manipulation of the editing structure that shaped the narrative, not apparent in the original script.

Editors use words like *structure*, *scene*, and *sequence* to explain the working methods of their craft. Once the narrative struggle had been won, Heim worked closely with Fosse to take the dynamic of *All That Jazz* to greater heights.

Throughout the film are short, quickly edited sequences referred to as "It's Showtime!" **montages**. They contained shots of Joe Gideon's morning routine including taking prescription pills and shots of him coughing and in distress. The sequential choices were not made during the shooting process but were structured in the editing room.

Of course, there is some artistic license in the making of *All That Jazz*, but practically everyone who knew Bob Fosse fairly well knew the picture was about him. This isn't the only film in which a director put his own life on the screen. Richard Pryor did so in *Jo Jo Dancer: Your Life Is Calling* later in 1986 (and he also claimed the film was not about him). Others include George Lucas's *American Graffiti* (1973), Francois Truffaut's *The 400 Blows* (1959), and Federico Fellini's 1966 film *8½*, a film that greatly influenced Fosse on *All That Jazz*, to the extent that he hired the eminent Giuseppe Rotunno to shoot

his film. Rotunno had shot eight of Fellini's films including *Fellini's Satyricon* (1969), and *Amacord* (1973), but ironically Rotunno did not shoot 8½ (which was photographed by Gianni Di Venanzo) one of the most celebrated autobiographical films. Both *All That Jazz* and *8½* are autobiographical films about a director, and both have a fantastical quality.

Alan Heim's editing and Bob Fosse's choreography and direction cannot be separated. *All That Jazz* was an unusual and visionary musical. It was not based on a book or play but was created as an original work. Fosse did not write an autobiography that was adapted into a movie but had a screenplay that in fact adapted the director's life, with the film becoming an autobiography. Fosse at the time of *All That Jazz* had directed and choreographed many stage musicals including *Chicago*, which is where the song "All That Jazz" is performed by the female character Roxie Hart and speaks of living high and loose. So, the phrase "all that Jazz" in the movie *All That Jazz* promotes the attitude of living freely and surrounding oneself with pleasure as a way of life.

The narrative structure that follows Joe Gideon through his life, relationships, and work as a theater director, film director, and choreographer shows what happens when one burns out by indulging in every possible vice. Fosse's directorial approach drives the film as an early example of a long-form music video. In 1981, two years after the 1979 release of *All That Jazz*, the MTV music video channel originated and the modern revolution of music television exploded across the country. Although many craft elements go into the creation of a feature film and music video, the biggest influence handed down from *All That Jazz* to the new art form of music videos in the 1980s was the rapid editing style.

At times Bob Fosse covered scenes with six to eight cameras, a technique known as **multiple cameras**, and ran up many **takes** from each camera position. This allowed Alan Heim to create a musical feel by the flow of cuts, which include practically everything in the postproduction toolbox. This kind of **coverage** allows the editor to perfectly match movement from shot to shot, or to ignore perfection and create a jump in action by mismatching one shot to the other or to move from one angle to a pleasing angle or one that defies traditional continuity. Heim entered the project with no working knowledge about dance and choreography, and he had a master teacher who was a demanding perfectionist to make sure every beat was covered and every move executed precisely the way it was designed and intended. He first worked with Fosse on the one-hour television special *Liza with a "Z,"* which was broadcast on September 10, 1972, and highlighted the talents of Liza Minnelli, who starred in Fosse's *Cabaret* (1972). He next edited *Lenny* for Fosse, which had a theatrical release in 1974. This film didn't advance Heim's experience in Fosse dance moves but did in developing a controversial character, the real-life comedian Lenny Bruce.[5] This dark figure would shed light on Fosse's view of the dark side of life.

In the classic days of Hollywood, editors specialized in editing musicals, and the narratives most often were bright and cheery. Again, Alan Heim had no such experience—and on *Liza with a "Z"* and especially *All That Jazz*, without direct experience in editing extensive dance sequences, he would become a partner and collaborator with Fosse. Fosse also served as the editor's mentor in the Fosse school of filmed dance based on the Fosse school of stage musicals.

All That Jazz is a musical so there are musical numbers, dramatic and comedic scenes and set pieces, and a play within the movie that was choreographed with the Fosse touch that he developed early on in his first film as director, *Sweet Charity*, released in 1969. Fosse tried to put his personal stamp on *Sweet Charity* but was yet to fully develop his cinematic style as he had his theatrical style on the stage. He broke ground on the next film, *Cabaret*—a musical based on a play released in 1972, a huge success and Oscar winner for director, actress, actor, cinematography, editing, song score, art direction, and sound— where the filmmaking better suited the Fosse choreographic style. The editor David Bretherton and Fosse did not get along well even though the result was spectacular, so Fosse selected fellow New Yorker Alan Heim for *All That Jazz*. Heim, an adroit editor, was the perfect choice to take on such a demanding assignment editing a musical and autobiographical film by Bob Fosse.

All editing especially in a musical sequence has a direct impact on the choreography of a scene. Editing is about pace and movement, so the editor follows the plan of the choreographer and director. Choreography is distinctive in its interpretation of the dance. The camera records as many takes and angles as the director feels they need to capture the dance. In postproduction the editor working with the director selects the moments in shots that cinematically bring the dance to life. In Fosse's case his dissecting of the human body in sharp angles gave him his vision. When looking at other dance work that is reminiscent of Fosse's style, the term *Fossesque* is used.

Fosse's admiration for Federico Fellini[6] had deep roots. In 1966 he choreographed and directed *Sweet Charity* on Broadway with his wife Gwen Verdon in the lead, based on Fellini's screenplay for *Nights of Cabiria*. In 1969 it became Fosse's first feature film, which starred Shirley MacLaine. The musical had music by Cy Coleman and lyrics by Dorothy Fields, and the book was by Neil Simon.[7] The narrative was changed from the black-and-white film that follows the romantic ups and downs of a hopeful female escort played by Fellini's wife Giulietta Masina in *Nights of Cabiria*. In the Broadway show Gwen Verdon (who eventually divorced Fosse) played a dancer for hire at a Times Square dance hall. Verdon is portrayed as Gideon's ex-wife Audrey Paris played by Leland Palmer in *All That Jazz*, and elements of their actual life together were written into this character.

Many major American directors have been influenced by important foreign film directors often capturing the mood of the European style. They

include Paul Mazursky, Wes Anderson, Woody Allen, and David Lynch (see Chapter 4). What makes *All That Jazz* unique is that not only does it connect with *8½*, a major autobiographical work featuring a director and his colorful and amorous life, but Fosse through his work with cinematographer Rotunno channels Fellini's visual style. *All That Jazz* is an Americanized *8½* with music and dance that is distinctly Bob Fosse.

Narrative and Cinematic Analysis

All That Jazz begins in black and then the **main title** appears in the form of letters spelling out the name of the film and built with Hollywood/Broadway style lights. The titles are in a three-dimensional form and are large in size, announcing to the viewer at the film will be glitzy and dedicated to show business. This strongly speaks to the theater where musicals are very often performed.

Classical music plays while a montage dedicated to Joe Gideon unfolds. Joe is a classical American first name. The expression "a regular Joe" represents he's an ordinary guy, a notion he has struggled with as an artist. He often sees himself as regular and ordinary but also strives for artistic excellence. Gideon is a biblical name, a man who was a judge and military leader. He is an artistic military leader moving forward to expand the language and accomplishments of the American stage musical. The clash between the meanings of his first and last names is demonstrated by a man who on the surface is cool and regular but inside is tormented and trying to bolster his personality. Joe Gideon is a stage and film director with a big reputation both artistic and with the ladies as he goes through his morning routine ending with him gesturing with his hands and saying "It's Showtime!" This phrase comes from show business, announcing the beginning of a show or theatrical event. In this movie the "It's Showtime" montages appear throughout the story and are expressed by Gideon in an exhausted manner demonstrating his ceaseless struggle to go on with the show until the end intervenes.

Throughout the film are scenes in which Gideon visits what was called the "attic" of his past life, an abstract set with objects that represent his past. Lording over this "attic" is Jessica Lange playing Angelique, an elegant angel of death dressed all in white. She is waiting for him to die, and throughout tells him how his lifestyle has led to a personal and health crisis. Her appearance is linked to Gideon's existence as a ladies' man who cheated many times on his wife. He tries to reject Angelique until the end of the film, also the end of his life, and after extreme heart problems submits to yet another beautiful woman.

Joe Gideon is at what is called a "cattle call," an open audition for dancers, for his new musical. The stage is bare. The George Benson[8] cover version of "On Broadway" is on the soundtrack and serves as the music for the dance

tryout as well as an ode to the Great White Way. The song links to the strug-
gling dancers who are looking for stardom. The dancers warm up, and to the
best of their abilities, everyone moves to the Gideon choreography. Like
Fosse, Gideon personally tells a dancer if they are out of contention. The
Benson music continues even though there is a piano player with sheet music
backing the singing auditions. They sing without any sound coming out of
their mouths. One of the male dancers is way out of step—he tries, but is
clearly out of his league; this shows that Gideon gives everyone a chance but
only picks the best. In the back of the house the producers watch the tryouts.
His wife and daughter Michelle (Ezsébet Földi) also watch. Dancers jump
over the camera, an action that goes back to old Hollywood. Dancers spin in
one spot, then a **jump cut** replaces that dancer for another one—this contin-
ues through many male and female dancers in sequence. Gideon picks the
dancers he wants in the show. He is interrupted by another visit to the "attic"
where he explains part of his life to Angelique. Back on stage, the music is
now played by a synthesizer.

Gideon drives himself hard. While staging a major musical he is also in
the editing room reviewing the cut of *The Stand-Up*, a film about a comedian.
One of the moments in *The Stand-Up* shows the comedian Davis Newman
(Cliff Gorman) in a comic riff about the Kübler-Ross five stages of death.[9] He
is in a comedy club, and the audience is hysterical with laughter. Gorman
played Bruce in the stage production *Lenny*. We see a **rewind table**, a **Movi-
ola**, and other equipment to make *The Stand-Up* and *All That Jazz*. The assis-
tant editor is a young woman named Stacy (Susan Brooks). It is apparent that
Gideon is having an affair with her.

Ann Reinking was a romantic partner of Bob Fosse and worked with him
as a dancer. She is considered to be the most important interpreter of Bob
Fosse's choreography and worldview of modern dance. In the film she plays
Kate Jagger, Gideon's girlfriend. He cheats on her, and in at least one case she
cheats on him.

Self-doubt is a major theme in *All That Jazz*. Joe reveals in several ways
that nothing he does professionally or personally is good enough. It is estab-
lished that he has a deep-rooted fear of being conventional, which drives
him to be more and more inventive. As a stage and film director no matter
how inventive he is, no matter what people tell him about his brilliance, that
nagging feeling in the back of his mind drives him harder and harder
physically.

The style of *All That Jazz* is both Fosseque and Felliniesque. From Fellini
he inherited the bold exaggerated visuals and the gift of applying autobiogra-
phy to a fictional narrative. Fellini is not a musical film director, so Fosse
brought together his love for Fellini with his distinctive view of dance.

Joe Gideon sees himself as part of the company of filmmakers. In addition
to the major Fellini references, he has a line that delves into the personal

lives of moviemakers when he says "Do you think that Stanley Kubrick gets depressed?" This question shines a light on Gideon as he wonders if a major film director such as Kubrick (see Chapter 2) feels the way he does and if that puts Gideon in Kubrick's league.

In **flashback** we see young Gideon backstage at an old burlesque theater studying his school books. The scene provides insight into his childhood. Around him are scantily dressed strippers who find young Joe cute. Some of them try to distract him, nuzzling and touching him. A corny comedian is bombing with the crowd. He introduces young Joe, who comes out dressed all in white and does his tap dance routine. At first everyone ignores him, then one man notices something and laughs heartedly. The laughter spreads throughout the room and the scene ends revealing a large wet spot on Joe's crotch.

Back in the rehearsal room, the show's composer sings and acts out a new addition to the score as a tryout. The cast and producers are there. The performance of the song backed by the rehearsal piano play is raw and not professionally sung. At its conclusion there is a call to play it again. Joe doesn't seem happy with it but announces that he'll be able to do something with it, pointing his ego towards others that he is a theatrical magician.

The Angel appears again. There are a series of **flash cuts**, which were first used in full during the 1960s. Fosse uses them as eighth notes to accent the pace of the movie.

Alan Heim as Eddie is at the Moviola. Joe sits with the producer of *The Stand-Up*, Joshua Penn (Max Wright). Joe tells Joshua that he needs more time and that he revised a scene for him to watch. Joe leaves him to go to rehearsal of the play. The producer screens the scene and remarks that it is better. Heim is Gideon's editor as well as Fosse's editor.

When Joe rehearses a male or female dancer, he often takes them into his arms, joining his body with theirs. When the dancer is female, there seems to be a sense of romanticism and a definition of traditional male-female relations.

Joe Gideon is not a well man. At times in public he holds his arm in pain. He takes his medication in front of his daughter and when asked, he tells her it is candy. He dances with her. It is pouring outside. Not for the first time his daughter asks her father if he is going to get married again. He smokes throughout the film and coughs incessantly.

Another "It's Showtime" sequence is filled with a choking cough. During a rehearsal he criticizes a dancer, Victoria, as if she can do nothing right. There is a rehearsal piano and drums. After being stopped again, Victoria walks off crying. She tells him she is terrible and asks if he can make her a good dancer. Joe smiles and tells Victoria he can make her a better dancer and kisses her on the forehead.

Joe's ex-wife Audrey is in the show in a major part playing a 24- or 25-year-old when she is considerably older than that. She and Joe talk about their

relationship. She never cheated on him and he constantly cheated on her. She is backed by the composer playing the piano. She has dialogue and lyrics and dances (choreographed by Joe). This is a dramatic scene and a musical number at the same time. It advances the narrative, entertains, and develops Audrey's character as well as presenting their back story.

The "It's Showtime!" montages begin to emphasize that Joe Gideon is running down. Joe has reimagined the show he is directing in the film just as Bob Fosse reimagined the **genre** of musical theater direction and choreography. He runs a scene for the producers. The cast is dressed as airline personnel, wearing airline hats and grey gloves, and both males and females are scantily dressed. The choreography is erotic, sexy, and suggestive. Drums and piano provide the music. After several uncomfortable moments watching near-simulated sex acts of all kinds, one of the producers claps, only to hear Gideon say the number is not over yet. The scene continues. There are references to the movie *Cabaret*, a movie with its own brand of eroticism. A scaffold is part of the set with dancers using it to move through the space. Smoke is everywhere. Flashlights are used for lighting. There are percussion instruments. The slogan for the airline is "We take you everywhere, but get you nowhere." The composer says, "Now Sinatra will never record it." When it's over the producers don't quite know how to react. Joe walks over to Audrey feeling he can never be good enough. She looks up at him and says, "The best work you've ever done," with admiration and frustration.

In theory the Angel of Death is there watching Gideon through the entire running time of *All That Jazz*. She is waiting for him to completely burn out and go with her to whichever place he's going—Heaven or Hell. We see her when director Bob Fosse and editor Alan Heim want us to see her. Now is another of those times.

We are in the editing room. There's a big screening planned for *The Stand-Up*; Katie and Michelle are making dinner in his apartment. After the meal is the floor show. The girls are dressed in black top hats and behind a large column as Joe watches. They put on a cassette tape of music for their number and dance down a flight of stairs in the duplex. They sing the song "Everything Old is New Again." The songs in *All That Jazz* fit into the narrative either in a direct manner or an ironic one, for the audience to discover. Even though the ladies are singing and dancing on their own, they have been directed and choreographed by Bob Fosse. Their work becomes Fossesque. On the wall is an object that looks like an Oscar statuette, but not quite. It is suggesting that Gideon has won something like an Academy Award, most likely for direction. In real life Bob Fosse won the Oscar for Best Directing on *Cabaret*. Gideon enjoys watching his girlfriend and daughter entertain him.

More coughing. It's Showtime! Gideon shows the producers, cast, and crew a model of the stage set for the play and shows them specific features it contains. They set up for a table read. Joe explains that each actor should just

read their lines with no acting so that the bare bones of the story can come through. Joe looks in ill health and in pain. The read around the table begins. It's a comedy so the actors begin to laugh, but Joe can't hear them. Their voices are dropped out of the soundtrack. Joe can only hear sounds his body produces, the last image is Joe holding his arm and the breaking of a pencil in his hands signifying the excruciating pain he is feeling. The table read is over, and the sound of the voices comes back to Joe via the soundtrack. Everyone leaves but Joe, who puts his head down on the table, exhausted, burnt out, with his body wracked in pain—angina. This scene was achieved by cutting out the dialogue from the table read and accentuating the **sound effect** of the sounds generated by Joe. The result is an experiential picture of what Joe is going through.

Next is the hospital. A doctor talks to Joe's producer and tells him the director's stay there will be two to three weeks. The play has to be postponed four months. Audrey reports she has seen Joe and he's fine. Joe is chasing nurses around his hospital room.

One of the producers goes to a small theater to visit Lucas Sergeant (John Lithgow), a pompous, self-involved theater director. The two are rivals, but Lucas says out of his compassion for the producer-director that he would replace Joe if necessary.

The Angel appears, watching Joe's every move. There is a montage of Joe having fun in the hospital. Her appearance is foreboding. Joe touches the rear end of a young nurse, who is taken by surprise and chastises him. The doctor is angry about the whole situation in his hospital.

In his hospital room Joe watches television. O'Connor Flood (Ben Vereen) is on the stage of a variety show. Vereen appeared in the stage and film productions of *Sweet Charity*. He is introducing a guest with a long list of superlatives about how great he is, and Joe says out loud every word before it comes out of the host's mouth. As Flood gets to the point of mentioning the guest's name, Joe abruptly shuts off the television and says, "I hate show business."

The doctor continues to be angry at the chaos Gideon has caused in the hospital and the inevitability of his death if he doesn't listen to his physician. Joe is in his hospital bed with a topless blonde woman. Joshua Penn brings all the good reviews for *The Stand-Up*, and Joe asks him to bring the not-so-good reviews to him. Now on the television is a review of his movie. The female reviewer resembles Pia Lindström (daughter of Ingrid Bergman), a tough TV movie reviewer from the era of *All That Jazz*. She calls *The Stand-Up* ordinary and many other insults, giving it her lowest rating.

Joe is scared. More tests are taken—they reveal a blockage in two arteries. In bed pictures are taken. There is a musical number featuring doctors. O'Connor Flood is on the television. Preparations are underway. Katie is with someone. The Angel is there. Joe is wheeled down the hospital hall with Katie and Audrey.

In a boardroom the producers and a bond company go over the figures and come to the conclusion that if the circumstances were right and Joe expired at the right time, the show could actually make a profit without even opening. **Intercut** with this is footage of an actual heart operation from a surgeon who in the past filmed his heart surgeries. The footage is graphic and difficult to watch. The intercutting of the ironic scene of the monetary results of Joe dying softens the harsh imagery but also puts the viewer on edge as to when they are going to see the operation again. During the editing process the heart operation footage was in and out of the cut, but eventually Fosse made the risky decision to keep it in the movie.

The Angel appears again. There is a hallucination scene shot with a heathy Joe directing it and a sick Joe in his hospital unable to do anything. The Kübler-Ross steps are repeated. Then an "After You're Gone" song and dance number—another preexisting song that has narrative significance to the film. Joe is next to camera while Audrey sings—he is both the director and the sick Joe in bed who can't respond. Katie does a "You Better Change Your Ways" number. Women are covered with feathers in a "Who's Sorry Now?" number on a ladder. Joe is told he blew his line. He says, "I don't want to die, I want to live." Then comes "Some of These Days." Doctors and nurses with tambourines perform another hallucination number in which Joe sees himself direct a musical number that is related to his impending demise. The Angel caresses him—signaling it is time to go and die, but Joe still hangs on and says, "Not yet."

In the hospital Joe has a heart attack. Something's gone wrong. Joe gets out of bed and goes into the hospital basement. Joe stages three routines. His perfectionism kicks in and he says, "I liked to run the whole thing again." Joe walks around the hallway bleeding. He goes into an older woman's room and kisses her passionately. She smiles and dies. The janitor finds him. They sing "Pack Up Your Troubles in Your Old Kit Bag," another preexisting song, this one referring to leaving with a smile, which is hard for Joe. He's a fighter but is beginning to move toward acceptance. Two orderlies find him and bring him back to his bed upstairs.

Nurses prepare Joe for a show and operation. His heart monitor turns into a TV. O'Connor Flood opens his show the same way, but this time he goes further to talk about Joe Gideon but in a negative light. Flood announces its Joe's "final appearances on the great stage of life." There is a show-stopping dance and singing number. Two women are dressed in skin-tight costumes featuring red and blue veins. One of the women is Katie, and later we see her sitting in the audience with another man. The whole look of the stage is sur-realistic with shiny design elements. The song "Bye Bye Life" (based on the preexisting song "Bye Bye Love") is backed by a band dressed in white. During the song Flood introduces people from Gideon's life via new lyrics. The audi-ence is also surreal with brightly colored makeup and way-out hairstyles.

Joe says goodbye to everyone in his past. He says goodbye to his daughter and wife: "I won't have to lie to you anymore." The doctor looks at his watch. Joe is now in a tunnel of sorts, looking forward in what becomes after a cut a POV **(point-of-view)** to the Angel who is smiling and waiting for Joe. The shots on him are the Angel's POV. Joe seems to be gliding. This is accomplished by placing the camera in front of him moving at the same distance consistently to get that floating quality. Later this technique would become the **Spike Lee Shot**. Finally, he gets right in front of the Angel. A sexy trumpet theme plays. Joe is sweating profusely. A **shock cut** or smash cut to Joe dead in a body bag shows that his life is over. Then comes a music cue for the original Ethel Merman recording of "There's No Business Like Show Business." This show business anthem that usually rouses an audience is now darkly ironic—show business has taken Gideon's life, and this song is the way he's lived his life to excess.

Conclusion

All That Jazz is a contemporary musical that broke the mold of the American musical, but, more importantly, in the end it is a deeply **personal film**—the vision of its creator Bob Fosse reflecting his life and exploring the ultimate human experience: death.

Notes

1. Vaudeville is a U.S. entertainment form popular in the early 20th century, featuring a mix of specialty acts including comedy and song and dance.

2. Burlesque is an entertainment in a variety show format popular in the United States from the 1860s to the 1940s that featured bawdy comedy and female striptease.

3. Dustin Hoffman (1937–) is an American film, theater, and television actor whose breakout role was Benjamin Braddock in *The Graduate* (1967). Other film roles include Ratso Rizzo in *Midnight Cowboy* (1969), Ted Kramer in *Kramer vs. Kramer* (1979), and Raymond Babbitt in *Rain Man* (1988).

4. British Academy Film Awards (BAFTA) are presented in an annual awards show hosted by the British Academy of Film and Television Arts to honor the best British and international contributions to film.

5. Lenny Bruce (1926–1966) was a stand-up comic, satirist, and social critic known for his freestyle comedy with integrated satire, politics, religion, and vulgarity. His trial for obscenity is a landmark for freedom of speech in the United States.

6. Federico Fellini (1920–1993) was an Italian film director and screenwriter known for distinct style that combined fantasy and baroque with earthiness. He is considered one of the most influential filmmakers of all time.

7. Neil Simon (1927–2018) was a prolific American playwright and screen-writer. His stage plays include *The Odd Couple* (1965), *Brighton Beach Memoirs* (1983), and *Lost in Yonkers* (1991). His screenplays include: *The Heartbreak Kid* (1972), *The Goodbye Girl* (1977), and *The Slugger's Wife* (1985).

8. George Benson (1943–) is a modern jazz guitarist who began his profes-sional career at age 21. He came to prominence during the 1960s and launched a successful solo career during the 1970s.

9. Elisabeth Kübler-Ross (1926–2004) was a Swiss-American psychiatrist, a pioneer in near-death studies, and the author of the groundbreaking book *On Death and Dying* (1968).

For Further Study

Screen

An American in Paris
Broadway: The American Musical
8½
La La Land
Six by Sondheim

Read

Broadway Musicals, Show-by-Show: Eighth Edition by Stanley Green and Cary Ginell
Dangerous Rhythms: Why Movie Musicals Matter by Richard Barrios
Fosse by Sam Wasson
The Fosse Style by Debra McWaters
The Secret Life of the American Musical: How Broadway Musicals Are Built by Jack Viertel

The Ultimate Period Film

Barry Lyndon

Based on the novel by William Makepeace Thackeray, *Barry Lyndon* (1975) takes place in a small village in Ireland where Redmond Barry is in love with his cousin who marries up to a British captain. When he wins a challenge to duel, he eventually finds himself in the Army. He then deserts and has to join the Prussian Army where he has to spy on an Irish gambler. He meets and marries the wealthy Lady Lyndon, but through his uncontrolled misbehaving is ultimately challenged to a duel by his stepson, during which he loses his leg and finds himself back where he began, in the status of the lower class, having learned little.

William Makepeace Thackeray was a British novelist (1811–1863) and writer in the 19th century. He is known for satirical works, especially *Vanity Fair*, with its wide view of English society. His other literary works include *The History of Henry Esmond* (1852), *The History of Pendennis: His Fortunes and Misfortunes, His Friends and His Greatest Enemies* (1848–1850), and *The Newcomes: Memoirs of a Most Respectable Family* (1854). During the Victorian era Thackeray was ranked second only to Charles Dickens. Ironically in the early 1970s when it was announced that Stanley Kubrick would be adapting *Barry Lyndon* into a motion picture, many literary experts criticized the director, stating that the novel was the author's least effective book. This attitude among the literati continued into the early days of the film's release.

Kubrick had viewed scores of period films and was always unimpressed with their look and photographic atmosphere. During the making of *2001: A Space Odyssey* (1968), Kubrick discussed the notion of filming strictly by candlelight with cinematographer John Alcott (*A Clockwork Orange* [1971], *The Shining* [1980], and *Greystoke: The Legend of Tarzan, Lord of the Apes* [1984]) in

reference to his next project, an epic biopic of Napoleon, a film that was never realized because of its size and expense. The fast lenses necessary to film by candlelight were not available at the time and were still not available when Kubrick began production on *Barry Lyndon.*

As Kubrick considered filming *Barry Lyndon*, he learned that the German Zeiss Company had developed very fast 50mm still photography lenses for the Apollo space program at NASA. Traditionally, period films used fill light in scenes where there were candles, producing an over-lit effect rather than the warm, soft, flickering light actually produced by candles. Kubrick got the super-speed lens and phoned Ed DiGiulio of Cinema Products, who delivered to him a 20:1 **zoom lens** (which can increase its shortest focal length 20 times) for *A Clockwork Orange* and asked him to mount the new Zeiss lens on a BNC Mitchell Camera[1] that Kubrick owned. DiGiulio told the director it could be done, but that doing so would make it unusable for any other application. Sure in his ways, Kubrick said that was okay and DiGiulio proceeded. Later Kubrick asked for a 35mm lens, and eventually DiGiulio also provided a 75mm lens.

Kubrick also decided not to shoot *Barry Lyndon* on sets in a studio. He felt the **genre** was diminished by the old studio look. He first decided to photograph the film at an actual location, Picketts Manor, but the house became too limiting for Kubrick's vision of the film. Production designer Ken Adam (*Dr. Strangelove: Or How I Learned to Stop Worrying and Love the Bomb* [1964], *Goldfinger* [1964], and *The Madness of King George* [1994]) wanted to build sets within interior locations, but Kubrick insisted he wanted to shoot his film on location. He also demanded that the locations be within close proximity to his home base in Borehamwood so that he wouldn't have to travel far and could sleep in his bed each night. Adam then had to utilize the rooms of several homes to create the scope of the estates in the film. Eventually Adam told Kubrick that in order to find all the locations for the film, he had to go further than instructed. His search extended to Ireland. Part of *Barry Lyndon* would take place in Germany, but Adam couldn't convince Kubrick to shoot there. At the end of the production Kubrick sent a **second unit crew** to Potsdam and East Berlin to get the German atmosphere of the period by filming castles and period streets.

Kubrick wanted *Barry Lyndon* to be almost a documentary of the period. He started out knowing practically nothing about the period but, after extensive research on every detail possible, including what toothbrushes people used, he became an expert on the era. Props like a Louis XVI–style bathtub were created and put into authentic locations.

For the wardrobe Kubrick maintained documentary realism by having his costume designers Milena Canonero and Ulla-Britt Söderlund purchase actual 18th-century clothes, which were still available in England at the time. Mostly people in the 18th century were smaller than in the 20th century, so

the original clothes had to be opened up and larger costumes created using the same patterns at a factory that the production maintained at Radlett in Hertfordshire, England.

Paintings are essential to the understanding of Kubrick's *Barry Lyndon*. Classical paintings serve two distinct purposes. During production they were utilized for research. Kubrick and his **production designers** Ken Adam, Roy Walker, and Vernon Dixon and the costume designers studied the compositions, architecture, landscapes, interiors, and clothing. Some of the artists reviewed were Thomas Gainsborough, who painted portraits and was known as one of the originators of the 18th-century British Landscape School; Joshua Reynolds, a British portrait painter who worked in the Grand Style that idealized the imperfect; Jean-Antoine Watteau, a French painter who revitalized the Baroque style; Daniel Chadowjecki, a Polish and later German painter and printmaker who presented the life of the bourgeoisie; and Johan Zoffany, a German neoclassical painter. To tell the story Kubrick borrowed period elements from principal painters of the era, in terms of color and composition. The brilliance of the look or visual style of *Barry Lyndon* is in the way Stanley Kubrick linked oil painting with motion picture photography.

In the film, paintings also adorn the interiors of many locations. During planning Kubrick learned that throughout that era paintings could be hung very high on a wall, and many walls were filled with various sized paintings. The artwork also defines the time and the taste of the owners whose walls were filled with art.

The use of the zoom lens, which in itself can bring an image from near to far or far to near by the simple manipulation of the pulling of a rod or the press of a button, is related to painting as well in *Barry Lyndon*. Throughout the film a setting, usually a landscape perhaps containing some figures, is established, then after several beats the camera either zooms in or zooms out, finally resting on a new and precise composition. The relationship between establishing a period look and the ability of photography to render light and movement is directly traced to the specific paintings researched for *Barry Lyndon*. The idea of borrowing or imitating the composition of a classical painting in a motion picture film is not totally radical and had been done before by other filmmakers, but Stanley Kubrick went a step further and directed *Barry Lyndon* to appear as if it was a series of paintings in motion. The overall effect is of a painting coming to life.

Bronx-born Stanley Kubrick began as one of the youngest photographers at *Look* magazine[2] in the 1950s. He became entranced with the movies and watched every film he could, convinced he could make better ones than most. After making 3 short films he made 13 feature films in five decades, of which *Barry Lyndon* was his tenth and longest at three hours and three minutes. Upon its original release in 1975, it was poorly reviewed and received

in the United States, but was a success in Europe where they understood the story and the elaborate style. Kubrick was most often ahead of his time: many of Kubrick's films took until long after they first appeared to be comprehended fully and be rediscovered. Stanley Kubrick lived most of his adult life in England at an estate where he had ample movie equipment and was within driving distance of major studio facilities. He had no trouble getting financing because Warner Bros. was his creative home since *A Clockwork Orange*, his ninth feature film, until his last film *Eyes Wide Shut* released in 1999 a few months after his death. Kubrick is considered one of the greatest American filmmakers of all time. He was meticulous and obsessive, taking a long time between projects and notorious for running a high **take ratio**, which at times would reach a hundred or more takes for a single shot.

A period film is one in which the events occur in a historical era, portraying life before the current time in which the viewer sits in front of the movie. The two major components are the physical—architecture, clothes and objects—and behavior and language. Depending on the period depicted there may or may not be electricity, automobiles, airplanes, and other aspects of modernity. The film's language may include unfamiliar idioms, expressions, and phrases from much earlier periods of time. Some period films have an inference of the time indicated, others have some detail, still others have an extraordinary amount of accurate detail.

Barry Lyndon is the ultimate period film because it contains all the elements needed to capture the atmosphere of the time, creating a hyperreality allowing the viewer to feel they are back in time living in an earlier day. Examples of period films include *Beau Brummell* (1954), *Amadeus* (1984), and *Gangs of New York* (2002).

Like many Kubrick films that are not well accepted when they first appear, *Barry Lyndon* over a long stretch of time became noted and accepted as a fine film in America. Before that even fans of the director who had seen practically all of his movies hadn't seen or didn't want to see *Barry Lyndon*. Bad word of mouth, the film's long length, and general lack of interest in period films were part of the problem. In the 21st century *Barry Lyndon* is well screened and ranked highly in the Kubrick oeuvre, taking its place among Kubrick's best films.

Barry Lyndon influenced countless period films, most importantly Ridley Scott's first feature film *The Duellists* released in 1977, which applied the *Barry Lyndon* lessons to create the atmosphere of its time and place.

During the Academy Awards for 1975 *Barry Lyndon* won four statues: Best Art Direction by Ken Adam, Roy Walker, and Vernon Dixon; Best Cinematography by John Alcott; Best Costume Design by Milena Canonero and Ulla-Britt Söderlund; and Best Musical Score by Leonard Rosenman.

Stanley Kubrick wrote the **screenplay** adaptation for *Barry Lyndon* himself without a collaborator based on the novel *The Luck of Barry Lyndon* written in

1844 by William Thackeray. Kubrick retained much of the book, including lines of narration, scenes, and storyline, and then developed a cinematic equivalent for each scene.

Throughout his career Kubrick had been attracted to misfits, men of narrow and low character—the lower form of human life like Jack Torrance in *The Shining* and especially Alex DeLarge in *A Clockwork Orange*. Barry was a man who found his way in life through deceit, cheating, and always staying on top of a situation until his inflated sense of self and pious attitude finally caught up with him.

Stanley Kubrick began his career at a young age in still photography working for *Look* magazine. After making the move to filmmaking he continued to constantly have a still (as well as motion picture) camera at hand while shooting his sets, family, and other aspects that caught his artistic eye. His cinematography (often **handheld camera** shots) can be seen in every film he directed alongside that of his director of photography. A stylized lighting style has always been a high-card of Kubrick's films, but in *Barry Lyndon* the lighting takes the place of the creation of light by oil paints applied to canvas with brushes. Interior scenes have a painterly patina, but many exterior shots especially come forth exactly as a landscape painting.

Much of *Barry Lyndon* is shot solely by candlelight. Previously, Hollywood shot period scenes by using either only additional traditional movie lights or candles and conventional lighting, in either case losing the delicate patina of a candle. The zoom lens became popular during the 1960s to change shot sizes or to slowly move in and out in a way that organically connects with the content. The dislike for zoom shots comes when the lens is jerked in and out quickly, causing a jarring effect that interrupts the concentration of the audience in a negative way. Ironically it was in the 1970s when *Barry Lyndon* was made that so many other films misused this cinematic tool. Kubrick's idea to start the zoom for a number of seconds after establishing a shot presents and dissects a composition in a cinematic method. All of this transcends and subverts the traditional approach to period filmmaking. When applied to the period costume design and production design, the narrative of *Barry Lyndon* achieves a hyperrealism in depicting a past century.

Classical music chosen for *Barry Lyndon* appears as if it was a score throughout the film. This is a technique Kubrick used to great effect on *2001: A Space Odyssey*. In that iconic film Kubrick experimented with linking centuries of music for a new context and using experimental music from an earlier time to make startling comments on the future seen in his visuals. In *Barry Lyndon* the music sounds like it is from the appropriate time frame. The soundtrack includes "March from Idomeneo" by Mozart, "Sarabande–Duel" by Georg Friedrich Handel, "German Dance No. 1 in C Major" by Shubert, and "Il Barbiere Di Siviglia" by Giovanni Paisiello. The music creates a constant emotional effect, a sadness that comments on Barry's rise and fall in life.

Narrative and Cinematic Analysis

A card at the outset of the film reads: "Part 1 By what means Redmond Barry acquired the style and title of Barry Lyndon." The **narrator**, Michael Hordem, an English stage and film veteran who was known for his Shakespearean work, has just the right quality, sounding like an old British gentleman from the era who was comfortable with Thackeray's language. It is established that Barry's mother (Marie Kean) is a widow and adores her son. The young Barry is playing cards with his cousin Nora Brady (Gay Hamilton). He is enticed by her but tries not to show it. She is his first love. The sweet-looking Nora looks at the handsome Barry with lust. Nora teases Barry: she takes off a ribbon, has him turn around, and hides it in her cleavage, then challenges him to find it. He is very hesitant to find the ribbon, knowing that Nora is trying to seduce him. After a dismissive attempt, he tells her he can't find it. She puts his hand on her bosom, and he then finds the ribbon. She kisses him and he follows suit.

There has been harsh criticism about Kubrick's choice of Ryan O'Neal as Barry. Never considered a particularly strong actor, O'Neal was best known for his appearances in the television nighttime soap opera *Peyton Place* in 1964 and the feature film *Love Story* (1970). Overall he is considered a movie star more than a serious actor. He is fine in the film, cast perfectly for the part, and his handsome, matinee-idol looks sell the performance.

In many period films there are wide landscape shots used to set the mood and to act as a divide between the end of one scene and the beginning of another. In *Barry Lyndon* there are many vast landscapes to show the viewer stately homes, mansions, and castles and the beauty of the times.

Captain John Quin (Leonard Rossiter), who was also in Kubrick's *2001: A Space Odyssey*, shows up on the grounds in his shiny red uniform. Barry is envious of Quin's outfit and the effect it has on women. He is especially jealous and angry of the way Nora and Quin look at each other, with Nora looking smitten and confident. To make matters worse Barry had to watch his darling dance with the smug Quin five times.

Nora tells Barry that he is a mere boy and that Quin is a man. Barry is far more handsome than Quin, who has wild eyes and a maniacal, twisted smile. Barry is becoming a rogue; losing the love of Nora has brought this out of him. He expresses his extreme anger by cutting logs with a sharp axe, swinging it as hard as he can, clearly with dark thoughts in his mind. As the movie progresses Kubrick in his writing and direction and working with O'Neal creates a deeply etched character with levels of emotion that lay beneath his boyish exterior.

Quin is a hardened soldier trained not to show his feelings, but Nora has stolen his heart and brought physicality and open emotion to his soul. Nora's family is deep in debt. A deal is made that if Quin marries Nora, the soldier

will take care of that and offer financial assistance. When Quin sees Nora with Barry, he accuses her of having two lovers and becomes furious. This conflict is resolved, and Barry is out of the picture.

At a long dinner table, the family is gathered. The scene is lit by actual candlelight—the candles are **on-screen** and the fill light is provided not by electrical light but by more candles on an off-screen rig. Ever the perfectionist, Kubrick had assistants keep charts of the candles and where they burned down to, given his famously high **shooting ratio**. When a candle burned down too much to affect the lighting **continuity**, it was replaced at the correct size.

The sumptuous food is detailed to look like period meals. Kubrick had all the period dishes researched and prepared to be historically correct by someone now referred to as a *food stylist*, responsible for how food looks in a film. Barry's uncle and Nora's father (Liam Redmond) sitting at the head of the table, and to one side are Quin and Nora and on the other is Barry, who cannot do anything but glare at the couple. He watches as Quin whispers to Nora and her father. Then the father calls for attention and announces that earlier Quin and Nora were married. He proposes a toast; everyone stands and raises their glass except for Barry, who remains seated and continues his deadly stare at the couple. When Barry is called out by his uncle, he stands, picks up his glass, and in one violent, shocking movement hurls the glass at Quin's face, where it shatters into uncountable pieces. Nora goes to Quin who is holding his face in bloody pain.

A pistol duel is arranged. The guns are brought out onto a field, prepared, and loaded. Each man has the traditional second, someone who arranges the duel. Ominous tympani music scores the somber event. The seconds come up with an out for Barry to avoid this deadly man-to-man conflict, but the stubborn and adamant Barry refuses. Quin does not look like the brave and strong soldier—he is unable to stop shaking. Barry is able to get a shot off directly at Quin, who is immediately dragged off to the other side of the field by Nora's brothers. Barry asks if Quin is dead and is told that he is. A large sum of money is lost based on Quin marrying Nora. Barry is told he has disgraced the family.

At his mother's home there is a discussion that Barry should go into hiding. He is seen off by relatives, although he leaves against his will. The composition of the road and land are perfect to underscore that Barry is setting off on a journey that will change him forever.

Barry rides on horseback, trying to get out of the area where he is known. He stops at an inn for water, his throat parched from the long ride with much still to ride. Sitting at a table are an older and a younger man. The older one tries to talk to Barry, who looks tired and stunned—he is offered a meal and drink but politely refuses. He thanks the men and rides off. He is on a tree-lined road when a man with his back to Barry is blocking the path. He turns

around and pulls two pistols. Barry immediately recognizes him as the older man at the inn. The younger man comes out as well and is told to frisk Barry. The older man introduces himself as Captain Feeney (Arthur O'Sullivan), and from Barry's reaction he must be the notorious highwayman. Feeney takes Barry's horse and gold but allows him to retain his boots. Now Barry can only walk to continue his trek. He finally gets to a town square where a military man is addressing the crowd about recruitment into the army.

Barry sees joining the army as good fortune. Barry is in a bright blue uniform while the troops are resting for a meal. Barry calls out loudly for another beaker to drink out of because the one he has is full of dirty grease. All the men laugh at him for being so fussy in a situation where soldiers are headed toward battle. One of the largest soldiers comes over to Barry, grabs his beaker, and drinks out of it, grease and all. Later the two men clash again, and it is suggested that they have a boxing match. The soldiers form a human ring and the two contestants take off their shirts. The big man may be large, but he is clumsy. Barry knocks him down several times; each time the man swings more wildly until he is knocked down for a final time, and Barry is declared the winner.

For action scenes such as these, a director usually brings in an expert trainer and time is scheduled while the actor learns the physical skill. Kubrick knew that Ryan O'Neal was trained to be a Golden Gloves boxer while still in high school. The authenticity during this fight is clear—O'Neal is the real thing, landing impressive blows against a very big man but one who did not know how to box. This touch gives another realistic element to this impressive period film.

The army marches on. Eventually Barry becomes a proper soldier, a step up from his boyish ways. Barry runs into Captain Grogan (Godfrey Quigley), an old family friend. They talk under a tent at night, lit by candles. Grogan knew what had happened with the Quin affair, and that Quin was not dead. Because of the money at stake riding on Quin marrying Nora, her brothers loaded Barry's pistol with tow, a fibrous material that did no harm. Nora had married Quin for the family debt, and was upset about the whole situation.

Barry fights in the Seven Years' War, a global conflict fought from 1756–1763. During a battle the soldiers march with their rifles pointed at the enemy. The handheld camera technique was utilized throughout the film, especially in battle sequences. Grogan is hit, and Barry brings him to a safe area. Grogan offers to literally give Barry all the money he has. Grogan dies, and Barry, who truly loves the man, cries as he holds him.

Six years go by. The army raids farms and confiscates livestock. Barry is given the assignment to carry a water bucket. When he gets to the river he sees that two soldiers have taken off all their clothes and left all their papers by a tree. He listens in on the conversation and determines that the men are romantically involved. They are unaware of Barry's presence. He puts on one

man's blue and white Prussian uniform, takes his papers, mounts his horse, and once again is on a journey.

Barry comes upon a house in which a young lady, Lischen (Diana Koerner), lives with her baby. She invites him in for supper. As he eats and the woman holds her baby, the light from the candles flickers on the walls. She explains that her husband has been off in the war for a very long time. They talk about loneliness. He holds and kisses her hand, and she asks him to stay for a few days. They kiss. He is the perfect gentleman. The woman is truly lonely, having been in the house for a long time. Barry never looked more handsome. Days go by and he tells her he must leave. He says goodbye and mounts his horse, and is again alone on a road until he is stopped by Captain Potzdorf (Hardy Krüger). They are both civil, but it seems Potzdorf is suspicious of Barry. They have dinner at an inn. Potzdorf asks Barry many specific questions and finally calls for his arrest. Barry avoids prison by joining the Prussian Army. During a fierce battle Barry gets Potzdorf out of a tight spot and rescues him. There is a ceremony to celebrate Barry's heroism. The Minister of Police gives him an assignment to act as a spy to get information on the notorious gambler, the Chevalier du Balibari (Patrick Magee). Barry goes to the Chevalier's home and immediately confesses that he was sent as a spy. Barry begins to cry. The Chevalier is moved by the lad's story. Barry makes his report to the police based on the Chevalier's wishes.

At a card game a man accuses the Chevalier of cheating him. The Chevalier and his assistant leave immediately. Barry reports this to the police. Barry and the Chevalier discuss the situation, and Barry reports to Potzdorf. Next morning a carriage is in front of the Chevalier's lavish home. Barry is dressed and made up to look like the Chevalier, and he leaves.

Barry now works with the Chevalier who indeed is a dishonest gambler, cheating people with the assistance of Barry. There is an elaborate gambling session underway with many men and women watching the proceedings. The Chevalier is playing against Lord Ludd (Steven Berkoff), who feels he has been cheated and demands satisfaction. During the day a duel takes place with Barry and Lord Ludd. It is a lively duel, and in the end Barry wins and Lord Ludd must pay up his debt.

There is a breathtaking shot of a white castle on a hill. The narrator states that five years have passed. Barry and the Chevalier sit at a spacious reflecting pool. They see the stunning Countess Lyndon (Marissa Berenson), her son Lord Bullingdon (Leon Vitali), and her close advisor and chaplain Reverend Runt (Murray Melvin). After filming *Barry Lyndon*, Vitali became Kubrick's personal assistant and worked with the director throughout the rest of his career, most notably taking care of young Danny Lloyd during the making of *The Shining*.

A gambling session is in progress. The Countess stares at Barry, and Barry focuses his gaze on her in return. She steps onto a large balcony, and after a

beat Barry walks up next to her. She turns and they kiss. Martin Scorsese (see note in Chapter 3) has stated this is one of his favorite movie scenes, remarking on the elegance achieved.

The Countess and Barry begin to court; they go boating and walk in the garden. Her husband, Sir Charles Lyndon (Frank Middlemass), dies. At this point the film goes into an intermission. This is part of a long movie theater tradition of the past, allowing patrons to stretch, go to the restroom, and replenish their supply of snacks. This is no longer the case, as movies three hours long or a bit less are screened straight through. This also allows for more showings. The length of an intermission during the era of *Barry Lyndon* varied, and it did have an impact on the overall movie theater schedule. The second part of *Barry Lyndon* begins with a card stating there will be an account of the misfortunes and disasters that befell Barry Lyndon.

In a chapel Reverend Runt marries Barry and Countess Lyndon. There is a gallery of people on a balcony who are there to witness the occasion. A combination of makeup, hair, costumes, and especially lighting give the impression that these are not real people. An astute viewer looking at the right spot in the right moment can see some movement. The gallery looks like it is filled with painted people, or well-placed dummies, which later became a common practice.

Now that he has higher social status, Barry's manners begin to drift. As Lady Lyndon and Barry ride in a coach, Barry smokes a pipe and keeps deliberately blowing smoke in his wife's face. When she tells him the smoke is bothering her, he smirks and blows a large puff of smoke in her face. Within a year after the marriage they have a baby boy, Bryan (David Morley), whom Barry adores. Barry's stepson Lord Bullingdon doesn't like the way he is treating his mother. He loved his father and doesn't see Barry as a replacement.

Barry frequents a club. He is seen with two topless women whom he is kissing and touching. Lady Lyndon stays home with her two boys. One day she, her son Bryan, and Reverend Runt are taking a walk when they look across the way and see Barry necking with the nanny.

Lady Lyndon, Reverend Runt, and two ladies play cards by candlelight. Then Lady Lyndon takes a bath in an elegant period bathtub, while a lady in waiting reads to her. Barry comes in and politely excuses her maidens. Barry apologizes to his wife, and they kiss in profile.

The next scene is at dusk. Barry is in his study, and Lady Lyndon comes in with the two boys. Lord Bullingdon won't give Barry a kiss and talks back to his stepfather. Barry takes Lord Bullingdon into a very large room and whips him repeatedly, followed by a strong chastising.

On the grounds there is a celebration of Bryan's eighth birthday. Leon Vitali plays Lord Bullingdon with great flair, as if he were a 18th-century Mick Jagger. That night Barry tells a story to Bryan who is in bed, while

Barry's mother looks on at her son and grandson. Bryan is afraid of the dark, and his father comforts him. Outside Barry's mother tells Barry that although he is surrounded with riches, he doesn't have a penny of his own as Lord Bullingdon is the heir to the Lyndon fortune. To solve this, Barry must get a title. A man gives Barry advice concerning this situation, and Barry and the man meet with someone who can advance Barry in terms of a title. Barry is at dinner along a long table, and he looks at the man's extensive original art collection. Barry buys an expensive painting. A line of men meet the king, who is introduced to Barry Lyndon.

Next is another landscape shot that sets the mood and places the scene. In a large schoolroom the two boys study at their desks. Reverend Runt, their tutor, leaves the room. Bryan asks Bullingdon a question and makes noise over a period of time, even though his stepbrother tells him to please be quiet. This erupts into a fight. Barry spanks Bullingdon, who becomes incensed and threatens to kill Barry.

A large audience attends a concert featuring Lady Lyndon on the Harpsichord[3] and Reverend Runt on the flute. Barry and his mother are in the front listening to the music. The boys enter the room in the middle of this. Bryan stomps into the room wearing heavy adult shoes, making a dreadful noise, with Lord Bullingdon next to him. They stop in front of their mother, and Bullingdon begins to insult Barry in front of everyone. Lady Lyndon cries and leaves. Barry physically attacks Bullingdon. The men in the audience pile on top of them to stop the noisy and ugly fight.

The man who could help Barry get his title comes into a restaurant and tells the waiter that he'll be dining alone. In the very back Barry is sitting alone at a table; he sees the man and walks up to him. The man is friendly but a bit standoffish because he's learned Barry is not the kind of person he likes to do business with. Barry offers a seat at his table for the gentleman, hinting that he would like to have dinner with him. The man lies and says he's expecting company, and Barry walks back to his far table.

Barry has spent all of Lady Lyndon's money, most of it trying to prove how aristocratic he is and on drinking, gambling, and women. The family is sunk with bills and debts. Yet he remains a loving father to Bryan. He takes the boy boating and reads to Bryan in front of a huge painting, which points to the large space they are in and their relationship to the environment, a constant Kubrick theme. Barry teaches the boy how to duel and how to play the gentleman's game of croquet. The boy loves riding, so Barry puts Bryan on a pony and they go riding. The boy wants a full-sized horse; Barry makes it seem that it's out of the question but buys one for Bryan's upcoming birthday. The boy finds out that Barry did indeed buy him a horse, but Barry tells the stablemen that Bryan is only to ride the horse in the company of his father. One morning Barry is shaving in his room when Reverend Runt tells Barry that Bryan headed out to the farm where the horse was held. Barry rushes

out, but when he gets there it is too late. The boy had ridden the horse, which threw him. He is bandaged heavily and lying on a stretcher carried by several men from the farm. A doctor is called. Bryan is in bed with his parents guarding over him. "Am I going to die? I can't feel anything," he tells them. To ease the boy's fears, Barry tells him a favorite story about his exploits in a fort. The boy dies. The funeral procession is long with everyone in black—it's a sad moment and a real tragic blow to Barry and Lady Lyndon, who adored him.

One night Barry's mother, dressed in her night clothes, brings in two men to carry the very drunken Barry from a chair on which he has collapsed, to his bed. Barry's mother is his only faithful soul. Lady Lyndon prays with Reverend Runt. The bills continue to pile up. Barry's mother takes over the running of the estate and summons Reverend Runt to the office where finances are dealt with. She tells him he has to go because the house doesn't need a tutor anymore. He counters that he can't leave because he doesn't want to leave Lady Lyndon in the fragile state she is in since the death of Bryan. He fights her, but loses. Lady Lyndon's condition worsens and she takes a small amount of poison, thrashing around her bedroom until she receives help.

Lord Bullingdon, who had left the estate in anger of Barry's presence in his father's home, is now back and with a purpose. He sets out to find Barry and discovers him in a men's club. Bullingdon walks slowly through the club past men playing cards and finds Barry drunk and collapsed in a chair. Bullingdon tells Barry he wants satisfaction, and a pistol duel is held. The location is a high brick building, and light comes through looking like a crucifix. There is hay on the ground. The tympani music repeats. A coin is flipped and paces are measured. Pigeons fly through the enormous space. Lord Bullingdon's gun goes off by accident while he is cocking the weapon. That is considered his turn, and he is horrified. He runs off and vomits. He comes back to his spot, and Barry sends a message by firing far away from him. Bullingdon is asked if he has received satisfaction, and he stubbornly says no. He is given a new pistol and shoots at Barry, hitting him and sending the man to the ground.

Barry is in bed at an inn where a surgeon comes in and says he'll have to lose the leg slightly below the knee. A coach waits. Lord Bullingdon comes out of the family house having completed his mission. Barry's mother plays cards with Barry. Barry will be given an annuity and must leave England. If he chooses to stay he will be arrested. Barry leaves the inn on crutches, and as he enters the coach, the image becomes a **freeze frame**. Barry moves to Ireland to be a gambler with very little success. He never sees Lady Lyndon again. The film ends with a card: "Epilogue: It was in the reign of George III that the aforesaid personages lived and quarreled; good or bad, handsome or ugly, rich or poor, they are all equal now."

Conclusion

Barry Lyndon is a satisfying film that is worth the effort of watching at its length of three hours and three minutes. For those who admire Stanley Kubrick and have seen all his films but this one, it is necessary viewing to understand the depth of this director's vision and to experience the high excellence a period film can attain.

Notes

1. The BNC Mitchell motion picture camera was introduced in 1932 and became the Hollywood standard for the remainder of the century. It was manufactured by the Mitchell Camera Corporation founded in 1919 by Americans Henry Boeger and George Alfred Mitchell as the National Motion Picture Repair Company.

2. *Look* magazine was published biweekly from 1937 to 1971 and whose content was general interest. Its goal was to achieve a higher readership than its rival the popular *Life* magazine. Stories on a wide range of topics were accompanied by photographs, some in a sizable format.

3. A harpsichord is a musical instrument played by means of a keyboard and a row of levers that the player presses. When the player presses one or more keys, this triggers a mechanism that plucks one or more strings with a small plectrum.

For Further Study

Screen

Amadeus
Dangerous Liaisons (1988)
The Duellists
The Remains of the Day
Waterloo

Read

Barry Lyndon by William Makepeace Thackeray
Mansfield Park by Jane Austen
Thackeray: The Life of a Literary Man by D. J. Taylor
Thackeray's Universe: Shifting Worlds of Imagination and Reality by Catherine Peters
William Makepeace Thackeray by Ina Ferris

The Origin of the Creative Jump Cut

Breathless

There's an old myth that can be applied to the principal topic here, that if one looks up **jump cut** in the dictionary, they'll find a photo of film director Jean-Luc Godard. His first feature film, *Breathless*, is a legendary movie—a textbook for the jump cut. The entire film is structured by this daring aesthetic device.

A jump cut occurs when a piece of film, video, or digital material is cut during the duration of a shot and joined to another shot in such a way that the spatial relationship is abruptly altered. When projected there will be a physical jump from the first piece to the second, causing a discontinuity in the action.

Jean-Luc Godard was born in France on December 3, 1930, and in 1951 began writing film criticism after an intense period of watching film in clubs dedicated to the study of cinema, especially the American cinema, which eventually lead to embracing the **auteur theory** in which the director of a film is considered the sole author of a motion picture. Along with François Truffaut[1] and other young filmmakers, Godard was part of the **French New Wave** that made films that rewrote the cinematic lexicon, forever changing the way films were made and looked. Their reinvented movie language and narratives influenced American filmmakers such as Martin Scorsese,[2] Francis Ford Coppola,[3] and Paul Schrader,[4] who challenged Hollywood starting in the 1970s and created a new kind of American movie. Godard has made movies for over 60 years and, like Pablo Picasso[5] in visual art and jazz great

Miles Davis[6] in music, has been responsible for many movements and styles that have greatly impacted the cinema.

Georges Méliès, the magician and filmmaker from the 19th century, is considered to be the father of the jump cut. He discovered it by accident and then used the technique to simulate magic tricks, but he tried to make the cut seamless to complement his illusions—the opposite effect of the modern jump cut in which the filmmaker wants the viewer to see the jump in action. The Russian **avant-garde** documentarian Dziga Vertov created the masterwork *Man with a Movie Camera* in 1929, which makes use of the jump cut to create the film's varying and dynamic pacing. Godard in *Breathless* and in many films throughout his long career used the jump cut to create discontinuity, a statement against the **classical Hollywood film** style that he admired but defied in order to create his daring and original films.

There are many examples of the jump cut in American and foreign films. Sergei Eisenstein (see note in Chapter 11) utilized it in his *The Battleship Potemkin* (1925) to impart a political message. The jump cuts used in some segments make the audience aware of the hyperreality of the film experience in order to focus the audience's attention on the political message rather than on drama or the narrative. Alexander Dovshenko[7] of the Soviet Union used it in *Arsenal* (1930) by presenting a close-up of a man's face closer and closer nine times. Director/critic Mark Cousins noted that the jarring effect represents the idea of visual conflict which was central to Soviet **montage** cinema at that time.

Jump cuts have been used in sequences where a character is experiencing extreme nervousness or tension, such as in the science fiction film *Moon* directed by Duncan Jones (son of David Bowie) in 2009 where the protagonist is searching for a secret room on a moon base. During *District 9* directed by Neill Blomkamp in 2009 the **protagonist** searches for illegal objects in a house. In both scenes jump cuts are used to engender a tense emotional impact on the viewer.

The popular 1986 music video "Everybody Have Fun Tonight" performed by the British New Wave Band Wang Chung features the two front men singing into microphones in the corner of a large room with the band playing in the background. This is no ordinary music video, in that every cut is a jump cut that moves the heads of the singers forward and back and side to side with the band jumping all over the background. At times the singers are deadpan as their heads are tossed about via the rapid jump cuts.

Jump cuts were rarely seen on television until the hit show *Rowan & Martin's Laugh-In*.[8] The technique became part of the show's hectic visual style, and in 1968 film editor Arthur Schneider won an Emmy for his outstanding use of the technique on the show. An active use of jump cuts remained an uncommon sight until *Homicide: Life on the Street*[9] incorporated them into this landmark dramatic television series.

Up until 1959 in France and 1960 in the United States (when *Breathless* was released) there was no real creative use of the jump cut in Hollywood. There were jump cuts in studio-released films from the beginning, but those were considered mistakes. If two angles were badly mismatched and there was a jump in action or in the position of anything in the frame, that was a jump cut. The best example and the most common noncreative jump cut can occur in a scene where two characters are having dinner at home, in a restaurant, or at a nightclub. The level where a beverage is in a drinking glass is established immediately. When it cuts to another shot then comes back to the first position the level of the beverage should either be the same or, if the character took a sip, nearly the same. If the level moves dramatically from top to bottom or otherwise—that is a jump cut. During the classical Hollywood studio era this was called a **continuity** error and the person maintaining continuity, the script supervisor who was responsible to make sure everything matched from shot to shot, was charged with the mistake.

Godard has maintained that he and his editor Cécile Decugis did not set out to apply jump cuts throughout *Breathless*, nor was the film shot with jump cuts in mind. Jump cuts are in the editor's domain. During the postproduction process the notion comes to them. In many ways they proceeded like jazz musicians, improvising from the major action and themes of the movie. The results of jump cuts in *Breathless* spread around the world as a new editing transition became a major aspect of the postproduction arsenal, joining the **dissolve**, the **wipe**, and other editorial tools offering a dynamic contribution to the pace or rhythm of a movie.

Narrative and Cinematic Analysis

Dedicated to Monogram Pictures, a low-budget Hollywood studio that made Westerns and action films, *Breathless* begins with a Humphrey Bogart–obsessed young man named Michel (Jean-Paul Belmondo) who shoots and kills a police officer and runs away. He meets a pretty and aspiring American student and journalist named Patricia (Jean Seberg) who sells the *New York Herald Tribune*[10] on the streets of Paris. She becomes pregnant and eventually betrays him, and the police catch up with Michel.

Breathless has a jazzy score by Martial Solal, a French jazz pianist and composer. The score has several movements, but its most memorable is a riff that has five notes followed by an additional seven to conclude it. It is seemingly endless in its repetition for the full 90-minute running time of the picture.

Michel, who is a petty criminal and ladies' man, goes too far. He has a gesture that he repeats throughout the picture in which he runs his thumb across his lips, which we learn is part of his obsession with crime movie icon Humphrey Bogart. This has to do with a sense of cool and the connection with the actor who in his early years often played a gangster.

As Michel rides in a stolen car, there are jump cuts that propel his speed. The entire film is not jump cut; Godard uses them to alter the pace or fracture the presentation of time and space. There is a dissolve to a **point-of-view shot** (POV) of Michel driving. This was a common transition during the time in which *Breathless* was made. It was soon to be taken over by the straight cut—a reaction to the technique of the old Hollywood studio system by the **American New Wave** beginning in the late 1960s. Dissolves in *Breathless* aren't always traditional but at times are considerably longer than the Hollywood standard of 24 film frames for one second, 48 film frames for two seconds. While driving, Michel turns to the camera, a device that lets the audience know they are watching a movie, when a character is directly addressing them. Godard uses this technique known as **self-referential film** sparingly, not throughout the whole film as others have done. He has also applied self-referential style to future films. Technique to Godard in *Breathless* is like playing jazz: putting elements in to accent the main themes like a drum shot, a guitar riff, or a horn section playing in unison for a short time.

As Michel is pursued, he finds a handgun in the glove compartment. He is speeding, which brings on a police chase that unfolds in a series of jump cuts. He thinks he has escaped the law, but one of the police officers catches up with Michel and chases him down. Michel then takes an action that will change his universe—he fires the gun and kills the officer. Michel goes to the apartment of one of the women he has been with, a model with pictures of herself on the walls. He asks her for money. There are more jump cuts in this scene, altering how we see the room and the two people within it. Godard also compresses the action of one shot that matches the action of a second shot, so that the tail of the first shot is quickly linked to the head of the next one. These are not jump cuts but **compression**—there is no jump in the action, just a compressed result that speeds up that moment in the film.

On the street Michael walks with Patricia, who is wearing a striped top and a very short haircut and selling copies of the *New York Herald Tribune*. Seberg made her film debut in 1957 in the title role of *Saint Joan* directed by Otto Preminger[11] after being chosen out of 18,000 in a $150,000 talent search. She went on to appear in *Bonjour Tristesse* (1958), *Lilith* (1964), and *A Fine Madness* (1966).

Michel talks to Patricia about money and sleeping with him. A **handheld camera** captures this in a very long take with no editorial interruption. They had been together for a couple of days, and she is not sure whether she wants to continue the relationship. Classical Hollywood films present a consistent **screen direction** in the manner that characters and objects are traveling, so the viewer won't be jarred. Godard as a critic and film lover was very aware of this rule, but in his first feature film he alters screen direction so in effect the characters and vehicles from one shot to another may be moving in an opposite direction than reality would warrant. Another woman is selling

Cahiers du Cinéma on the street and holds it up to Michel. Godard likes to use references and cameos. Here he is referring to the legendary film magazine where he, Francois Truffaut, and others of the French New Wave wrote criticism and articles that radically changed how writers look at the cinema, developed the auteur theory, and rediscovered Hollywood directors who lacked attention.

From the moment Michel kills the police officer he is on the run, looking for money and ways of getting out of the country. He remains cool and hip. Michel goes to a building to see a friend he hopes will help him. The building is spacious and is photographed in one long take. Michel talks to the friend and the camera is hand held.

Michel goes to the front of a movie theater where there are posters of Bogart, and he makes his thumb/lips gesture at the picture of his hero. An **iris transition,** in which a black circle closes up or opens up over an image as an editing transition, is utilized here. The iris transition was used extensively during the silent film era. This use of older film language contrasts with cutting-edge camera and **postproduction** elements that reference each other and highlight Godard's love for all cinema—the old and the new. Godard with his extensive knowledge of the cinema specialized in many schools of filmmaking, especially Hollywood and French filmmaking. Michel goes into a restroom, knocks out a man, and then robs him. Back on the street with Patricia he tells her he wants to sleep with her that night; she is noncommittal.

They are driving. The camera is shooting from the back seat, focused on the back of their heads. Here there are a series of jump cuts. Michel is giving Patricia a list of the parts of a woman he loves. On each phrase there is a jump cut accentuating his words.

Patricia takes an escalator to a restaurant and goes to a table where a man is waiting. He tells her a story, and there are jump cuts during this punctuating his speech. They leave. Michel walks through the same restaurant—outside, the man and Patricia kiss as Michel watches them without them seeing him. **Fade out to black**. Image of the Eiffel Tower, the most famous French landmark. Patricia runs across the street, still wearing the striped shirt. She goes to a room, and Michel is there in bed. Patricia sits on the bed. This is a long take, one of several uninterrupted takes in the film. Michel looks through a French men's magazine with photos of naked women. As he thumbs through, there are jump cuts. There is a long held close-up on Michel's face. He often calls Patricia a "coward," because she won't go on the run with him and because she won't commit to sleeping with him. Michel runs his thumb over his lips once again.

There are many time cuts in *Breathless*, when a cut from one shot to another places a character in a completely different location and time. In Patricia's room she has an Auguste Renoir poster on the wall. Michel expresses his disinterest in great art. Patricia tells Michel she is pregnant—the audience

never finds out who the father is. Michel makes a series of phone calls trying to get money and get out of town. Patricia plays a classical record on her phonograph. Patricia and Michel are in front of a mirror in the room—there are jump cuts. Michel makes more phone calls. Patricia slaps Michel; he has his shirt off. He takes a long look at Patricia. They are both lying in bed with sheets over their heads as jump cuts play out. She tries to discuss books with Michel but again he is not interested in art of any kind. They make love **off-screen**. Michel and Patricia question each other. Michel rides an elevator. Michel steals another car; Patricia is having a curbside drink. At the front of the *New York Herald Tribune* building Godard, playing an unnamed cameo, reads a newspaper, then recognizes Michel and points him out to the police.

Another iris transition. Jean Pierre Melville, the French film director who influenced Godard and the whole French New Wave, plays Parvulesco, the writer, and is being questioned by the press during a conference. Patricia is there representing the *New York Herald Tribune*, trying to get a question in. Parvulesco is very attracted to her. When Patricia asks her question, there is a jump cut on her, then a slow dissolve.

Michel tries to sell the stolen car to someone but he recognizes the cop killer from his newspaper. The man removes the distributor cap, rendering the vehicle impossible to run. There is a fight edited with jump cuts. Car. Back seat view on driver—many jump cuts. Michel leaves the car, then comes back. Jump cuts on driver, on Michel and Patricia in the back seat of cab.

Camera on back seat—jump cuts. Interior of the *New York Herald Tribune* office. A detective shows Patricia Michel's picture in the newspaper; she says she doesn't know him. When he says he is a police officer she admits she knows Michel. Michel is on the street reading the newspaper. Jump cut on street. A motorcade passes by—jump cut. Patricia goes into a small movie theatre. Otto Preminger's **film noir** *Whirlpool* (1950) is playing. This is another reference by Godard, as Jean Seberg worked with Preminger on other pictures. Patricia is being followed. President Eisenhower's name is mentioned in connection with a motorcade. Fade out to black.

The police are closing in on Michel. They steal a Cadillac and Patricia drives. An electric sign confirms that an arrest of the cop killer is imminent. The model former girlfriend of Michel is on the street with a newspaper. Michel goes to a bar looking for someone. Patricia and Michel go into a studio where his former girlfriend is posing in front of bright lights for a photographer. Mozart is put on a phonograph. Patricia looks into the camera as the image fades to black.

Patricia goes to a bar and orders a scotch, only to be told by the bartender that he doesn't have scotch. So, she has a coffee. Patricia calls the police on Michel. Later she tells him she called the police because she doesn't want to be in love with him. The police arrive and shoot Michel. He runs very slowly in the street trying to get away; the scene is exaggerated and melodramatic.

Patricia runs after Michel, who falls to the ground. Close-up on Patricia, and they look at each other. Michel makes a series of funny faces as he did much earlier in the film. She looks at him; Michel dies. Patricia looks into the camera and rubs her thumb over her lips; she turns.

Conclusion

In addition to being a landmark film because of the extensive and creative use of the jump cut, *Breathless* is also an inspiration as an independent film that now looks like what we call *guerilla filmmaking* or *run-and-gun filmmaking*. This is moviemaking on the cheap and quick. Godard gives the viewer the impression that he made his decisions mainly on location and on the spot, and that his cameraman Raoul Coutard grabbed the camera and followed the action as it evolved. *Breathless* is a film that is well ahead of its time and helped lead the French New Wave, which changed the way we watch and make films.

Notes

1. Francois Truffaut (1932–1984) was a French film director, screenwriter, producer, actor, and film critic. His *The 400 Blows* (1959) came to define the French New Wave. His other films include *Shoot the Piano Player* (1960), *Jules et Jim* (1961), and *The Wild Child* (1970). Truffaut wrote for the French film magazine *Cahiers du Cinéma*, was instrumental in creating the auteur theory, and published a book-length interview with Alfred Hitchcock in which the master discusses all of his films.

2. Martin Scorsese (1942–) is an American director, producer, screenwriter, and film historian whose many films approach themes such as Italian-American identity, Roman Catholic concepts of guilt and redemption, faith, machismo, modern crime, and gang conflict. He is an early member of the American New Wave and in 1990 formed the Film Foundation, a nonprofit organization dedicated to film preservation.

3. Francis Ford Coppola (1939–) is an American film director, producer, screenwriter, and film composer. He was a central figure in the American New Wave of the 1970s. He is most famous for *The Godfather* (1972) and *The Godfather Part II* (1974), and his visionary look at the Vietnam War in *Apocalypse Now* (1979). Coppola is a larger-than-life figure who in addition to directing productions large and small also owns a winery and is in the hospitality business.

4. Paul Schrader (1946–) is an American film director, screenwriter, and film critic. Schrader became a notable screenwriter with films such as *Taxi Driver* (1976) directed by Martin Scorsese, and transitioned to film directing with *Blue Collar* (1978). He wrote film criticism for many years as well as the landmark book *Transcendental Style in Film: Ozu, Bresson, and Dreyer*, published in 1988.

5. Pablo Picasso (1881–1973) is widely considered the most influential painter of all time. He is distinctive in the many styles and periods he worked in, including Realism, his Blue Period, his Rose Period, his African influence period, Cubism, and Surrealism. He lived a long life and left a staggering amount of work. His name has become synonymous with art and painting itself.

6. Miles Davis (1926–1991) was an influential Jazz musician who revolutionized the genre. His instrument was the trumpet, and he developed many movements including the Cool School, Hard Bop, and Fusion. He embraced Rock, Funk, Electronic Music, and Rap. With each new band he formed, Davis encouraged and showcased new players, many of whom later developed successful solo careers.

7. Alexander Dovshenko (1894–1956) was a Soviet screenwriter, film producer, and director of Ukrainian origin. He was one of the most important filmmakers of his time and a pioneer of Soviet montage theory along with Sergei Eisenstein. His films include *Arsenal* (1928), *Earth* (1930), and *Ivan* (1932).

8. *Rowan & Martin's Laugh-In* was an irreverent sketch comedy show that ran on NBC from 1968 to 1973. Comedians Dan Rowan and Dick Martin were the hosts, and the cast who were previously unknown at the time included Goldie Hawn, Lily Tomlin, and Arte Johnson. There were memorable characters such as Wolfgang the German Soldier, poet Henrik Ibsen, and Ernestine the telephone operator, The show was also known for catch-phrases such as "You bet your sweet bippy," "Sock it to me!" and "Look *that* up in your Funk and Wagnalls." The show was fast paced and over-the-top funny.

9. *Homicide: Life on the Street* was a police procedural television series that aired on NBC from 1993 to 1999. It chronicled the work of a fictional version of the Baltimore Police Department's homicide unit.

10. The *New York Herald Tribune* was a newspaper published from 1924 to 1966. It was widely regarded for the quality of its writing and won the Pulitzer Prize many times.

11. Otto Preminger (1905–1986) was a director and actor known for his dictatorial temperament on set. His films include *Laura* (1944), *Anatomy of a Murder* (1959), and *Hurry Sundown* (1967).

For Further Study

Screen

Band of Outsiders
Jules and Jim
Les Carabiniers
My Life to Live
A Woman Is a Woman

Read

Everything Is Cinema: The Working Life of Jean-Luc Godard by Richard Brody
Godard on Godard by Jean-Luc Godard, edited by Tom Moline
Jean-Luc Godard: Cinema Historian by Michael Witt
Jean-Luc Godard: Interviews edited by David Steritt
Jean-Luc Godard: Portrait of the Artist at 70 by Colin MacCabe

Surrealism David Lynch Style

Eraserhead

Henry Spencer lives in an industrial area never identified. When he learns a former girlfriend is pregnant, he agrees to marry her and they live in his claustrophobic flat. The baby born is fowl-like in nature. The woman leaves, and Henry is seduced by the Beautiful Girl Across the Hall. The story becomes more surreal as a Radiator Lady appears, singing "In heaven everything is fine," and a man on a planet sends out electrical current leaving Henry in a world engulfed with floating particles. David Lynch's vision is dominated by dream imagery, a key element of surrealism. Lynch's images are personal and resonate with meaning. *Eraserhead* (1977) can be seen as one continuous dream or nightmare with connective scenes.

David Lynch is an unusual filmmaker not only because of the content and look of his movies (and television work) but as a person. He was born in Missoula, Montana, and was a Boy Scout—for someone with such a dark vision, he has been described as having a golly-gee personality. He studied fine arts painting in college and by the 1960s was making short films. His art and early films put forth a decidedly disturbing worldview with a surrealistic edge. Dysfunction and mutilation are among the themes in his artistic vision. The strangeness of David Lynch is deep within his paintings, films short and long, screenwriting, television and Internet work, music, and even the furniture he designs—as an artist, he is the real thing.

Narrative and Cinematic Analysis

The titles for *Eraserhead* appear immediately; then the side of the head of the lead character Henry Spencer (Jack Nance) who sports a haircut short on the sides and very tall on the top comes into view. Finally, in the same shot is

an unidentified planet. Henry, still positioned sideways, floats first down and then **off-screen**. Lynch and landmark **sound designer** Alan Splet begin with a spacey atmospheric sound wash. Splet started with Lynch on the short *The Grandmother* (1970) and went on to collaborate with the director on *The Elephant Man* (1980), *Dune* (1984), and *Blue Velvet* (1986). Splet also created sound environments that interpreted the visuals and expressed the content for other films, including *The Unbearable Lightness of Being* (1988), *Henry & June* (1990), and *Wind* (1992). Here, Splet and Lynch have achieved more than just sonic atmosphere: they make sound a character in this unusual film. The sound design enters the head of the viewer like a scary creature whose noises and effects travel around the brain like an uncontrolled entity that frightens at every turn.

The camera lens pushes into the planet and moves through the surface of this black-and-white film. This independent film is not the Hollywood black-and-white of *Casablanca* (1942), *The Asphalt Jungle* (1950), *Psycho* (1960), or *The Last Picture Show* (1971). It uses chiaroscuro—an Italian word meaning "light/dark," the use of extreme levels of black and white contrast—and the painter's eye of composition to create images that are not always composed to please the eyes of an audience raised on traditional movies. The viewer is forced into a museum of strangeness, fear, and horror. A decrepit man sits in a window. Broken glass. He pulls levers—a spindly eel-like creature is catapulted into water, then into a black hole. Hollywood had long presented scary creatures in films such as *The Creature from the Black Lagoon* (1954), which by their very presence shivered the spine, but Lynch utilizes not only movement and brevity but also the dread of a possible reoccurrence.

There is the sound of static. Lynch and Splet are not concerned that the listener may think there is something wrong with the speakers from which they are receiving this information, but present a sound most find irritating or even creepy. Henry walks to a large factory. Interior of Henry's apartment building. Henry's haircut is reminiscent of Elsa Lancaster in *Bride of Frankenstein* (1935) minus the white streak and the extreme angle; his points straight up. By switching genders, Lynch presents a subliminal reference to a movie often considered to be horror and absurd, as *Eraserhead* continues to be catalogued by many critics and audiences. Henry goes into an elevator. He has a sad and worried expression throughout the film. Beautiful Girl Across the Hall (Judith Anna Roberts) tells Henry his girlfriend Mary X (Charlotte Stewart) invited him to her parent's house for dinner. Henry empties the content of his brown paper bag. He puts on an organ music record, another trope used in conventional movies. We see the source of this sound—which is therefore diegetic as opposed to an invisible orchestra playing a soundtrack score—and wonder why he is playing this record. The notion of confusion in *Eraserhead* is constant throughout the

film. There is also a firm connection of the organ and the horror **genre** that harkens back to *Phantom of the Opera* (1925). In the memorable unmasking scene in this silent film classic, Lon Chaney as the deformed phantom is playing the organ when the horrifying reveal occurs. The off-screen accompaniment of chilling, undulating chords provides aural horror as Christine, played by Mary Philbin, shares her terror with the audience in this shocking reveal.

Lynch historically has been unable to explain anything within the film or how anything was accomplished, so the viewer is left to their own devices. Shot of a radiator. A picture of Henry's girlfriend is torn in half. Mary looks out of a door/window. The sound of steam. Henry has pens in a white pocket protector, a practice more common in the 1950s. It can only be assumed that *Eraserhead* takes place in 1977 when it was released, because the time and place are not firmly established. Henry meets Mary's mother Mrs. X (Jeanne Bates), who questions him. The father Bill X (Allen Joseph) announces they are having chicken. Bill asks Henry to carve the chickens. Henry cuts into one, and it starts to bleed profusely. The mother has a nervous fit, and Mary leaves the table. Mrs. X, now over her fit, asks Henry if he had sex with Mary. Mary cries. The living room lights spark. A premature baby is at the hospital—we are not sure if it is a baby. This sets fear in the viewer as to what is to come. Then comes talk about Henry and Mary getting married.

Mary is in Henry's apartment. Their baby is on a table on a striped pillow. It looks like a fetus/chicken, one of the scariest and confusing moments in independent filmmaking of the era. Now the viewer's worst fears have arrived. This is not the Frankenstein Monster or the Mummy of the 1930s, the Wolf Man of the 1940s, or any of the classic monsters of Universal Studios fame, but a modern horror: possibly part human, part fowl, and impossible for the majority to fathom. Henry smiles at Mary feeding the baby. Moss-like material below the radiator (this was in the X family's house also). Henry sees a theatrical stage. The window goes dark. Mary is in bed, and Henry sits on the edge of the bed. Wind. Not the sound heard in most other movies—otherworldly. They don't face each other. The baby cries. Mary shouts "Shut up!" Mary shakes the bed in anger then leaves with a suitcase. A bare tree in a mound of dirt is next to the bed, just one of the unexplained surrealistic images in *Eraserhead* that is left to interpretation. As a painter and a student of art, the work of great surrealists such as Salvador Dali, Rene Magritte, and Giorgio de Chirico were probably in Lynch's mind throughout his early days at the easel and in the world of *Eraserhead*. He has created his own form of surrealism out of his dreams waking and sleeping and from his unique and dark manner of thinking and seeing the world around him.

Thunderstorm. The Beautiful Girl Across the Hall is walking there. Henry takes the baby's temperature. The baby is swaddled in gauze, and its

temperature is normal. Suddenly the baby's face is filled with nasty dots, an image that the viewer can easily imagine in color while watching this black-and-white film. In this case realism is not the order of the day, but the image is drawn from the audience's worst and most irrational nightmares. Henry tries to leave the room—the baby cries loudly. Then the baby is quiet, and Henry tries to leave again. He sits next to the baby, who is infected. A bubbling sound. The sound design in most films is at least 50 percent of the movie-watching experience; with *Eraserhead* the ratio is considerably higher. Radiator. Light comes up. Doors open. Old stage. Checkerboard tile floor. Curtains, footlights. The Lady in the Radiator (Laurel Near) has a white bouffant hairstyle. Her cheeks are puffed out and textured. Organ music plays and she dances step-by-step to the side, while eel-like creatures fall on the floor of the stage. The lady crushes one with her shoe. This sequence is one of the most memorable in the film because it unfolds like a dream, one no one could rationally explain or interpret.

Mary comes back. She and Henry are in bed. She keeps rolling over to Henry and he pushes her off. An organ tone. Henry pulls all the eel creatures off Mary, then throws them against a small cabinet that opens by itself. A small eel quickly crawls out. A low tone. The sound design of *Eraserhead* doesn't only consist of expressive **sound effects**. Tones, low, loud, and of varying lengths and aural texture are atmospheric tools that are both subliminal and maddening. A knock. Henry opens the door and sees blackness, then the Beautiful Girl Across the Hall. She is locked out of her apartment. She comes in to see Henry. Henry covers the baby's mouth. Henry looks like an old silent era movie actor like Roscoe Karns in *Wings* (1927) or Thurston Hall in *The Squaw Man* (1918). Mary is gone again. The Beautiful Girl Across the Hall says she would like to spend the night with him. She looks like she wants to kiss him. They kiss and caress in a strange kind of hot tub with dark material on the sides and a milk bath, which they enjoy. They go under the milky surface. She looks frightened. A piece of the planet is shown.

Fade in. The Lady in the Radiator is again on stage singing a song that contains the lyrics "Everything is fine." Organ music. Henry touches her hand. White light. Curtains. A man with a distorted face appears. An eel slithers. Henry's head pops off, still moving, and the baby's head is in the suit's neckline. This transference brings the baby and Henry in one body, and not only makes them father and son but also becomes another disturbing image with psychological repercussions. Henry's disembodied head bleeds, disappears, then lands on street outside. Inside, a boy brings in the head. The boy is brought to the machine man (Hal Landon Jr.), who drills into the head. He works the machine. Pencils move down a line. The piece from the head is now a pencil. The machine man deems it okay. The boy is given money. This can be absorbed as a surreal comment on industrialization and an obsession with products.

Henry knocks on door of the Beautiful Girl Across the Hall—there's no answer. Henry is back in the room—the baby laughs. Organ music. Henry leaves to find a strange man touching the back of the Beautiful Girl Across the Hall. Henry takes out a scissor and cuts the gauze bandages on the baby. Innards are revealed. Henry stabs the baby while blood and guts pour out. The floor lamp goes on and off. Sparks. A hippo head pops around the room. The lights go out. A planet. Particles float around Henry. Ridley Scott's *Alien* (1979) and *Blade Runner* (1982) often have particles in the air as a way of layering the image with texture. Lynch does achieve that, but the particles are so visually connected to Henry that they go beyond texture to establish that Henry may now be somewhere else—on a planet not in our solar system. A distorted man makes sparks. The Lady in the Radiator hugs Henry while the screen goes very bright. Thus ends this David Lynch cinematic experience.

Conclusion

Surrealism was born out of the Dada art movement, which developed in Europe at the beginning of the 20th century. It was comprised of artists who rejected the logic and aestheticism of modern capitalist society. They expressed nonsense, irrationality, and antibourgeois ideas in their work. Surrealism is a cultural movement beginning in the 1920s that produced art works and writings. The works were illogical and rendered with photographic precision. André Breton was the founding leader of this provocative movement. He was the author of many books, including several about surrealism and one a manifesto.

Cinematographer Fred Elmes (*River's Edge* [1986], *The Ice Storm* [1997], and *Broken Flowers* [2005]) met David Lynch when they were both at the American Film Institute (**AFI**). Herb Cartwell had been shooting *Eraserhead* when it had a shorter schedule, but when the film continued to press on in production, he had to leave. Cartwell shot the first couple of months of the project, and Elmes photographed the last couple of years. The process was slow, but Lynch knew what he wanted. Lynch and Elmes never looked at movies, paintings, or photographs for reference but talked about the mood, how things looked, and the light and shadow. There are very few day scenes in the film as sunlight wasn't acceptable to Lynch. They could only shoot outside on heavily overcast days. They developed their own language to communicate Lynch's concepts.

Eraserhead is about isolation, loneliness, and a desperate need to escape from the grim life that entraps the central character, but Lynch has never explained his film or what he was trying say in it or with it.

The AFI gave Lynch approximately $10,000 to create *Eraserhead*. Preparations began in early 1972. Lynch and his small crew worked below the

mansion of the AFI center in a group of (what Lynch called) stables, garages, quarters for maids and mechanics, a huge hayloft as well as a greenhouse and the grounds around it where a small studio was established. They had about five or six rooms and the large loft where the other sets were built, and a mini **soundstage** and studio. **Flats** were bought from a studio that was going out of business for $100. When filming one set was complete, it was taken apart and the flats were used to build another. Sets were built within sets.

The baby, which is a startling image that shocks and sometimes disgusts as well as fascinates viewers, remains a mystery. Lynch refuses to discuss how it was made and functioned. He doesn't even take credit for creating it. Like a great magician Lynch keeps all the images in *Eraserhead* a secret, believing once people knew how they were done, the images would lose their power. In total, *Eraserhead* took four years after the set-building process began.

Shooting began on May 29, 1972. The AFI was busy running the school so there was little interference. Over the years of filming, Jack Nance went to a barber to maintain Henry's unique haircut, but when that became too expensive one of the women on the crew learned how to cut and tease Nance's locks. Jack Nance appeared in four other David Lynch films: *Dune* (1984), *Blue Velvet* (1986), *Wild at Heart* (1990), and *Lost Highway* (1997). Nance was in *Twin Peaks: Fire Walk with Me* (1992) but was cut out of the film before release. The director also cast Nance in his iconic television series.

For almost a year, shooting moved forward steadily. Lynch was very precise in everything he did, overseeing each and every detail. Nothing could be moved without his permission. To deal with the small budget, Lynch would send one of the crew out to swap meets and if he liked something—like an electric fan, a little duck that floated in a bowl of water, or a tailless mounted fish put on a wall—it made it into the movie. Henry's entire wardrobe was gotten from the Salvation Army[1] and Goodwill Industries.[2] The aunt of a crew member gave the production the vaporizer used to treat the baby's illness and some old worn sheets for Henry's bed. Some of the crew donated their living room furniture for the set of Henry's building lobby.

Someone told Lynch that the big studios threw out sound film stock. So the crew went to Warner Bros., went through the trash, and filled a Volkswagen car with big reels that were used in the **postproduction** of the film. Sound design was key to the mood and atmosphere of *Eraserhead*. Lynch working with Alan Splet created an expressive work in which the sound is just as important as the picture.

Elmes read books on **special effects** to learn how to shoot the special images in the film. Contacts were made with professional special effects people at the studios, and they helped the *Eraserhead* project by giving them instruction and tips to how to achieve things.

When shooting first began, Peter Bogdanovich's *Paper Moon* (1973) was being developed at the CFI lab and the controls administered over the

black-and-white process benefited *Eraserhead* when that project was finished. The lab ran black-and-white less often and was not as technically exacting as before, which caused some consistency problems. *Eraserhead* also had other photographic issues because they used film stock that wasn't the best quality. Camera problems were also part of the difficulty in production of the film.

The explosion of the planet was a difficult effect to produce. Lynch made some preparations but, when it came time to shoot it, everyone realized they didn't have a workable plan. A catapult was built and lead weights were put in it that would spring out and explode. Fred Elmes explained that he would be behind the camera very close to this, so an elaborate shield was built to protect him. Three cameras were running, but the catapult wasn't really working. Eventually out of frustration Lynch picked up the weights and threw them through the nose of the planet and out at the camera.

David Lynch maintained secrecy all during the making of *Eraserhead*. No one was allowed on the set without his permission, which was a rare occurrence. He wouldn't even let members of the AFI who were paying for the film take a look at anything.

The AFI put in more money, but at the end of the first year they told Lynch, who needed still more money, that they could only help him out with equipment and that he would have to find money elsewhere. In spring 1973 production of *Eraserhead* came to a halt.

On May 29, 1974, shooting resumed. Lynch separated from his wife and was illegally living in Henry's room at the AFI stables. To make money the director delivered the *Wall Street Journal* earning $48.50 a week. **Production designer** Jack Fisk (*The Thin Red Line* [1998], *There Will Be Blood* [2007], and *The Tree of Life* [2011]) and his wife actress Sissy Spacek gave money to the production and worked on set for a day—Fisk as the Man-in-the-Planet and Spacek as continuity clerk.

Lynch phoned a veterinarian asking for a dead cat. Then in his basement he put the animal in formaldehyde in a bottle. Shortly after doing this he couldn't get the cat out of the bottle; finally it popped out and he dissected the cat. The cat was in the film, but the sequence was cut out.

A major crisis occurred when the AFI told Lynch he could no longer stay in the stables. Unlike others at the AFI, Lynch was able to retain the rights to his film, which was essential to him. The AFI gave Lynch 30 straight hours to finish shooting in the stables. There were about 30 hours of work to do, mainly Henry's scenes in his elevator, but Lynch and his crew normally worked a pace that was meticulous and dedicated to the vision of the film. They did complete the film under this killing deadline, during which Lynch and the crew were beyond exhaustion. Lynch then rented a small guest house joined to a double garage, which they transformed into a postproduction studio where Lynch and Splet would finish the film.

There were still special effects shots to complete, which were mostly shot in Fred Elmes's living room. They had an animation stand and had limited time to rent a camera, usually over the weekend so that they would get an extra day. Lynch enjoyed doing this himself hands-on, as opposed to the Hollywood style where there is a specialist for everything.

Splet and Lynch completed the sound work in 63 nonstop days. The rough cut of *Eraserhead* was rejected by Cannes and the New York Film Festival but was screened at Filmex, where people didn't know what to think of what they had seen. The film was long, so Lynch cut 20 minutes. The Filmex screening led to the signing on of distributor Ben Barenholtz of Libra Films located in New York City. It became a cult classic, running at midnight to audiences that spread the word. After the release *Eraserhead* was shown at several festivals including Edinburgh, Scotland. Admirers of *Eraserhead* include Stanley Kubrick, John Waters, and William Friedkin.

Eraserhead is a model for and tribute to the personal film. Lynch goes beyond traditional Hollywood filmmaking and even sidesteps most of the conventions of the **avant-garde** or **experimental** film. Critics and scholars often use the word *vision* when talking about an exceptional film or filmmaker, and David Lynch certainly deserves to be identified as a film director with vision.

Notes

1. The Salvation Army was founded in London in 1865. It is a Protestant Christian denomination found internationally. It raises money and tends to the poor, destitute, and hungry by meeting their spiritual and physical needs. It collects contributions on the street, runs charity shops, and operates shelters for the homeless, disaster relief, and humanitarian aid.

2. Goodwill Industries is an American nonprofit organization that provides job training, employment placement services, and other community-based programs for people in need. They also sell donated clothing and household goods in their thrift stores.

For Further Study

Screen

The Blood of a Poet
Lost Highway
Mulholland Drive
Twin Peaks: Fire Walk with Me
Un Chien Andalou

Read

David Lynch by Michel Chion
David Lynch: The Man from Another Place by Dennis Lim
David Lynch Swerves: Uncertainty from Lost Highway to Inland Empire by Martha P.
 Nochimson
Lynch on Lynch by Chris Rodley
What Is Surrealism? Selected Writings by André Breton, edited by Franklin
 Rosemont

Nonfiction, Diary, Essay Filmmaking, and Editing as a Magician's Tool

F for Fake

During this unconventional **documentary**, an **on-screen** and **off-screen** Orson Welles investigates many facets of the concept of fakery, using his own life; much of the film is devoted to chronicling the experiences of notorious art forger Elmyr de Hory and his biographer Clifford Irving. Irving wrote *Fake! The Story of Elmyr de Hory, The Greatest Art Forger of Our Time* (1969). Irving himself was a person not unknown to fakery, having pulled his own hoax by claiming he had written an autobiography of the reclusive millionaire and aviation pioneer Howard Hughes. Irving went to prison for 15 months for fraud when the book was exposed as a fake.

Orson Welles began his career in theater and radio before directing *Citizen Kane* at age twenty-three. If Welles had only directed *Citizen Kane* (1941), long viewed as one of the greatest American movies ever made, he would still be considered an important and influential filmmaker. His next film was *The Magnificent Ambersons* (1942), which some critics and scholars speculate was his true masterpiece, but Welles's version was taken out of his hands by the studio while he was out of the country trying to create a multinarrative film for RKO Pictures, *It's All True*. Welles's editor Robert Wise[1] was pressured to finish *The Magnificent Ambersons* according to the studio's dictates. Welles went on to make Shakespeare adaptations and **films noirs** and eventually

reinvented the **nonfiction film** with *F for Fake*—a film that was both true and false.

As a longtime actor on stage and film; director of stage productions, radio productions, films; and devotee of magic, Orson Welles's view of fakery and illusion is essential to the creation and complexities of *F for Fake* (1975). As a magician Welles used illusions to create experiences for his audience. He was a traditional magician who learned the craft by observing the masters. Many of Welles's endeavors included a degree of fakery to make the viewer believe a play or a film was real. Welles entered the world of fakery with his outlandish and clever radio broadcast adaption of H. G. Wells's *War of the Worlds* in 1938, which went beyond standard dramatic techniques. The listening audience was tuned in on Halloween eve while dance music played on the radio. Then an announcer interrupted abruptly with a frightening message that hostile aliens had landed in the United States. News bulletins were conjured up by Welles and his team to convince the listener this nightmare was real. Panic was widespread, and Welles was on the map as a master faker. This incident is recalled by Welles in *F for Fake*.

This film was conceived when filmmaker François Reichenbach[2] shot **footage** on Elmyr de Hory for French television and hired Welles to edit it. While Welles was editing the project, the scandal concerning Clifford Irving and his fake Howard Hughes autobiography broke. Welles was fascinated and decided there was a feature film to be developed. He began expanding the Hory and Irving stories into a larger film treatise on the notion and essence of fakery.

Orson Welles is the on-screen presenter and narrator of *F for Fake*. The film includes digressions and tangents about Welles's relationship with his companion Oja Kodar, *Citizen Kane*, and *War of the Worlds*. Welles also talks about being a painter as a young man, and painting is a major subject in the film.

Welles had a longtime passion for magic and performed as a magician on stage and television throughout his career. In *F for Fake*, decked out in the traditional magician's garb featuring a black cape, Welles devotes a sequence to his performance of a showy magic trick. For Welles, magic was illusion, the creation of something before an audience's eyes that defies logic. As a magician Welles knew what professional magicians understood—that in the end what they did was fake. It was manipulation and a form of scamming the audience. This understanding permeates *F for Fake* and expands on the idea of fakery.

The structure of *F for Fake* was created in the editing room through the mastery of Orson Welles and his imaginative vision. Welles often appears in the cutting room with an editing table while the film is running, talking about various subjects in a structure that slides from one segment to another. In at

least two moments, Welles talks about the movie the viewer is watching, creating a **self-referential film** trope. Welles had always been a natural storyteller and knew when to segue from one segment to another and when to bring himself in to present his **point of view** (POV). His deep, convincing voice as the **narrator** makes the viewer feel that what they are seeing and hearing is all true. Welles was a much in demand narrator for films and television, including *Directed by John Ford* (1971), *Future Shock* (1972), and *Shōgun* (1980).

The structure of *F for Fake* works effectively with constant creative flair. The tales of the forger, the faker, the illusionist, and the creator of a hoax must be open to proceed in any direction at any time to successfully dazzle and fake out their viewers. For Orson Welles *F for Fake* was a deeply **personal film**, one that shot to the heart of who he was as an artist and as a man.

Forgery, the art of copying something and passing it off as an original, has a long history, going back more than 2,000 years. Roman sculptors made copies of Greek sculptures. During the Renaissance era painters took on apprentices who studied by copying the great painters; then they were allowed to sell those works. During the 16th century those who forged the work of Albrecht Dürer[3] started adding signatures to their fakes. Michelangelo[4] created a cupid figure and treated it with materials so it would appear to be an ancient work, and sold it. In the 20th century Salvador Dali,[5] Pablo Picasso (see note in Chapter 3), Paul Klee,[6] and Henri Matisse[7] were the subjects of forgeries that were sold to galleries and museums. De Hory forged Picassos and many other major artists.

The Criterion *F for Fake* **DVD** contains an introduction by director Peter Bogdanovich[8] (the director of *Directed by John Ford*), who had known Welles for a long time and who was deeply involved in Welles's work in myriad ways. Bogdanovich explains that *F for Fake* is not a traditional documentary but a kind of essay/documentary. The Reichenbach footage of de Hory was edited into the Welles film, and new material was staged and shot. The editing of the film is rapid at times and makes use of all of the material Welles had available to him. Some of the film was originally shot in 16mm and blown up to 35mm. The new material was shot in 35mm. Descriptive names for art forgers are mentioned in the film—*charlatan, impostor,* and *fraud.* We are told that missing drawings of Picasso will be part of the film. The identity of the creator of the Cathedral of Chartres[9] is questioned. *F for Fake* was not a commercial film and was not properly distributed. Bogdanovich tried to get the legendary impresario Joseph E. Levine to pick up *F for Fake*, but he fell asleep during a screening of the picture. Bogdanovich advises the viewer to go along with the experimental film and not to fight it. This is a new form Welles intended to explore in more films, but he was not able to make that happen during the last ten years of his life when he struggled to raise money for a large number of projects, some already underway.

Narrative and Cinematic Analysis

F for Fake opens at a train station. Welles is dressed as a magician all in black with a large hat. The crew is visible, so the viewer knows they are watching a movie being made and that it is the movie they are watching, a self-referential notion. Oja Kodar, Welles's real-life female companion, appears in a train window dressed in furs. Welles performs a magic trick with a coin for a young boy. Welles says that a magician is just an actor playing the part of a magician. The concept of fraud is introduced.

Welles presents an introduction to the film. He says in the next hour everything presented will be the truth, thus leaving the concluding half-hour as suspect. **Freeze frames** are used throughout the film, where the image stops and appears as a still frame. We're told that de Hory had 60 different names and 60 different personalities. Welles says a painting is either a good fake or a bad fake. He is now in an editing room where there is a **Moviola** editing table fashioned with a large viewer. The music is by Michel Legrand, most famous for the score of *The Umbrellas of Cherbourg* (1964) and for the song "The Windmills of Your Mind" from the score for *The Thomas Crown Affair* (1968), for which he won his first **Oscar**. The editors for *F for Fake* were Marie-Sophie Dubus with Dominque Engerer, and an uncredited Orson Welles and Gary Graver. The cinematography was executed by Christian Odasso in France and Ibiza, and Gary Graver in the United States and France.

Oja Kodar walks down the street with men gaping admiringly at her, **intercut** with Welles watching this scene on the editing viewer. Freeze frames are used on the men's expressions and to create an editing rhythm, which emphasizes the male reaction to a pretty woman. This editorial technique allows the viewer to see their exaggerated reaction frozen in time for a matter of seconds. The men are a wide range of ages and looks. The scene is an artful version of something that could have been seen on Alan Funt's television show *Candid Camera*.[10] In the end it's a provocative **sequence** that sets up the concept of how film can manipulate, give various views, and create a false reality. What's been shown is not continuous but executed with many cameras and intricate editing.

One of the subjects of *F for Fake* is the nature of editing. Although editing is used to create continuity and a sense of reality, it is actually fake as well. In the Kodar sequence many pieces of film are manipulated to appear as if these men were really looking at her walking and reacting on cue. There is some truth to this, but the result, the timing, and reactions seen are achieved by the precision of the cutting and the choreography of the intercutting. All of *F for Fake* demonstrates that editing is both magical and an artifice created by how shot-by-shot the film explores fakery through the editor's art of manipulation of shots and film frames. Welles even reveals the place where the film could have been edited. There are many large film cans in his editing room,

all identified by colored tape and labeling with a black marker. *F for Fake* is a tour-de-force of editing because it deconstructs the documentary form, and the result is a new nonfiction creation unlike anything else Welles has ever been associated with.

Actor Lawrence Harvey, who worked with Welles on *The Deep* (1970), appears in a short cameo. Welles puts Kodar in a cabinet and makes her disappear. Tricks. A card says "Everything in this film is strictly based on the available facts." Welles explains the experiment with Kodar as the art of girl watching. Introduced is Edith, Clifford Irving's wife, who was involved in the Howard Hughes autobiography hoax. Welles calls the Moviola editing machine a time machine. There is a lot of fiction about de Hory's life. Irving and de Hory made each other famous by creating each other's legends. The film on the editing table breaks, and Welles tells us he has to patch up the film and the story, a remark with a double meaning: fixing the film break and coming up with a continuation of the story that seems to be made up on the spot, although it isn't all that.

A young man from Omaha tells the camera he traveled a great distance to meet Elmyr de Hory. Welles calls de Hory the "Paganini of the palette." De Hory says in his pronounced Hungarian accent that he has never made the mistake of identifying whether a painting is real or a fake. Welles says that Irving is a better magician then he is. More freeze frames—a way of stopping the action and pace, to see deeper into the image. Also, the film grain freezes, revealing this is an image recorded on film, not reality. Some of the images in *F for Fake* are optically blown up to alter the composition.

A lunch party. Some of the **footage** is **grainy** and has scratches. Edith deposited the money from selling the Hughes manuscript in a Swiss bank. "Hanky-panky men" is another term Welles uses to describe fakery perpetrators. The shots that are blown up appear like a pointillist painting where the painter uses tiny touches of paint and color to build an image. The cameramen employed high-speed camera technique so it seems that de Hory is painting at breakneck speed. He is known as one of the great painters of fakes of the 20th century. De Hory felt that art galleries and museums are fallible, that they make many mistakes with their judgements that real paintings are fakes and fake paintings are authentic. De Hory copied a long list of great painters slipping into their style undetected.

De Hory has a rock-solid ego, bragging that his work was better than the original artists. Welles recites a Kipling verse,[11] intercut with de Hory doing a drawing in charcoal. Welles and his cameras are around as de Hory walks through the streets and invites people at a restaurant to a party. We see a drawing of old Howard Hughes.

The film moves to the Beverly Hills Hotel, where Hughes lived a nocturnal life. A mystery package was left for him by a subordinate, which turned out to be a ham sandwich. In Las Vegas Hughes hunkered down in a room at the

Desert Inn. Rumors state he went out late at night with tissue boxes on his feet rather than shoes. Hughes lived in an upper floor, and no one ever saw him. Irving had a faked tape of Hughes talking. Handwriting experts found the manuscript of Irving's alleged Howard Hughes autobiography and his signature to be authentic. About expertise, de Hory said a person should decide if a painting is good or bad, not real or fake. Single shots of de Hory and Irving are intercut so it looks like they are in the same area and relating to each other. Irving became disillusioned with de Hory, saying he wasn't a great painter because he didn't have a personal vision. Welles is at a seafood restaurant with an entourage. He makes a comment about the rarity of great art, using oysters as an example—only a very few have pearls inside. Welles says Hungarians are con men, linking de Hory's heritage to his lifestyle.

Throughout the movie Welles pronounces the word biographer as *beeographer*. François Reichenbach is shown often. De Hory is not from the aristocracy as he claims. The scene changes from New York to Pamplona. De Hory has a beautiful, large house but says he doesn't have a dime.

Paul Stewart of the Mercury players[12] speaks about their early days. The focus shifts to Welles's *War of the Worlds*. **Stock footage** of a sci-fi movie is shown and the radio broadcast is heard. Welles tells a story of alien sightings. Someone in South America imitated Welles's broadcast and went to jail. Welles caused a ruckus but did not go to jail. Mercury members Richard Wilson and Joseph Cotton speak about *Citizen Kane*. It's discussed as to whether Cotton was to impersonate Howard Hughes in an early concept for the landmark film. We see a *News on the March*[13] segment. This is not the one used in *Citizen Kane* but a fake **newsreel** about Hughes. There is a narrator similar to the Welles film. The tone is irreverent at times. The newsreel plays out over a period of time because it is interrupted and intercut with other material that comments on it. The newsreel is constructed mainly of news footage from the life of Howard Hughes. At the end of his life Hughes was in a hotel room with air conditioning, trying to live germ free.

The question is: Did de Hory forge the Hughes manuscript? Howard Hughes was known to use doubles of himself. Eventually Clifford Irving confessed about his fakery, and wrote a new book. De Hory says he lives on through his own paintings, which he sells for $10 apiece. He made Modigliani drawings, and he never starved. It is posited that de Hory is gay. He was put into prison at one point, where he continued to make drawings and many people visited him.

F for Fake is episodic—what makes it work as a whole is Welles's storytelling ability—assembling so many parts and pieces and having them flow one into another. We see Oja Kodar walking on the street in the same dress as earlier. Picasso painted fake Picassos. Chartres Cathedral is shown in a filtered shot. Welles is outside, speaking in a poetic manner. Dusk. Bells. A **double exposure** shot of Welles and Kodar. She is dressed in black. There is

talk about her grandfather. She is walking down a street wearing the dress from the "girl watching" sequence. She came upon Picasso. Welles reminds the viewer that he promised he would save Oja's story for last. Oja was vacationing near where Picasso was painting. She was with a guy who played the trombone outside day and night. A black-and-white still of Picasso's eyes. Kodar walks past his window always in a different outfit. A still of Picasso looking out the window. Another double exposure of Kodar walking, then a double exposure of Picasso and Kodar. She runs in slow motion. Shots of her naked in different poses. Twenty-two paintings of Kodar are made. Sections of the painting now believed to be by Picasso are shown. In return for being with Picasso, Kodar wanted the paintings. Paris is in fog. The paintings show up in a gallery—shots of storms symbolizing Picasso's fury. Kodar in black attire. Welles tells a story that the paintings were not sold. Welles in close-up; Kodar in close-up; he continues to the story. She says her grandfather had a secret studio, that her grandfather painted the pictures, not Picasso. A still shot of the grandfather. Welles and Kodar discuss this back and forth. They argue. Two shot (a shot in a movie that contains two people). Light blue background. Welles says art itself is real. She leaves. Kodar's grandfather lived in Hungary. He didn't paint the pictures. Welles reminds the viewer he told them at the outset that he would tell the truth for one hour, and now for the last 17 minutes he was lying his head off. The grandfather is covered with a sheet. Welles the magician makes him rise into the air. He has a cigar in his mouth. Welles pulls the sheet away and the body appears to have disappeared into thin air.

Conclusion

Orson Welles was an innovator for his entire career. In *F for Fake* he has created an entertaining and engaging film that is both a documentary and an essay film. This film, which was lauded for its intricate editing, is also strangely autobiographical. Welles saw himself as a fake and made a cinematic and lively argument to prove it.

Notes

1. Robert Wise (1914–2005) was an American film director, producer, and editor. His credits as film editor include *The Hunchback of Notre Dame* (1939), *My Favorite Wife* (1940), and *The Devil and Daniel Webster* (1941). He won Academy Awards for both best director and best picture for both *West Side Story* (1961) and *The Sound of Music* (1965).

2. François Reichenbach (1921–1993) was a French film director, cinematographer, producer, and screenwriter who directed 40 films between 1954 and

1993. They include *America as Seen by a Frenchman* (1960), *Arthur Rubinstein— The Love of Life* (1969), and *Do You Hear the Dogs Barking?* (1975).

3. Albrecht Dürer (1471–1528) was a painter, printmaker, and theorist of the German Renaissance. Although he worked in many mediums, history best recognizes him for his engravings.

4. Michelangelo di Lodovico Buonarroti Simoni (1475–1564) was an Italian sculptor, painter, architect, and poet of the High Renaissance. He was considered to be the greatest living painter during his lifetime. Among his greatest achievements are the sculptures *Pietà* and *David*, and the ceiling in the Sistine Chapel in Rome, in particular the fresco *The Last Judgement*.

5. Salvador Dali (1904–1989) was a Spanish surrealist painter known for striking and bizarre images. A skilled draftsman and a consummate showman and self-promotor, Dali's most famous works are *The Persistence of Memory*, *Christ of Saint John of the Cross*, and *Tuna Fishing*.

6. Paul Klee (1879–1940) was a German artist influenced by expressionism, cubism, and surrealism. He was a fine draftsman who experimented, wrote, and lectured about color theory. His later work was abstract and featured line, shape, and tonal contrast.

7. Henri Matisse (1869–1954) was a French draughtsman, printmaker, and sculptor but best known as a painter known for his use of color and line. He originally was considered part of the fauvist movement, which featured painterly qualities and strong colors over realism, but by the 1920s he was considered a master of the classical tradition in French painting. *The Dance* is one of his most famous paintings.

8. Peter Bogdanovich (1939–) is an American film director, producer, screenwriter, author, critic, film historian, and actor. He got his start working on **B movies** for Roger Corman and became an early member of the **American New Wave**. His films include *The Last Picture Show* (1971), *Paper Moon* (1973), and *Mask* (1985).

9. The Cathedral of Chartres is a cathedral located in Chartres, France, mostly constructed between 1194 and 1220. It is considered a masterpiece of early gothic architecture.

10. *Candid Camera* was an early reality show created and hosted by Alan Funt. It began as *Candid Microphone* on radio starting in 1947 and under that title became a series of theatrical shorts. It arrived on television as *Candid Camera* in 1948 on the CBS network. It ran in various forms and hosts until 2014. It consisted of mostly practical jokes filmed with a hidden camera.

11. Rudyard Kipling (1865–1936) was a British journalist, short story writer, poet, and novelist. His works of fiction include *The Jungle Book*, his many short stories such as *The Man Who Would Be King*, and poems including "Gunga Din" and "Mandalay."

12. The Mercury Players were members of the repertory Mercury Theatre founded in New York City by Orson Welles and John Houseman in 1937. They created theater, radio, and film productions. The members included Joseph

Cotton, Agnes Moorhead, and Ray Collins. Their work had a visionary approach in content and staging. Some of the plays include a version of *Julius Caesar* through fascism in the late 1930s, a Voodoo version of *Macbeth*, and inventive Shakespeare adaptations. On Radio they presented adaptations of *Treasure Island*, and *The Count of Monte Cristo*. They moved on to Hollywood for a number of films, starting with Welles's masterwork *Citizen Kane* released in 1941.

13. The original *News on the March* newsreel segment in *Citizen Kane* is a revue of the life of Charles Foster Kane on the occasion of his passing. This is a reimagined newsreel based on *The March of Time* newsreel series produced by Roy E Larsen, Louis de Rochemont, and Richard de Rochemont and narrated by Westbrook Van Voorhis, which was shown in movie theaters and presented news items. It was sponsored by Time Inc., and distributed by RKO Pictures and 20th Century Fox.

For Further Study

Screen

Fata Morgana
Photographic Memory
Sans Soleil
Sherman's March
The Thin Blue Line

Read

Citizen Welles: A Biography of Orson Welles by Frank Brady
Experimental Ethnography: The Work of Film in the Age of Video by Catherine Russell
Orson Welles by Joseph McBride
Orson Welles: A Biography by Barbara Leaming
This Is Orson Welles by Orson Welles and Peter Bogdanovich

Remakes

The Flight of the Phoenix (1965), *Flight of the Phoenix* (2004)

A **remake** occurs when a film is made again. There is usually a long time gap between the original and the remake, so it may be **reimagined** to speak to a new audience. A remake can be kept in the same period with visual and narrative elements in place or it can be updated, with characters altered or characters dropped, and new characters added. The original can be reinterpreted or fashioned into a very different narrative.

Why remake a film that has a history of being popular, successful, artistic, and cinematic? Examples give some insight. *Battle of the Sexes*, directed by D. W. Griffith[1] in 1914, was remade by Griffith in 1928. *Ocean's 11*, directed by Lewis Milestone[2] in 1960, was remade by Steven Soderbergh[3] in 2001 as *Ocean's Eleven*, with two more **sequels** and a third all-female version. Alfred Hitchcock directed *The Man Who Knew Too Much* in black-and-white released in 1934, and then remade the film in color released in 1956; in 1998 Gus Van Sant[4] remade Hitchcock's 1960 *Psycho*. Frequently, the initial appeal of a film makes it a good choice for remaking. A comparison of *The Flight of the Phoenix* and *Flight of the Phoenix* further explores the nature of the remake.

The basic story of the original *The Flight of the Phoenix* concerns a pilot and his copilot who fly a rag-tag group of men back home after a day working on an oil rig; during the flight the old, beat-up plane stalls and crashes in the desert. The group waits for help and then begins to contemplate rescue plans. One of the passengers, a German gentleman identified as an airplane designer, takes charge and begins ordering the men around with his plan to rebuild a plane out of the scrap parts. Near the end of the film there is an ironic twist when it is revealed that the German character is not a

conventional airplane designer but works only on models. In desperation they complete the reconstruction, and in a dangerous attempt the plane flies them to safety.

The director, Robert Aldrich, who also produced this film, was born into a wealthy family; his grandfather was a U.S. senator and cousin to Nelson Rockefeller.[5] He studied economics at the University of Virginia and was a letterman on their 1940 football team. In 1941 he dropped out of college for a $50-a-week clerical job at RKO Pictures. His family didn't accept the choice of working in the movies, which lost him a stake in Chase Bank that would have made him a millionaire. He quickly became an assistant director to Jean Renoir,[6] Robert Rossen,[7] Joseph Losey,[8] Abraham Polansky,[9] and Charlie Chaplin. In the 1950s he became a television director, and in 1953 helmed his first feature film, *The Big Leaguer.* He continued to direct successful pictures, and after the 1967 megahit *The Dirty Dozen* was able to open his own movie studio. He was fiercely independent, with a forceful cinematic style that featured **extreme low angles** and tackled content that traditional Hollywood would never come near. Robert Aldrich was a **maverick**.

Director John Moore, who was responsible for the sequel, was born in Ireland and attended the Dublin Institute of Technology. He went on to direct commercials including a launch advertisement for the home video console *Dreamcast*, which impressed 20th Century Fox. They gave him $17,000,000 to make *Behind Enemy Lines*, which was followed by the remake of *The Flight of the Phoenix*. He also directed *Max Payne* (2008) and another remake, *The Omen*, in 2006.

Narrative and Cinematic Analysis

The original film, *The Flight of the Phoenix*, was released by 20th Century Fox in 1965. A blistering sun fills the screen. A plane takes off and flies over a desert. The plane's radio goes out. Richard Attenborough is the copilot Lew Moran, who has a drinking problem. Ernest Borgnine is Trucker Cobb, a man with mental problems; he and the other passengers are getting nervous, sensing something is wrong. Captain Frank Towns, played by the inimitable Jimmy Stewart, has a flashlight and is trying to troubleshoot the problem. Peter Bravos as Tasso is playing a stringed Greek instrument. There is a vicious sandstorm underway. Lew takes a slug out of his liquor bottle. Heinrich Dorfmann, a German man with white/blonde hair and wire-rimmed glasses, is played by Hardy Krüger. Ian Bannen is "Ratbags" Crow, a lively man who constantly ribs everyone.

A fire breaks out. There are barrels tied up in the back. Lights are shorting out. The titles begin with the **main title**. Ronald Fraser as Sgt. Watson. Peter

Finch as Captain Harris. As each person is presented, the image goes into a **freeze frame**. Christian Marquand as Dr. Renaud. Dan Duryea as Standish. George Kennedy as Mike Bellamy. Gabriele Tinti as Gabriel. Alex Montoya as Carlos. William Aldrich as Bill. Barrie Chase (the only woman in the film, who is only a human apparition) as Farida. The Associates and Aldrich Company had a part in presenting the film. The barrels become loose and begin to fall. Screenplay by Lukas Heller based on the novel by Elleston Trevor. The barrels hit the passengers.

Up until now *The Flight of the Phoenix* appears to be like any other action film. The character and action tropes are there—colorful people with potential to clash, a disaster in the making, and a fast-moving story. The exception is Robert Aldrich, a maverick of the first generation, an **independent film** maker, in control over the making of the film and in spirit is always looking for a way to take audiences where they have never been. In this **genre** include *The High and The Mighty* (1954) starring John Wayne, a routine drama in the air, and *The Crowded Sky* (1960) featuring Efrem Zimbalist Jr., which also had a traditional happy ending. *The Flight of the Phoenix* takes this genre and turns it upside down, using the Hollywood form to pull in an audience and then surprising them at every turn.

Crash landing. One of the younger men is injured, dies, and is buried. The burial is shown in an extreme low angle, a signature Aldrich shot. The director has been known to have his crew create a hole in the ground of a set or location to position the camera at an angle far steeper than the standard variation of this shot. This creates a radical point of view that makes the subject in front of the lens larger than life and puts the viewer in a place they have not looked up from in a conventional movie. Towns admits the accident was caused by pilot error. Captain Harris takes charge. They have some drinking water and pressed dates to eat. Waiting for rescue. The writing (based on the novel) and acting in collaboration with the director continues to create vivid characters with details and overviews that set them all radically apart. Aldrich takes the story to the edge of absurdity, a feature present in the majority of his films, but *The Flight of the Phoenix* remains believable within reason and is highly watchable.

Trucker Cobb has a radio, which the others grab from him so Towns can find a station that may help them in their plight. Dorfmann uses his electric shaver, which causes static on the radio. Towns becomes aware of this and loses his temper. Towns tunes in a local station. The sand kicks up with a strong wind. Lew gives an injured person a slug of liquor. The filmmakers found a way to inject a pop song into the film: over the radio we hear "The Phoenix Love Theme (Senza Fine)," sung in Italian by Connie Francis, written by Gino Paoli and Alec Wilder. This was a convention that Aldrich felt he needed to ensure a large audience, especially for a movie that delivered constant action but in an innovative manner that the average Friday night–

Saturday night audiences were not expecting. Hollywood understood a pop song meant records, possible **Oscar** nominations or wins, and musical entertainment in a nonmusical film. For example, *Laura* (1944) features a song of the same name written by David Raksin that was highly influential in prompting others to add a song to their film. The all-time master of the form is Henry Mancini, who is responsible for a long line of hits in movies including "Moon River" (1961), "Days of Wine and Roses" (1963), and "Love Story" (1971). Many serious film composers refused to be involved in musical commercialism, but the practice has been firmly in place for decades.

Towns writes in his journal; we hear his words in **voice-over**, which allows an understanding of how he is thinking and feeling. There is a monkey who acts as a pet among the men, an element placed in the film to entice animal lovers and younger viewers. Fires burn in barrels as a signal. During the day a plane flies above, but no matter how much noise they make while waving wildly, the plane doesn't spot them and flies away. Captain Harris announces he is going to march out to freedom; Sgt. Watson will go with him. Dorfmann proposes building a new plane out of the wrecked one, setting the story on track for its outrageous premise. Trucker Cobb decides to join Captain Harris and Sgt. Watson. Captain Harris is told about Cobb's problems and tells others he doesn't want to bring along an unbalanced man. Sgt. Watson comes out of the interior shelter very quickly, trips, and says he has hurt his leg and can't go on the march. Dorfmann tells Lew he's an aircraft designer. Cobb tells Dr. Renaud that he's a "head case." The doctor assures Cobb that what he is experiencing is normal and soon will pass.

There are two crosses in an area designated by the men as a cemetery. This is an ominous visual symbol, signaling that men are dead and they all might wind up in that cemetery one way or another. Sgt. Watson runs, proving there is nothing wrong with his leg; Towns sees him and is very angry. Watson immediately starts to limp again. Cobb leaves, and no one sees him go. Towns learns this and goes to find him. Shown now is Cobb, his face burned and collapsed on the sand. Dorfmann and Lew argue over the abilities of Towns as a pilot. Vultures fly over and peck at Cobb. This is another classic movie convention, which gives *The Flight of the Phoenix* believability so it can later subvert the Hollywood narrative ideal. Towns arrives and finds Cobb dead. Water is rationed out. The rescue plan includes the men hanging from the wing, an idea so outrageous it seems unlikely (but true) that this will happen. It will take 12 days to build the new plane, and the water supply will last for 10 days. Towns shoots down Dorfmann's theory. The rest of the men feel that if there is a chance, it's better than watching men die.

Night. They begin work. Dorfmann leads the project. Towns knows Sgt. Watson is faking his injury. Sun. Men rest; Dorfmann works, constructing a

still to make water. Crow challenges Dorfmann about his German background especially during WWII. Dorfmann says, "I wasn't involved." This is a movie cliché that covers many post-WWII films. It almost always is intended as a lie or cover up. Here it is never resolved. Dorfmann is a pivotal character in *The Flight of the Phoenix*. He is clearly German played by a German actor, Hardy Krüger, and the emphasis is on his stubborn, iconoclastic character.

Sgt. Watson sees Captain Harris on the ground and in bad physical shape from his scouting trip. Harris sees Watson run, proving he's not injured. **Dissolve.** The men have set up living quarters inside the plane. Dorfmann gets water and goes outside to feed the still. Dorfmann orders the men to work. Towns tells everyone that water is being stolen. Dorfmann says it was him because he is working harder than everyone. Mirage music. The score paints a picture of the environmental conditions with sound. Dorfmann pours water back. Five are dead. Lew and Towns argue; Captain Harris wants to get back to work. Differences are another major theme in the movie. The men are very different from each other and represent different aspects of life and class. The only commonality is that they are stranded in the desert and want to get back to civilization. The situation has leveled the cultural playing field. Three men on each side pull the plane with cables. March music.

Towns has a chart for water use. They use a winch to pull a wing into position. Sgt. Watson remembers watching an Arabic woman dancing seductively. "The Phoenix" is painted on the side of the plane in black, referring to the mythological bird associated with the sun that gains new life coming out of the ashes of another bird—born and reborn. Captain Harris hears something and climbs a dune. He sees a man on a camel. Dr. Renaud joins him and then Towns runs up. The score now presents Hollywoodized Middle Eastern music.

Dorfmann continues to work on the plane. Those watching the man on the camel come back. Captain Harris wants Sgt. Watson to go with him to talk to the Arabs, but Watson refuses the order. There are three days of water left. Harris asks Watson for his revolver and he refuses. Harris goes up alone but then Renaud joins him. Night. Arabs. Towns and Lew on top of a sand dune looking down. Dissolve. Dawn. They find both Dr. Renaud and Captain Harris with their throats cut. Towns and Lew go back to base camp. Watson smiles at Towns and says "He's dead, isn't he?" and Towns slugs him. Mirage music. Watson sees a lady dancing in a **double exposure**. She is played by dancer and actress Barrie Chase. It is a Hollywood convention to cast one woman into what would have been an all-male movie. Farida dances, and even though she can't be seen that well through the double imaging, it is enough to create an erotic sequence. The scene is played as a hallucination brought on by exhaustion and the heat and has a flashback element because of the story Watson told earlier about the Arabic woman he saw dancing in

the past. Although this is somewhat of a convention, it is presented in an unusual and inventive way and is a fine use of the talents of Barrie Chase, who was Fred Astaire's last dance partner and whose father was Borden Chase, a top Hollywood screenwriter who wrote *Red River* (1948).

Towns wants to test the engine immediately. Dorfmann is against this, causing a heated exchange. Towns gives an order to the men to test the engine—he is really testing his authority. Dorfmann throws a long wrench at Towns that hits the body of the plane, then goes inside and won't move or talk to anyone. Night. Lew goes to the still and brings water to Towns. Towns says he can't be told what to do; Dorfmann has gotten to him. Lew offers water to Dorfmann, who says "Leave me alone." He is told the next day is the last day of water. Day. Dorfmann comes out and says he wants to speak to everyone: "Who is in authority, Mr. Towns?" There is a pause and Towns says "You are." Dorfmann says that he'll go back to work.

Night. They work on finishing plane. Inside their shelter we see Dorfmann, Lew, and Towns. Towns looks at a catalogue from Dorfmann's company. In disbelief he realizes they are all model planes. Asking where the big ones are, he is told page 23. Towns hands the catalogue to Lew, who is also very taken aback. On the page is the biggest model plane they make. They are radio-controlled. The men ask for the real thing and Dorfmann replies we make nothing but model airplanes, but the principles are the same. The men call them toy airplanes, and call Dorfmann crazy. Towns closes his eyes for emphasis. Lew laughs out loud for a long time, reacting to the insane situation they are in, which turns into crying. This scene is pivotal and comes as an ironic shock. It reveals that Dorfmann believes a model plane is the same as a real-life, full-size airplane and that everyone may have put their belief in him to rescue them for naught. The scene is artistically dangerous and, coming so late in the picture, creates a giant narrative twist for the audience, who now have no idea what is going to happen. This sequence ranks among the best in film history that shake up the characters and the audience at the same time.

Towns is in the cockpit. Dorfmann tells him they have limited cartridges to start the engine. Vibration must be kept to a minimum. Towns puts in the first cartridge, and the propeller turns a bit. The second is fired—a bit more propeller movement. Finally, Towns announces he's going to fire the next one, not to start the engine but to clean out the system. Dorfmann screams in anger "I forbid you!" but Towns does it anyway, and dirt and garbage fly out of the engine. By the sixth charge the propeller is turning perfectly. The men jump up and down. Dorfmann smiles and falls to his knees. Towns looks over to where the dead are buried. The men pull the plane to the edge of the dune. Sun. Towns places a ladder. The monkey is in a basket. The men get onto the wing. Towns puts on his gloves and readies the plane for flight. The men are lying on the wing. The plane flies over the dune then over the crash

site. Dissolve. Green. Land. Oil refinery—men working. The plane lands over a hill. Dissolve. The men climb over rocks and we see their **point-of-view** (POV) of the oil refinery. Road. Water. They walk down the road into the water. The men drink water and are elated. Dorfmann and Towns come together—the men are swimming as workers look on. The image transforms into a small box, and the end credits roll alongside. A card explains that Paul Mantz died in the making of the film. The legendary aviator had an unexpected crash while flying a stunt for the film.

Aldrich's longtime collaborators—director of photography Joseph Biroc, editor Michael Luciano, and composer DeVol—contributed to Aldrich's vision. They knew just what he wanted to do on a given picture and how to give it to him. The style of a director may come from how they see a film; and especially the director of photography and the editor not only make it happen but make contributions that the director can apply to future films.

The remake drops "the" and is called *Flight of the Phoenix* to modernize the title. It takes place in current times, the 21st century in 2004, as was the original, in the 20th century in 1965. It begins with the song "I've Been Everywhere" sung by Johnny Cash, which relates to the travel-weary pilot and crew. A bit later "Gimme Some Lovin'" sung by a teenaged Stevie Winwood with the Spencer Davis Group plays on the soundtrack. The song was a big hit in 1966, the year of its original release, and is currently considered a rock classic. It is lively but has no real connection to the story or characters; it is simply a gem on the soundtrack and a lure for CD or Internet sales. The screenplay is by Scott Frank and Edward Burns, the latter also a noted actor and director celebrated for *The Brothers McMullen* (1995). The cinematography is by Brendan Galvin, film editing by Don Zimmerman, and music by Marco Beltrami.

The plot is similar but with some significant changes. Where the original featured all white males, this remake is more diverse with two African-Americans, 2 Hispanics, and a woman among them. The cast is Dennis Quaid as pilot Frank Towns, Tyrese Gibson as copilot A. J. (the new version of Moran), Giovanni Ribisi as Elliot (the new version of Dorfmann), Miranda Otto as Kelly Johnson, Tony Curran as Alex Rodney, Sticky Fingaz as Jeremy, Jacob Vargas as Sammi, Hugh Laurie as Ian, Scott Michael Campbell as James Liddle, Kevork Malikyan as Rady, Paul Ditchfield as Dr. Gerber, Jared Padaleki as John Davis, Martin Hindy as Newman, Bob Brown as Kyle, and Anthony Wong as the lead smuggler. A few of the characters, including Towns, A. J., and Elliot, are for the most part the same characters as the original, but most are newly created for this version. The principal point of this remake is to bring the original story up to date. These characters are contemporary and express some of the qualities of the characters in the original film. In this way the remake is successful: the characters are relatable where the original might seem dated to a modern audience. The diversity is

essential. Back in the 1960s most movies of this action genre sported an all-male cast, perhaps with one woman for what was then considered sex appeal.

The first shot is the Gobi Desert of Mongolia. An Amacore oil rig is unproductive. Captain Towns and his copilot A. J. are sent to shut it down and transport the crew out of the desert. On route to Beijing a major dust storm knocks out one engine, forcing them to crash land. There is a fire inside the plane put out by Towns. Their radio is out. Two passengers thank Towns. The company executive Ian tries his cell phone with no results—this is a new character conceived for the remake to create class issues and have a corporate presence. One of the Hispanic men prays on his rosary, introducing a religious theme. In a makeshift ceremony there are two crosses put up to honor the men who died. Towns is asked to speak but says he is the wrong person to do so. Elliot says with an edge, "Why don't you say you're sorry?" even though earlier he thanked Towns in what sounded like a sincere tone.

It is learned that Elliot just completed taking a year off to travel around the world. He wears a khaki colored military jacket, has white blond hair, and wears wire eyeglasses (just like Dorfmann in the original version, but he is not identified as German), and walks with a strange, unexplained gait. Giovanni Ribisi's performance falls short of the masterful one that Krüger contributed in the original. It appears that the actor supplies a lot of physical and personal quirks to Elliot to develop the mystery behind him and make him more complex. However, this kind of method performance, a school of acting that uses sense memory to create realistic portrayals, makes him less than believable and difficult to follow compared to the defined emotions and actions Krüger brought to his role. Remakes are mostly made for contemporary audiences who weren't around when the original was made or haven't seen it on TV, **VHS**, or **DVD** and will be open to changes and new interpretations. Audiences who have seen the original in its time will most likely be more critical toward the remake and even less likely to see it, choosing to watch their beloved original over and over again. They are in a position to compare the actors and their performances as well as presentation of the action. Unless the new viewer has been informed concerning the original, the new film will be fresh and exciting, just as the first film was to those who have seen the 1966 version.

The crew are 200 miles off course. Elliot is considered off-kilter by those who know him. One of the African American men wears an eye patch. Their food supply consists of water, juice, and hearts of palm. Night. One of the survivors becomes lost.

Kelly Johnson, played by Miranda Otto, is not overly exploited for her gender. She is not a Hollywood stereotype. She dresses in a practical jumpsuit most of the time. Women work in this field, and so does Kelly. No romance is implied until later, very subtly that Towns is attracted to her, and she responds with a nice smile and a polite kiss. Nothing else comes of this.

One of the Hispanic characters says "It's coming" when the wind starts up again, perhaps indicating that there is some spiritual force there. It appears that he sees something. A lost passenger is tracked down. Several shots of a man dead in the sand, and then Towns shaving. Kelly thinks that help is coming. Ian talks about corporate responsibility—a political aspect to this version not in the original. Ian is stopped for taking water. There is a fight, and the water vessel breaks apart, spilling the contents. Elliot announces they will build a new plane out of the crashed plane. This is a key plot point in both versions. He says he designs planes—experimental ones. Towns is against Elliot's plan and wants to wait for help. Kelly looks for Liddle, and then goes after him. Towns says he'll go.

Dawn. Sand dunes. Towns walks among rocks. He finds a Paul Theroux paperback, a writer who is a novelist and travel book specialist. He sees an off-oval rock formation that has an ancient quality, referencing a cult, an unusual religion. He finds Davis dead—bullet cartridges are on the sand next to the body. Another passenger shows up and was there before Towns. They think it was smugglers who killed Davis. This takes the place of the Arabs in the original. The smuggling and spiritual religious aspect give a modern believability to this sequel. This person looks like a young version of Sgt. Watson. Towns tells James if he comes back with him they'll build the plane. Everyone agrees to build the plane, and they start that night. There are a series of barrels with liquid to light them. Elliot immediately takes charge of the project. He jumps on the wing to put it into place, and three others work on it.

A big fuel explosion. What remains will be needed for the escape flight. Sun. Elliot puts pressure on Sammi. While the men work they groove to the Outkast song "Hey Ya" on a portable stereo, providing entertainment and offsetting the narrative rhythm of the film. It is a contemporary version of the Connie Francis song in the original. A series of shots that detail the work on the plane.

Dusk. An electrical storm is forming. Elliot doesn't understand why they have to get away from the plane (which is not grounded). He stays on the wing and is knocked off by Towns when lightning strikes. "Phoenix" is painted on the plane for the same reasons as in the original. Elliot with his arms spread wide walks in the desert on a cliff. Someone is stealing water. Elliot says it was him because he's working harder than everyone. Three men watch and see a camp set up with foreign men. Three men from the camp go over the top; the guard has a pistol. Camels. They meet a man from the desert. Ian knows his language and talks to him. The man is covered up except for his eyes and wants to know where the plane is. He pulls a gun and kills one of the men, duplicating the use of villains and murder in the original. Towns shoots at him, but the man rides off on his horse. They carry Alex to

the base camp. He's badly injured. There is a rock version of Arabic music on the soundtrack. This is similar to the original film using a Hollywood approach to Arabic music rather than playing the real thing. Kelly tries to help Alex, but he's dead.

Top shot. Alex is buried. Elliot walks away from the burial ceremony. The man from the desert is injured and brought back to base camp, and Elliot kills him. Elliot challenges Towns, saying he's only concerned with the plane project. Elliot goes into a tirade against Towns, who decks him. Elliot gets everyone including Towns to say he is in charge.

Day. Men are working, and Elliot drives them hard. Binocular shot (as if seen through the double lenses of a binocular)—Towns sees two men watching them. Elliot looks through his notebook and say's the plane is ready. Plane looks good, Towns writes in his notebook. Kelly comes in and they talk. Towns finds the catalogue for the company Elliot works for—and sees all model planes. Elliot says he's the chief designer. They ask him about the big stuff. The models are called toys by Towns, who flings the catalogue on the ground so others can look at it. Elliot says models are more efficient than regular aircraft. Frank goes berserk. Elliot is thrown on to the ground by Ian. He holds a gun to Elliot, who says "I'm a very important person." Towns pulls the gun from Ian's hand. Wind moves the plane up and down. They all go inside. The interior turns over. The impact of this scene in the original is heightened by the superb acting and Aldrich's direction, which maximize the absurdity of the idea and the fact that it works. The remake follows the reveal and the escape but doesn't have the dumbfounding impact the original has.

Up from black. The plane buried in sand. The men drag the plane with harnesses. Elliot gives Towns the five cartridges and they shake hands. Towns climbs into the cockpit. After the second charge the propeller starts to turn, then stops. By the fourth cartridge Towns announces that he will clean out the system with the next cartridge but that it will not turn the propeller. Dark smoke comes out. Towns shoots off the fifth cartridge, and the propeller spins fast and ready to fly. The group reacts. A ladder is put up against the wing. Kelly kisses Towns on the cheek. A line of men on horseback. The group lies on the wing. There is a gunshot. Towns says the rudder is lost. Elliot goes out to fix it. Rifles. A shot of the land **intercut** with a shot of Towns. They take off over the cliff. Sun. They fly over the sand. They fly to the oil rig company. Cut to black. "Gimme Some Lovin'" plays again, and it still doesn't make much sense in terms of the lyrics.

A series of snapshots of everyone doing well. The last image is a magazine cover sporting a picture of Elliot with the text "NASA's New Hope." The **montage** is effective, but it projects the characters into the future rather leaving the audience with what they survived. In the original it doesn't seem to

matter where they are going after the action of the film but rather only what went on during the film.

Conclusion

Remakes may bring a classic film or just a good film to a new generation who hadn't seen the original, and relates better to modern filmmaking. Studios feel a remake is a safer bet than an original story because there is a bit of a guarantee that if the original was successful, the remake will succeed. Audiences who enjoy a remake if they have any commitment to film history should watch the original. With DVDs, so many television movie channels, and online access, this is easy to do; then there will be a lesson learned about filmmaking in a different era and there's the possibility the original will still deliver.

Notes

1. D. W. Griffith (1875–1948) was an American director, writer, and producer who pioneered modern feature filmmaking technique. His films include *Birth of a Nation* (1915), *Intolerance* (1916), *Broken Blossoms* (1919), and *Way Down East* (1920). He was one of the founders of the Academy of Motion Picture Arts and Sciences. He is credited for developing and using the close-up in his film.

2. Lewis Milestone (1895–1980), born in Moldova, was an American motion picture director who won best directing Oscars for *Two Arabian Knights* (1927) and *All Quiet on the Western Front* (1930). He began in Hollywood as a film editor, then an assistant director. Other films he directed are *The Front Page* (1931), *Of Mice and Men* (1939), and *Mutiny on the Bounty* (1962). A low point in his career was after WWII when he was blacklisted because he was suspected to be a communist sympathizer and traveled with his wife to Europe until the political climate cooled down.

3. Steven Soderbergh (1963–) is an American film director, producer, screenwriter, cinematographer, and editor. He helped to usher in the independent film movement of the 1990s when his film *Sex, Lies, and Videotape* (1989) won the Palme d'Or at the Cannes Film Festival when he was 26 years old. He moved on to Hollywood films such as *Out of Sight* (1998), *Erin Brockovich* (2000), and *Traffic* (2000) for which he won the Academy Award for Best Directing. Throughout his career he has returned to smaller films like *Kafka* (1991).

4. Gus Van Sant (1952–) is an American film director, screenwriter, painter, photographer, musician, and author. He is acclaimed as both an independent and mainstream filmmaker. He has moved through many film styles including experimental and was a leading figure in the New Queer Cinema in the 1980s.

His eclectic sensibilities have produced films such as *Mala Noche* (1985), *My Own Private Idaho* (1991), *Good Will Hunting* (1997), and *Elephant* (2003).

5. Nelson Rockefeller (1908–1979) was an American businessman and politician. He was governor of New York (1959–1973) and vice president of the United States (1974–1977). He was president and later chairman of Rockefeller Center Inc. and assembled a significant art collection.

6. Jean Renoir (1894–1979) was a French film director, screenwriter, actor, producer, and author. He was the son of the painter Pierre Auguste Renoir. He made more than 40 films from the silent era to the end of the 1960s. *La Grande Illusion* and *The Rules of the Game* (1939) are often cited by critics and film scholars as being two of the greatest films of all time. His other films include *Nana* (1926), *Boudu Saved by Drowning* (1932), *Toni* (1935), and *The River* (1951).

7. Robert Rossen (1908–1966) was an American screenwriter, film director, and producer. He moved to Hollywood in 1937 after writing and directing for the stage in New York. He worked as a screenwriter for Warner Bros. until 1941. Most of his later films as director were made for his own companies, usually in collaboration with Columbia. He was later blacklisted because of an earlier membership in the Communist Party. His films include *All the King's Men* (1949), which won Oscars for Best Picture, Best Actor (Broderick Crawford), and Best Supporting Actress (Mercedes McCambridge); *The Hustler* (1961); and *Lilith* (1964).

8. Joseph Losey (1909–1984) was an American theater and film director who studied in Germany with Bertolt Brecht and returned to the United States, where he headed to Hollywood. He was blacklisted in the 1950s and moved to Europe, where he made most of his films. His films include *The Servant* (1963), *Accident* (1967), and *The Go-Between* (1971).

9. Abraham Polansky (1910–1999) was an American film director, screenwriter, essayist, and novelist. He was a committed Marxist and member of the Communist Party, and eventually was blacklisted. He wrote the screenplay for *Body and Soul* (1947), an independent production directed by Robert Rossen (see note 7) that was nominated for an Academy Award for Best Screenplay. As a director Polansky is credited with *Force of Evil* (1948) and *Tell Them Willie Boy Is Here* (1969).

For Further Study

Screen

Born Yesterday
Cat People
Night and the City
Solaris
3:10 to Yuma

Read

Film Remakes by Constantine Verevis

Film Remakes as Ritual and Disguise: From Carmen to Ripley by Anat Zanger

Make It Again Sam: A Survey of Movie Remakes by Michael B. Druxman

Robert Aldrich: Interviews by Eugene L. Miller and Edwin T. Arnold

What Ever Happened to Robert Aldrich? His Life and Films by Alain Silver and James
Ursini

The Documentary as an Investigative Tool

Gimme Shelter

Gimme Shelter is a **direct cinema** film concerning the disastrous 1969 Rolling Stones free concert held at a raceway in California in which the notorious Hells Angels motorcycle gang[1] was brought in as security. The concert ended with many injuries and the death of a young man with a gun who was stabbed to death by one of the gang's members.

The Maysles Brothers, Albert and David, and Charlotte Zwerin—as cameraman, soundman, and editor, respectively—made films separately. But when they first got together in 1969 to make *Salesman*, they became part of the American version of France's **cinéma vérité** called direct cinema that vitalized the **documentary** form, which had relied heavily on **narration,** and instead let life unfold in front of their camera and microphone to be structured and brought to life in the editing room.

Albert Maysles started out as a psychology professor and researcher. He served in World War II and then received a BA from Syracuse University and an MA in psychology from Boston University. He taught psychology at Boston University for three years and worked as a research assistant at a mental hospital. These experiences would serve him well as a documentary filmmaker, giving him a better understanding about behavior and personality. In 1960 both brothers joined Drew Associates,[2] a documentary film company that would pioneer direct cinema.

David Maysles also studied psychology at Boston University. He served in the Army, stationed in West Germany. In the 1950s he worked in

Hollywood as a production assistant on the Marilyn Monroe films *Bus Stop* (1956) and *The Prince and the Showgirl* (1957). He became disenchanted with conventional filmmaking and joined his brother to make documentaries. David also studied psychology, which gave him insight into the human condition. His Hollywood experiences gave him an insider's look into how by-the-book filmmaking was done and an interest in other paths to making movies.

Charlotte Zwerin studied at Wayne State University and established a film club that initiated her interest in documentary filmmaking. She moved to New York and joined Drew Associates. There she began to work as an editor, then editor and director with the Maysles Brothers.

The Rolling Stones were formed in London in 1962. They were at the forefront of the musical British Invasion, which started when the Beatles came to the United States in 1964. They identified with the counterculture they found in the United States and were considered to be the bad boys of rock and roll. Their music is rooted in blues and early U.S. rock and roll.

Traditional documentaries explored life in its myriad aspects. For decades, documentary filmmakers stayed within the parameters, with an occasional experiment. Then in the 1960s the French created the cinéma vérité movement, armed with new lightweight equipment, and searched for the truth of their subjects. Americans were highly influenced by cinéma vérité and shaped it into their own style, calling it direct cinema—meaning they would use the camera and microphone to directly record what they saw.

Prior to *Gimme Shelter* (1970) there had been other rock and roll movies. *Rock Around the Clock* (1956) featured Bill Haley & His Comets in a fictionalized account about how rock and roll was discovered. *The Girl Can't Help It* (1956) is about a mobster trying to make his moll a star, with performances by Eddie Cochran, Little Richard, and Gene Vincent. Elvis Presley starred in a number of motion pictures in which he played fictional characters, there was always a romance involved, and he performed a series of songs. These films include *Jailhouse Rock* (1957), *King Creole* (1958), *Kid Galahad* (1962), and *Viva Las Vegas* (1964). The Beatles had major hits with two films, *A Hard Day's Night* (1964) and *Help!* (1965). *The T.A.M.I. Show* (1964) was a concert movie with a number of performers including the Beach Boys, Chuck Berry, James Brown & His Famous Flames, Jan and Dean, Smokey Robinson and the Miracles, the Rolling Stones, and the Supremes. The concert movie *Monterey Pop* (1968) featured the Mamas and the Papas, Simon and Garfunkel, the Who, Otis Redding, Jimi Hendrix, and Ravi Shankar. The most well-known and legendary rock movie is *Woodstock* (1970) with performances including Canned Heat, Ritchie Havens, Joe Cocker and the Grease Band, Ten Years After, Santana, and Jimi Hendrix.

Narrative and Cinematic Analysis

Gimme Shelter begins in black with audio of Mick Jagger addressing a New York City concert audience. Then an outside photo shoot of the Rolling Stones pops onto the screen, which cuts to a sold-out Rolling Stones concert at the legendary Madison Square Garden. They perform "Jumpin' Jack Flash" with the camera on Jagger, then drummer Charlie Watts. There is a red/orange colored light on them that spills into the audience. Jagger repeatedly thrusts his hips in a sexual manner. There is an upside-down horseshoe shape on Jagger's shirt. Main title. Single shots of each band member with text to identify lead singer Mick Jagger, lead guitarist Keith Richards, guitarist Mick Taylor, bassist Bill Wyman, and drummer Charlie Watts.

Watts and Jagger are now in the Maysles Brothers' cutting room. David Maysles is wearing headphones. Everyone in the room is looking at a cut of the film that will become *Gimme Shelter* on a **Steenbeck editing table**. The audience is viewing a film within a film; they are watching a **self-referential film.** It also moves back and forth in time, giving it a **nonlinear structure**. The Stones listen to a call-in radio show broadcast about what happened at the free concert at the Altamont Speedway in California. Sam Cutler, the personal road manager for the Rolling Stones, is on the program. Also on the show is Sonny Barger, founder, representing the Hells Angels. He is angry that the Hells Angels are being accused for the mayhem at the concert and says he was asked to sit on the stage to prevent people from the crowd storming the stage. Also, as always, they protected their bikes, which they love more than anything. Barger said people from the crowd jumped on the Angels. Watts is most thoughtful, some would say naïve. In the editing room he says some of the Angels he met at the beginning of the concert were nice. They cleared the crowd by driving their bikes through.

Back in Madison Square Garden the Stones perform "(I Can't Get No) Satisfaction." Originally the Maysles Brothers set out to film the Rolling Stones' American tour and make a concert film, but when the free concert at the Altamont Speedway was announced, they followed that story and the documentary changed course, heading into the dark side. Red/orange scarf on Jagger; the rest of his clothes are all black. **Pan** down the band. Close-up on Jagger, who is clapping to time. "Well, all right." Return to the editing room. Steenbeck. Press conference. Jagger tells reporters that on December 6, 1969, the Rolling Stones will give a free concert to prove that a large crowd can get together for a nice day and evening and get along. Melvin Belli, the prominent lawyer known for representing celebrities, talks on the phone to a land owner who no longer wants to hold the concert. He says he doesn't want to rebuild his raceway after the concert is over. Belli is told 100,000 kids are making their way to the concert venue. Also on the Steenbeck we see the band goes to a motel. "You Got to Move" is performed. This is in Alabama,

the Stones travel to Muscle Shoals recording studio, a legendary venue where a host of musicians have recorded including Rod Stewart, Bob Seger, Aretha Franklin, Paul Simon, and Willie Nelson. The Stones listen to a playback recording of "Wild Horses." The camera focuses on faces: Jagger, then Watts who stares into the camera, then casts his eyes down and then back into the camera and finally off to the side. This character study captures the mood of the man. Next a hotel interior. Jagger dances in a white jacket and orange ruffled shirt to "Brown Sugar." The band loads into a helicopter.

The audience at the Madison Square Garden show is presented in **slow motion** in orange light. Jagger is seen in slow motion, bathed in purple and orange light. Slow blues. Footage of Jagger in slow motion. He is dancing. His voice can be heard singing on the soundtrack but he doesn't appear to be singing in **sync-sound** on camera. **Double exposures**. This break in style from straight-on documentary camerawork to slow motion and **special effects** is interpretive and right for this dreamy blues number. The Maysles Brothers wanted a special film to present one of the greatest rock and roll bands, so to capture their scope they felt it was necessary to create a lyrical segment that could be an interpretation of the audience **point-of-view** or what people see in their mind's eye when they listen to the record at home.

In a recording studio, Richards is lying on the floor with speakers on either side, listening to playback. At the end of playback is applause. Richards wears a Marilyn Monroe T-shirt. Belli's office. The owner of the Altamont speedway, Dick Carter, says he would like to have the concert at his facility. Mike Lang, who was one of the men who put on Woodstock, was involved in moving venues to Altamont and getting this event ready for the Stones. This was billed as a free concert, which brought young people from all over the country to be a part of it. Jagger in a camper with the door open is talking to the press about the meaning of the event.

Tina Turner is on stage at Madison Square Garden singing "I've Been Loving You Too Long." The Stones are in the hallway. In another room they dress and tune up for the show. The music fades out. Jagger talks to two girls. Music up. Tina Turner fingers the mike in an explicit manner. Tight shot on Turner. Orange light—Turner on the Steenbeck screen. Jagger says, "It's nice having a chick occasionally." Backstage, Jagger wears an American flag hat and a purple scarf. On stage he wears the flag hat and orange scarf. "Honky Tonk Woman" is performed. Girls rush the stage, and security pulls them off. Coin-like objects line the side of Jagger's pants. The audience. He tells the audience that he lost a button on his pants and that he hopes his trousers don't fall down—big audience reaction. Girls clap and wave.

Watts is in the editing room. Belli—it will take 200–300 people to move the venue. Mr. Carter comes into Belli's office. Discussion of parking cars; Carter says he knows other landowners with a lot of land adjacent to his place. Belli looking dumbfounded.

Stage. Radio guy working at concert. Highway. The workers put the concert together at night in 30-degree weather. "Jumpin' Jack Flash" is heard as we see kids coming to the concert. Daybreak. The last song at Madison Square Garden. The band leaves the stage. Traffic back-up. Shot of a helicopter with the band in it.

Crowd on ground. Stage scaffolding. Sam Cutler addresses the crowd. People are drinking and taking drugs. Drugged-out guy and sound man. A man is swirling his body around furiously. A young couple makes out as their dog waits next to them. A guy reports a drug freak-out. The number of people there keeps changing; one estimate is 150,000. A woman goes around to gather contributions for the Black Panther Party.[3] A synthesizer is adjusted. A baby has been born during the event. Cutler tells an African American man to get off the stage. A naked woman is in the crowd; she looks like she's on drugs. A guy is bleeding. Cutler orders people around. A girl at the front of the stage who wants to see Jagger is taken away. Cutler argues with the African American man from before, who says he's just doing his job. The Hells Angels come on the scene on their motorcycles. The disoriented naked woman is still in the crowd. From the stage Cutler thanks the workers who moved the venue. It is said that this concert will be the best part of 1969. The Flying Burrito Brothers perform "Six Days on the Road"—the crowd enjoys them. A shirtless guy gets passed over the crowd. People are beaten with weighted pool sticks by the Hells Angels. An Angel pushes people back. Somebody is hurt. People blow large bubbles. Jagger comes out of his camper, but he is tightly surrounded by people and can't go anywhere.

The Jefferson Airplane performs "The Other Side of This Life." A man in white with ribbons on him dances wildly. A topless girl dances wildly. The shirtless man is still pulled around and above the crowd. Angels clear the stage. A man dances up high by the lights. An Angel drinks a can of beer and smokes a cigarette. A young African American man with an afro hairstyle dances and is photographed using pixilation, a **stop-motion** animation technique that makes the image move fast and jumpy. A fight breaks out. Angels. Grace Slick keeps saying "Easy" to try and calm the crowd. Marty Balin, the singer of the Jefferson Airplane, is punched by a Hells Angel and falls from the stage. The music stops. One of the Airplane group, guitarist and vocalist Paul Kanter, announces to the crowd that his singer was punched out by the Angels. An Angel argues back defending the action by saying people are violating their motorcycles, and when they do they are going to get hit. More people are slammed with pool sticks by Angels. Grace Slick blames both sides and tells them both to stop.

The Grateful Dead arrives. Michael Shrieve, the drummer of Santana, is with them explaining what is happening. Jerry Garcia, guitarist and vocalist, is dumbfounded and finds it hard to believe. Phil Lesh, the bass player and vocalist, speaks, also in disbelief that the Hells Angels would beat musicians

and concertgoers. The Dead had a long relationship with the Angels and hadn't encountered this sort of melee before. The Angels clear a path for the Stones by riding their bikes through the crowd. The image is powerful and menacing. Lots of drinking.

The Stones are on the stage. Jagger is very stoned. Surprisingly their opening number is "Sympathy for the Devil." The song is in first person with the devil talking about all the evil deeds he has done throughout the ages. An Angel stares with menace at Jagger as he sings. A man with a hat looks very upset. Jagger is wearing black and orange. The naked woman is still in the crowd, and she looks totally out of it as before. Angels go to her. People in the crowd have flowers. The Angels beat someone. Jagger asks, "Why are we fighting?" One of the Angels talks to the crowd in an unflattering manner. A black man with a bright green sports jacket is seen—he may be the victim who later is stabbed to death. Jagger calls for an ambulance and a doctor. Jagger admits every time the Stones perform "Sympathy for the Devil," something weird happens in the crowd.

They perform "Under My Thumb." The Angels pull out a bike buried among the crowd. A guy on the stage is freaking out. He is close to where Jagger is singing. He is there for a long time looking very out of control. Abruptly an Angel on the stage sees him and throws him off the stage. End of song. The African American man in the green jacket—Meredith Hunter, 18 years old—is stabbed by an Angel. He was trying to get to the stage, and had a gun.

Cut to the Steenbeck screen, and Jagger asks them to roll the film back. It is stopped when the man is stabbed and stopped again to show Jagger the gun, which is seen against a girl's white dress. The controls of the Steenbeck allow forward and backward movement of the film and stops to produce a **freeze frame**. Back to the action at Altamont, we see the girl with the white dress and her boyfriend trying to console her. A medic explains what happened. A helicopter is ready to transport the band out of the area. On the stage the Stones conclude the concert. They and the crowd appear to be in a celebratory mood. The Stones board the helicopter and it takes off. Still nighttime, people move away from concert site, walking over rough terrain. There is a rainbow caused by the lens. Now in the editing room, Jagger leaves, as he gets up and looks in the camera, there is a freeze frame. The song "Gimme Shelter" plays as a **montage** rolls of an exodus of people moving toward the light as night turns to daybreak. In a long take the camera shoots into the light as the concert goers walk away. Four young men seen in silhouette walk past the camera and then leave the frame. This is the last shot of *Gimme Shelter.* Credits. Music up again. The song can be interpreted as a call to take shelter from the Vietnam War, but in the context of the documentary it compels the people at the concert to seek shelter from the onslaught of violence brought on by the Hells Angels and fueled by the inability of the Rolling Stones to stop the ongoing mayhem.

Conclusion

In America, the 1950s were largely conservative. The 1960s exploded with race issues, gay liberation, woman's liberation, the formation of the Black Panther Party, radical politics, and rapidly growing protests. The arts flourished and young people broke away from traditional values, growing their hair long and wearing colorful clothes and beads. The youth movement strived for a new way of living, which led to the Woodstock Musical Festival held in New York State from August 15–17, 1969. Over 400,000 people attended and at least 30 rock and folk bands performed. Just as many were invited, including the Stones, who declined for various reasons. The message of Woodstock was that a large group of people could get together in peace and enjoy music without strife. Drugs were a big part of the culture in the audience and in the music. How do you end such a decade like the 1960s? Altamont was supposed to be that conclusion, but the result was anti-Woodstock, rejecting that people could live together in peace and harmony. Although there were three weeks left in December until the decade of change was over, for many the 1960s ended on December 6, 1969, the day and night of a free concert where the Hells Angels were asked to provide security, but where there was something destructive in the air and everything went wrong.

Gimme Shelter is important because it is a document of a cultural event that concluded a decade that began with resonating change. It is a landmark in documentary film that captured an unanticipated cultural event.

Notes

1. The Hells Angels motorcycle club was formed in 1948. The founder of the Oakland chapter was Sonny Barger. They have been associated with criminal activity and in the 1960s with the counterculture. They ride Harley Davidson motorcycles and travel the roads often. They wear jackets with a distinctive logo design. Their legend is based around their notorious activities and their menacing actions and behaviors.

2. Drew Associates is a documentary company formed in the early 1960s by Robert Drew. Staffed with documentary filmmakers committed to experimenting with the form, the company produced many landmark films including *Primary* (1960) about the presidential race between John F. Kennedy and Hubert Humphrey, considered to be the first direct cinema documentary. *Crisis: Behind a Presidential Commitment* (1963) concerned the civil rights movement and started a discussion about the political power of direct cinema over traditional documentaries.

3. The Black Panther Party was a revolutionary socialist organization formed by Bobby Seale and Huey Newton in October 1966. Its core objectives were to arm citizens to monitor police departments across the United States as protection

against racially motivated police brutality and harassment. They instituted social programs like free breakfast for children and community health clinics. The original organization ran to 1982.

For Further Study

Screen

Madonna: Truth or Dare
Monterey Pop
Salesman
Shine a Light
Woodstock

Read

Altamont, The Rolling Stones, The Hells Angels and the Inside Story of Rock's Darkest Day by Joel Selvin
Hells Angels: A Strange and Terrible Saga by Hunter Thompson
The Pop Festival: History, Music, Medic, Culture by George McKay
Robert Drew and the Development of Cinéma Vérité in America by P. J. O'Connell
The Rolling Stones All the Songs: The Story Behind Every Track by Phillippe Margotin and Jean-Michel Guesdon

CHAPTER EIGHT

Time and Space

Hiroshima Mon Amour

Hiroshima Mon Amour (1960) is a symphony in time and space, as a European woman and a Japanese man conduct a romantic relationship after the dropping of an atomic bomb by the United States on Hiroshima close to the end of World War II.

Alain Resnais made a landmark short color **documentary** *Night and Fog* (1955) in which long **tracking shots** of Nazi concentration camps are **intercut** with historical footage of the era when the camps were in operation. **Narration** written by a survivor of the Holocaust is spoken. This exploration of time, space, and collective memory established Resnais' complex cinematic vision. He was considered a member of the **French New Wave** by many, but his intricate editing style and haunting content put him in a category of his own. Many of those associated with this influential movement were film critics, but not Alain Resnais. He also was older than the majority of the movement's figures. The French New Wave of the 1960s reinvented world cinema. Generally Jean-Luc Godard and Francois Truffaut are referenced, but Resnais is still included by history as a solid and influential practitioner of the French New Wave, adding cinematic richness to what was a rewriting of the rules of filmmaking.

In 1943 Resnais decided to apply to the newly formed film school IDHEC[1] to study film editing. After military service in Germany and Austria, he returned to Paris in 1946 to start his career in film editing, but he also began directing short films of his own. Resnais's training and interest in editing shaped the way he saw narratives in his mind, and influenced his choice of material and the way in which it was photographed. *Hiroshima Mon Amour* is driven by its complex editing. Filmmaking, more than theatre and other media, is about the manipulation and presentation of time

and space. The nature of film is to explore the nature of time in a scene and how it relates to other **sequences** in the film. Space is present in the exploration of the composition and movement in every shot. Every film director manages time and space as part of working in the cinematic medium, but some directors use it in the forefront to give the viewer a truly expansive cinematic experience. Resnais is a master of cinematic time and space, as were Stanley Kubrick (see Chapter 2), Andrei Tarkovsky,[2] and David Lynch (see Chapter 4).

The content in a Resnais film includes the relationship between consciousness, memory, and the imagination. He was interested in formal **structure** in his narratives and innovating in the way they are presented and play out. His academic study of editing and his collaborations with Jasmine Chasney, Henri Colpi, Kenout Peltier, Eric Pluet, Albert Jurgenson, and Colette Leoup in the cutting room of his films defined and evolved his **postproduction** style.

Resnais did not want his name to appear in the credits more than once, so for the three times he was a writer on his films, he used the pseudonym Alex Reval. He worked with many screenwriters and had great respect for their work. A completed Resnais film was remarkably close to the finished screenplay. Resnais felt that he shared authorship with the writer. He described his films, however imperfect, as an attempt to approach the complexity of thought and its inner workings.

At the final stages of World War II the United States dropped nuclear weapons on the Japanese cities of Hiroshima and Nagasaki on August 6 and August 9, 1945, respectively, when the Japanese refused to follow Germany's suit and sign an unconditional surrender. President Truman[3] made the fateful decision to drop the atomic bombs, and at least 129,000 people, mostly civilians, were killed.

Hiroshima Mon Amour is a film that eludes a shot-by-shot analysis because of the ethereal nature of the storytelling and the desire to be understood by an examination of the ideas, emotions, and structure within.

Narrative and Cinematic Analysis

This black-and-white film features a French actress and a man who is an architect that have an affair while she is in Japan performing in a film concerning peace and the impact of the atomic bomb that was dropped on Hiroshima. The man lost his family in that catastrophe. She remembers her lover, a 23-year-old German soldier back in Nevers, France[4], during World War II who later was killed. The relationship between the actress and the architect is deemed an impossible love.

That is the story within *Hiroshima Mon Amour*, but this plot synopsis does not amplify what the film is about: memory, loss, time, and space.

This is a French film in the French language whose topic is Hiroshima as a place, and the representation of the effects on civilians after the dropping of the first atom bomb. The relationship of a Japanese man and a French woman is studied. Explored also are two different views of the city of Hiroshima, which after the devastation became synonymous with that event totally. The French view didn't see it from a first-hand perspective, and the Japanese did. This difference also highlights those between the man and woman.

Michelangelo Antonioni (*L'Avventura* [1960] and *Red Desert* [1964]), Fritz Lang (*Metropolis* [1927]), and King Vidor (see Chapter 15) are known to scholars as film directors who employ architecture as an expressive tool in their work; with this film Resnais joins them. The streets and buildings in *Hiroshima Mon Amour* create a mood of timelessness and loneliness, an empty world for the man and woman to explore.

The first image in the film is of the man and the woman naked. He is lying on top of her, and they are caressing. This is framed in a medium close shot. The composition is abstract. The framing makes it unclear as to precisely what parts of the body are revealed to the camera. There is what appears to be sand, or more pointedly ash, the kind that fell upon Hiroshima after the bomb, covering the citizens of this doomed city. The bodies of the lovers are enveloped in it. The ash suddenly becomes a glitter material also adhering to their skin. The transition from the sand/ash to the glitter is accomplished with a **dissolve** without a change of angle, achieving a magical transformation. This also occurs in a change from the glittering skin to normality. The voices of the man and the woman are heard in **voice-over** before they are seen.

An intimate relationship between a French woman and a Japanese man was not traditional in movies at the time of *Hiroshima Mon Amour*. It becomes a look into the mystery of why people are attracted to each other and the complications that emerge because of the emotional lives of the participants.

A long sequence unfolds in which the harrowing results of the bomb are seen and addressed. It is a **montage** that at times is **intercut** with variations of the lovers' image, giving the impression that both sequences are in a parallel timeframe. The woman presents a voice-over talking about the city and the documentation of this devastating event. During this emotionally crushing segment of the film, documentary footage of how the bomb devastated Hiroshima is presented. This material has an undeniable power of truth and graphic proof, including details of deformities caused by radiation. We're told that there were 200,000 dead and 80,000 wounded, all in nine seconds. The timeframe of the entire film is unclear, and when it seems to define this, the information doesn't always seem to make sense.

The man keeps saying that the woman has seen nothing in Hiroshima, which moves her to continue to present her thoughts in voice-over. Her thoughts are of a memory presentation, even though she was not actually there during the horrific events but rather was a very young woman in

France. The man seems to be saying more than she saw nothing. He is a Japanese man who knew about the unimaginable suffering that occurred at Hiroshima, although he wasn't actually there at the time either. His position is direct. While she was in France, she probably rejoiced that the bomb ended the war, he says. His repetition of that line is in contrast to her scope of the events and moves beyond realism into the realm of lyricism and poetry.

The cinematography by Sacha Vierny, who had worked with Resnais on *Night and Fog*, and Japanese cameraman Michio Takahashi (credited on the film as Takahashi Michio) is lyrical and poetic, an approach that opposes the tragic content but is dynamic in capturing the episodic and elegiac structure of the storytelling. The lighting is dramatic and explores the chiaroscuro of the cinematic medium. The composition of shots and the framing of the images is not traditional, but expressive and often presents a detail rather than the expanse in an artful manner. The consistency of the cinematographic look is seamless, especially considering that Takahashi shot material in Japan first and then Vierny worked in France without being able to see any of the previously shot material.

Although Renais gave his attention to every aspect of a film, the nature of film editing was deeply engrained in the conception of his films, the writing of the screenplay, and importantly through the way shots were created and how they linked to form sequences. He was deeply involved in the actual editing of his films. *Hiroshima Mon Amour* was edited by Jasmine Chasney, who would later work with the director on *Last Year at Marienbad* (1961); Henri Colpi, who would also work on that film; and Anne Saurraute, who had been an assistant editor on *Night and Fog*. The structure of *Hiroshima Mon Amour* is dreamlike and presents memory as more than **flashbacks**, a device certainly used in Hollywood films before Resnais films. In this film memory is presented in the past through the flashbacks and in the present through the complex relationship between the man and woman. The wall between the past and present is broken down to reflect the impact that the past has had on the woman concerning her early relationship with the German soldier and the overwhelming impact of the war and the destruction of Hiroshima. It is the power of editing to transform time and space that makes *Hiroshima Mon Amour* such a powerful poetic and artfully elusive experience. The result is highly emotional while leaving events open ended. The film was influenced by the work of Sergei Eisenstein, the Russian director (*Battleship Potemkin* [1925] and *Alexander Nevsky* [1938]) who developed and practiced the art of montage in which cinema stories were told with a significant emphasis on how shot units can be structured to amplify meaning.

The editing grammar of the **fade out** to black, in which an image of full brightness darkens until it can no longer be seen, and the dissolve in which one image fades into another were staples of editorial language at that time. The fade to black is a way of concluding a scene, and a dissolve is a way to

create a transition between one scene and another. In *Hiroshima Mon Amour* these techniques are employed, but not in a traditional manner. Often a fade to black in this film appears suddenly in a scene, and a dissolve is often used as a linking device. There are many more of each of these methods in this film, and they alter time in an unconventional cinematic way, in a manner that is more like life and memory where things happen in their own way and not as a planned dramatic event.

In a long sequence the man asks the woman specific questions about her dead lover. It is clear that he wants to know as much as possible to the extent that, although he doesn't cross the line between who he really is and who he could be, it appears that he is the German soldier.

Time between the man and the woman starting with them in bed is elongated and difficult to pin down. This is complicated by the intercutting of flashbacks and exactly where and when she performs her poetic, lyrical, and sad voice-over. It is her memory, but is she talking to the viewer or the man or to herself, or a combination of both? Space is fragmented by changes either of location, editorial structure, or the way the shots unfold, presenting information that seems to be altered by memory.

The woman's persistent memory in *Hiroshima Mon Amour* is a person not just recalling the past, but still living it. Through text and the remarkable performance by Emmanuelle Riva in her first movie, we see the transition into the deep pain the character experienced when she was 20 and her German soldier lover was shot, resulting in his early death.

The acting is pure film acting, performing in front of a camera and unfolding the character during a sequential order of shots. It is modern and not theatrical. Eiji Okada's performance as the man gives the screen a person who is obsessed with desire and burdened with the memory of Hiroshima and of his family, who are never seen. The actor had appeared in 22 Japanese movies up to this point. The characters are both married to others, yet driven to play out their relationship with each other.

The music by Giovanni Fusco and Georges Delerue sets a strangely sad mood, which is far from the Hollywood lyrical approach given to films about relationships between men and women. The orchestration is limited and rhythmic unto itself. A solo piano is heard often, providing an emotional accompaniment to the images and transcending the common nature of that instrument.

The voice-over becomes more than just the traditional role of **narrator**. It is the voice of the woman, and at times she is presenting information from the past and her emotional truth and memory. Other times she is revealing her inner voice with highly emotional and personal passages. She also speaks in voice-over to the man and how she feels about him, and at other moments to her dead German soldier lover. This change in voice perspective is identified only by the different paths the vocal text travels.

The relationship between the man and woman is complex. They start in the film as lovers. Fifteen minutes unfold before they are even formally presented to the camera. When she tells him she is going back to France the next day, they begin an emotional struggle that reveals complex aspects of their outer and inner lives. In a particular moment two words she speaks to him bring the dynamics of the relationship to a dangerous point: "Deform me," possibly meaning that he has the power to bring her to a state similar to what happened to the people of Hiroshima.

There is the making of a **film within a film** in *Hiroshima Mon Amour*. The woman is an actress working in a film about peace. She is seen on location with the crew filming a demonstration. There are placards and posters with messages for peace on earth. Although the march is being filmed, the reality of it becomes larger and more filled with people and signs and less of the filming process. Where at first we see the crew of this movie, the reality becomes the protest as the subject of this sequence. There is a sudden shift, and the organized protest march becomes chaotic with people running in all directions. The man has come to see her there, and now they are separated and panicked until they come together, and the mood changes again.

Nevers, France, where the woman lived as a girl, is only shown in flashback. It is talked about, and the man is intrigued with it and what happened there. As she watches the man sleep, there is a **shock cut** to her, young and bloodied over the body of her lover, a German soldier. This memory hasn't been formally introduced and seems to relate to the sleeping man when the image returns. Her memory is so attuned that it can be triggered instantly.

There are long emotional exchanges between the man and the woman concerning whether they will see each other again. She says no, and he continues to press by trying to understand what happened to her in Nevers. For both this is a trying, affecting experience.

Through flashback it is revealed that she and the German soldier got together in ruins and in barns. The balcony on which the person who shot him is shown and at first not identified. He was 23 and she was 18. The Japanese man begins to talk to her as if he knew the woman then.

During a long and involved sequence in a tea room, they continue to talk about what happened in Nevers. She talks about the past and projects herself as if she is emotionally no longer in the tea room but back in time. He questions her about the events in Nevers. She goes into a sense memory, remembering an emotional time in her life by mentally transforming herself back to that time. The man becomes the soldier through the tense of his words. In flashback her hair is cut off. The same actress plays herself at 18 and as a wife and mother, most likely in the 1930s. The sequence travels back and forth between WWII and the present day in the restaurant. She is confined to her bedroom. She is put into the cellar when her parents feel she is not rational.

Talking to the dead soldier in voice-over she says, "The only memory I have left is your name," also highlighting the film's major theme of the memory and how it works and how it stays with someone. When she agrees to stop screaming, she is allowed to go back to her room. In the restaurant she talks to the man as if he were the dead soldier. The woman turned 20 while she was kept in the cellar. Her memory of the soldier began to escape her. A time of humiliation, the girl with hair shorn and blood on her face (which is not explained, presumably from holding the soldier) is forced to walk among many, who all laugh at her and jeer because she gave comfort to the enemy and is now a broken person. The balcony is seen again, now defined as the place where a person shot the soldier—another example of how memory works. Images can pass through the mind without understanding but represent a specific event. Nevers was liberated after the incident with the soldier. For a film with many edits, there is a very long take on the woman talking about herself and her story that emphasizes the story structure created by Duras and Resnais, one that has ever-changing rhythms. There is a narrative transformation back to the cellar, and it is stated that the girl now 20 years old became what was considered to be reasonable, a repeat of information that is also part of the memory process. The woman tells the man that one day she won't remember what happened in Nevers.

The man is the only one who knows her story, not even her husband, and he takes pride in that. The man talks about love's forgetfulness, telling her he will forget her and about other encounters he will have. This actor has a challenging role. There is less known about his character actually and emotionally. His narrative voice and his intentions change within the text of the film. Overall he seems to be a man without a defined history and one who is largely a mystery to the viewer.

There is the notion that a war could bring them together again, which they both appear to understand. A war brought the girl together with the German soldier, and the bombing of Hiroshima brought the man and the woman together. Tragedy and suffering are emotions explored and become a shared experience.

They part. She has emotional difficulty getting back to her room at the Hotel New Hiroshima. She is deep into an emotional memory, talking about herself and speaking to the departed soldier. Then she is outside a tea room, and tells herself she will stay in Hiroshima with the man. He appears back at the tea room and agrees that she'll stay in Hiroshima with him. There is a distant siren, which is not explained but recalls the chaos of Hiroshima after the atomic bomb. In a haunting, dreamlike sequence she walks ahead of him on a sidewalk. He asks her to stay. She talks about him in voice-over. She says he is destroying her and that she is hungry for infidelity, lies, and death. She talks about the night not ending, no dawn, a metaphor for Hiroshima after the bomb.

All the flashbacks, memories staged past and present, alter the sense of time in which *Hiroshima Mon Amour* evolves. Time in this film is altered by the way the characters present their actions, emotions, and feelings. The poetic and lyrical narrative suspends time and lives within the mind-space of the man and the woman.

There is a different tea room. He tells her he wishes she had died in Nevers. She agrees.

A rail station waiting room. They both sit on a long bench. In voice-over the woman says she wants to see Nevers again. Then she speaks directly to Nevers that she wants to go back. She talks to the man with sensory language, but she is actually thinking of the soldier. There is a flashback of her and the soldier together. Love is a theme in the movie. She says she died of love in Nevers, indicating that the experience with the soldier may have made it difficult to feel this way again. Trying to stop the memories from that relationship, she says that she relinquishes him to oblivion, which is how she feels at this specific moment, but because of the strength of memory, this may not be forever.

A bar/restaurant called the Casablanca is established. The name is a reference to the 1943 movie starring Ingrid Bergman and Humphrey Bogart, which largely takes place in Rick's Café in Casablanca. This is the only recognizable reference or film quote in the film. The films of the French New Wave were often filled with references to other films or cultural items, especially the work of Jean-Luc Godard (see Chapter 3), in which they appear to accent and advance the narrative. Resnais was less interested in this practice; he concentrated on manipulating time for a robust cinematic experience.

The man arrives, and the woman is already seated. At a table in the back sits a man and three ladies. This man approaches the woman. He is not identified. He asks her questions, trying to get into a conversation with her. Is he a procurer? What are his intentions? He is persistent. The man and the woman are still sitting separately. They look pained as if they are suffering. She is detached from the stranger. The man seemed to be concerned that she would be interested in the stranger. She seems torn within herself about the man. The stranger is just a catalyst—someone who could interfere, but nothing comes of his approach to her.

There are shots of Hiroshima, the city as it is when the story takes place. The woman is in her hotel room, and the man arrives. Once they part there is little explanation of how they continue to meet, how he knows where she is. Whatever expectations the viewer has for how the film ends are circumvented when she says to him, "I'm forgetting you." She tells him his name is Hiroshima; he responds by saying her name is Nevers. They become all that has occurred in the film, which has now concluded.

It may be that they accept who they are and will come together again, or this cryptic moment may mean that they now understand that they come

from two different worlds geographically and emotionally but cannot be apart. Resnais avoids a happy ending that would allow the audience a simple answer to the complexity of such a relationship. What is important is that there is an internal logic that follows the film from beginning to end, which is that life flows in a poetic and lyrical fashion where time and memories influence lives.

Conclusion

The decision by President Truman to drop atom bombs on Hiroshima and Nagasaki was based on the fact that the Japanese military leadership and the fighting soldiers themselves would not give up under any circumstances. Estimates of casualties if the war in Japan were to continue were astronomical, thus leading the president to use the ultimate weapon. The impact of that decision inspired *Hiroshima Mon Amour* and has had an impact on world politics in all the decades since.

Marguerite Duras wrote the screenplay for *Hiroshima Mon Amour*. She was a French novelist, playwright, screenwriter, essayist, and **experimental** filmmaker. This screenplay received a nomination for Best Screenplay at the Academy Awards. She was a perfect collaborator for Alain Resnais in that both had expansive imaginations and were constantly looking for new narrative forms.

The early works of Duras were considered conventional in form and were criticized as being romanticized, but with her 1958 novel *Moderato Cantabile* she moved into an experimental pattern, paring down her texts to give ever-increasing importance to what was not said. She was associated with the nouveau roman French literary movement, although she did not definitively belong to any one group. She was noted for her command of dialogue.

The combination of Resnais and Duras on *Hiroshima Mon Amour* and the world-changing event of the dropping of an atomic bomb on Hiroshima in Japan produced a relationship film that is unprecedented in its emotional impact, its social implications, and as a cinematic work.

Notes

1. IDHEC stands for Institut des Hautes Études Cinématographiques, which was the main French film school training French and foreign film professionals from 1944 to 1985.

2. Andrei Tarkovsky (1932–1986) was a Soviet filmmaker, writer, editor, film theorist, and theatre and opera director. His work in film featured long takes, unconventional dramatic structure, and spiritual and metaphysical themes. They include *Andrei Rublev* (1966), *Solaris* (1972), and *The Sacrifice* (1986).

3. President Harry S. Truman (1884–1972) was the 33rd president of the United States from 1945 to 1953. He took the office upon the death of Franklin D. Roosevelt. He was a World War I veteran who assumed the presidency during the waning months of World War II. He is known for the Marshall Plan to rebuild the economy of Western Europe and for intervening in the Korean War. He was a liberal democrat. He was born in Missouri and is famous for saying "The buck stops here" when he was president.

4. Nevers was the principal city of the former province of Nivernais. It is 160 miles south-southeast of Paris.

For Further Study

Screen

Cinéma! Cinéma! The French New Wave
Last Night at Marienbad
Muriel
Night and Fog
The Truck

Read

Alain Resnais by James Monaco
Alain Resnais: Or, the Theme of Time by John Ward
Duras: A Biography by Alain Vircondelet
Hiroshima Mon Amour—a Screenplay by Marguerite Duras
A History of the French New Wave by Fred Neupert

Fantasy as Reality

King Kong (1933)

"He's always been king in his world but we'll teach him fear! We're millionaires, boys—I'll share it with all of you. Why, in a few months he'll be up in lights on Broadway; Kong! The Eighth Wonder of the World!!!"

Those are the words of Carl Denham, moviemaker and promoter extraordinaire, spoken by actor Robert Armstrong in one of the most excitable, bombastic, egomaniacal performances in the history of American film. He is talking about a monkey, a very big monkey, the biggest ape seen on the screen up until that time.

For filmmakers, Merian C. Cooper and Ernest B. Schoedsack, a man in a monkey suit, a puppet manipulated with strings, or even a real gorilla wasn't good enough for their Kong. They would find a man who perfected an animation technique called **stop-motion** in which a sculpted model of King Kong would be shot then moved a bit, ever so little at a time, and shot frame by frame—Willis H. O'Brien.

Cooper and Schoedsack decided not to film their epic (which Cooper had obsessed about for years), on location in a jungle, but on a sound stage for more control, where the atmosphere, detail, and created reality would be supplied by Van Nest Polglase, Mario Larrinaga, Byron L. Crabbe, and their art department crews.

The theme—practically one as old as time, "beauty and the beast"—is written into the head of the film through a fake old Arabian proverb supposedly penned by Executive Producer David O. Selznick[1]: "And the prophet said: 'And lo, the beast looked upon the face of beauty. And it stayed its hand from killing. And from that day, it was as one dead.'"

The linking of beauty and the beast began as a French traditional fairy tale in 1740. Much later, artist, poet, and filmmaker Jean Cocteau conceived it as

a romantic, haunting, and surrealistic film *La Belle et la Bête* in 1946, and over the years this theme has been preserved and modified (sometimes not for the better) in literature and film.

In *King Kong* the theme of beauty and the beast is not only presented even before the film formally begins but is spoken seemingly endlessly by Denham and others throughout the film. The theme is played out dramatically by the beautiful Ann Darrow, performed to the hilt by Fay Wray, and the Eighth Wonder of the World, King Kong. Wray was told by Cooper, "You will have the tallest, darkest leading man in Hollywood." In this version, the pairing is more bizarre and less poetic than the Cocteau classic and the location far less romantic than Victorian France; however, it is more exotic and dangerous.

The rest of the cast includes Bruce Cabot as Jack Driscoll, First Mate, Ann's rescuer and then fiancé; Frank Reicher plays Captain Engelhorn, the ship's steady leader; Noble Johnson plays the Chief of the natives. Victor Wong played the witty and excitable Chinese cook.

Narrative and Cinematic Analysis

King Kong tells a compelling and simple story. It begins with an **overture** that plays with a black screen. One of the **DVD** double disc sets presents an overture before the movie starts. This often accompanied theater screenings in major cities for big roadshow movies that appeared in major venues before opening in theaters nationwide. These musical introductions were similar to the overtures performed for Broadway musicals where the major musical themes are played in succession, presenting a preview of the show. For the *King Kong* overture moody harp music evokes the movement of the ocean. There is an action theme that will be played during creature battles. Climbing music is played when Kong holds Ann Darrow in his hand and scales the Empire State Building in New York City. Music for Kong when he falls off the Empire State Building concludes the overture. RKO Pictures title. Black-and-white. Score under credits and the proverb concerning beauty and the beast. Kong is credited on the screen as "Kong: The 8th Wonder of the World." Moving picture ship. A theatrical agent talks to a sailor near the ship's exterior and learns that the crew aboard is three times the normal size. The agent goes aboard. During a meeting with showman Carl Denham, he learns there are gas bombs aboard. The agent agrees that the public wants to see a pretty face. Denham is exasperated as he has been searching for the perfect one. Denham is an especially colorful character. New York Times Square. A line-up of down-and-out women. At a produce store, pretty Ann Darrow tries to steal a piece of fruit because she is starving and has joined the down-and-outers of the Great Depression. Denham checks her out and brings her to a cafeteria. She tells him she's done film extra work. Denham has found his beauty.

The ship sails. First Mate John (Jack) Driscoll gives orders and accidently smacks Ann in the face. The ship—now on the ocean for six weeks. Ann tries on costumes. Driscoll keeps saying that women have no place on a ship. Beauty and the Beast is Denham's theme for the spectacular movie he's going to make. He shows the skipper a map of Skull Island. A wall. He says there is something on the other side, later revealed as King Kong. No white man has ever seen this giant gorilla. Ann appears in the Beauty and the Beast costume for a screen test. Jack and the captain watch. Denham puts a filter on the camera lens. Denham shoots his own movies with a crank camera to ensure **footage** because on an earlier picture the cameraman ran away when a large animal appeared and Denham lost a "swell" shot. There is humor in the film—unfortunately some is racist at the expense of the native characters and the Chinese cook. It was released in 1933 when there was less sensitivity and more ignorance in Hollywood towards such humor.

"Confound this fog!" Drums. A clearing. Skull Island. Denham smokes his pipe. Twelve men go ashore. Ann has a shorter hair style. A small boat is lowered into the water. Big birds. On shore. A Native compound. They walk toward the door and the wall. The natives chant "Kong, Kong!" They move forward, and come upon a ceremony. Natives. They are preparing a young girl to be the bride of Kong. Denham begins to film the event. The Native chief sees them and everyone turns around. **Mickey-Mousing** music accompanies the chief walking down steps, with a low musical note for each step he takes. (This musical descriptive term relates to Walt Disney's early Mickey Mouse animated cartoons where this musical technique began. Denham tells the crew to come out in the open.) "Bluff 'em." Skipper (the captain as he's called by Denham) talks to the chief in his native language. The sacrifice ceremony of a young girl deemed the Bride of Kong is spoiled. The chief points to Ann. Denham says, "Blondes sure are scarce around here." Another unfortunate racist remark that in 1933 was considered funny, clever, and right for a particular character. They leave. Denham whistles "St. Louis Blues."

Jack and Ann on deck—"I love you"—they kiss. Jack is called in by the captain and leaves. Natives boat up to kidnap Ann. Drums. Torches. Jack can't find Ann. The Chinese cook finds a native necklace. Search for Ann. Rifles and boats. At the compound the natives are pulling Ann's arms. Doors open to reveal two brick poles. They tie her to them. Steps. Close the door, bolt. Everyone watches from top of the wall. A big gong rings. Kong roars. Kong appears and goes up to Ann. She gets out of the ropes and Kong picks her up. He takes her away.

Men arrive and run after Kong. They move through the jungle. The men see a giant footprint, then a dinosaur. It charges towards them and gas bombs are thrown. The dinosaur gets up, and they shoot at it. Denham wishes he could bring one home alive. There are Kong noises. Footprint. They make a

raft and go down the water. A creature comes up from the water, and they shoot at it. The creature turns the raft over. It takes one of the men in its mouth then flings him away. Running. The creature follows the dinosaur. Land. Forest. A man up in a tree is attacked. Running. Kong puts Ann in a tree. Men cross a tree bridge; Kong lifts the bridge and men fall. Jack escapes down a rope. A tree comes crashing down—Jack is hiding below, and Kong tries to grab him. Jack stabs Kong with a knife. Jack cuts the rope that the creature is climbing. The dinosaur comes to a new place and fights with Kong. They wrestle, and it throws Kong into a tree. Ann falls. She watches. Kong breaks dinosaur's jaw. He frees Ann from the downed tree and picks her up. Jack climbs a rope. Two are left alive. Denham shows up, and runs back for more bombs. Jack tracks down Kong. Chase. **Fade out** to black.

Back at the ship, Denham tells the crew what happened. They will leave at dawn. Jack follows Kong and Ann. Kong puts her down on rock. An eel-like creature comes, and Kong fights it. Jack looks on, trying to get to Ann. The creature tries to strangle Kong but the ape kills it, then beats his chest to indicate his absolute supremacy.

Kong carries Ann up a mountain. He puts her down, and she collapses. Kong picks her back up, and takes off her clothes. She wakes and tries to get out of his hand. He tickles her. He sniffs his finger after touching her body— a controversial moment in *King Kong*. Jack accidently knocks over a rock. Ann tries to get away, but a winged creature attacks her. Jack frees her and they begin to climb a rope. Kong kills the winged beast. Kong pulls up their rope—as Ann and Jack get closer and closer to Kong, they let go and drop into the water. Kong is angry. Fade out to black.

The couple runs toward the big door that divides Kong from the natives. They make it. Denham and the crew are there. What about Kong? Gas bombs. We've got something he wants (meaning Ann). Kong comes to the door. They bolt the door. Kong is now pushing hard. Everyone tries to hold him back. Kong breaks through the door. Everyone runs away in fear. Denham tries to get to the gas bombs. The natives throw spears at Kong. He eats a native and crushes another with his foot. At a small boat they throw bombs at Kong. He is knocked out. Denham gives his famous speech which includes, "We're millionaires, boys—I'll share it with all of you . . . Kong! The Eighth Wonder of the World!"

Marquee of a New York City theater. Night. A large crowd inside the theater. A tall curtain. House packed to capacity. Backstage with Ann, Jack, and Denham. One of the press says, "Beauty and the beast," and Denham in his usual excited state says, "Play up that angle, boys!" Denham walks on the stage and makes a speech about the adventure. The curtain opens and reveals Kong—the audience reacts in surprise and wonder. Denham brings out Ann, then Jack. Denham tells the sellout crowd that they are to be married—the press takes their picture. Kong goes wild and is agitated by the

flashbulbs. He breaks free and out of the theater. He eats a man. Wrecks the Third Avenue elevated train. Mickey-mouse score. Kong breaks the track so the train crashes. Pulls down the train. Punches in the train. Kong climbs a building. Police cars, fire trucks. Kong pulls woman out of bed; when he sees she is not Ann, he drops the woman out of window and she falls to her death.

Jack and Ann are in a hotel room. Kong puts his arm in the window, knocks Jack aside, and takes Ann, then climbs the building. Jack and Denham in the hall. The roof. Kong and Ann. He puts her down, then picks her back up. Denham and Jack get searchlights.

Kong is climbing the Empire State Building. Airplanes. Climbing to the top. Four planes. On top. Kong puts Ann down. A plane shoots at Kong. Planes continue to shoot machine gun fire at Kong. He grabs a plane by the wing and throws it down to the ground. Kong is wounded. More gunfire. Kong tries to pick up Ann, then puts her down. A sad look on Kong's face. He is hit again by machine gun fire. He is trying to hold on. He lets go. In a wide shot he falls. Jack comes for Ann. Kong is dead on the street. We see Denham and a policeman who says it was the airplanes that got Kong. With music blaring Denham ends the movie with the classic line, "It wasn't the airplanes that got him, it was beauty that killed the beast!"

King Kong was RKO Production 601. The film was directed by two daredevils: Merian C. Cooper and Ernest B. Schoedsack. Cooper had received a prestigious appointment to the U.S. Naval Academy but was expelled during his senior year for uproarious behavior and raving about air power. He went to the Military Aeronautics School in Atlanta and graduated at the top of his class. He served in World War I in a flight squadron and was highly decorated. After the war he worked nights at the *New York Times* and wrote articles for *Asia* magazine, where he met Schoedsack. In 1925 they made the documentary film *Grass: A Nation's Battle for Life*, which follows a tribe in Persia on a seasonal journey to a better life.

Schoedsack began in the film industry in 1914 as a cameraman for Mack Sennett, who ran a studio that specialized in comedies. Schoedsack was a cameraman in World War I and flew in combat missions. After the war he remained in Europe working as a cameraman. He worked with the Red Cross and helped refugees from two wars.

Cooper was fascinated with gorillas. He was considered to be a modern-day Carl Denham, and that role was modeled after Cooper. Schoedsack was held in an internment camp during the war where he shot in war zones, and was the model for First Mate Jack Driscoll on the ship that landed on Skull Island. The men were friends and had worked together before. *Chang* was a silent film drama released in 1927. Inspired by what they saw in adventure, Schoedsack photographed *Grass*. At the time Schoedsack was married to zoological historian Ruth Rose. She was quiet and tough, and did whatever

was necessary in writing the screenplay. They filmed the first gorilla fight with a Komodo dragon. During the 1920s and 1930s the two couldn't get backing for their films.

In 1931 they met Willis O'Brien, the **special effects** master. *King Kong* inspired all special effects creators who followed until the present day. A figure in an O'Brien film was a forerunner of Kong. He did the special effects for *The Lost World* (1925) and *Creation* (1931). O'Brien had a lot of unrealized projects because he also had trouble getting backing even though he had great technical facility. *Creation* played a significant role in the development of *King Kong*. When Schoedsack was directing *The Most Dangerous Game* (1932), which featured Robert Armstrong and Fay Wray, Cooper was making a test reel for *King Kong*. The actors moved from shooting *The Most Dangerous Game* to shooting tests for the effects in *King Kong* back and forth for many hours a day. Finally, David O. Selznick greenlighted *King Kong*. Edgar Wallace, a crime writer, journalist, and playwright, wrote a treatment similar to the finished film, but died suddenly in February 1932. At this point the title of the film was to be *The Beast*. The replacement writer couldn't do the revisions Cooper wanted, so Ruth Rose was brought in and got the script into shape. All the plot points were set up before Kong appeared. The two men decided on the final title, *King Kong*.

The making of *King Kong* is filled with facts and details. A Los Angeles auditorium filled with extras was used for the Broadway theater sequence. A Kong hand was built to wrap around Ann. The Navy biplanes were real. The men behind *King Kong* played cameos, Merian C. Cooper was the pilot and Ernest B. Schoedsack was the gunner. They killed King Kong. Live action and **miniatures** were used in film. The New York scenes were shot first. Kong smashing the train was an afterthought.

The rough cut was 13 reels, considered bad luck in Hollywood, The Third Avenue Train sequence made it 14 reels. Ted Cheeseman was the editor on *King Kong* who cut the film down to 11 reels. *King Kong* was the beginning of the spectacle film created with special effects that is enormously popular in the 21st-century box office.

King Kong was the first live action film that had an animated lead character. The Kong puppet was covered in foam rubber and rabbit fur. The audience had compassion for Kong, believing the big ape was real. The whole production was steeped in secrecy, because the producers felt that if the public knew about the film, it would take away from the audacity of it. The Kong figure used to make the film was 18 inches tall. Marcel Delgado was one of the great model makers and worked on the film. The armature for Kong was manufactured in secret and engineered to precise specifications. It was shot frame by frame in the stop-motion technique. A frame was exposed of Kong in a specific position, his body parts were then moved slightly, and another

frame was exposed. This was repeated over and over until the sequence of action was complete.

Different faces of Kong with different expressions were sculpted. Hot lights melted the rubber on the puppet, and Kong looked different each time because of this. There were different armatures for the three Kong puppets built. A short face and a long face were created. The hair on Kong moved on screen because when O'Brien manipulated the puppet for different positions for frame-by-frame work, his hand inadvertently moved the fur around. The fur became animated through the process and created an unplanned reality to the creature.

O'Brien developed and perfected stop-motion photography over 20 years, and the process has not changed over the decades. It was a labor-intensive process: at a rate of 1,440 frames for every minute, it could take the animators 150 hours to capture a minute of the *King Kong* film. A surface gauge, a tool for measuring lines on fixed materials, was used as a reference point. There were stop-motion moments that had to be redone because of mistakes or because the filmmakers weren't happy with the results. There were usually two takes so that the better one could be chosen. This added to the already massive workload in making Kong come alive. Patience of the highest level was necessary. They had to work a section all at once—they couldn't stop, because light changes would affect the photography.

The dinosaur battle with Kong took seven weeks to shoot. They had to figure out Kong's moves before executing them in front of the camera. Kong is an uber-gorilla. The movements had to mean something; acting was involved. O'Brien's wife saw her husband in Kong. Motivation is necessary in stop-motion animation, just as it is for a live-action actor. Kong picking flowers while Ann is attacked is a moment of gentleness by Kong toward Ann, a different side of the ferocious giant ape.

A series of plywood tabletops were used to shoot the stop-motion material. There were holes drilled into it to tie down the puppet. The feet were locked to the floor. Support rods can be seen in some shots. A storybook jungle was created for the desired effect, not a realistic one that would break the fantasy quality of the film. Trees were made of wooden dowels and were cut out of copper sheets. Real plants were also used. Leaves, vines, and moss were part of the cinematic jungle. **Matte paintings** on glass were used for backgrounds where the camera shot through glass.

Mario Larrinaga was an art technician on the picture and worked on the matte paintings. The painting was dressed with real pieces for a 3D effect. In the back a fully painted glass painting done in an impressionistic style was there to create depth. Some shots were done in-camera. A shot was made, then the film was rolled back and a second shot was taken to make a composite shot. Many techniques such as a traveling matte were used that mask

the shape of moving objects, allowing great freedom of composition and movement.

Dunning **bi-packing** was the process of loading two reels of film into a camera so they both could pass through the camera together. The **optical printer** was operated by Linwood Dunn, one of the early masters of this piece of cinema equipment, which was used to create visual effects. With the optical printer the operator didn't have to bi-pack. Separate pieces of film were then put together in the optical printer. Rear screen projection was also used in which prefilmed footage was projected into the back of a disguised movie screen on set while the actors acted in front of it, forming a combined image. Some effects were low-tech: when Ann's clothes were pulled off by Kong, wires were connected to individual articles of clothing and pulled off one at a time.

Many techniques were utilized in one shot. O'Brien had a patent for all the techniques he utilized in *King Kong*. The majority of this movie that contains many fantasy elements was made a frame at a time. *King Kong* became the new bible of moviemaking. The 1930s became a pioneering time for fantasy filmmaking. O'Brien invented the concepts of modern special visual effects.

The sound of *King Kong* is essential to the overall affect of the movie. The musical score was composed and conducted by Max Steiner,[2] and the sound was created and executed by Murray Spivak. Spivak tapped on his assistant to make the sound of Kong hitting his chest. Spivak was a New York drummer who read music, and he pioneered the concept of sound design and inspired a generation to follow. Kong was made during the days before safety film. The industry was still using the dangerous nitrate film, which could explode or suddenly break into flames if not handled properly.

If a copy of a sound was made in those days, it was degraded just by the sheer fact of duplication. Spivak created new film sound techniques. Spivak worked in a garage that he set up as a sound studio. For the dinosaur battle scene he recorded sounds at a local zoo. Roars were recorded at half speed to give them depth, and the sound of a tiger was recorded backwards. Sweetening the art of adding sounds to build the overall effect was applied. Spivak also had a large megaphone and made sounds through it with his voice.

The visual effects were costly and time consuming, and the budget was spiraling out of control. RKO wanted to use preexisting music from their library, which would be of little cost. Cooper told Steiner to compose an original score knowing it would greatly benefit the film, as preexisting music would add little to the dynamic story and innovative visuals. It took eight weeks for Steiner to compose the score for *King Kong*. The music was directly tied to the film: Steiner worked by weaving music cuts he composed into the film. The relationship of Ann and Kong had a theme. The Kong theme was

three descending notes and Ann's theme was in three-quarter time. Music climbs the Empire State Building along with Kong and Ann. The music was varied in tone and nature and acted like **sound effects** at times. The score worked very closely to the editing of *King Kong*. Spivak mixed sounds to the music not to interfere, but in harmony with the music. Steiner's descriptive music emphasized movement.

Studio executives were concerned about Steiner and his methods. Audiences needed a push, and Steiner's commitment to Cooper provided it. Spivak would come home and Steiner would call him telling him he was going to quit, almost every night. The music and sound gave Kong a heart and a soul. Music says goodbye to Kong as he barely holds on to the top of the Empire State Building.

Five years later in 1938 a new release of *King Kong* was subject to censorship by the Motion Picture Production Code.[3] They felt the public shouldn't see a native's head bitten off and other violent scenes. The lady held upside down by Kong outside a New York City apartment building and then dropped to her death was another scene considered offensive. About four and a half minutes of *King Kong* was cut out, creating the 1938 censored version. An editor took the deletions home and kept them safe. British filmmakers put the censored material back in. However, there were 29 missing shots, including a Spider Pit sequence where sailors fall off a log into a pit of spiders. Cooper found it too shocking and felt it stopped the story. Cooper burned the material as he usually did to shots or scenes he didn't like.

King Kong was made during the Great Depression. It opened at the RKO Roxy and Radio City Music Hall in New York City and at the Grauman's Chinese Theater in Hollywood. There was a model head of Kong outside Grauman's, and Fay Wray posed in front of it while people took pictures. It was a sensation. Everything came together on *King Kong*.

Willis O'Brien never received recognition. He continued to work on movies after *King Kong*, including *The Last Days of Pompeii* (1935). In 1950 O'Brien finally received the recognition he so richly deserved by winning an **Oscar** for Special Visual Effects for *Mighty Joe Young* (1949). In a kind of spiritual harmony, Robert Armstrong died 16 hours before Cooper, the man he had essentially played in *King Kong*.

The studio rushed out a **sequel**, *Son of Kong* (1933), just nine months after *King Kong* to capitalize on that film's sensation. The story begins around a month after Kong was shot down by airplanes and falls from the top of the Empire State Building to a New York City street. Because of Kong's destruction, Carl Denham, again played by Robert Armstrong, is overwhelmed with lawsuits. He and the captain of the ship (again played by Frank Reicher) leave port again for Skull Island to find another Kong. After drama concerning a young woman, Hilda Petersen (Helen Mack), "Little Kong," the son of

King Kong, makes his appearance. In the end Little Kong is responsible for rescuing Denham in raging waters.

King Kong has many remakes and sequels aside from *Son of Kong*: a Japanese production, *King Kong vs. Godzilla* (1962); *King Kong* (1976), directed by John Guillermin; and *King Kong* (2005), directed by Peter Jackson. There are many other productions all over the world that touch on the Kong legacy. Many use variations of the basic *King Kong* narrative. Kong has been enhanced by digital effects that may improve the believability of the fantasy/adventure, but even with its black-and-white imperfection compared to 21st-century visual effects, the 1933 *King Kong* is a masterwork of story, image, and sound that has influenced and inspired so many in the motion picture industry and is reflected in the blockbusters of the current century.

Conclusion

As a character King Kong joins Godzilla as an enduring creature who captures and holds the imagination of moviegoers from decade to decade. The beauty and the beast theme harkens back to the traditional fairy tale created in 1740 by French novelist Gabrielle-Suzanne de Villeneuve and resonates as a story of transformation and love. The original *King Kong* released in 1933 not only set the standard for the long-running franchise but is definitive in capturing the hearts and minds of movie fans as well as being a landmark in special effects filmmaking.

Notes

1. David O. Selznick (1902–1965) was an American film producer, screenwriter, and film studio executive. He was best known for producing *Gone with the Wind* (1939) and *Rebecca* (1940), both winning him Best Picture Oscars. He brought Alfred Hitchcock to the United States and was known for his copious notes and obsessive attention to every detail in a film.

2. Max Steiner (1888–1971) is considered to be the father of the modern film score. He composed over 300 film scores for RKO and Warner Bros. He was nominated for 24 Academy Awards and won three: *The Informer* (1935), *Now Voyager* (1942), and *Since You Went Away* (1944). He was best known for composing separate themes for the characters in a film as well as themes for parts of the action.

3. The Motion Picture Production Code, known as the Hays Code, is a set of industry moral guidelines that applied to most movies released by the major Hollywood studios from 1930 to 1968. It spelled out in detail what was acceptable and unacceptable content in motion pictures produced for the public in the United States.

For Further Study

Screen

The Creature from the Black Lagoon
Godzilla
Jungle Woman
Mighty Joe Young
Son of Kong

Read

King Kong: The History of a Movie Icon from Fay Wray to Peter Jackson by Ray
 Morton
Living Dangerously: The Adventures of Merian C. Cooper, Creator of King Kong by
 Mark Vaz
The Making of King Kong: The Story Behind a Film Classic by Orville Goldner and
 George Turner
Muybridge's Human Figure in Motion by Eadweard Muybridge
On the Other Hand: A Life Story by Fay Wray

Destruction of the Well-Made Hollywood Movie

The Last Movie

The Last Movie released in 1971 and directed by Dennis Hopper was obviously not the last movie ever made, but some argue that it was the last American movie of its era. The American cinema would not be the same after Dennis Hopper attacked everything Hollywood had built in terms of narrative, performance, look, structure, style, and content with *The Last Movie*.

As a young actor in 1955, Hopper did a stunning and frightening dramatic turn on the landmark medical drama series *Medic*[1] by appearing to experience what seemed to be an all- too-real epileptic seizure in front of the cameras. He was a member of the teen pack in *Rebel Without a Cause* (1955) and remained close to the legendary James Dean,[2] his mentor whose early death in 1955 at age 24 would haunt Dennis Hopper forever, and even become part of the content of *The Last Movie*.

After he appeared in many Hollywood movies including *Giant* (1956), (James Dean's last movie), Hopper and Peter Fonda[3] created *Easy Rider* (1969), which Fonda produced and Hopper directed. The movie was a game-changer. It shunned older audiences who during the period were more likely to stay home and watch television while the under-30 crowd responded well to a **low-budget movie** that evoked their youth culture. This began the **American New Wave**. It seemed Hopper could write his own ticket, and he did by choosing to direct a film that would further comment on life as he saw it and expose the tiredness of conventional Hollywood. *The Last Movie* was highly anticipated, but almost immediately spurned by critics and audiences despite winning the Grand Prize at the Venice Film Festival in 1971. *The Last*

Movie almost became Dennis Hopper's last movie as a director, but eventually he was able to direct again. *The Last Movie* was largely unseen for almost five decades except for on inferior **VHS** until 2018 when it was restored and available on Blu-ray and **DVD** with insightful extras.

During the mid-1960s the Hollywood studio system began to crumble. The original moguls were just about gone. Hollywood movies were not making real money. American musicals and Westerns, once staples of the industry, took a hit in quality and box office strength. Hollywood stars of the 1940s and 1950s had either passed on or lost their luster. Superstar directors like Frank Capra,[4] John Ford,[5] and Howard Hawks[6] were not making movies young audiences wanted to see. Baby boomers and those under 30 were going to the movies in big numbers. The movies were starting to change to reflect a new generation.

Film schools were turning out young filmmakers like Francis Ford Coppola (see note in Chapter 3) and Martin Scorsese (see note in Chapter 3). The American New Wave started with *Bonnie and Clyde* (1967), which reflected contemporary life in a story about a pair of criminals during the Great Depression. *The Graduate* (1967) is another iconic youth movie of this period. Other directors working during this transformative time include Robert Altman,[7] Peter Bogdanovich (see note in Chapter 5), George Lucas,[8] Steven Spielberg,[9] Brian De Palma,[10] and Hal Ashby.[11] Content was more contemporary and production techniques were inspired by select old Hollywood filmmakers and European masters, but reimagined by the young directors.

Dennis Hopper tried for years to gain financing for *The Last Movie*, which would have been his first feature. At the end of the turbulent counterculture 1960s, a new generation was there to take over and make their own kind of movies in their own way. *Easy Rider* was a movie in which two men set out to bike across the country to find America—they found it, but didn't live to report back. *The Last Movie* was positioned to take on an even larger subject—the nature of filmmaking itself. *Easy Rider* was a low-budget **independent film** that made a lot of money, which gave Hopper the clout to make *The Last Movie*.

The early cuts of *The Last Movie* sported a more traditional form of storytelling. Then Alexandro Jodorowsky, a friend of Hopper's and the director of the infamous *El Topo* (1970), badgered Hopper to become more **experimental**. A reworked, disjointed presentation of the narrative took over the film, which led to its box office and critical failure but placed *The Last Movie* at the forefront of American **avant-garde** feature films—surprisingly, one released by Universal, a major studio.

The concept of a **film within a film** as a trope in *The Last Movie* goes back as far as *Mable's Dramatic Career* in 1913 and *Singin' in the Rain* (1952). The movie-within-a-movie trope would continue to be a part of American movies as seen more recently in *The Player* (1992), *Boogie Nights* (1997), *Ed Wood*

(1994), *Adaptation* (2003), and *The Disaster Artist* (2017). Most movies are a singular experience, a narrative that is designed to pull the viewer into the story so that they are not aware they are watching a movie. When the story involves the making of a movie, or part of another film is shown and inter-relates with the main story, the viewer becomes aware that they are watching a movie and are involved in the moviemaking process and how the content of one film informs the narrative of the other.

The Last Movie is also a **self-referential film** in company with *Behind the Screen* (1916), *Hellzapoppin'* (1941), *8½* (1963), *Contempt* (1963), and *Wes Craven's New Nightmare* (1994). Hopper wanted filmmaking itself to be part of the content. The moviemaking process is revealed and its effect on culture is examined. The film we are watching in *The Last Movie* is made up of three movies: a dramatic film, a Western, and one being shot with equipment that can't produce a tangible movie, another possible meaning for the title *The Last Movie*. Westerns were slowly dying after a long reign as a very popular American **genre**.

The story of *The Last Movie* is told in the **metafiction** tradition borrowed from literature, which occurs when an author points to the artificiality of a work or the departure from novelistic conventions. This inspired *Barton Fink* (1991), *Fargo* (1996), *Fight Club* (1999), and *Inception* (2010). Hopper takes the reality of making a Western movie and presents it as artificial by showing the mechanics of how it is made. It is the editing process that brings reality to the Western story, but this film remains unfinished to the viewer's eye. The disjointed editing of *The Last Movie* ridicules the continuity system that Hol-lywood lived by and fractures the dramatic reality of this film.

The title *The Last Movie* is controversial and provocative. Is Hopper saying this is the end of movies? Is the Western within the film the last movie? Has the cinema reached its end? Is it the end of movies and the beginning of cin-ema? There is no answer in the content of the film itself, but interpretation finds that Hopper was attempting to end film as we know it so it could be reborn in a new form. When *The Last Movie* failed so dramatically in the mar-ketplace and in the critics' circle, Dennis Hopper believed that this could be his last movie as a director.

The premise of *The Last Movie* is more than offbeat. An American Holly-wood cast and crew are in Peru to shoot a Western directed by **B-movie** master Sam Fuller of *I Shot Jesse James* (1949), *Run of the Arrow* (1957), and *40 Guns* (1957), who plays himself with bravado, almost stealing the picture. The production **wraps** and he and the cast and crew depart Peru fairly early in the film. The locals are inspired by the idea they should emulate the Americans and direct their own movie. They don't have movie equipment, so they build a camera, light stands, and other "equipment" out of bamboo. Light for night scenes is provided by torches held by the locals who comprise the crew. Kansas, played by Dennis Hopper, stays and lives with the

Peruvians who take moviemaking to a new and dangerous level, shooting their own film lit by fireworks.

Kansas is a professional Hollywood stuntman who worked with the Hollywood Western production. The "director" of the Peruvian production pulls Kansas into his project, and eventually Kansas is abused and beaten. The Peruvians believe the violence that happened to the Hollywood actors was real and apply reality as they shoot their film-within-a-film.

The Last Movie deliberately plays out as if it were a work in progress. There are **scene missing cards**, scratches, interruptions, and other physical examples of the elements of celluloid being cut together in progress. The viewer doesn't believe they are watching a finished film because what they know about watching movies is violated by the rewriting of the Hollywood rules.

Many movies have presented **cameos**, often just a few. Prior to shooting Hopper called up many of his friends to appear in the movie, actors who had been in television and movies, mainly Westerns—but the difference is in *The Last Movie* they are often shot in such a way the audience can't really identify them. A sample of the credits of this "unknown" cast includes: Rod Cameron (*Laramie*), Peter Fonda (*The Hired Hand*), Henry Jaglom (*Psych-Out*), James Mitchum (*Trackdown*), Michelle Phillips (*Dillinger*), Dean Stockwell (*Cattle Drive*), and Russ Tamblyn (*Many Rivers to Cross*).

The Western movie within *The Last Movie* is filled with references and subtext. James Dean is mentioned, as are the large cast of Western movie and television actors that refer to that genre and the celebrity of the actors, many of whom were fan favorites. There is little dialogue from most of these performers. Michelle Phillips from the Mamas and the Papas[12] is in the Western within the drama of *The Last Movie*.

Dennis Hopper spent much of his time working on *The Last Movie* abusing cocaine and hard liquor, much of the time cavorting with female companionship—this took a toll on his psyche and may have affected his directorial judgment.

The elliptical structure and self-conscious editing of *The Last Movie* that reflected Hopper's mindset at the time confused and angered audiences who saw it on first run. The run lasted little more than two weeks, and then the film was locked in a studio vault.

The Last Movie takes *Easy Rider* steps ahead in the dismantling of the traditional American movie. *The Last Movie* was an attempt to crash into the limits of cinema, and for that Hopper was punished for his vision, although perhaps he should have been commended for his dangerous ideas and attempting to expand the cinematic form.

Dennis Hopper was a **maverick filmmaker** who always wanted to push the creative cinematic mark further and further. Setting up in Taos, New Mexico, he went for the far fence with *The Last Movie*. The estimated $1,000,000 budget far exceeded *Easy Rider*, which cost an estimated

$400,000. *The Last Movie* was a monumental failure in part because of expectations built up after the success of *Easy Rider* and a narrative and cinematic structure that was too difficult for commercial audiences at the time. After *Easy Rider* a long successful directorial career was expected by many. Hopper made a great film that changed the way Hollywood would make films and market them to an under-30 audience, but few were ready for the complexities of *The Last Movie*. Dennis Hopper didn't see that coming.

After *The Last Movie* Dennis Hopper went back to acting and hoped to get another shot at directing. That didn't come until 1980 with *Out of the Blue* followed by *Colors* (1988), *Catchfire* (1990), *The Hot Spot* (1990), and his final film as a director, *Chasers* (1994), a service comedy nobody found funny. In later years Hopper said *The Last Movie* was ahead of its time and that audiences and critics were just beginning to understand his artistic vision. It was Hopper's hope to bring the film to new audiences on DVD, but he didn't realize his wishes when he died on May 29, 2010, at age 74.

Narrative and Cinematic Analysis

Black. A Spanish-speaking voice. Peruvian music—all played over the Universal Pictures logo. This technique would later become popular as a way of bringing the viewer into the film immediately instead of watching the studio logo and waiting for the movie to start. Here the audience was confounded, wondering if this was a foreign film rather than a very American one partly about the great American art form of the Western movie. A church. Kansas. A dark face. A Peruvian ritual. Padre (Tomas Milian). Bells. Flutes, harp, violins. A Peruvian director wears a sheriff's badge. Beeps, a self-referential trope signing this is a movie. A parade. Wooden statues of Jesus in crowns. Marching drums. Film equipment made of bamboo. A religious ceremony. A dead cowboy—discharged bullet casings. A movie microphone. A painted background. A movie church. A priest speaks to Kansas.

A bar. A stage—a man with a guitar sings. A woman with her hands on her skirt dances. **Slow motion.** A man on a horse is shot, possibly a reference to Sam Peckinpah's seminal *The Wild Bunch*, which made extensive use of people being shot in slow motion, often sitting on horses. A shootout in front of a saloon. A man in jail. Lots of people hit by gunfire. Many famous Western movie and television actors—not all are recognizable. The Banker's Daughter (Michelle Phillips) in a white dress comes to the aid of a cowboy who was hit. Someone yells out "Bitch" and shoots her.

"A Film by Dennis Hopper" credit comes 12 minutes into the picture. **Off-screen** the Minstrel Wrangler (Kris Kristofferson) sings his classic "Me and Bobby McGee." Sometime before the release of *The Last Movie*, the trade papers mentioned that Dennis Hopper would direct a movie called *Me and*

Bobby McGee. It was never made, and no substantive information about it was ever released.

Kansas, now clean, rides home. A Peruvian woman, Maria (Stella Garcia), a prostitute, stays with him. At a bar Kansas speaks about seeing movies as a child. Hopper tapped deeply into his own biography for this film. Michelle Phillips and others sing. Audiences knew Phillips for her work in the Mamas and the Papas, not as an actress. So here to those it is a performance moment, not just a character singing. Men and women are dancing 1960s style. A shootout outside. Camera noise heard. A woman holds a man who was shot. Kansas walks to the next room. Honky-tonk music. He goes outside. Native American music. Kansas is dressed in a suit jacket and black cowboy hat and holding a drink. Kris Kristofferson, now on camera outside, continues to sing his song. He says "Kansas, they're looking for you." The song continues.

Kansas rides into shot. Lights. Dolly to move camera. The director's name is Sam. Samuel Fuller seems to be playing himself by the way he portrays the director of the Western within *The Last Movie*. He shouts, "Forget it," a Sam Fuller way of saying let's move on to the next shot. Script Clerk (Sylvia Miles, an actress known for her outrageous behavior) is working on the set. Fuller wears a black hat with crossed metal rifles. Camera on tracks for a **tracking shot**. **Blood squibs** being placed on the bodies of the cowboy actors. Fuller fires a gun to signal a **take**. The film within the film wraps, and the production is over. Director Fuller gives a farewell speech to his cast and crew. He talks about hard terrain in Peru and that he will see them in Hollywood. This film within the film is fairly conventional, a Western shoot 'em up, a programmer made most likely for a B slot of a double bill following the A marquee film with big stars, again a reference to Fuller who made B movies.

The **main title** for *The Last Movie* comes in at 25 minutes, way past the Hollywood norm. This makes it a cold open, a scene or scenes that lead into the film, usually plot and action oriented, not convoluted as they are here. A field. Kansas and Maria are running and cavorting. The images for the making of the Hollywood film had a blue palette. This changes for other parts of the movie, which have a warm tonal base. A destroyed church. A man is shot and falls. Church bells. A hand is over a camera lens. This is done on some productions to wait for the action to start while film is rolling and setting up occurs. A man falls from a roof. A horse. Kansas driving a truck on a road. Mountains. Clouds.

A man is tied to the trunk of a car. A priest and people walk the street. Kansas and Maria on horseback. Killing in the streets. The movies have been here and had a negative influence on the behavior of the inhabitants. Two men go outside. Gunfire. Peruvian men are making a movie. Men run with torches. A bamboo camera. Moving torches to simulate movie lighting. The Peruvian director has Sam Fuller's hat on. Kansas talks to the director.

Kansas shows them how to throw a fake punch and tells them that the movies are not real. What is reality is a major theme in *The Last Movie*. Kansas knows how movies are made, but the Peruvians think they are real life. Padre tries to stop them. The director speaks in Spanish. **Flash cut** of sky. Kansas and Maria are naked under a waterfall. They make love on a rock. This isn't so much exploitive nudity and sex but for Hopper more to capture the lifestyle of the characters. Kids march with Padre. Kansas wears a white hat, which traditionally in American Westerns signals a good guy but, as in the Peckinpah movie, it isn't that simple. Maria sunbathes. Their discussion concerning her having nice things like a refrigerator is **intercut** with them continuing the same conversation indoors, an experiment in screen time. Kansas tells her he can get movies made in Peru, that people go to Mexico to make films but there's something special about Peru.

Kansas is with a friend who wants money. Two women are in the room. They order drinks for the two women. Lots of improvisation by the actors throughout the film. Kansas helps a woman put a fur coat on. Maria is treated badly and wants to go home. A car. Interior. Harry Anderson (Roy Engel) is paying for everything. A band. A scantily dressed dancer. People at tables. A stage. Western.

Backstage. A mirror on the ceiling. Two women make love as everyone watches. Kansas is very drunk. Kansas argues with the owner of the house of prostitution. Kansas slaps Maria. She has a black eye and facial bruises. Maria wants a fur coat. A man points his rifle at Kansas. He and Maria go into a room, and she gets a mink stole.

Mining gold. A rocky area. Donkeys and men. A smashing sound. Bamboo equipment to film Kansas. He is put in prison. Also in the prison is Art (James Mitchum, son of Hollywood legend Robert Mitchum, who had appeared in Westerns) who shoots a gun and is hit in the face with return fire. The Peruvian director has a script. Kansas on horseback. The crew has bamboo equipment. Shooting. Kansas is bleeding. In the house of prostitution a band plays—a woman dances. Kansas is drunk and slaps a woman. Guys grab him. Kansas is bloody and dirty in church. A baby is breastfeeding, and breast milk is squirted on Kansas. **Jump cuts** of Kansas lying on ground. He gets up. Maria dresses and is going to the fiesta.

Bird masks on bodies. Locals in hats singing. Torches. Trumpets. Drums. The Peruvian director talks to a crowd. He fires a gun like Sam Fuller. Fireworks on bamboo equipment. Night. They march Kansas off. Padre. A bamboo horse.

Maria goes to see Kansas in prison. He feels the Peruvians who are making the movie with bamboo equipment want him to kill him. She says it's just for fun. Kansas says the Padre told him it's a game. They argue. Maria goes home. Kansas wants to see Padre. The Peruvian director laughs. Padre drinks with Kansas. "I sinned, father." The Peruvians drag Kansas down the road

followed by bamboo equipment. A bamboo cross. Kansas sings "Hooray for Hollywood." Kansas runs and falls, apparently dead, then gets up. A banging sound similar or possibly the same to one in the *Easy Rider* drug sequence, reminiscent of a pile driver. It is heard several times in *The Last Movie*. Kansas falls and seemingly dies again. He gets up and makes a face to the camera. Scene missing card.

Slate. A man on a roof with a rifle. **Pan** up to a high platform. Cowboys from earlier. Two talking: "Would you know gold? Have you seen gold?" Kansas and a friend are under a tent at night with a campfire going. They talk about movies that have gold in them like *The Treasure of the Sierra Madre* (see Chapter 22). The gold theme goes back to the prospecting days of the Old West, but this is 1971, the year of the film's release, no information is given to document otherwise. Day. A building is on fire in the background. **Zoom** back. In the foreground people sit. Black. White. The word "End!" is scratched into the surface of the film, which makes it wiggle and look like it is part of an experimental film, most notably executed by Stan Brakhage, considered the most important in the field. "Filmed in Peru." The cast is listed in alphabetical order and the end credits roll.

Conclusion

The Last Movie embraces the rebellious spirit of America. If it had been as successful as *Easy Rider*, it could have had a lasting influence on American and global filmmaking. If it had been more available for home viewers or those who attend festivals and independent movie theaters, it could have inspired challenging work, but it was, and in some ways still is, too much of an experimental cinematic experience and too much of a departure from what audiences can comprehend. And maybe *that's* why it is named *The Last Movie*.

Notes

1. *Medic* was an American medical television drama that aired on NBC from 1954 to 1956. Created by its principal writer James E. Moser, it was the first doctor drama to focus on medical procedures. It featured Richard Boone as Dr. Konrad Styner, who introduced each episode and narrated them. At times he appeared in the show. It set the standards for the next decade of medical dramas on television.

2. James Dean (1931–1955) was an American actor who became an icon of teenage disillusionment and social estrangement. His other two films are *East of Eden* (1955) and *Giant* (1956). His early death by car crash further pushed him into cult status. He was a highly expressive actor whose expressions, delivery, and body in motion were distinctive and all his own.

3. Peter Fonda (1940–) is an American actor, the son of Henry Fonda and brother of Jane Fonda. He is an icon of the 1960s, cultivated through appearing in films produced by the King of the B's Roger Corman, who made exploitation films for a young demographic. His cult status developed out of his appearances in *The Wild Angels* (1966) and *The Trip* (1967).

4. Frank Capra (1897–1991) was an American film director, producer, and writer. His films include *It Happened One Night* (1934), *Mr. Smith Goes to Washington* (1939), and the iconic *It's a Wonderful Life* (1946). His films presented an idealized America with a positive spirit.

5. John Ford (1894–1973) was an American film director associated with the Western. His peers considered him the greatest director of all time. He also moved into other genres and adapted *The Grapes of Wrath* (1940) into a classic motion picture. He won a record four Academy Awards for directing. His films include *Stagecoach* (1939), *The Searchers* (1956), and *The Man Who Shot Liberty Valance* (1962).

6. Howard Hawks (1896–1977) was an American film director, producer, and screenwriter. Working in Hollywood Hawks spanned many genres, including Westerns, gangster films, science fiction, film noir, and comedies. He created what came to be known as the "Hawksian Woman," strong characters who stood up and stood alongside the male characters. His films include *Scarface* (1932), *Bringing Up Baby* (1938), *Only Angels Have Wings* (1939), *His Girl Friday* (1940), *To Have and Have Not* (1944), *The Big Sleep* (1948), *The Thing from Another World* (1941), and *Rio Bravo* (1959).

7. Robert Altman (1925–2006) was a very prolific American film director, screenwriter, and producer known for his extra-large casts and multiple storylines. His films include *McCabe & Mrs. Miller* (1971), *Nashville* (1975), and *Short Cuts* (1993). He had a subversive sensibility and covered a lot of different subjects over his career including the fashion industry, play adaptations, and health foods.

8. George Lucas (1944–) is an American film director, screenwriter, and entrepreneur. He created the *Star Wars* and *Indiana Jones* franchises as well as founded Lucasfilm and Industrial Light & Magic.

9. Steven Spielberg (1946–) is an American film director, producer, and screenwriter, one of the co-founders of DreamWorks Studio. He has had a very successful career in box office commercial hits and blockbusters, including *Jaws* (1975), *E. T. the Extraterrestrial* (1982), and *Jurassic Park* (1993).

10. Brian De Palma (1940–) is an American film director and screenwriter best known for psychological thriller, suspense, and crime films. Highly influenced by the work of Alfred Hitchcock, his films include *Carrie* (1976), *Dressed to Kill* (1980), and *The Untouchables* (1987).

11. Hal Ashby (1929–1988) was a film editor and director. His films include *Harold and Maude* (1971), *Being There* (1979), and *Bound for Glory* (1976). He had a hippie sensibility and lived a very un-Hollywood existence.

12. The Mamas and the Papas were an American folk rock vocal group that recorded and performed from 1965 to 1968. The group was composed of John

Phillips, Denny Doherty, Cass Elliot, and Michelle Phillips. Some of their hit songs include "California Dreaming" (1965), "Monday, Monday" (1966), and "I Saw Her Again" (1966).

For Further Study

Screen

The American Dreamer
The Artist
Coming Apart
Easy Rider
Fight Club

Read

Dennis Hopper: Interviews by Nick Dawson
Dennis Hopper: A Madness to His Method by Elena Rodriguez
Dennis Hopper & The New Hollywood by Mattheiu Orlean and Jean-Baptiste Thor
Dennis Hopper: The Wild Ride of a Hollywood Rebel by Peter L. Winkler
Hopper: A Journey into the American Dream by Tom Folsom

The Adult Film as Art Film

The Lickerish Quartet

Lickerish: Anglo-French. Mid-14th century. Lustful desires. To live in debauchery.

Radley Metzger began working primarily as a film editor in the 1950s. He cut trailers for Janus Films, which was a major distributor of foreign **art films**. Metzger's directorial debut was the drama *Dark Odyssey* in 1961, which he codirected with William Kyrikis for whom he was assistant director on *Guerilla Girl* (1953), a wartime thriller. In 1961 along with film distributor Ava Leighton they founded Audubon Films, which specialized in importing international features including adult erotic movies.

Metzger's second film as a director was *The Dirty Girls* (1965), which established him in the erotic film **genre**. *Therese and Isabelle* (1968) was a big hit in the United States, creating a strong market for softcore **adult films**. Metzger took himself seriously as a filmmaker and was quite a stylist of well-made movies.

An art film is an **independent film** in which the aesthetics are stressed and the content challenging, often **experimental** in nature. Film as an art without commercial gain as a goal. *The Lickerish Quartet* (1970) is a softcore adult film (in which the sex is simulated, not explicit, and the stories are a bit more developed than hardcore films) that is also an art film. This unique mixture of film styles challenges the viewer's perceptions of time, reality, and storytelling itself.

What makes *The Lickerish Quartet* worthy of evaluation is its ephemeral, elusive, and existential qualities that transform it into a complex maze of storytelling. Adult films rarely have much of a plot. The thin narrative is just there to set up and move the performers from one erotic scene to another. In contrast, *The Lickerish Quartet* has multiple narratives, and characters inside

and outside the story who change roles. Each of the four main characters has their own story, which interact with World War II timeline flashbacks. The black-and-white **stag film** that appears throughout *The Lickerish Quartet* is a **film within a film**—a movie inside the main movie that interrelates with most of the elements in the structure and keeps changing in action and who appears in it. This genre is called the **self-referential film**: the film relates to itself. The viewer is aware that they are watching two movies, but here the line between the two realities fades away early in *The Lickerish Quartet*. Metzger put in his own influences, and applied his vision to create a sub-genre, the softcore art film.

The production values of the main film, which is in color, are of high quality while the stag film, badly scratched from use, is deliberately created to appear of inferior quality. The editing is elegant in the main film, but made to appear abrupt and accidental in the second, characterized by its breaks and tears.

Before the 1970s men gathered together and screened very crude pornographic stag films. The name refers to the act of a man going to a place or event by himself, "going stag." They were also called *blue movies*. The context of the word *blue* refers to material that is indecent and profane. These films were made and distributed secretly in 8mm, Super 8mm, and 16mm. The quality of the performers and the productions were in the cinematic basement.

The Porno Chic movement films appeared in neighborhood theaters in the 1970s attended by husbands and wives or boyfriends and girlfriends. Later these titles were available on video cassette so couples could watch them at home. Although these films including *Deep Throat* (1972), *Behind the Green Door* (1972), and *The Devil in Miss Jones* (1973) were sexually explicit, unlike the older hardcore films they had an overriding concept and specific if simplistic storylines.

The Lickerish Quartet was based on the story *Hide and Seek* by Michael DeForrest, with the screenplay collaboration by DeForrest and Radley Metzger. The characters in *The Lickerish Quartet* are hiding from each other, about their past, and about who they really are. The film has intriguing characters, erotic action, and sharp, witty, dramatic dialogue dotted at times with sarcastic humor. Lines are repeated by characters; lines are repeated from one character to another. Some of the erotic scenes and moments are in color and appear to be happening in real time except when a character triggers a memory, or the director chooses to present the past that comes in the form of a black-and-white **flashback**. The scenes within the stag film change without explanation. While they watch the stag film a lot of questions are asked about how the film was made and who the players are, as we see shifting versions that at times include the family as participants themselves.

The Lickerish Quartet is an art film with a lavish location and production design, and flowing **tracking shots**. The music is ornate, almost baroque.

The film within a film replicates in detail, look, and style a classic stag film, but has a constantly altered reality.

Narrative and Cinematic Analysis

The Lickerish Quartet film opens with a card that says, ". . . all this present reality of yours—is fated to seem a mere illusion to you tomorrow . . . Pirandello. *Six Characters in Search of an Author.*" Luigi Pirandello's[1] landmark play examines the relationship between actors, author, and director. The selection of this quote to open *The Lickerish Quartet* sets the film's tone, which is, What is reality? Who are people when they claim to be one person and then another?

The sound of a projector. Gray film leader. Opening tropes to establish a film within a film is to begin. Scratches. A stag movie starts. Black-and-white. Throughout these segments the images will be in black-and-white, while all other shots and scenes are in color. A sexual encounter with a blonde woman (Silvana Venturelli) and a man. An **off-screen** male voice laughs. Pull back. A screen. A vase. Ornately decorated, large room. A woman's voice off-screen says, "It's only a film." Film jumps in a projector gate. A hand on a projector trying to stop the film from jumping. The wife (Erika Remberg) and the husband (Frank Wolff) are shown separately in **split-screen** with the other side of the screen a black field. This is to indicate there is a separation emotionally and physically between them. The son (Paolo Turco) is shown full screen complaining about the quality of the film. They start to argue. The film they are watching is now running smoothly. The sex scene continues. The family discusses whether the performers are really enjoying themselves or just faking, another trope that references the views of many people towards adult films. **Intercuts** of the sex scene, with color detail of a painting depicting a creature piercing a man's buttocks. This painting that depicts religious and sexual torture was created for the film by an artist selected by the art director Enrico Sabbatini. It seems inspired by *The Garden of Earthly Delights* painted by Hieronymus Bosch[2] from 1495 to 1505. The camera **pans** from the sex scene to a mechanical bird toy repeatedly dunking its beak in a glass of water, up and down, a funny and odd image with sexual connotations. A woman in a purple dress and shoes lying on a couch in partial view will later be revealed as a **flashforward**, which are presented in color. The stag film continues, heavily scratched. The woman opens a door and a man comes in. **Voice-over** of the husband and wife talking about how familiar she looks. The wife questions whether the husband has started in the right place, the film is all out of order. Time and the reliability of narrative structure are main themes in *The Lickerish Quartet*. The woman in the stag film takes a cork out of a wine bottle and puts it in her mouth. They both drink wine. Close-up of the bird toy moving up and down. The woman and man kiss.

A woman with streaked hair enters the stag film and meets the others. The wife wonders where they find girls to act in these films. The woman with streaked hair is now topless. The two women pull the man back and forth and he quickly kisses them. Voice-over, and a period shot (one that takes place in the past) possibly a **flashback** depicting a naked man and woman in bed. This is well photographed and not scratched. When these shots and scenes appear, they are in black-and-white. Stag film. Scratches. More sex-play. A man with dark glasses is revealed. Color detail of the painting—a frog is over a naked woman's crotch.

Close-up of the husband watching the movie. Flashback. An old brick building. The blonde woman from the stag film is in WWII period clothes and hair style. She is the same age as in the stag film, but she couldn't have been in the timeframe depicted here. Characters are beginning to appear in multiple identities, reflecting the Pirandello influence in *The Lickerish Quartet*. The wife feels that the girls in the film are probably prostitutes. She seems to be commenting on the stag film even though the blonde woman in the flashback appeared to be a prostitute, and later in other flashbacks it appears that the wife was a prostitute. The stag film continues. The two women have sex—a reference to *Therese and Isabelle*, an earlier Radley Metzger movie about a lesbian relationship, is mentioned. The husband watches the film. The split-screen technique with the black field continues for the husband and wife, but not the son who reacts with disdain indicating that he doesn't want much to do with his parents. The family continues to comment on the silent stag movie.

Full shot of the large and ornate room. The camera moves behind the movie screen, revealing where the family is positioned. Full shot. The son announces he's had enough and starts to storm out of the room. The husband says he'll run the film in high speed and reverse. They argue. The son makes a snide remark about the husband's need for control. The husband laughs as he puts the film into high speed and reverse. Everyone leaves the room. The camera swings behind the screen. The image drains from color to black-and-white.

The credits begin. Black-and-white. Steps. A hall. Baroque, Euro-rock music. The family puts on their coats and leaves. They walk out and off grounds. Two white painted arrows on a rock point to the other. Dusk. Full shot of the castle where the action so far has taken place.

Color. Night. A carnival. Bumper cars, pan to the family walking. A Wall of Death attraction. The family watches from above as the performers ride motorcycles around a circular wooden structure. Applause. A woman rides simultaneously with another rider. Three riders ride around the Wall of Death. **Point-of-view** of the riders. Objective angle as they ride up to the top and thrust their arms out. All three ride their motorcycles around the barrel-shaped structure in synchronization. Clapping. Pan from below looking up.

They take off their helmets. The woman is a redhead—the family recognizes her from the stag movie. The woman rider takes a bow, turns her head, and seems to look up at the son as he looks down in the same **eyeline match**. Stag film. The blonde woman is clapping. Color. The family discusses whether the redheaded motorcycle rider is the same person as the blonde woman in the stag film. The wife and son are not sure; the husband seems sure. They walk to where the motorcycle rider is cleaning her bike. Flashforward of the family walking on the road to their castle with the woman. Metzger constantly shifts back and forth in time to create a narrative in which anything can happen at any moment. Back to present time. The husband suggests a private showing of the stag film, believing she is the star. He leaves them. The son tells his mother it isn't the same girl; he's going to make a fool out of himself.

Flashforward. Inside the castle on the steps, the husband and wife walk with the motorcycle rider who is still in her white uniform. The son is way behind them. The husband tells her how much he and his wife enjoyed her performance. She says he looks like a man who has had adventures. He intimates that they are going to have an adventure. Outside. They walk together. She tells him she's not having an adventure. He pursues the idea with her.

Quick cut. Flashback. A man falling down steps—clean photography, no scratches. Color. The woman from the carnival agrees to go with the husband. Color. Evening. Exterior of the castle. Interior. The woman from the carnival walks around the room. The husband sees stacks of film cans. Black-and-white—flash of the stag film: the blonde woman is having sex with the man. Color. The husband turns around to look at the woman from the carnival. Flashback. The woman from the carnival is dressed in period clothes and hairstyle. A shot of a WWII-era old building, all as before. The husband says there is something about her that is familiar. The wife comes into room and tries to find out where they may have met—so does the husband. The woman from the carnival says no to their suggestions. He brings up WWII. The woman sits on a round table. The son is sitting on a couch in the background. The husband says at times he feels like 150. The woman replies that she is 155 years old.

A shot of a younger man by a projector. This will turn out to be a flashforward. Back to the woman standing at the two doors. Flashforward. A woman in purple dress and shoes reclining, as earlier.

The woman from the carnival asks, "Who has the gun?" No one understands what she means. A later scene makes it seem she knows the conclusion of the period sequence. Black-and-white—a gun firing. A man falling down stairs. Color. The husband says there isn't going to be a shooting, and the woman says, "Of course there is."

The son rings a loud gong and introduces the stage show. He puts on flamboyant makeup. The husband and wife discuss that the woman from the

carnival should be in the movies, but she is defensive. The wife makes reference to the woman's body, who replies, "What do you know about my body?" The wife suggests showing a film. A flash of red. The son enters dressed as a magician and makes fire appear. He then makes a deck of cards disappear. The husband is irritated. The wife says he was a precocious child, and she couldn't let him out of her sight. The husband says the boy had the best education; he couldn't have done more for him if he was his own son. The woman wants to see more magic, something spectacular. The son covers her in a cape and tells the husband to start the projection. The lights go off. The stag movie is projected on them. He drops the cape and the woman is gone. The son laughs. The stag movie is still running while the wife and husband look for her.

Exterior: the castle at night. They search for the woman. A series of shots include intercutting of the search with torches, and shadow play on the screen. Now it is shadow play with two hands. Two shots of the boy and the woman playing hand puppets in front of the projector bulb. The wife and husband come in from opposite entrances, still holding their torches. They want to watch the film. The woman is looking forward to it. The son says no, it's filth; they use it to get worked up because they can't do anything else. The son and husband verbally fight. The wife talks about the son's vision of Saint Margaret when he was three, tormented, tortured. A detail of Saint Margaret is shown from the painting. After, he cried in his room for days. The husband doesn't believe the boy. Black-and-white flashback to a hand opening a door, not scratched. The wife says her husband doesn't understand this. The husband starts the projector. The son looks upset. A shot of the woman in the purple dress and shoes as before. The stag movie plays. Wide shot of the women on couches watching the movie—the husband stands next to the projector. This is a **dolly shot** that stays on them and moves to the other side of the room. Stag film. A blonde woman gets up, walks to the door and lets a man in. Her face is hidden by her long hair. The wife now thinks it will be revealed that their guest is the performer in the film. They sit down on a couch. Color. The woman turns and looks at the wife. The wife turns and looks at her, making several nervous expressions. Stag film—the blonde woman pulls a cork from a wine bottle with her teeth. She pours him a drink. Color. Camera on the son watching from the back. Stag film. A man takes off his shirt. She takes off her clothes. Her face is still hidden. They kiss and go into an embrace. Color. The wife watching the film. Stag film. Color. The husband looks puzzled. The bird toy. The woman with streaked hair takes off her shirt. Shots of wife and husband looking confused and in disbelief. The stag film is different than before. Color. The wife and husband look at each other; the camera pans to the woman from the carnival who is watching the screen. Color. The wife looks distressed. Stag film. Color. The woman from the carnival watching the movie, **rack focus** to husband behind her looking at her.

Flashback. A WWII soldier approaches the blonde woman from the carnival dressed in period garb. Back to the rack focus shot—the husband is in focus, while the woman from the carnival is in the foreground out of focus. This technique guides the viewer to who the director wants to see on the screen and informs them what is going on in the minds of the characters. Stag film. Focus on the wife watching the film nervously, rack focus to the woman watching her. Stag film. Rack focus shot as before. The woman asks the wife if the son really saw Saint Margaret. The wife doesn't know. Voice-over of husband being snide about it. The wife says it was her son's vision. Shot of the son with three paintings behind him depicting the trials of Saint Margaret. He says he did see her. A painting detail of a creature biting someone's head. Black-and-white. Flashback: hand opening a door. A shot of a woman bent over a man's body. Details of a painting. Surrealistic. Sexual imagery. The paintings capture a primal and violent world. Voice-over of the vision described by the son. A naked woman with a frog–like creature covering her between the legs. Stag film. Intercut of painting details, Stag film. Close-up of the woman from the carnival. Stag film. A figure hanging from a bare tree. A dragon-like creature. Stag film. Painting detail. The son finishes his story and starts to take his makeup off. Then a visual connection between violence towards Saint Margaret and sex acts on screen from the stag film. The wife questions whether the son made it all up to get attention.

The projector is shut off. "Can't be same film." The woman asks about where they find the women to make the films. This is a repeat of a line the wife said earlier that links the two characters who eventually both appear in the stag film. This seems to be an answer to their question, but complexities will continue. In *The Lickerish Quartet* the more you know, the less you really do because of contradictory information and the Pirandello idea that characters are in search for who they are. Running the film backwards is blamed for the film being altered. The woman wants to leave. The husband says he'll get it right. The stag film starts again. A blonde woman turns and starts to reveal her face. Close-ups of husband and wife surprised. Stag film. It is a different woman than the woman from the carnival. The son laughs. He is next to a mirror with many round ones that reflect many images, a symbol for the myriad aspects of the characters on and off the screen. Stag film. The husband stares at the screen in disbelief. Stag film. This new woman who appears to be blonde sits on a bed. The husband is frustrated. The wife and woman turn to him. The woman says she has never seen a film like this before, a comment referencing Radley Metzger telling the viewer what he is presenting here has not been achieved in any other movie. Both wife and husband admit they were mistaken about the woman being in the stag film. The woman decides to stay over. She is shown to a room. She looks in a reflecting surface with many little mirrors, seeing her reflection many, many times over—another sign of the prismatic quality to this film. She takes off her red wig,

revealing her identity as the blonde woman in the original stag film, and laughs. Identity is a significant theme in *The Lickerish Quartet.*

Exterior. Day. Montage of the sweeping property. The husband is out walking and sees the woman. Flashback. A soldier comes out of a stone building carrying a rifle. Color. The husband continues to walk, looking for the woman as the sound of gun shots from the flashback continue. Flashback. The blonde woman in the period scene. The soldier with the rifle walks away. Color. The husband finds the blonde woman; the gun shots fade off. He notices that her hair is a different color. Cut to a finger on a projector button. It's pressed and the husband walking towards the woman and talking to her is rewound, plays in black-and-white, then replayed with the same dialogue. He talks to her. Color. They continue the conversation. Black-and-white. This is a daring artistic moment. It is a more direct trope that this is a movie the viewer is watching. The reality and sense of time are challenged, and the manipulation of the film speed in a so-called realistic scene is related to the husband altering the projection speed of the stag movie. Flashback. The soldier gives cigarettes to the blonde woman in the period scene. She accepts the cigarettes and takes the soldier inside her place. Color. The husband and woman walk and talk around the castle. The wife looks down on them. The son looks out at them—both are watching from above.

Black-and-white period scene. The blonde woman's room as she walks in the door. Color. Present. The wife is looking down to the husband and woman going inside. Black-and-white period scene. The soldier puts down his rifle and takes off his helmet. He approaches and kisses her; she quickly pulls back. He throws a number of chocolate bars on her bed. She takes off her blouse. He turns his back to her, then turns around, but now it is not that same solider but the husband dressed as a WWII soldier. Now the flashback has more validity because the husband is of age to have been in the war, triggering thoughts of whether this is now his story.

Color. Library. The woman climbs up the bookshelf ladder. The husband pushes the ladder, which swings her across the room. She throws books down to the floor. There are many old pistols on a shelf. He throws books to the floor. He pushes the ladder again, and she swings around to the other side. They throw books at each other. He talks about his wife's son. He says that his story about Saint Margaret can't possibly be real, another example of the unreliability of what characters say in the film and the questioning of the film's sense of shifting reality. The husband tries to give her the impression that he is an aggressor sexually. The floor has a sex dictionary printed onto it. He speaks to her lovingly. She abruptly turns around and denies making films. She talks about memory; he says she's "terribly young." She says again that she is 155 years old; she said this to deepen the mystery concerning who she is and how the family perceives her. She says she is a virgin. He doesn't believe that, and she says, "Don't you want to be the first man?" He is kissing

her neck. They undress. He says his wife thinks he is impotent. She says she doesn't think he's impotent. This is reflective of the difficult relationship the wife and the husband have. The blonde woman turns her head and sees a gun on a book. Black-and-white. A pistol fires several times. Color. He comes closer to her and says he has a heart condition. Black-and-white. A gun fires several times and an unidentified man falls down the steps. The gun and the gunshots serve two purposes: they are a part of the murder mystery within the film and a comment on the erotic activity. Color. The husband lays on the floor, which is covered with sex words with dictionary definitions. The sex words are intercut with them as they roll around the floor making love.

Exterior of the castle. Several views. Zoom back to the upper level. The son is there leaning against a slab of stone. The woman approaches him and they talk. She thought he was avoiding her. He says he thought they understood each other better than that.

The husband and wife are at a fountain. He says they were mistaken, it's not the same girl—this girl is a virgin. He tells his wife the library is a mess, sending her the message he had sex with the blonde woman. The wife mocks the woman's virginity and his virility. The wife says she is the same girl, that she recognized her the minute she saw her. Color flashback. The carnival. The woman then with red hair taking off her motorcycle helmet. Back to scene. The husband walks away.

The woman and the son talk. Stag movie. The other blonde woman pulls out a cork from a bottle with her teeth. Color. Back to their conversation. She says what happens to a woman in a film doesn't really happen to her. The son says watching the movie is "too real." She says, "That's the best part." This is an unreliable moment. The woman is saying first that she is not in that film. He seems to believe it's her and real, then she affirms that reality. Keeping the viewer guessing is a main strategy in *The Lickerish Quartet*.

Flash cut to the son and the woman having sex standing up in a field in a very wide shot. Back to real time. The son and woman staring into each other's eyes. Cut to both of them making love as before. Black-and-white flashback to WWII. A couple naked on a bed. The door opens. Someone is about to come into the room. Color. The son in the screening room; he walks and then turns. Black-and-white flashback of the couple on the bed as before. The woman comes into the screening room. They stare at each other for a long time. Cut to the son and woman in the field as before. Back to scene, they continue to stare at each other. She walks towards him. They come together, he pulls away from her, and they move back together. They dance Bossa Nova style. He runs up the steps; she follows him. Bossa Nova music. They run outside. She continues to dance. He swings from a tree branch. The sun pulsates. They dance. The son takes his shirt off. The music ends. This proto–music video sequence is yet another filmic style presented by Metzger. *The Lickerish Quartet* can be seen as a compendium of genres and

cinematic modes. They undress and move to each other. They kiss. Intercut of a painting. They lie in the grass. They kiss. The sun comes through the trees, a shot often seen in films of this era, connotating beauty and sensuality. Close shot—she gets up and hugs a tree. A painting detail of sexual torture. The relationship between lovemaking and the violent images seem to be the dark emotions the son has from his vision that is always with him. Music comes back in. Zoom in on him on top of her as they continue to make love. Stag film. A blonde woman and a man on top of her—this is from the revised version. Color. They continue their encounter. The **zoom lens** and the application of changing image sizes heighten the actions. Flashforward. A shot of the man in front of projector, as earlier. Projector light beam—sun. Pull back from close to far as they lay on each other in the grass.

Exterior of the castle. Pan down from the top of the building to the husband walking out of a door. He walks down the road. The wife is hiding behind a stone shape. He passes the stone structure she is hiding behind and sits down. She says the blonde woman is just a carnival tramp. Husband says, "It takes one to know one." He brings up where he met her. She retorts as to whether he is ready to hear that. Flashback. The husband as a WWII soldier in a room as earlier. Color. The wife gives him an elaborate recall as to how they met. She says it was at an elegant party in San Tropez right after the war. The town had been badly damaged. She had just come back from school in Switzerland. She knew his sister. The husband doesn't agree. He asks her to explain her son, who he calls "The Boy Wonder." She won't explain him. The husband turns and walks off; she follows him. They stop. He describes the bad conditions he found her in. She slaps him. He turns her around and says, "So we've all seen some bad times." She pulls away from him and walks away. She goes inside the castle and puts herself into an old prison. He finds her. They talk from between the bars. He says she was desperate, and she denies the charge. Black-and-white. Flashback. Close-up of a soldier's hands as he gives cigarettes to the hand of a woman. Color. The wife breaks a wine bottle on the prison bars, splashing him on the face. She says sex has always been a discomfort to her but she tried to enjoy it for the sake of their marriage. She says she felt intimacy was his right and privilege. She rejoiced at the onset of his impotency. He denies it and says he has a bad heart. She ridicules that he says it forces him to have sex slow and easy. He says the woman says he isn't impotent. She says she's lying just to please him; all whores are notorious liars. Husband says he found her in a whorehouse, sick, starving, and if it weren't for him she and the boy both would have died. They exchange snide remarks. She asks if he had sex with the woman. Again he remarks that the blonde woman is not a virgin. This elaborate scene presents backstory that reveals a part of their lives that may have little connection with their current elegant lifestyle, but it goes beneath the veneer of what has been presented earlier, deep into how their relationship reflects their perceptions towards the

stag film and what may have really happened between them during World War II. In a commentary track on the DVD Metzger slyly sidesteps all questions about the reality of the film's story and leaves it up to the viewer's perceptions of how *The Lickerish Quartet* unfolds. Clues to the narrative and characters constantly unfold throughout the film; putting them together after screening can be as intriguing as watching it.

A screening room. The wife enters. She presses a switch to bring the lights down. Her shadow is on the screen. She starts the projector and runs the stag film. On the screen the image is out of focus, then sharpens. A hand is being secured to a bed. Color. The wife is watching the screen. A sex scene involving the blonde woman and the woman with streaked hair occurs. Shot on the projector running the movie, and the camera pulls back to reveal the wife watching the screen. Stag movie. Color. Wide shot of the wife watching the stag film. The woman comes into the room, her hair is done up in a French knot. She walks behind the screen and approaches the wife. Stag film. Full shot as erotic action continues. Color. The blonde woman stands behind the couch as the wife continues to watch the film. Stag film full frame. The woman sits on the top edge of the couch. The wife says she hasn't experienced many tender moments. They both are looking towards the screen. The woman asks the wife to tell her about herself. Stag film. The erotic action continues. Color. Two shot. The wife tells the woman she ran away from home when she was 13 and joined the circus, a bargain basement production with fake freaks. She says she wasn't especially good at anything. One morning she found she was pregnant; all of this was before she met her husband. The two women sit very close to each other. Things got worse, the wife continues to explain. It doesn't matter what she did, but when things are bad one tries to get by somehow. Stag movie. Color. The camera moves, adjusting the composition until both women are looking at each other and the projector light shines brightly between them. They kiss, blocking that light. Projector.

Pyramid objects on a table next to the drinking bird toy. This object goes back to at least 1945. The movement of the bird from upright to over and dipping its beak in a class of liquid is driven by heat and is sometimes mistakenly given as an example of perpetual motion, and that is exploited for that nature here. This bird toy has been seen in many television shows and movies including *The Simpsons*, *Alien: Covenant*, and *When Harry Met Sally*. Metzger's use of it is both exploitive and curious.

Clothes on the floor. The woman in the purple dress and shoes reclines on a couch, later revealed as a flashforward. The camera moves down to the wife and woman kissing and touching. Stag film. Color. They are holding each other. The wife suddenly gets up. She is naked and walks to the screen as the stag film is projected on the back of her body. She turns to the woman and says, "Who are you anyway?" Voice-over—she says she is the girl from the

carnival and reminds her she was brought back here for a party. Stag film. Color. Back on the couch, they are very close together and intimate. Stag movie. Full shot on the screen. Woman's hand on her back. The camera then reveals that the woman in the stag film is the wife.

Stag film. A woman's hand is on the back of a man who is on top of her. Color. It is implied that the woman intimately touches the wife. Stag film. The man the woman in the stag film is having sex with appears to be the husband. As the woman and the wife continue their rendezvous, they are also watching the film. Stag movie. The husband and the wife continue their erotic interlude. Intercut from the erotic activity between the two women to the erotic action in the stag movie between the wife and the husband. The wife has a climax in both scenes. Cut from the stag film to the wife on the couch with the husband. They are both watching the screen.

Stag film. The husband and wife make love. The images are heavily scratched. Voice–over—she cryptically refers to mental illness caused by lack of vitamins for the boy but also fantasy. The husband and wife continue to make love in the stag film. The room is the same as earlier. Intercut three shots of the boy opening the door with several shots of the husband and wife in bed making love, all which are without scratches. The son sees his mother in bed with a strange soldier, which later may have an impact on the relationship between the son and stepfather. Also intercut are color shots of the boy in the present watching the screen and the painting. It can be assumed that the boy in the film is the son based on how the scene unfolds, but it is never totally substantiated, another layer of perceived reality.

Color. Two shot of husband and wife. The husband says, "God knows who his father was," and she says "Yes." Black-and-white. Another man runs up steps to the room. This is scratched like the stag film. Inside a room. The couple hears him and turns. The man enters the room with a knife. Color. Repeat of the woman from the carnival saying, "Who has the gun?" Because of the connective editing it appears that the woman knew what had happened, but again there is no evidence of this. Metzger's sense of altered and shifting realities presents a filmic puzzle with many pieces and cinematic elements. Black-and-white. Scratched film. The man in the bed who is the husband shoots the man who has entered the room several times with a pistol. The shot of the gun firing in close-up is the same as it was earlier. The wife reacts. Color. The man is badly shot and falls down the steps. Back to a two shot of the husband and wife watching the screen. He turns off the projector.

There is a discussion between the husband, wife, and son that sums up the major theme in *The Lickerish Quartet*—the elusive nature of change as life unfolds. The wife says that things don't stay the same from one moment to the next, that things change. The husband asks where this all leaves them,

and the wife says, "in the dark," allusions to watching a movie and searching for one's true identity. It's where they all began and leave off. In between is a game of hide and seek. She leans on the husband's shoulder. The camera moves behind screen. The son runs out of the room and down the steps to find the woman. He is now running with her on a path. Now he is looking for the woman in a grass and tree area. He is alone. Another angle—he goes to the tree where they had their erotic encounter earlier. Flashback of him and the woman physically engaged. Alone, he sits on the grass. The sequence has been about his memory and how much he wants to be with her again. Zoom up to castle.

A blonde woman in the black-and-white stag movie is on screen in the main room. She claps and then bounces happily. The man with dark glasses comes out from behind her on the bed. Color. Another couple does also. The woman with the purple dress and shoes reclining on the couch as earlier. Stag film. The two have sex. Color. The man is next to the projector as earlier but now in present time. Voices talk over stag film images about the performers and whether they are enjoying it. The conversation is similar to the opening of the film when the family first watches the stag movie. Stag movie. Two women making love. Voice-over, a repeat of the earlier line about *Therese and Isabelle* referencing the earlier Radley Metzger softcore movie. The man is in front of the projector.

Color. Pan to the woman in the purple dress and shoes, reclining on a couch. She is blonde and was possibly in the stag film, but that is unclear. "It's only a film." Voice-over: "A double feature at that." Color. The man in front of the projector. He's wearing a tuxedo; everyone in this scene is well dressed. Cut to the woman with streaked hair now seen in color and now a different character. She didn't like the film much. Someone says these films are all alike, and another says that this one is different, a comment addressing the entire movie the viewer is watching. The man in the dark glasses was seen in the stag film but now seen in color and as a different character. He wonders where they get the girls. The exchanges are similar to earlier. "Prostitutes probably." Stag film. The bird toy going up and down to the water. There are several breaks in the film causing **jump cuts**—the camera pans over to a bed. The husband and wife are having sex; this is scratched. They look the age they were for the color scenes in the film. Intercuts between the stag movie and those watching it. Some have seen enough. The man running the projector talks about running it high speed and backwards. He now appears not to be the son when older but one of the stag film performers. The woman in the purple dress responds sarcastically. Everyone gets up. Full shot. Talk about not being late, the last time it goes on is midnight. Are they talking about going to a movie? This movie? Why so dressed up? Then it is said it will be a surprise, maybe a reference to the carnival daredevil show. They all leave the frame, and the camera moves around to the back of the movie screen. Then

the projector goes on by itself. It runs, but the viewer only hears the sound of the projector operating and sees the light flickering from its bulb. End. The Pirandello aspect of *The Lickerish Quartet* has come full circle. There are some answers and maybe more questions about identity and reality. Radley Metzger has taken the soft core form and turned it into his art.

Conclusion

The Lickerish Quartet is a brave voyage into a new kind of art film, a new kind of adult film. The story, characters, the inventive film within a film, and flashbacks create a film with European tendencies. It is an erotic film that transcends the genre through aesthetics, narrative, and structure.

Notes

1. Luigi Pirandello (1869–1936) was a playwright, novelist, poet, and short-story writer who won the Nobel Prize for Literature in 1934. His plays are seen as forerunners to the Theatre of the Absurd movement. His works were magical and unfolded as if they were a psychological analysis. His plays include *So It Is (If You Think So)* (1917), *The Man with the Flower in His Mouth* (1923), and *Diana and Tuda* (1927).

2. Hieronymus Bosch (1450–1516) was a Dutch/Netherlandish draughtsman and painter from Brabant. His work is known for fantastic imagery, detailed landscapes, religious concepts, and narratives. His most acclaimed work is the triptych altarpiece *The Garden of Earthly Delights*.

For Further Study

Screen

Camille 2000
Carmen, Baby
The Private Afternoons of Pamela Mann
Score
Therese and Isabelle

Read

Big Bosoms and Square Jaws: The Biography of Russ Meyer, The King of the Sex Film by Jimmy McDonough
Black and White and Blue: Adult Cinema from the Victorian Age to the VCR by Dave Thompson

Cinema Sewer Volume 4: The Adults Only Guide to History's Sickest and Sexiest Movies! by Robin Bougie

The Other Hollywood: The Uncensored Oral History of the Porn Film Industry by Legs McNeil

Raw Talent: The Adult Film Industry as Seen by Its Most Popular Male Star by Jerry Butler

Birth of the Independent Cinema

Little Fugitive

After his mom must suddenly leave home to tend to her sick mother, a young boy is tricked into believing he has shot and killed his older brother. The little one runs off by himself and spends a long day at New York's Coney Island beach and boardwalk. At the end of the day, a man who runs a pony ride realizes something is wrong, finds out the boy's telephone number, and phones his brother, who comes and brings him home before their mother arrives, with the boy's grandmother now feeling better.

The Little Fugitive is a landmark **independent film** released in 1953, written and directed by Ray Ashley, Morris Engel, and Ruth Orkin. Ashley's birth name was Raymond Abrashkin. He taught in New York City schools, and his writing career began as the education editor for the liberal-leaning *PM Newspaper*. He wrote the syndicated comic strip *Timmy* and served in the United States Maritime Service on supply ships.

Morris Engel joined the Photo League[1] in 1936 and had his first photographic exhibition in 1939 at the New School for Social Research.[2] He worked briefly for *PM Newspaper* and joined the Navy, where he was a combat photographer from 1941 to 1946 during World War II. After the war he taught workshop classes at the Photo League and was co-chair of a group that analyzed postwar labor issues.

At age 10 Ruth Orkin received her first camera and began taking pictures of her friends and teachers. She briefly attended Los Angeles City College for photojournalism in 1940 and then became a messenger at MGM studios in 1941. She left because there was a practice of not hiring women as

cinematographers. She joined the Women's Auxiliary Army Corps during WWII in an attempt to gain filmmaking skills as the group promised. This did not happen, and Orkin was discharged in 1943. In that year Orkin moved to New York City to become a freelance photojournalist. In 1945 she received an assignment from the *New York Times* to photograph Leonard Bernstein. Her career grew and she got assignments for *Life*, *Look*, *Ladies Home Journal*, and other publications. She was a member of the Photo League and married fellow member Morris Engel in 1952.

The independent film, currently also known as an indie, began in 1908 when Thomas Edison's[3] Trust had a monopoly over the movie industry. A number of companies refused to join the trust and became known as independents. D. W. Griffith (see note in Chapter 6), who directed for the Biograph Company, started in New York and was independent. The operation eventually moved to Hollywood where the major studios were forming. In 1919 the first major independent studio was formed. United Artists was put together by Mary Pickford,[4] D. W. Griffith, Charlie Chaplin,[5] and Douglas Fairbanks.[6] In 1941 the Society of Independent Motion Picture Producers was formed to protect the rights of filmmakers from the overwhelming control of the studio system. The original members were Orson Welles (see Chapter 5), Mary Pickford, Charlie Chaplin, Walt Disney,[7] Samuel Goldwyn,[8] David O. Selznick,[9] Alexander Korda,[10] and Walter Wanger.[11] **Low-budget films** made with new lightweight equipment began to appear, including *Meshes of the Afternoon* (1943) by Maya Deren,[12] *Fireworks* (1947) by Kenneth Anger,[13] and *Little Fugitive* in 1953. In 1962 the Film-Maker's Cooperative was formed as an artist-run nonprofit organization headed by Jonas Mekas,[14] Stan Brakhage,[15] Shirley Clarke,[16] Gregory Markopoulos,[17] and others. Roger Corman[18] was behind a slew of **exploitation films** that were not bound by the production code that restricted content in studio films. With the success of *Easy Rider* (1969), produced by Peter Fonda, directed by Dennis Hopper, and starring both men (see Chapter 10), the **American New Wave** of independent films, some distributed by the major studios, saw the rise of those from film schools and other untraditional means during the 1970s. These filmmakers with distinctive visions include Francis Ford Coppola (see note in Chapter 3), Martin Scorsese (see note in Chapter 3), George Lucas (see note in Chapter 10), Steven Spielberg (see note in Chapter 10), Brian De Palma (see note in Chapter 10), Peter Bogdanovich (see note in Chapter 5). John Waters,[19] and David Lynch (see Chapter 4). The **cinema of transgression movement** were films that used shock and humor, created on Super 8mm. In 1978 the Sundance Institute was founded by Sterling Van Wagenen and Charles Gary Allison with chairman Robert Redford. They promoted and exhibited independent films with a goal to show the wide range of burgeoning independent movies. In the 1990s independent films and filmmaking had come of age. Actors were

lending their talents to indies as well as studio films. *Teenage Mutant Ninja Turtles* (1990) from New Line Cinema grossed $200 million, making it the most successful independent film to date. Miramax put out *Sex, Lies, and Videotape* (1989), *My Left Foot* (1990), and *Clerks* (1994). The studios got involved and created their own boutique independent film studios: Sony Pictures Classics, Fox Searchlight Pictures, Paramount Vantage, and Warner Independent Pictures. The art house theater was a venue for independent films. Then there was the rise of Castle Rock, Turner Entertainment, TriStar Pictures, Hollywood Pictures, Lucasfilm, and Five and Two Pictures as well as many others. Where once Hollywood was the only place to make a movie, those with some or no training were empowered to make a movie—independently.

The important contribution that independent films made to cinema was to present a new kind of narrative. Hollywood movies stress entertainment and stories that speak to the widest demographic. Independent films project the voice of the person who wrote and/or directed it. Content in an independent film is personal and more wide ranging than in commercial films. Independent films are more inclusive in terms of race and sexual identity and often feature people who are more real than do the beauty-oriented Hollywood films. Independent films have explored unknown and known worlds that audiences can relate to.

The Little Fugitive was a breath of fresh air when it appeared on the movie scene in 1953. It showed middle-class life at the time, explored the wonders of Coney Island, and was filmed and acted in a naturalistic style. The **handheld camera** work and the **documentary** technique along with the endearing performance of the boys was refreshing when compared with the staid content and look of many Hollywood films at the time.

Francois Truffaut (see note in Chapter 3) stated that Morris Engel and his films gave his colleagues Jean-Luc Godard (see Chapter 3), Alain Resnais (see Chapter 8), and others the inspiration to create the **French New Wave**, which in itself inspired many young American filmmakers in the 1970s.

Narrative and Cinematic Analysis

Little Fugitive is about Joey Norton, a seven-year-old boy played by Richie Andrusco, and his adventures at Coney Island, the legendary amusement park. Chalk on a sidewalk. Lenny Norton (Richard Brewster) is the big brother. Joey is the little brother. Lenny is a good ball player and a good harmonica player. They switch **voice-overs** at the beginning. A harmonica is heard on the soundtrack. The score, which features the adroit harmonica performance by Eddie Manson, is as pure and direct as the cinematography that follows the exploits of the boys throughout the film. It speaks of Americana and a simpler time as well as providing sonic narrative assistance to

the story. Lenny and his friends play stickball. Harmonica. "Home on the Range" is played. Lenny is given money for his upcoming birthday. In their apartment their mother (Winifred Cushing) is on the phone. Grandma is very sick, she tells the boys. She is leaving on the two o'clock train to be with her. She tells Lenny to take care of Joey. The boys have franks and beans for lunch, a 1950s staple for children. Everyday life is shown in anticipation of a wistful drama that is going to unfold. Mother in voice-over. Their neighbor is home if anything happens. Harmonica. Mother leaves money for the boys. She exits. Lenny washes the dishes. Joey makes a crayon birthday card for Lenny and wraps a present in it. He gives it to him, and Lenny says "Drop dead." This is delivered as normal friction between brothers. Lenny will go through a major change towards his brother as events unfold. Love between brothers and family is one of the themes in *Little Fugitive*.

Lenny talks with friends about how to get rid of Joey. Summer. Joey in a backlot. A friend has a rifle. The friend helps Joey hold the gun, and puts in a bullet. Joey squeezes the trigger, and the shot hits Lenny. You shot your brother! Ketchup on T-shirt. Take it on the lam. The friend gives Joey Lenny's harmonica to remember him by. This situation moves the story in a dramatic and poignant direction. Mother calls home from train station. Joey doesn't answer, takes the money she left, and goes out the window. Joey is on the train. Lenny is back in apartment looking for Joey and sees that the money is gone.

Joey arrives at Coney Island. A perfect setting because Joey sees the legendary amusement park and beach as a new world of fun and distraction. Engel had a special camera rig that allowed him to film without being seen— so the thousands at Coney Island during the filming were extras without knowing it. This gave the film a natural realism. Joey sees policemen in several places. The Midway. Organ music from the merry-go-round. The brass ring. Joey on a merry-go-round horse. Organ music continues. This ride and others as well as the games to come were all familiar to audiences at the time. Joey stretches for the ring, has to pull himself back on the horse after stretching too far. **Point-of-view shot**. A photo store. Cutout of a cowboy. Interior. A photographer works with Joey in taking his picture. He goes to develop it. Joey takes a crate and looks into the camera—the image is upside-down. Joey turns a cowboy cardboard figure upside down to match the image. Joey gets his photo. Photography was very important to the creators of the film, and it references the constant relationship between still and motion picture photography. The upside-down image is a comic moment and an instructive one because that is how that camera operated.

A candy store. Joey gets an ice cream pop, then eats a hot dog on the boardwalk. All the foods available in Coney Island are American delicacies

enjoyed by children and tap into nostalgia for many viewers. Knock 'Em Down game. Joey is given three balls. There are metal bottles stacked up in a formation. He throws and misses three times. Stand-alone horse. Batter's cage. Ten cents. A man keeps a chart. Joey in the cage. Swings, misses, and hits. Last ball. Score 14. There is a purity to life here, an honesty that would later be replaced by realism, but Joey's world in the early 1950s is an escapist dreamland. Joey waves to a horse, eats big slice of watermelon, and spits out pits. Brick area. Joey throws a rock to hit a can. Knock 'Em Down game. Joey misses three times again.

Lenny in their apartment holds Joey's gift. Mom calls, and says she will be home before 6 o'clock. The seriousness of this situation is sinking in for Lenny, and his brotherly instincts are going into effect. Joey gets a cotton candy, pulls off the paper cone, makes ball out of it, and throws it at paper cups. He goes back to the Knock 'Em Down. This time Joey wins a prize—a necklace. Joey is a very determined little boy who just found that his hard work paid off by completing a task. Funny mirrors. Sledge hammer game. Bowling game. Boat. Small roller coaster. He rides it, then eats corn on the cob. Harmonica. Coney Island is now a universe onto itself for the film. It has everything a boy needs.

Nathan's Hot Dog stand. A bottle of pop. Joey is on a horse eating a box of popcorn. He has a gun in holster belt. 25 cents—He puts his hand in his pocket—he's running out of money. Under the boardwalk, Joey looks up at the light through the wooden slats. A couple is kissing. Beach. On lifeguard stand—a kid around his age collects bottles. Joey watches him, looks for bottles, gives one to the boy. The boy tells Joey how to get a deposit. They go to the deposit area. An Asian child puts sand in bottle. Joey takes the bottle, looks for more in a trash basket. He brings the bottle to the deposit place. A life guard whistle. A crowd. A man knocked out from swimming. Joey gets more bottles, cashes in three more, gets 25 cents. The beach becomes a place for commerce. Joey learns fast and solves his economic problem. He wants to do everything available here at Coney Island.

Joey wants the Pony Ride Man (Jay Williams) to put him on horse. Pony Ride Man tells Joey a story, waves goodbye. Joey is back on the beach collecting bottles. Four pony rides. Joey collects more bottles. **Montage** of the cash-in—Joey riding horse—He cashes in more bottles. Joey goes to the Pony Ride Man again, who asks him who he is here with. Joey rides off. Harmonica. Eating a hotdog. Getting dark—lights are going on. The Wonder Wheel. Parachute ride. The sky gets darker. **Fade-out**.

Joey is sleeping with the harmonica under the boardwalk. Day. Pony ride. The beach is empty. He drinks and splashes his face at a water fountain. The tide is coming in. Joey plays with a dog. Joey on a stationary horse. Pony Ride Man calls him over. He shows Joey how to rope like a real cowboy with an

invisible rope, shows him how to steer using the stationary horse. Pony Ride Man offers Joey a job, and asks him for his Social Security card because has to write to Washington to hire him. He tells Joey he'll be right back. Joey fills a bucket. Pony Ride Man talks to a policeman, and tells him Joey's story. There is a purity in the Pony Ride Man and his concern and care for Joey.

Dissolve. Lenny arrives at Coney Island. The dramatic tension of the film now lies in the fact that both boys are in the same place but not together. Lenny asks people if they've seen Joey. Montage of merry-go-round horse. Lenny on the beach getting wet. On the boardwalk Joey plays bowling game. Lenny dries his clothes and is wearing a bathing suit. Lenny swims. A couple lay a blanket by Lenny's sneaker onto Lenny's clothes. They are kissing in an embrace. The man gets up and gives Lenny his pants. Bowling. Lenny sees chalk messages—leaves one for Joey. Lenny asks someone the time, then goes on the parachute ride. Joey with a balloon—Lenny sees Joey! The parachute ride starts, drops down. Point-of-view, and Lenny runs after Joey. The high angle of the ride's view was a clever way to get Lenny to see Joey. The beach. Lenny sees a balloon, then it flies off. A thunderstorm. Lenny asks someone for the time again—gets an ice cream—it's getting closer to when mom comes home. Lenny asks how you find a policeman. Timing becomes critical. Lenny doesn't want his mom to know what happened.

Raining hard. Montage of people getting out of the rain. The boardwalk is empty. Under the boardwalk. A flooded street. A lost children sign. Empty beach. Joey walks into the shot, picking up bottles. There are many wastebaskets. **Off-screen** Lenny calls out to Joey. On camera Lenny runs to his little brother. He tells Joey he can keep the harmonica. They walk off. The innocence of the younger brother is not totally aware of what happened as Lenny is.

They make it back in time to their apartment. Joey watches a TV Western program while interacting with his toy pistol, another nostalgia element for Baby Boomers. Lenny changes Joey's shirt. Mom comes home. She looks at their eyes and tells them they have been watching TV since yesterday. Next Sunday, she says, she is going to take them to Coney Island! The boys smile at each other. End.

Conclusion

Little Fugitive is one of the great films about children. The filmmakers understood that they think and act differently than adults, and there's a charm that permeates the movie. It also captures time and place in a way that vividly communicates life in the 1950s to those who didn't experience it directly and to the memory banks of those who had.

Notes

1. Photo League was a cooperative of photographers in New York that was active from 1936 to 1951. Its members were some of the most noted American photographers of the mid-20th century. They integrated formal elements of design and visual aesthetics with the powerful and sympathetic evidence of the human condition.

2. The New School for Social Research was founded in 1919. It was dedicated to academic freedom and intellectual enquiry—a home for progressive thinkers. Its faculty supported a wide range of the arts and academic endeavors.

3. Thomas Edison (1847–1931) was an American inventor and businessman. He was very prolific and held 1,093 patents. He is best known for inventing the electric light bulb and for his part in creating motion pictures. His range of interest was wide, and he explored the stock ticker and many other uses of electricity.

4. Mary Pickford (1892–1979) was a Canadian-born film actress. She was a cofounder of the Pickford-Fairbanks Studio. She was one of the original 36 founders of the Academy of Motion Picture Arts and Sciences. Known as "America's Sweetheart," she was one of the most popular actresses of the 1910s–1920s. She appeared in many films, including *Tess of the Storm Country* (1914), *The Poor Little Rich Girl* (1917), and *Coquette* (1929).

5. Charlie Chaplin (1899–1977) was an English comic actor, filmmaker, and composer who became a worldwide icon with his character "The Little Tramp." He dominated the silent era and moved into talking pictures. Some of the movies he's known for include *The Kid* (1921), *The Gold Rush* (1925), *City Lights* (1931), and *Modern Times* (1936). He had complete control of his films and was meticulous about their detail.

6. Douglas Fairbanks (1883–1939) was an American actor, screenwriter, director, and producer. He was best known for his swashbuckling roles in silent films including *The Thief of Bagdad* (1924), *Robin Hood* (1922), and *The Mark of Zorro* (1920). He was married to Mary Pickford.

7. Walt Disney (1901–1966) was an American entrepreneur, animator, voice actor, and producer. A pioneer of the American animation industry, Disney was an innovator in the cartoon and long-form animation movie. Some of his films include the experimental *Fantasia* (1940), *Pinocchio* (1940), and *Mary Poppins* (1964).

8. Samuel Goldwyn (1879–1974) was a film producer and one of the founding contributors to the motion picture studios system in Hollywood. He was the most successful independent producer in the United States in his time. Some of his films include *Dodsworth* (1936), *Wuthering Heights* (1939), and *The Best Years of Our Lives* (1936), often cited as one of the greatest American films. Goldwyn is also known for his malaprops such as "An oral contract isn't worth the paper it's written on."

9. David O. Selznick (1902–1965) was an American film producer, screenwriter, and film studio executive. He is best known for *Gone with the Wind* (1939)

and *Rebecca* (1940), both of which won an Academy Award for Best Picture. He became an independent producer in 1935 by forming Selznick International Pictures. He brought Alfred Hitchcock to Hollywood from England and was known for his attention to detail, communicating to his staff with hundreds of memos.

10. Alexander Korda (1893–1956) was a Hungarian-born British film producer and director. He was a leading figure in the British film industry, the founder of London Films, and the owner of British Lion Films, a distribution company. He was the first filmmaker to be officially knighted. Some of his output includes *Rembrandt* (1936), *The Prince and the Pauper* (1920), and *Bonnie Prince Charlie* (1948).

11. Walter Wanger (1894–1968) was an American film producer from the 1910s to 1963. He was strongly influenced by European films and developed a reputation as a socially conscious movie executive who produced provocative message movies as well as glittering romantic melodramas. Some of the films Wanger is associated with include *Scarlet Street* (1945), *Joan of Arc* (1948), *Riot in Cell Block 11* (1954), and *Invasion of the Body Snatchers* (1956).

12. Maya Deren (1917–1961) was a Ukrainian-born filmmaker and one of the most important experimental filmmakers and promoters of the **avant-garde** in the 1940s and 1950s. She was also a choreographer, dancer, film theorist, poet, lecturer, writer, and photographer. She combined her interest in dance with highly expressive and innovative cinema techniques. Her films include *Meshes of the Afternoon* (1943), *A Study in Choreography for Camera* (1945), and *The Private Life of a Cat* (1947).

13. Kenneth Anger (1927–) is an American underground filmmaker, actor, and author. He has produced almost 40 works since 1937. Nine of his works are grouped together as the Magick Lantern Cycle. One of the first openly gay filmmakers, Anger has explored homosexuality in many of his films. Other content includes the occult, surrealism, erotica, and psychodrama. He explored the dark side of Hollywood in the book *Hollywood Babylon* first published in 1959. His work includes *Fireworks* (1947) *Scorpio's Rising* (1963), and *Invocation of My Demon Brother* (1969).

14. Jonas Mekas (1922–2019) was a Lithuanian American filmmaker, poet, artist, film historian, and archivist, considered to be the godfather of American avant-garde cinema. He wrote a column for *The Village Voice* and was responsible for creating the Anthology Film Archives, the largest and most important repositories of avant-garde films. He also was one of the founders of *Film Culture* magazine. His work as a filmmaker includes *Guns of the Trees* (1962), *The Brig* (1964), and *Walden (Diaries, Notes, and Sketches)* (1969).

15. Stan Brakhage (1933–2003) was an American **nonnarrative** filmmaker considered to be one of the most important figures in 20th-century experimental filmmaking. Over five decades he created a large body of diverse work, which included handheld camera work, painting directly onto the celluloid, fast cutting, in-camera editing, scratching on film, collage film, and the use of multiple exposures. He was deeply interested in mythology and the themes of birth, mortality,

sexuality, and innocence. His many films include *Dog Star Man* (1961–1964), *The Act of Seeing with One's Own Eyes* (1971), and *The Garden of Earthly Delights* (1981).

16. Shirley Clarke (1919–1997) was an American experimental and independent filmmaker. Her film *The Connection* (1961) based on the play by Jack Gelber concerning heroin-addicted musicians was a landmark for the emergence of a New York independent feature film movement. *The Cool World* (1964), another of her feature films was the first movie to dramatize a story on black street gangs without relying on Hollywood moralizing. Based on a novel by Warren Miller, it was shot on location in Harlem.

17. Gregory Markopoulos (1928–1992) was an American experimental filmmaker. He attended the USC film school in the 1940s and went on to be one of the founding members of the New American Cinema Movement. His films include *Twice a Man* (1963), *The Iliac Passion* (1964–1967), and *Hagiographia* (1970, first version).

18. Roger Corman (1926–) is an American independent film producer, director, screenwriter, entertainment businessman, and actor, a trailblazer in independent and low-budget filmmaking. His output is staggering, and he mastered the exploitation film genre. He gave a start to a generation of actors and directors, including Francis Ford Coppola, Martin Scorsese, and Ron Howard, named by critics the "Corman Film School." He's made beach movies, motorcycle films, horror films, and anything he could produce cheaply and that young people would pay to see at a drive-in or movie theater. From 1954 through 2008 he directed 55 films and produced as many as 385 movies. His films as director include *Attack of the Crab Monsters* (1957), *Machine-Gun Kelly* (1958), and *X: The Man with the X-Ray Eyes* (1963).

19. John Waters (1946–) is an American film director, screenwriter, author, actor, stand-up comedian, visual artist, and art collector. His films made in the 1970s and 1980s, often in Baltimore, feature his regular troupe of actors known as the Dreamlanders, among them Divine and Mink Stole. He explored the low-life of America made for bargain basement budgets with what could best be described as anti-craft. Then he shifted to his Hollywood period where the films were not as raunchy and were well made. The raunchy ones include *Pink Flamingos* (1972), *Female Trouble* (1974), and *Desperate Living* (1977). His glossary period includes *Hairspray* (1988), *Cry-Baby* (1990), and *Pecker* (1998).

For Further Study

Screen

Faces
Jazz on a Summer's Day
Nothing but a Man
The Searching Eye
Shadows

Read

Celluloid Mavericks: A History of American Independent Filmmaking by Greg Merritt
The Cheerful Subversive's Guide to Independent Filmmaking: From Preproduction to Festivals and Distribution by Dan Mirvish
The Encyclopedia of American Independent Filmmaking by Vincent LoBrutto
Feature Filmmaking at Used–Cars Prices: Second Revised Edition by Rick Schmidt
Independent Filmmaking by Lenny Lipton

Parallel Storytelling, Character Connections

Magnolia

Magnolia (2000): multicharacter, multinarrative film begins with a **narrator** presenting three examples of highly improbable coincidences that imply that forces beyond chance have direct action on our lives. Characters are introduced, and slowly but steadily their connections with each other are revealed.

After the release of and acclaim for *Boogie Nights* (1997), there were great expectations about what director Paul Thomas Anderson would do next. *Magnolia* would define life in 1990s America. The lifestyle, morals, and the emotional essence of its many characters would define the world the viewer lived in when the film was first released. Now it is one of those rare films that the young and not-so-young viewer can watch to understand that era in the same way as *Easy Rider* (1969), the Paul Haggis film *Crash* (2004), *Heathers* (1988), and *American Beauty* (1999) informed their times. Paul Thomas Anderson accomplishes this by understanding that 1990s culture was part of his coming-of-age and synthesizing what he experienced into a group of characters and storylines that succinctly defined American life at that time. He recognized that the 1990s had evolved to a point where life was so complicated that society was in a perpetual crisis mode.

Narrative and Cinematic Analysis

Narrator—a story of the hanging of three men. The narrator is not a character in *Magnolia* but a traditional narrator, here presenting the film's concept and a philosophy of life that will unfold during the following just over three hours. Small screen. Black-and-white. The three men are shown

murdering the victim. Only a matter of chance. 1983. Fire. Color. Airplane
over a lake. Scuba diver. Blackjack dealer at a Reno, Nevada, casino is acci-
dentally killed while underwater by a low-flying plane. That pilot commit-
ted suicide. Two nights before, the pilot played blackjack at that dealer's
table, didn't get the card he wanted, then attacked the dealer. The pilot went
back up to his room and shot himself to death. Chance? 1961 award dinner.
A forensic science organization talks about a suicide. 1958. A seventeen-
year-old on the edge of a roof jumps. There was an argument below. A
woman with a shotgun aimed at her husband, missed, and shot the jumper
as he passed in front of their window. His parents were having one of their
frequent arguments. Their gun was never loaded. The boy had been dis-
tressed about their fight and loaded the gun. A safety net was installed just
days before that would have saved him, but the bullet killed him before he
could reach it. Narrator—this is not chance. Strange things happen all the
time. Paul Thomas Anderson's way at looking at life in *Magnolia* has much
validity. It is the notion that chance plays a little part in this that validates
the idea that the world in the film is open to unpredictability at any and all
moments.

Credits—Aimee Mann sings "One" on the soundtrack, written by Harry
Nilsson[1] and made popular by Three Dog Night,[2] which speaks to the loneli-
ness of the characters and that in the end they mainly have themselves as
they search for connectivity.

Frank T. J. Mackey (Tom Cruise) is on a TV screen selling his program for
men to dominate women and control them sexually and emotionally. A bar—
Claudia Wilson Gator (Melora Walters) snorts cocaine. She has sex with a
man on her bed. The longest running game show *What Do Kids Know?* is on
the TV. Profile of the longtime host Jimmy Gator (Philip Baker Hall)—Stanley
Spector (Jeremey Blackman), a whiz kid who always seems to know the
answers, is with his father Rick Spector (Michael Bowen), who is rushing him
because he has an audition elsewhere. He also complains that Stanley has so
many backpacks and books. He pressures the boy to win a lot of money. Quiz
Kid Donnie Smith (William H. Macy) is first shown as a kid winning a big
prize, then as an adult getting braces at the dentist. He crashes through a
glass store window with his car. Earl Partridge (Jason Robards) is in a hospi-
tal bed in his expensive home. He is dying of cancer. He has a male nurse,
Phil Parma (Philip Seymour Hoffman). Linda Partridge (Julianne Moore) is
Earl's younger wife, and she desperately needs pills. Officer Jim Kurring
(John C. Reilly) is watching TV in his apartment. A message he made to get a
date plays. Police briefing—Jim goes into his police car with a rifle. The date
tape audio plays out over him, then he talks to himself. He tries to do good.
Anderson skillfully and with much flair introduces his characters. He will
weave the story of their lives in and out of the multiple narrative structure of
Magnolia for the rest of the picture.

"Partly clearing 82% chance of rain." This is a heading to the next section of the film. The card has clouds on it. Paul Thomas Anderson is a director who references other movies and literary sources. This is an influence inspired by the work of his former teacher David Foster Wallace[3] in terms of the connection of words, ideas, and text.

Jim arrives at an apartment with an uncooperative woman. He is there investigating a disturbance, and she denies it. He asks her if she is alone in the apartment. She says no. There is a loud noise. He puts handcuffs on her and calls in for backup. He moves to the bedroom closet. She drags the couch she is cuffed on to follow him. He opens her closet and finds a dead body. She says it isn't hers. Anderson breaks stereotypes in the film by showing characters in circumstances that move beyond the cliché. He also broadens the characterization of types that the viewer thinks they know, like a police officer.

Linda is talking to someone involved in the family business. She doesn't know what to do. She is wearing a fur coat. He advises her to administer liquid morphine for the tremendous pain Earl's experiencing. She gets a prescription for it.

Earl in his sick bed. He asks Phil about his son. He says his wife is a good girl, daffy, nuts. Hasn't talked to his son in a very long time. Asks Phil to find his son Frank Mackey. "Also Sprach Zarathrustra," the theme music from *2001: A Space Odyssey*, plays. Kubrick's choice for a movie about space had influenced everything from parodies to commercials to feature films and beyond. Here it speaks to the superman Mackey thinks he is and is selling to men at his seminar. Mackey on stage moving into different power poses; some seem inspired by martial arts. The all-male audience yells in excitement for him. "Seduce and Destroy." Mackey is wearing a black leather vest and his hair is in a ponytail. Control. He has a wireless microphone attached to the side of his face. He works up the crowd. An African American woman comes into the area and is taken into a back section of the facility. Mackey tells the men they can turn friends who are women into sex objects.

Phil phones for Frank and gets a hang-up. The black woman is a journalist with a camera crew. Frank talks to a young man in the first row about his relationships. Crude language. References his book. There are many intervening variables in *Magnolia*. Frank is unaware of the mission set forth by this journalist looking for the truth concerning a controversial character.

Game show host Jimmy Gator comes to the door of his daughter's apartment. A young man stops him and says Claudia is sleeping. Jimmy moves into the apartment and she wakes up. He wants to talk to her and straighten things out. He tells her he's sick, has cancer. She is screaming and throws him out.

Through the **intercutting** all of the people and stories in the film, the viewer begins to see connections between them and the larger issue that life

is hard and everyone has issues to deal with that are made difficult by the strangeness in life. Some call it chance, others the randomness of everyday living.

Furniture store, Donnie comes in. He talks to his boss, who tells him he's not doing his job. Donnie says he has no money. As the Quiz Kid he was a former successful game show contestant. Donnie promoted the store. He has debts, needs oral surgery, braces. Donnie was once struck by lightning. He wants $5,000. Being struck by lightning and surviving is strange, and Donnie promotes the fact. The viewer wonders what physical or mental impact this may have had on him, and his actions that follow make this intriguing.

Crime scene. Outside a young African American boy walks with Jim to his police car. Boy says he is a rapper, performs for Jim. Stanley studies with lots of open books at a library. He gets into a car with his father. "Are you ready to keep winning?" "Sure."

"Clouds. Light Showers. 99% humidity Winds SE 12 MPH. Rain." These weather facts present information that may affect the characters in a common way, and they translate into a manner of understanding the emotional life of those in the film. Stanley and his father are wet. They arrive at a studio. A woman takes him in. There is a room for the parents. Stanley talks to the lady—Emmy awards in Jimmy Gator's office. Anderson likes to shoot very long takes in the manner of Stanley Kubrick (see Chapter 2). At times he employs Kubrick framing, which places a figure in the center of the frame counterbalanced on either side by figures or objects.

Phone. Jimmy's wife Rose (Melinda Dillon) tells Jimmy to come home after the show. Someone says, did you tell her what happened at your daughter's apartment? Rain. The police officer goes into an apartment. Loud music— Claudia does drugs. Jim keeps banging on her door with his night stick. Inspired by Robert Altman, *Magnolia* is peopled with many, many more characters than the average drama. There are connections between them. Even with these two major influences, Kubrick and Altman, Anderson here was a young film director out to define his times like all the great film artists of the past, such as *The Best Years of Our Lives* (1946) directed by William Wyler, *The Breakfast Club* (1985) directed by John Hughes, and *The Graduate* (1967) directed by Mike Nichols.

Linda gets yet another prescription for medications, this time from a female doctor. Opioids were a problem then and currently. *Magnolia* reflects issues and problems of the 1990s and by doing so looks into what is to come, because problems and concerns don't really go away. So viewers during initial release and now can directly relate to the film on this issue. Viewers then and currently watch *Magnolia* and have a double reaction, to understand what happened before and why many issues and problems may never really go away. Phil is watching television. Jimmy says, "What do these kids have against adults?" Phil calls for a take-out order, bread, *Playboy*, *Penthouse*, and

Hustler. One of the images on the TV was a topless woman lying down and two male hands starting to take her panties off. A reaction shot on Phil seems to show he is aroused by this. When he orders the three men's magazines it seems for sexual reasons, but the sex image gave him an idea. *Magnolia* understands that things aren't always what they seem to be. Earl is dying in bed, talking to himself. Everyone in the film is struggling against the inevitability of life.

A break in Frank's presentation. Everything is ready for the interview. He is wearing just his underwear in front of the black female interviewer. He puts on black pants and a brown shirt. He sits in front of her. He tells her it's hard for him to get girls because of his reputation. He puts his hair into a pony tail. He talks nonstop about his prowess. She tells him to put on his microphone. "What do you want to know?" Is Frank trying to seduce her, or to be provocative? It is in his nature to believe in his doctrine, and Anderson is trying to provoke the viewer by presenting another outrageous moment.

Raining. Donnie is in a bar. The man behind the bar has braces. Another man is at the opposite end of the bar. Donnie sits at a table and orders a tequila. Claudia finally opens the door. Jim tells her to turn down the music. Jim comes in. He tells her loud music can damage your ears. They got a call that there was yelling and screaming coming from this apartment. She tries to explain. "I'm here to help you," he says. Jim is a good cop, a helpful man whose life is about to change, a notion that happens to many of the characters in *Magnolia.*

The quiz show. Stanley has to go to the bathroom. Adult contestants file in. Ricky Jay plays Burt Ramsey, the producer of the show. Jimmy takes a drink before coming out to host the show. The quiz show reflects the heyday of this television genre in the 1950s and 1960s. This one is a parody of the form and one which explores the nature of intelligence.

Donnie is now sitting next to the man at the bar. He keeps talking about love. Donnie says he has lots of love to give. Linda goes into a drug store with a handful of prescriptions. The two pharmacists talk about her. Stanley's father says "Let's make money" to the other parents The announcer introduces the kids, adults, and the host. Love is a universal theme, especially for the cinema. How it is defined and what it is will be explored through Donnie and others. A relatable subject for movie viewers of all decades.

Phil watches the quiz show as earlier. Phil and Earl talk. Cut around to all of the characters in the film as their lives proceed. Phil's order arrives. Quiz show intercut. Phil looks through the men's magazines and finds Mackey's ad. **Pan.** Phil talks to Mackey's representative on the phone. He explains that Earl is dying and wants Phil to find his son. Interview. She brings up his parents. Frank says his father died, lies about his mother. He asks for coffee. The viewer is constantly learning that the characters in *Magnolia* are complex and that things are not what they seem. Still raining. The drug store

pharmacist continues to be rude to Linda about the drugs. She curses him out, has an emotional tirade. Earl is in bed. Phil still talking to Mackey representative. "Where did your name come from?" the female interviewer asks Mackey. She steadily grills him. A true rags-to-riches story, Frank tells her. Swish pan. This technique denotes the speed of time.

Jimmy is acting strangely. Stanley correctly answers an opera question. Kitchen. The same opera Stanley sang, but the singing is done professionally this time. Still raining. Jim calls her Claudia. "Not going to write you up." She makes him coffee. Jim lectures her again about volume level music should be played at. He thinks she has been abused. Claudia tells Jim that person is not coming back. Drug abuse, physical abuse, and abuse of self are some of the themes developed in the film.

A break in the quiz show. Stanley again says he has to go to the bathroom and again is told no because it's one minute to air. Phil is still on the phone. Dogs. Morphine pills get knocked over. Earl is having an episode. The audio for the Mackey ad is playing. Phil hangs up the phone with the Mackey phone representative.

Backstage, Jimmy tells a woman who works on the show that he is dying of cancer. The quiz show starts up again. Bar. Quiz show on TV above the patrons. "I'm Quiz Kid Donnie Smith." A guy at the bar says he knows who he is, also that he was hit by lightning. Donnie complains about his life. His parents took his money. This appears to be a gay bar but is not directly identified as such.

Interview. They talk about the past. Mackey refers to his book, *Seduce and Destroy*. This reflects a genre of books for men long popular and available. "Do you remember Miss Sims?" she asks him. Mackey gets defensive. Interviewer had heard his mother died. She talked to Miss Sims. He's the only son. Mom died in 1980. Mackey's company got it wrong. Mother's name was Lily. He gets angry. "Why would you lie?" Rain.

Three musical notes are presented to the quiz show contestants and adults get the question right. The number three has great significance in life and film. In life it is the number of harmony, wisdom, and understanding. In filmmaking, directors and editors learned that two shots of a related subject didn't work as well in terms of rhythm and content as three shots in a row. Stanley is distressed. Office. A lawyer talks to Linda. The character's name is Alan Klingman (Michael Murphy), who was part of Robert Altman's "repertory" group of actors. "Are you on drugs?" Linda wants to change Earl's will. She didn't love him, married him for his money, but now that he's dying she loves him again.

Quiz show. The father talking to himself, wants Stanley to snap out of his slump. Linda doesn't want Earl to die. The lawyer tells her to renounce the will, then the money goes to Frank Mackey—she doesn't want that. She leaves his office upset. Quiz show. Harmonica trio. Adults get the question

right. Stanley urinates in his pants. Hits his button by mistake: "I don't know the answer." Jimmy talks too much and gives away the answer to the next question. He has trouble speaking and collapses. The producer orders the control booth to go to a show card, taking the live feed off the air. Stanley (who may be named after Anderson's idol, Stanley Kubrick) is experiencing the nightmare and humiliation of many. This moment is relatable and causes an emotion of being trapped in the viewer.

Claudia snorts cocaine, then comes out to Jim in the room. Jimmy is revived. Stanley's father goes to his son; other boy says Stanley pissed his pants. The father pulls up his son and sees it. Jimmy is backstage drinking bottled water, says he's alright to go back on. The father says to Stanley, if you answer right, I'll get you anything you want. Jim and Claudia—she clicks her jaw. Police radio. Blue sheets on her windows. He has a call. Jim tells her he would like to see her again. Jim comes back in. He asks her for a date. She says yes. Jim conquers the fear of rejection that the audience recognizes.

Interview. Father left, and Frank took care of sick mother. Frank staring down the interviewer says he's quietly judging her. Quiz show. Audience applause. One-on-one challenge. Stanley refuses to get up. A bar patron is rude to Donnie. Actor Henry Gibson who plays this character also worked with Robert Altman, most famously in the director's masterpiece *Nashville* (1975), which takes a panoramic view of America in the mid-1970s and most likely was a strong influence on *Magnolia*, which takes a panoramic view of America but in a different decade. Donnie tells Brad the Bartender (Craig Vinsland) that he loves him. The quiz show is on TV. Donnie gives a monologue about useless knowledge. "The past is not through with us." "No, it is not dangerous to confuse children with angels." This statement concerns Donnie, Stanley, and all children. Donnie leaves, throws up in bathroom toilet. Jim is in his car. It's raining. He turns the car around. Claudia is doing drugs. She puts on the television—a quiz show is on.

Quiz show. Stanley still will not get up for the one-on-one challenge. Jimmy asks him to pass to other kids. The kids want Stanley to go. Mackey's staffer is walking fast with a phone. Mackey operator, talking with Phil on the phone, letting him know where he is as he rushes to Frank. Quiz show— Jimmy talks to the kids, who want Stanley to answer a question. Stanley refuses to participate anymore. Staffer still on the phone letting Mackey operator know where he is again as he gets closer to Frank. Phil is on the phone listening and waiting. Earl is suffering in bed. A garage door opens. Linda drives car into garage and signals for the door to shut. Green room parents react to Stanley's behavior. TV control room.

Interview: "Time's up, get out!" Frank shoves her and storms out of the room. In the hall, the staffer hands Frank the phone. Phil is holding. Rain continues. A group of dogs bark. Quiz show—Jimmy talks to the audience. Stanley says "I'm not a toy or a doll" to Jimmy. Jim's police car. Rain. He goes

behind a building and is shot at. Jim calls in shots fired. It's the young African American boy. Donnie talking over the toilet about "sins of the father." The Mackey operator talks to Frank about Phil. Frank screams at her. She wants him to get on the phone to Phil.

Linda in the car, in the garage. Stanley continues to talk, and the producer tells the control booth to take the show off the air and run the credits. Stanley's father breaks a chair in the green room out of anger. Jim has lost his gun and searches for it on the ground in the rain. Stanley runs out of the studio. Linda in the garage. It fills with carbon monoxide. Frank is on phone with his operator. Phil gets up, walks toward dogs barking. Linda gets out of the garage and walks into the house. She is angry that Phil tried to contact Frank. Frank is holding the phone, not answering his operator who is still talking to him. He hangs up. Linda berates Phil. Frank charges down the hall with staffers behind him. The connection between characters intensifies.

Chaos on the game show set. The father leaves the green room and comes to get Stanley. Night. Jim with a flashlight trying to find his gun. Claudia watches the quiz show credits run and cries. Linda lies next to Earl in bed—she is crying. She goes into the pharmacy bag. She apologizes for slapping Phil, wants Phil to tell Earl she is sorry. She walks away. She leaves morphine drops for Phil. Phil is crying. Frank is back on stage, goes back into his presentation act and postulates his philosophy: I will not apologize for who I am. He starts to unravel. Earl tells Phil his wife Lily was the love of his life but he cheated on her over and over. They were married 23 years—she was Jack's mother. (Frank's middle initial is J.) "I loved Lily," he repeats to himself. The boy was 14 and was forced to take care of his mother and watch her die. **Voice-over** that love was stronger than anything. Monologues are prevalent in *Magnolia*—they allow the characters to talk about themselves, give backstory, talk about their relationships with others, and have the viewer stop and listen to them. Jason Robards delivers a powerful monologue as Earl is dying; Robards invokes his extensive theater background, especially as the foremost interpreter of playwright Eugene O'Neill.

Jimmy comes home, his wife with him. Claudia is in the shower. Earl's voice-over continues. Claudia goes back to using drugs. Earl's voice-over continues: "Use that regret." Jim continues to look for his gun. Donnie and keys. Clippings. Earl's voice-over. "What did I do?" Pills. Linda drinking in her car, takes pills—still raining. Frank in a car. Another nurse comes to relieve Phil, but he tells him he's staying on. Drops of medicine. Phil cries. Claudia is snorting drugs. She sings: "It's not going to stop." Jim singing on his bed. Jimmy sings. Phil sings. Earl sings. "It's not going to stop." Linda sings. Frank sings. Stanley sings. "So just give up." They all were singing the same song, but from different locations. A female voice constantly sings with the others. The message is that life isn't going to stop, the pain isn't going to stop, the

state of humanity now isn't going to stop, so don't try to change it or fight it. This connects and unifies all the characters in their pain and struggles.

Rainy street. "Rain clearing, Breezy overnight." Claudia and Jim in a car. Dogs at the door of Earl's house. Frank doesn't go right in, wants to stand by the door. Linda in her car—the African American boy tries to wake her up—he comes into the car through the other door and goes through her purse. Life isn't always fair, and people are unpredictable. Rose with Jimmy: You love me—my handsome man. He wants to apologize that he cheated on her. Claudia and Jim at a restaurant. She talks to Jim that people are afraid to say things. They agree to tell each other about themselves. She leaves the table. Donnie opens a door, climbs a ladder, opens a safe, and takes out cash. Frank is inside but at the front door. He says he's not going to help Earl. Frank is afraid of the dogs and tells Phil to keep them away from him. He goes to his father's bedside, calls his father an obscene name—in pain. "Mother—she waited for your call." Earl is largely unre-sponsive. "Die (another expletive)." Why did Frank come here? These are automatic, not planned feelings. Donnie closes the safe, leaves—the key breaks off in lock. Donnie drives off. Linda appears to be dead but isn't. The black boy does rap and counts her money. Linda is put into an ambulance on a stretcher.

Rose wants Jimmy to tell her the truth. Claudia comes back to the table in restaurant. She's worried Jim is going to hate her once he finds out about her. He assures her he won't. "I lost my gun today." Jim was married. They kiss. Jimmy and Rose—she may have thought he molested her. Crazy thought in her head. Rose asks if he ever touched his daughter. He says he doesn't know, and in great anger she tells him he should die alone. Many viewers fear this from the outset. The signs were there, and there is a disturb-ing reality to this unthinkable act. Film viewers must wonder, is this why Claudia was so upset? Frank at his father's bedside, crying. "Don't go away," as he curses Earl again. Restaurant—Claudia is very upset, wants Jim to agree to never see her again. He says no, he cares for her. She leaves the res-taurant. Frank is upset and crying at Earl's bedside. Phil looks on in back-ground, crying. Frank doesn't want to go away but still curses him.

Ambulance. Donnie in his car turns around. Claudia in the back seat of a vehicle doing drugs. Rose is driving on the other side of the road. Jimmy is alone in the house, goes to a drawer, gets a gun. Donnie goes back to the door with the broken-off key. Jim in his car, sees a man (Donnie) climbing a pole. A frog falls out of the sky onto the windshield and makes a loud sound. Then a lot of frogs fall. They are bouncing off the car. Claudia is drugging in her apartment. Frogs fall behind her. Breaking windows. Phil hears frogs fall on Earl's house. Earl's swimming pool—frogs fall. Rose's car hit by frogs. Ambu-lance is hit by frogs, turns over. Jimmy has the pistol to his temple. A frog flies into the house from above, knocks the gun out of his hand; he falls to

the floor. An electrical unit is hit, sparks. More frogs fall into the house from above. Car crash. Donnie continues to climb the pole and is hit by a frog. He is knocked to the ground. Jim runs out from his car and pulls Donnie away. Frogs continue to fall. Rose comes to her daughter's apartment. Frogs falling hard at an alarming rate. Stanley is in his room. He is listening to the frogs falling and sees their shadows. Frank and Earl. Earl becomes conscious. Sound of frogs falling. Cut to black.

Card: "So Now Then." The narrator goes over the cases of deaths covered at the beginning of *Magnolia*. The images are repeated. Door open. Phil with dogs. Men are with him. We are told about coincidence, chance, intersections, and strange happenings by the narrator. Hands cover Earl's dead body with a sheet. Earl's body is carried out of his house. Frank is on a couch in Earl's house. Phil hands him a phone. Phil crying. Hospital. Linda in bed. **Dissolve.**

Stanley's tells his dad, "You have to be nicer to me." The father tells Stanley to go to bed. Jim and Donnie: "I thought he would love me." Donnie is bleeding. "I have love to give." "Where to put it." A gun falls to the ground. Inside the furniture store, Donnie puts the cash back in the safe. Jim says sometimes people need help, sometimes they need to be forgiven. Outside Donnie squeegees frogs off of his car. Donnie drives off. Jim talks in his car: "What can we forgive?" He is grappling with making the call to send someone to jail and the larger issue of forgiveness for himself and others. Music. Claudia with a sheet pulled around her body. A red sheet on window. A lamp. Jim talks to Claudia, and after a while comes into the shot. His voice is low. The volume of the song playing is well over it. The camera moves in close on Claudia—finally she looks into camera and smiles. The narrator tells the viewer that strange things happen all the time. "And so it goes"—a possible reference to Kurt Vonnegut's masterful novel *Slaughterhouse-Five* (1969). "We may be through with the past, but the past ain't through with us." Major theme of *Magnolia*: the past is always with us affecting the present.

Conclusion

The stories within *Magnolia* concern how relationships can grow out of happenstance. It's about secrets and about the complex connections that form out of people living their lives. It is about a wide range of characters who mirror aspects of American life. It is a film that attempts and succeeds to define the end of the 20th century and anticipates the 21st. Chance is the major theme of *Magnolia*—how much of modern life is affected by chance and the results of behavior and actions on individuals and those who intersect with their lives.

Magnolia is a detailed homage to director Robert Altman (see note in Chapter 10). Many filmmakers have worked in the parallel story form with many

characters, but none with more cinematic mastery than Robert Altman, especially in *Nashville* (1975) and *Short Cuts* (1993). The latter most inspired Paul Thomas Anderson and his masterpiece *Magnolia*. Anderson works this three hour and eight minute movie with masterful direction and insight into his characters, but most importantly—the world in which they live.

There are two set pieces in *Magnolia*. First the main characters are shown separately from each other in different places but they sing the same song, "Save Me," written by Aimee Mann.[4] The intercutting of the individuals while they sing becomes a shared expression of calling out for help against the forces that constantly push against them.

The second is near the end of *Magnolia* when thousands of frogs fall out of the sky and onto cars and buildings. The major characters are affected and bombarded by the creatures. There are several passages in the Bible concerning frogs, the most dramatic that informs *Magnolia* is from Exodus 8:2–4: "But if you refuse to let them go, behold, I will plague all your country with frogs. The Nile shall swarm with frogs that shall come up into your house and into your bedroom and on your bed and into the houses of your servants and your people, and into your ovens and your kneading bowls. The frogs shall come up on you and on your people and on all your servants."

This scene is surprising and not really explained in the film. *Magnolia* is a film about how people live their lives in extremity: a prominent man who had sexually molested his daughter when she was young, others dealing with drugs, confrontation with death and identity. The frogs may be God's message that enough is enough.

Long-form movies are not just a two-hour movie in which an hour is added. They have their own structure, writing, and directing. *Magnolia* is a major directorial accomplishment. The lessons Anderson solidly learned from Robert Altman and others are that movies should be about people who are complex and that the whole world is definitely connected in more ways than can be comprehended. The notion that movies are entertainment is true some of the time, but *Magnolia* proves that film is an art form that is a mirror up to our world and that there are lessons to be learned about life in watching a movie.

Notes

1. Harry Nilsson (1941–1994) was an American singer/songwriter whose work pioneered vocal overdub experiments, a return to the Great American Songbook, and fusions of Caribbean sounds. His songs include "Without You" and "Everybody's Talkin'," which was prominently featured in the landmark film *Midnight Cowboy* (1969).

2. Three Dog Night is an American rock band that formed in 1967 and that has charted 21 *Billboard* top 40 hits, three of those making it to number 1

between 1969 and 1975. Songs include "An Old Fashioned Love Song," "Joy to the World," "Eli's Comin'," and "Mama Told Me Not to Come."

3. David Foster Wallace (1962–2008) was an American writer and university professor who worked in the metafiction style. His masterpiece is the 1,079-page *Infinite Jest* published in 1996, which is noted for its use of long, experimental footnotes. Other works include *The Broom of the System* (1987), and the short story collection *Girl with Curious Hair* (1989). He also wrote nonfiction works including the essay collection *Consider the Lobster* (2005).

4. Aimee Mann (1960–) is an American rock singer-songwriter, bassist, and guitarist who has been acclaimed for her songwriting and as a lyricist. She was bassist and vocalist for the band 'Till Tuesday during the 1980s, and then became a solo artist. Her studio albums include: *Whatever* (1993), *I'm With Stupid* (1995), and *Charmer* (2012).

For Further Study

Screen

American Graffiti
The Big Chill
Boogie Nights
Cloud Atlas
Nashville

Read

Blossoms and Blood: Postmodern Media Culture and the Films of Paul Thomas Anderson by Jason Sperb
Magnolia: The Shooting Script by Paul Thomas Anderson
Paul Thomas Anderson by George Toles
Paul Thomas Anderson by José Francisco Montero Martinez
Robert Altman: Jumping off the Cliff by Patrick McGilligan

Mental State as Narrative

Memento

Movies by nature are concerned with time. They begin and end at a chosen time. Scenes run various amounts of time, and each narrative film covers a period of time, sometimes short, sometimes long, sometimes undisclosed.

Since the inception of the medium, filmmakers have experimented with those notions. When the **flashback** and **flashforward** were created, they gave filmmakers a storytelling tool to moderate how a narrative would unfold. In every way, when shooting or editing, time is ruling the direction of a film story.

Memento (2001) is a neo-noir film. A **film noir** usually involves crime, takes place at night, and has a doomed man and a woman responsible for his troubles known as a femme fatale. Traditionally in the 1940s to 1950s films noirs were in black-and-white and the genre was influenced by the tenor of the times after WWII. This was a period when some of the men who fought in the war couldn't get jobs and turned to or fell into criminal ways. The **neo-noir** popular in the 1980s and 1990s was in color, took place in an unidentified time, and wasn't always played out at night. These films did stick to the core elements of a doomed man and the femme fatale in a crime drama.

Memento's lead character Leonard Shelby, portrayed intensely by Guy Pearce, suffers from anterograde amnesia, where the ability to manufacture new memories is lost; thus he has a complete inability to recall the recent past although his long-term memory before the incident that caused this remains intact. Leonard sees his situation as generated by the inability to create new memories. *Memento* managed to find new narrative tropes, stretching the genre of film noir, and moving the narrative art of filmmaking to break new ground.

Hollywood has made good use of the amnesia trope in thrillers and film noirs. Here almost anything goes, because the protagonist can't remember anything, so the screenwriter can concoct any kind of situation. Films that apply this concept include *Spellbound* (1943), *Somewhere in the Night* (1946), and *The Dark Past* (1948). The mastery in *Memento* lies in the specificity of Leonard's illness. By remembering elements in the past, he is persistently driven to revenge the brutal murder of his wife while his illness hampers his cognitive abilities. The viewer is placed firmly in Leonard's broken memory and struggles along with him to make sense of developments as they unfold.

The complex structure of *Memento* was written into the film during the script phase by director Christopher Nolan (it was nominated for an Academy Award) and was staged and fine-tuned during the shooting of the picture. Editor Dody Dorn was nominated for an Academy Award for her execution of the time-shifting of the narrative and the manipulation of time and space frame-by-frame that was largely accomplished in the editing room through the collaboration of director and editor.

Narrative and Cinematic Analysis

Color. *Memento* is a neo-noir—films in the classic film noir tradition but that take place after the post-WWI period they were originally set in, are in color, and the production design is as non-time-specific as possible. Polaroid[1] in a hand. Image of a man on a floor—blood. The picture is shaken, and the image on it fades. The camera takes a picture. Blood. A gun is fired. Teddy (Joe Pantoliano) was shot, he yells. These shots were presented in reverse order of the actions they depicted.

Black-and-white. A room. Leonard (Guy Pearce) in bed. He narrates in film noir tradition, which is first person. The question of whether he is a reliable or unreliable narrator is more complicated than the standard form. At times he is both, but in conclusion he really is always reliable even when the viewer questions his validity because he is memory impaired and is honest about it, so what he says throughout the film is the truth as he can process it. Classic films noirs were shot in black-and-white with high-contrast lighting. *Memento* takes the narrative tropes of the form to tell a contemporary story. The cinematography here places the viewer in the noir space but is more modernistic in style. Cutting back and forth between color and black-and-white forces the viewer to understand the intended purpose that unfolds during the course of *Memento*. Leonard finds a key. Fade out to black. A hand on photograph of Teddy on counter. Leonard is talking to Burt (Mark Boone Junior), the front desk man at the motel. Leonard is trying to identify the man in the picture when Teddy comes through the door. He calls him Lenny, and Leonard corrects him, saying "Leonard." Teddy tries to fool Leonard

about his car. Leonard shows Teddy a Polaroid and tells him it's not right to make fun of someone with a problem. Teddy knows about Leonard's illness. They drive. Teddy asks Leonard to close the window who finds it is rimmed with broken glass. Leonard says he has a lead. Leonard doesn't remember why. Leonard finds bullets on the seat of a vehicle. He checks one of his Polaroids. It is a picture of Teddy. The notation below indicates to kill him. Teddy enters a building. Leonard knocks Teddy down with a gun. He thinks Teddy murdered his wife. Teddy informs Leonard he doesn't know who he is. Teddy tells Leonard to go downstairs to discover who he really is. Teddy turns his head and Leonard shoots him.

Fade in. Leonard finds a Bible in a drawer next to his bed. He looks out the window. **Voice-over**—Leonard talks about Sammy Jankis (Stephen Tobolowsky), who also had a memory problem. Leonard has written "remember Sammy Jankis" on his hand. Color—Leonard writes, "Doesn't believe his lies he's the one KILL HIM" on the back of a Polaroid of Teddy with a gel pen. He pushes a magazine into his handgun. He doesn't remember telling Burt to hold his calls and that he likes to look people in the eye. The viewer is intrigued with Leonard's behavior and starting to get a bit on edge about what he might do with the information he's processed and the gun. He explains that he can't make new memories since his injury. Leonard realizes by the expression on Burt's face that he's told him all this before. Leonard tells Burt that he hopes his condition won't be a problem there. Burt tells him no, as long as he pays his bill. Teddy knocks on the front glass door and calls him "Lenny," an identity trope. Leonard perceives himself with the full form of his name and expects everyone to call him that. When Teddy shortens it to the casual form, Leonard becomes angry because it is not who he is in his memory.

Black-and-white. In his room Leonard takes off a note taped to his leg with the word "Shave." **Voice-over**. He says trusting your handwriting becomes an important part of your life. In a series of shots, Leonard sets up to shave. The phone rings. He grabs it quickly and says, "Who is this?" Phone scenes are common. In most cases the viewer becomes aware of who the on-camera person is speaking to. In *Memento* this is a prime mystery, and listening to Leonard's response through the many scenes of this nature is a mystery that keeps audiences guessing.

Color. Leonard in a bathroom. He washes his hands—there is a message on them: "Remember Sammy Jankis." He pulls down his shirt and on his wrist is written "The Facts." Further down there is more writing, but someone comes into the bathroom. He leaves and walks into a dining area. A staff person gives him an envelope, a Polaroid picture, and keys, saying he left those on his table.

Leonard opens the door to a room. There is a chart on the wall. He places Polaroid pictures on the chart where the location matches. In an old film the

protagonist would take black-and-white or color photos from a standard, conventional camera; here is a Polaroid, which places it anywhere from the very late 1950s. If the film took place in the 21st century a digital or smart phone would be used. The Polaroid is effective here because not only is it instant but it quickly produces a print that can be catalogued. Leonard opens up the envelope, which says, "For Leonard from Natalie." Natalie (Carrie–Anne Moss) works at the diner and is the femme fatale, a woman who causes trouble or leads to the demise of the doomed man, a character type that fits Leonard. There is a copy of Teddy's driver's license in it, but the name is John Edward Gammell. Leonard makes a phone call and asks for Gammell; the voice is Teddy, and he tells Leonard he'll be right over. A series of shots showing tattooed words and phrases as Leonard inspects his chest and arms. There is tattooed writing on his legs: "The Facts." Now he sees more of this: "Fact 1 Male, Fact 2 White." In another place on his body he sees "Fact 3 First Name John," then written in a black marker below this it says "or James." Then he sees "Fact 4 Last Name: G_____." On the other leg is "Fact 5 Drug Dealer" and "Fact 6: Car license number SG137IU." He checks this against the paperwork Natalie sent him. "I found you!" He writes on the back of Teddy's picture as seen earlier. As he starts to put his shirt back on he sees written on his upper chest, "John G. raped and murdered my wife." He writes "Kill Him," on the back of a picture, finishing the caption. He loads his gun.

Black-and-white. Leonard never remembers talking on the phone to the person who calls. Explains that Sammy gave him insight into his own predicament. Says Sammy's story helps him to understand his own situation, but that he is disciplined and organized. This is ironic because his severe memory impairment makes it nearly impossible for Leonard to trust these two skills of his.

Color—Sammy had put in a claim when Leonard was working for an insurance company, and he was assigned to determine whether Sammy had a real disability or was faking it. Leonard walks into a restaurant. In one of the booths is a dark-haired woman wearing dark sunglasses. Leonard passes her, and she pulls him back. She tells him he doesn't remember her. He sits down. Leonard has two bad scratches on the side of his face. She says he had explained his condition at another time. She has a cut on her lip. She knows about the tattoos on his body. She tells Leonard about a license plate number that belongs to John Edward Gammell, John G. She says that Leonard wants revenge but won't even remember it. Great irony. Leonard's sole purpose is to get revenge on the person who raped and murdered his wife. He knows he might not remember it but is still driven. Even if someone tells him he succeeded, he would remember the event or the fact they told him. He's convinced that his actions can have meaning. She passes an envelope to Leonard. He has information that Natalie lost someone, and she will help him. Natalie

asks him about his wife again; she did the last time. He starts to describe her, and Natalie stops him and says not to recite the words. She asks him to close his eyes and remember her. Important moment. Natalie understands that Leonard says or describes something by rote. She hopes by closing his eyes he will tap into a memory bank still undamaged. He does so. Images of Leonard's wife (Jorja Fox) in flashback are **intercut** with his telling Natalie about her. This is a visualization of Leonard's memory of his wife. Natalie gives him an address for an abandoned, isolated building—a guy she knew deals drugs there. Natalie links Leonard to her, bonding them as survivors. In the bathroom he washes his hands and sees the message on his hand as earlier about Sammy.

Black-and-white. Leonard. Motel room. Phone. He talks about being an insurance investigator. Flashback—black-and-white—a series of faces and his voice-over about how he could tell clients were lying by looking in their eyes and watching their body language. Sammy was Leonard's first real challenge.

Color. A car. Leonard starts to pull out and sees Teddy on the car hood calling him Lenny. It's established that Leonard tells Teddy about his condition every time he sees him. These repeats in time firmly place the viewer in Leonard's damaged mind. They try to make sense of what happened as he is. Restaurant—Teddy asks Leonard about John G., if he thinks he is still in the area. Leonard doesn't know who he is. Teddy explains he's the guy Leonard is looking for. Earlier Leonard had told Teddy that maybe someone was trying to set him up and kill the wrong guy. Leonard says the police do not rely on eyewitness testimony, that memories can be distorted. This is said rationally, but what about Leonard's own memory? Leonard is determined to find the man who murdered his wife and severely damaged his memory. Leonard says he lost his keys.

Leonard walks up to Burt. He sounds like he doesn't know who tells Leonard the keys are probably in his room. Burt opens the door to Leonard's room and realizes they are in the wrong room. The envelope is there, so Leonard thinks it is his room. Burt explains it was his room, but his boss told him to rent Leonard another room, taking advantage of Leonard's condition. This gives insight towards how anyone can manipulate Leonard without him knowing about it.

Leonard goes into the restaurant as before. Natalie says, "You don't remember me?" They both have the same facial injuries as before. **Fade out** to black. This is also an earlier Hollywood convention to signal the end of a scene. It also can be a visualization of Leonard's mind unable to remember a moment any longer.

Fade in. Black-and-white. A room. Telephone. Leonard tells the story of Samuel R. Jankis, a 58-year-old semiretired accountant who was in a car accident. Flashback to Sammy and his wife (Harriet Samson Harris). Sammy

is not found definitely mentally impaired. Unable to work, his wife filed a claim. Leonard visited Sammy at his house. Sammy couldn't make new memories. He would watch TV for a couple of minutes because he couldn't remember how a show began. Sammy's wife tells him it is time to prepare and give her an insulin shot. Sammy was only able to function with pre-learned tasks. Leonard thought Sammy remembered him, but the man replied he couldn't. Leonard is suspicious and orders more tests. As the film progresses, the Sam Jankis story becomes curious. Leonard may see himself in Sammy. He may feel he has insight into whether Sammy is deceiving the insurance company. Either way, much time will be spent in a film that is essentially a murder mystery.

Color. Leonard. Bed. There are two scratches on his face. Voice-over—he's wondering where he is. Natalie is lying next to Leonard. Voice-over—Leonard doesn't know who she is. Natalie wakes up and turns to him. She touches his chest and the tattoos. She gets dressed and tells Leonard she should be able to talk to her friend about the license plate. He makes believe he knows what she is talking about. She tells him its John G.'s license plate that he has tattooed on his thigh. She leaves. He takes out a Polaroid that is referenced to Natalie. On the back is written "She has also lost someone. She will help you out of pity." Natalie comes back. She writes something down on a piece of paper. He is grateful for her help, and she says she is reciprocating because he helped her. She gives him the paper and asks if the next time he will remember her. Is she testing him or truly concerned? He nods his head no. She pulls him down to her for a kiss. He gets into his car and drives just a bit, and then sees Teddy on the hood calling Lenny.

Black-and-white. Phone. Leonard talks about Sammy's condition—he can be taught through repeated actions. It is a different part of the brain from short-term memory. Flashback—a doctor tells Sammy to pick up any three objects on a table. Sammy is combative. The same objects were electrified each time the test was administered. Motel room—Leonard on the phone. Sammy kept making the same mistakes. Fade to black.

Color. Leonard drives to a house. Dusk. Natalie comes to the door. He is angry and asks her who is Dodd (Callum Keith Rennie) as he waves a Polaroid of him with his face beat up at her. She says that she won't have to worry about him anymore. Inside she tells Leonard that he offered to help her when he saw what Dodd did to her face. He thinks again that someone is trying to get him to kill the wrong guy. Natalie takes Leonard's jacket off. Writing on his chest is backwards. She says she lost somebody too; his name was Jimmy. She shows Leonard a picture of the two of them. He left and never came back. She asks what Leonard is going to do when he finds John G., and he says he's going to kill him. She tells him she might be able to help.

Night. Natalie lies on Leonard's chest. He talks about his wife. She wasn't in the bed that night so he thought maybe she was in the bathroom. Somehow he knew she was never going to come back to bed. He touched her side of the bed, and it was cold. He gets out of bed; Natalie is asleep. Leonard walks through her house. He picks up the picture she showed him of her and Jimmy. Natalie feels his side of the bed. Leonard acknowledges that Natalie has also lost someone and will help him out of pity. He comes back and lies next to her. Cut to black.

Fade in to black-and-white. Leonard on the phone. Sammy picking up objects and being shocked. Sammy angry at doctor as before. Sammy didn't respond to conditioning at all. Enough data to show that Sammy's condition was psychological, not physical. His claim was turned down because he wasn't covered for mental illness. Leonard feels conditioning works for him, but there is no real proof of this. Fade to black.

Color. Flashes of his wife being attacked. Plastic over her face. Leonard smashed into mirror, breaking it. A bottle with blue crystals breaks on floor—Leonard in bed with a blue shirt on. He opens a drawer and finds a Bible with a pistol on top of it. He opens up the closet door and finds Dodd with his mouth gagged. Sound at the door. He looks through the eyepiece— Teddy looking in. Leonard doesn't recognize him, so he finds the picture of Teddy. He lets Teddy in. Muffled sounds from Dodd in closet. Leonard opens the closet door and reveals Dodd with the gag on. Teddy asks if that is John G., Leonard doesn't know. Leonard pulls tape from Dodd's mouth and asks him his name; he says Dodd. Leonard asks him who did this to him, and Dodd replies that Leonard did. Leonard goes to his pictures and finds the one that has Natalie's name on it. Teddy asks who Natalie is. Leonard doesn't know how he got Dodd up here. Leonard wants to leave Dodd there; Teddy disagrees because the maid will walk in and see Dodd, and she can identify Teddy and Leonard.

They take Dodd outside. Leonard has his gun to Dodd's back. They get to Dodd's car. Teddy goes to his car, and both cars pull away. Teddy is following Dodd's car. Leonard gets out of Dodd's car, Dodd drives off, and Leonard gets into Teddy's car. They drive to Natalie's house. Leonard shows her a picture of Dodd as before but doesn't seem sure that he knows her. Cut to black.

Fast fade into black-and-white, Leonard in the hotel room. He's on the phone talking about the effect of the insurance company's decision on Sammy's wife. Flashback: She tells him to snap out of it. She is very frustrated, crying and slapping him. He apologizes, he's trying to get better. Leonard on the phone—he never said Sammy was faking. Fade to black. These scenes concerning Sammy and his wife are in black-and-white because they are flashbacks. They also have an unreality to them because of the fragile narrative link that both men have mental defects. Why would Leonard remember

this so accurately? He implies his problem is short-term memory, but he is perseverating on the Sammy story, and the viewer continues to wonder about significance of this.

Color. Leonard is in a bathroom holding a liquor bottle. He looks at the scratches on his face in the mirror. He takes a shower, and hears someone coming through the front door. Dodd opens the shower door abruptly. They fight. Leonard hits Dodd in the head with liquor bottle. Leonard tapes Dodd's mouth, and drags Dodd to a wall, takes his picture, gets dressed.

Fade in from black. Black-and-white. Motel room. Leonard is on the phone explaining that to bully someone in Sammy's condition makes it harder to help him. He heats up a needle in a syringe, then puts it down and breaks a pen in half.

Color. Leonard running through a trailer park. He realizes he's being chased. Dodd shoots at Leonard but misses. Leonard gets into his car. The driver's side window is shattered. Leonard pulls out a note about Dodd. He drives to an address written there. He knocks on a door and breaks in. There is a man on the floor. Leonard realizes he read the apartment number upside down. He apologizes and sprints to another room. He uses a credit card to open it. He needs a weapon. Leonard looks around and finds a liquor bottle. He goes into the bathroom, crouches down, and closes the door halfway as he concentrates on the front door to the motel room.

Fade up from black. Black-and-white. Motel room. Leonard fills syringe with pen ink. He picks up a paper, "Tattoo: Fact 5 Access to Drugs." Fade to black. The connection between the ink-filled syringe and drugs is ironic and a bit of a joke to the viewer who was misled.

Cut to color. Dusk. Exterior. Fire burning. A desolate area by a factory. Leonard is exhausted. A car behind him beeps its horn and flashes its lights. The person in the car pulls him over. Its Dodd who pulls a gun, and Leonard peels out. Dodd follows him. Leonard has stopped. Dodd gets out of his car with his gun. Dodd talks to Leonard from outside the car. Dodd forces his way in and sits next to Leonard, who quickly gets out of his car. Dodd shoots and blows out the driver's side window, the reason for the broken glass there earlier. Foot chase. Cut to black.

Black-and-white motel room. Leonard holding Tattoo note as before. He starts to write on his body using the ink syringe. The phone rings; Leonard picks it up. Fade to black.

Cut to color. Night. Leonard drives to a factory area. He stops the car and gets out holding a brown paper bag. Gathers wood and makes a fire—puts a teddy bear on it, then a hairbrush. Flashback to wife on bed in her underwear. He pinches her. Cut to the hairbrush burning. He takes a paperback book out of the bag and smells it. Cut to wife in bed reading it. He dresses. A book burning. Short scene in flashback of the two of them talking about rereading books. Book burning. Clock. Voice-over. Leonard talks about

doing this before—he probably burned truckloads of his wife's belongings. He says he can't remember to forget her. **Dissolve** from close-up of Leonard to full shot of him still sitting in front of the fire and the burnt artifacts of his wife. Cut to black. This sequence expresses Leonard's memories of his wife. They play in a reliable fashion. The intercutting is an exorcism of sorts. Leonard hopes that by burning some of her belongings, his pain will lessen.

Fade up. Black-and-white. Leonard on the phone in the motel room. He says he has friends in the police department, that they haven't even been looking for John G.

Fade to black. Color. Leonard in bed. He turns and touches his wife's pillow. Clock. Teddy bear. He calls for his wife. He sits up on the edge of the bed and asks her if everything is okay. **Flash cut** of her being attacked. Back to Leonard, he gets up and walks to the closed bathroom door. Flash of bathroom tile floor. Back to Leonard at door. Flash of wife covered in plastic sheeting. Back to Leonard at the door asking if she is okay. Flash of the attack. Leonard opens the bathroom door and finds a blonde woman in a black dress, snorting cocaine. "Was it good for you?" He asks her to leave. The attack is vividly remembered, if this is a memory. The actions seem to match Leonard's story. By bringing his wife into the film Leonard is humanized further as the viewer sees what happened that night. The woman in the black dress is another "don't always believe what you see" moment. She appears to be an escort or someone he picked up, but *Memento* watchers are learning to wait before making judgement concerning what is happening.

Cut to color. Inside Leonard's car he is holding a note on the Discount Inn. Street. He takes a Polaroid of the Discount Inn sign. Inside his room he puts up a chart. Places the motel Polaroid on it. On the phone. He appears to be ordering an escort, saying a blonde is fine. Blonde woman in a black dress in his motel room. He gives her instructions of what to do to re-create his wife going into the bathroom, the night of the murder. He gives her the bag of wife's items and asks her to place them around the room as if they were hers. Night. They are lying in bed together. She gets up; he is in bed alone. The sound of the bathroom door closing. This is not an erotic encounter but a re-creation of the attack so Leonard might better understand what happened.

Fade in. Black-and-white. Leonard talking on the phone and tattooing the note about a drug dealer on his leg. Sammy's wife comes to Leonard's office. His wife placed food around their home and didn't feed him, hoping that when he was ready to eat, he would find it.

She wants to know if Lenny thinks Sammy is faking. She thinks if she said the right thing, he'd snap out of it. She wants Leonard to tell her what he honestly believes about Sammy's condition. Leonard says he thinks that Sammy is physically capable of making new memories. She cries, then smiles and thanks Leonard. Cut to black-and-white. Leonard on the phone in a

motel room. He feels he helped Sammy's wife; she just needed an answer. Fade to black.

Color. Teddy is sitting in the passenger seat of Leonard's car and surprises Leonard, who doesn't recognize him and starts to strangle Teddy. Leonard says he has unfinished business. Teddy tells him his business is finished and he's only here for Natalie. Leonard doesn't remember who Natalie is. Teddy tells him he just walked out of Natalie's house. Teddy says Natalie can't be trusted, she's trying to turn his situation to her advantage. Teddy tells Leonard not to go back into Natalie's house, to stay at a motel. Teddy gives him a coaster from the bar where Natalie works. Her boyfriend is a drug dealer. She works with him. He writes messages on the back of coasters and gets them to him when she serves him his drinks. Guys are going to want to know what happened to Dodd, and they are going to come after her. Natalie doesn't know anything about his investigation. Teddy wants him to write down not to trust Natalie. Teddy says to him that before the incident that's who you were—you don't know who you have become since. Teddy leaves the car. On a picture of Teddy is written "Don't believe his lies. He scratches out "Don't trust her" from the back of the picture labeled "Natalie." There are multiple realities playing out. Leonard has had interactions with Natalie and feels she can help him, but he doesn't remember them or her. Teddy is a forceful personality, but it is unclear to Leonard and the viewer whether he knows what he says about Natalie. He presents the authority of a cop investigating Leonard's case; he seems to be badgering and manipulating him.

Fade in. Black-and-white. Leonard looks under a bandage on his body while he talks on the phone and sees a tattoo that says, "Never answer the phone." Leonard asks who is on the line, and they hang up. Fade to black. All the phone call sequences are now in question because of Leonard's tattoo message and the hang-up. It appears that whoever was on the other end of the line kept Leonard talking until he asked for identification.

Color. Natalie drives up and comes in. She was badly beaten up by Dodd, and blames Leonard. He tries to calm her down. She sits down and he gets ice. Her face is bleeding. She did what Leonard told her to do. She told Dodd she didn't have cash or his illegal drugs—it was Teddy who was to blame. Dodd gave her to the next day or he would do her in, and began to physically abuse her.

Leonard wants to go after Dodd. Natalie says he will kill him. She calls him Lenny. He says his wife used to call him Lenny and he hated it. More unfolding information as to why Leonard doesn't like to hear his name shortened. He wants to know where to find Dodd. She told Dodd about Leonard's car. He was beating her so she had to tell him something. He goes out. Teddy in the car again. Teddy starts to talk—Leonard doesn't know who he is and leaps to strangle him. Cut to black.

Fade in. Black-and-white. Leonard in the motel room. Close-up on his arm and tattoo, "Never answer the phone." The phone rings in a series of shots, but Leonard doesn't answer it. He lifts the handset a bit and drops it down. He calls the front desk; tells them he doesn't want any calls. Fade to black.

Cut to color. Natalie's house—Leonard goes through a folder of information. Natalie comes in. She's agitated. She closes the curtain and tells Leonard someone is coming, calls himself Dodd. He wants to know what happened to Jimmy. She's angry at Leonard, explains that Dodd met with Teddy, there was a lot of cash, and the associates of Jimmy may have been responsible for this. Leonard says he doesn't know Teddy. Natalie wants Leonard to kill Dodd. They argue. She mentions his wife and he gets angry. She says she can call his wife a whore. She says she's going to use him. He grabs her face. She tells him venereal disease can cause short-term memory loss. She says his wife gave him venereal disease and turned him into a freak. She tells him she can say whatever she wants and he won't remember, maybe they will become lovers. He hits Natalie, sending her to the floor. She leaves and gets into a car. Voice-over—Leonard is desperately looking for a pen to write all of this down. Natalie comes into the house bleeding. Cut to black. This vicious side of Natalie is a strong dramatic turn. She is desperate because of the threat from Dodd, and she takes advantage of Leonard's memory problem in the strongest manner, literally telling him she can do anything to him and he won't remember. All this is motivated because Leonard is our narrator in the fullest sense. The gap seems to progress situations to dramatic heights and because he doesn't remember them—he is unaware and confused.

Fade in from black. Black-and-white. Leonard in a motel room uses a glass to hear what is going on in the next room. Knock on his door. It's Burt, who says that a guy is on the phone now who is a cop. He says Leonard is really going to want to hear what he has to say. Fade to black.

Color. Leonard and Natalie get out of his car and go into her house. She tells him he can crash on her couch. Leonard tells her that the police are not looking for the killer because they don't think he exists. Flashback with Leonard's voice-over. He was asleep when something woke him up. He felt his wife's side of the bed and it was cold. He gets up out of bed and walks toward the bathroom. Sounds of his wife struggling. Leonard goes for his gun in the closet. He goes to the bathroom door and breaks it down. A man with his head covered is assaulting his wife who is flat out on the floor. She is covered in plastic sheeting. Leonard shoots the attacker and goes to his wife. The attacker smashes Leonard's head into the bathroom mirror shattering it, Leonard falls to the floor next to his wife. The attack is repeated with new information concerning how Leonard was mentally injured by the assailant.

Dissolve back to Leonard telling this story to Natalie. He feels there was a second man, that somebody hit him from behind. The police didn't believe him. He tells her John G. was clever, he manipulated the crime scene so the police thought they solved the case. She says he can stay there for a couple of days. She has to go back to work. He takes a Polaroid of her. She says "My name is Natalie," and leaves. Later, Natalie comes back. She closes the curtains and says someone is coming, same as before. Cut to black. When scenes repeat, it is a sign of Leonard's memory trying to comprehend what he is experiencing. With each struggle he learns something different but is more confused.

Fade up from black. Black-and-white. Leonard in the motel. The phone rings. Someone pushes an envelope under the door. On the outside it says, "Take my call." Inside the envelope is a picture of Leonard shirtless pointing to his chest. Fade to black.

Restaurant. Natalie brings a beer to Leonard's table, it's on the house. Natalie asks him what is the last thing that he does remember. Shot of wife's eye covered in plastic sheeting. He says, he remembers his wife dying.

Black: fade up on black-and-white. Leonard is on the phone upset; he knows the caller is a cop. He talks about his condition and that cops don't believe him. He says he didn't even believe Sammy. Fade to black.

Color. Leonard comes into Ferdy's Bar. Natalie is the bartender. He orders a beer. She is cold to him. He says he's looking for Natalie. She says she's Natalie. He asks if they met before; she says "Why don't you tell me?" She knows—her boyfriend Jimmy told her about his mental condition. She tells him a cop is looking for him and that he wouldn't remember what he'd done. "Are you Teddy?" she asks. "Did Teddy send you?" He doesn't know. "Where's Jimmy?" she asks. He tells her he doesn't know.

Fade to black-and-white. Leonard is on phone in the motel. He thinks what is happening to him is poetic justice for not believing Sammy. Presumably he is talking to a police officer on the phone. Tells him how bad it is to have this condition. Flashback to Sammy's house. Wife tells him it's time for her shot. He gives it to her. She changes the time on her wristwatch. She again tells him it's time for her shot. He gives it to her. She changes the time on her wristwatch again. She says "Sammy, it's time for my shot." He says, "It won't hurt." and gives her the shot. She died of an overdose of insulin, and Sammy wound up in an institution, unaware she was gone. Back to Leonard on the phone. He says he was wrong about Sammy and about Sammy's wife; she wasn't interested in the money. She just wanted to understand his problem. Sammy sits alone in the home. His brain didn't respond to conditioning, but he wasn't a con man. Leonard says "What drug dealer?" Fade to black.

A car speeds and stops. Leonard holds a paper with a license number. Emma's Tattoo Shop. A woman (Marianne Muellerleile) gives Leonard a tattoo. The Facts tattoos. Teddy wants to know what Lenny is still doing in the

area. "Fact 6 license number." Teddy tells Leonard it is not safe for him to hang around in this area anymore. He tells Leonard about a bad cop and how he set him up, but the story is unreliable. "He's laughing at you" Teddy is a snitch. If someone knew Teddy was helping Leonard, they'd kill him. Teddy tells him to get out of here. Leonard looks at his picture of Teddy and reads "not to believe his lies." Leonard drives to Ferdy's Bar. Natalie is outside by the dumpster. She knocks on the window, and he winds it down. She looks in and says "Hey Jimmy." She says she's sorry, she thought the driver was someone else. Cut to black.

Fade in from black. Black-and-white. Leonard is in a motel room on the phone with the cop. He says Jimmy deals drugs in the bar where his girlfriend works. The cop wants to meet him in the lobby. Leonard packs and leaves, walks to the lobby. Teddy is there and calls him Lenny. Leonard calls him Officer Gamble. They walk down street. Leonard goes to takes his picture. Teddy says not here. He goes to a vehicle and stands in front of it and says "Over here." Leonard takes his picture. Leonard asks if it is Officer or Lieutenant Gamble. Teddy tells him not to write it down because he's undercover. Teddy gives Leonard directions. Leonard writes "Teddy" on the picture and his phone number. Leonard gets into an open-back truck and drives to a dilapidated building. He has a tire iron. He enters the building and looks around.

Color. Flashback. Leonard's wife is in a kitchen and walks to the window. Black-and-white. Leonard walking in building. A car drives up; a man gets out. Color. A shot of his wife earlier, sitting outside leaning against a house. Black-and-white—Leonard in a building. A man comes in looking for Teddy. Color. Quick flash of his wife. Black-and-white. Leonard looking. He says "Jimmy." A man asks Leonard what he is doing there. He's Jimmy. Leonard asks him if he remembers him, and Jimmy says yes. He asks Leonard where Teddy is. Leonard knocks Jimmy down with one punch. He drags him along the ground. He tells Jimmy to strip. Jimmy tells him he's making a big mistake. He says his associates are not the kind of people Leonard wants to get angry. He takes off his jacket, shirt, and pants. Jimmy gets panicky and says he has $200,000 in the car. Color. Wife sitting in house—voice-over—Jimmy saying, "What do you want from me?" Black-and-white—Leonard: "I want my life back." He strangles Jimmy to death. There is a color intercut of the wife during the attack. Leonard takes a picture of Jimmy dead. He changes his shirt. Leonard holds the picture. The image of Jimmy dead goes from black-and-white to color. He puts on Jimmy's clothes. They are the same clothes Leonard has been wearing throughout the movie. He puts his clothes on the body and pulls the dead Jimmy downstairs and leaves him in the basement. Somebody says, "What does he know about Sammy?" in a whisper, most likely Leonard. He runs upstairs. Someone is getting out of a car. Leonard looks at the picture of Teddy—there's no writing on back. Voice-over—Leonard: "What have I done?" He runs. He goes outside.

Teddy is there. Leonard doesn't know who Teddy is, says there's a guy inside and hurt, they need to get to a doctor. They walk inside. Teddy bends over Jimmy. Leonard pulls his gun. Teddy says the guy is dead. Leonard hits Teddy hard in the head with the butt of his gun. Leonard pulls Teddy's identification and sees that he is a cop. Teddy says he's the guy who helped him find Jimmy. They go back up the steps. Teddy says Jimmy raped Leonard's wife and damaged his brain. Jimmy knew him from the Discount Inn. It was where he supplied drugs, and the desk man tipped him off if anyone inquired. Teddy tells him his wife survived the assault. Shot of wife wrapped in plastic sheeting—her not believing Leonard's condition. Flashback of his wife and Leonard intercut with Teddy talking to Leonard. He gives her an insulin shot. Teddy says Sammy was a con man, that Sammy didn't have a wife. Leonard can't accept this and tells the story the way he had been. Teddy says Leonard's wife had diabetes. Flashback of wife covered in plastic sheeting. Sheeting pulled off—Leonard reacting. Flashback, Leonard giving his wife a shot. Leonard says his wife wasn't diabetic. Teddy says, "You sure?" Flashback of Leonard giving wife a shot. Again Leonard denies that his wife was diabetic. Teddy says he can only get him to remember things that are true like Jimmy in the basement. "He was the right guy to you." Teddy tells Leonard to enjoy the vengeance while he can still remember. They argue about whether Leonard will remember if Jimmy was the right guy or not. Teddy tells Leonard that he helped him find the real John G. over a year ago. Teddy says he was the cop assigned to the investigation of Leonard's wife's case. He says he helped Leonard find the guy who raped his wife and injured his skull. He says they found him and Leonard killed him. Teddy says he worked with Leonard to start hunting down the killer of his wife again, but he forgot he had already murdered the man. Exposition is an essential aspect of filmmaking.

Teddy says it was two junkies who didn't realize that his wife could live alone. Teddy took the picture of Lenny shirtless right after killing the rapist. Teddy says Leonard took out information from the file to create a puzzle he couldn't solve. Tells him he is John G. Leonard goes up to Teddy and puts his gun to his neck.

They go outside. Lenny takes Teddy's keys and throws them in the bushes. He gets in his car and takes the bullets out of his gun. He writes on the picture of Teddy not to believe his lies. He burns the picture of Jimmy's dead body and the one of him shirtless after he killed the man who killed his wife. Voice-over—Does he lie to himself to be happy? he says to himself that in Teddy's case he will. Teddy still looks for the keys. Leonard makes notes about the car license number. Leonard gets out of the car. He puts a bag in the other car and takes a picture of it. Teddy tells him it's not his car. Leonard says it is now. Teddy says Jimmy owns it and someone will recognize it. There's a box of money in the car, Leonard throws the gun in it. Leonard says he'd rather be mistaken for a dead guy than a killer. He gets into the car. Teddy asks him to

help find the keys. Leonard drives off. He drives. Voice-over. He has to believe when his eyes are closed that the world is still there. Intercuts of him and his wife. He says that we all need memories to remind ourselves of who we are. Streets passing by. He stops abruptly at the tattoo shop from before. He looks at the note about the license play. Voice-over. "Now where was I?" Cut to black.

What makes *Memento* so unique is that in other films the exposition comes at the end and resolves the story. Here there are answers about what happened, but they are only believable if Teddy is reliable and that Leonard's memory is not only failing but distorted, confusing Sammy's story with his. This unreliability puts everything in question.

Conclusion

Multiple screenings of *Memento* shed additional light on the meaning of the story. The film is so packed with twists and turns, and many only make sense after studying the film a number of times. The use of real time, flash-backs, black-and-white, and color are helpful to the viewer to follow and understand the story. These tropes also have complications. They may seem to have a logic at first but systems that the viewer develops can fail because their use isn't always consistent and the time frame is constantly shifting due to Leonard's deficit.

Everyone needs memories to tell them who they are. *Memento* is a search for Leonard's identity within the murder mystery. *Memento* is about changing relationships and reality. The film puts the viewer into the damaged mind of the main character. We experience the pain of amnesia and the frustration of tracking down a killer. Ultimately *Memento* concerns the nature of reality, both the one Leonard struggles with and the viewer lives every day.

Notes

1. Polaroid is an instant still photography camera that uses self-developing film to create a chemically developed print shortly after taking the picture.

For Further Study

Screen

Head
The Killing
Trans-Europ-Express
The Trip
200 Motels

Read

The Cinema of Christopher Nolan: Imagining the Impossible by Jacqueline Furby and
 Stuart Joy
The Fictional Christopher Nolan by Todd McGowan
Memento and Following by Christopher Nolan
*Story Maps: The Films of Christopher Nolan (The Dark Knight Trilogy, Inception,
 Memento, The Prestige)* by Daniel Calvisi and William Robert Rich
Under the Eye of a Clock: A Memoir by Christopher Nolan

Teamwork On and Off the Screen

Our Daily Bread

During the Great Depression[1] a young married couple, like many others, is suffering from the financial pressure of that grim period. They are given a piece of land to work by a relative, but don't know how to run a farm. Others stop by and ask if they can join in, and a collective farm is created. Things are going well when a punishing drought threatens the crops and the dejected husband runs off with another woman. While driving on a road away from the farm he hears a water source, goes back by himself and convinces everyone at the collective that working together they can bring the water to the crops. They succeed, and the story ends on a triumphant note.

Director King Vidor was born in 1894 in Galveston, Texas, where he survived the hurricane of 1900. Later, because of that experience, he wrote a fictionalized account of that event called *Southern Storm* for the May 1935 issue of *Esquire* Magazine.[2] Vidor was a **newsreel** cameraman and movie theater projectionist. He made his debut as a film director in 1913 with *The Grand Military Parade*. Starting in 1915 he worked as a screenwriter and director of six short juvenile delinquent films for Judge Willis Brown[3] before directing his first feature *The Turn in the Road* (1919). The success of *Peg o' My Heart* (1922) garnered him a long-term contract with the Goldwyn Studios that would later be folded into MGM. In 1928 he received an Oscar nomination for *The Crowd*, released that year and considered by many film critics, historians, and scholars to be one of the greatest silent films ever made. His earlier film *The Big Parade* (1925) became one of the most acclaimed antiwar

films of the silent film era. Vidor's first sound film was *Hallelujah!* (1929), which featured an African American cast.

In the 1960s, French film critics such as Francois Truffaut (see note in Chapter 3) and Jean-Luc Godard (see Chapter 3) and American movie critics like Andrew Sarris[4] were staunch promoters of the **auteur theory**, which claimed that the director was the author of a film regardless of who wrote it, shot it, designed it, or edited it. Listed as auteurs were Orson Welles (see Chapter 5), John Ford (see note in Chapter 10), Howard Hawks (see note in Chapter 10), Raoul Walsh,[5] William Wellman,[6] and others. Among those not on the list of auteurs was King Vidor, a director who had always been in total artistic control of his films and consistently embraced humane content and stories with positive points of view. Although he applied a distinctive style to every film he directed, Vidor did not have an overall style that was consistently visible in every movie. Vidor didn't specialize in one **genre** as John Ford did with Westerns. Vidor's films were not dark in their image of the human condition like some of the lionized auteurs but often hopeful and optimistic, reflecting his own nature. The films directed by Vidor were entertaining, socially responsible, and masterfully created and executed.

With *Our Daily Bread* released in 1934, Vidor, a man considered a red-blooded American patriot, found himself in some political trouble with the views he expressed in the film. Some perceived *Our Daily Bread* as embracing socialism not democracy, because those in the film lived together in a commune-like environment where each person has a skill that others can utilize. The commune is its own society with a leader, rules, and codes. Eventually the ill wind labeling towards Vidor subsided.

In order to bring water from its source to the drought-ridden crops in *Our Daily Bread*, Vidor was inventive. Because the film was made during the Great Depression there were many golf courses that were no longer in use because money was scarce for extracurricular activities. So *Our Daily Bread* was shot on an unused golf course. To portray the men digging a trench from the water spot to the crops, Vidor lined up a group of men and gave them some shovels and some pickaxes. So they would work in harmony he told them there would be a beat of 4/4: the pickaxes would swing on the 1 and 3 counts, and the shovels would dig in on the 2 and 4 counts. At first a man banging a drum in a 4/4 beat was used and the men followed while they were photographed digging the trench, then a more reliable tool was used—a metronome, a device used by musicians that produces an audible click at a regular interval set by the user.

The long and winding trench was created a section at a time, a shot at a time. Water was poured into the trench and flowed steadily by the magic of editing from the hands of editor Lloyd Nosler, making it seem that the water was traveling in a consistent pattern established by the men. This long

sequence is a **montage** driven by the onset of edits. *Our Daily Bread* is an early sound film, but there is no music in the whole movie until the water starts to flow in the trench—then the music is cued and creates a lot of excitement, which makes the images even more thrilling.

Our Daily Bread was a risk-taking film about the Great Depression because it was made during the time in which it took place, but it was not a grim look at this economically difficult period like *The Grapes of Wrath* (1940) that John Ford adapted from the John Steinbeck classic novel. *Our Daily Bread* was a positive movie about empowerment and the fruits of the land during one of America's most challenging crises.

Narrative and Cinematic Analysis

Inspired by today's headlines. Inspirational music. A man climbs steps, knocks on a door. Mary Sims (Karen Morley) answers; he is the rent collector (Sidney Bracey). She pleads for them to give her and her husband John Sims (Tom Keene) two more days. John is hiding in the hall. She phones her Uncle Anthony (Lloyd Ingraham) and invites him to dinner. John takes a ukulele to the delicatessen to trade. He gets a skinny chicken from Schultz the Butcher (C. E. Anderson), who is tired of bartering.

Fade out. **Fade in**. Sims's apartment. The uncle tells them everyone is talking about working the land. She asks if he can help John get a job. Uncle Anthony owns a piece of farm land. It is not paid up. He gives John and Mary the deed and draws them a map. Sims is known as a man with big ideas that don't always work out. They arrive at the uncle's land. There are many wipes in the film used as time transitions—the direction they move in varies. A wipe is when one image physically pushes or wipes another image off the screen. Wipes were popular at this time, but by the 1940s they were waning and eventually largely disappeared. In contemporary film the **wipe** is considered to be intrusive and old fashioned. In *Our Daily Bread* wipes are highly effective as well as an editorial transition that audiences then accepted as a device to signal a change in time.

John and Mary enter the farm house. Mary begins to clean up. They make dinner in the fireplace. Time to sleep. They are on separate "beds" they made on pine boughs. The Motion Picture Production Code[7] of the day required that even married couples could not sleep in the same bed because of the perception that sexual activity could occur. Mary asks John to come closer to her because she's afraid. He pushes his "bed" closer. At first Vidor appeared to be upholding the code but then tempted the rule by having John get closer. This couple has a real innocence, and the reason for being closer is because Mary is uneasy with their new undertaking. Vidor is establishing the closeness of their relationship. Later it will be tested.

Fade out. Fade in. John shovels dirt and is having a hard time of it. By the fence a Swedish man Chris (John Qualen) is fixing his tire. John comes over and tells him how to fix it more easily. Chris was a farmer in Minnesota and his farm was taken away by authorities when he couldn't keep up with it financially.

There is plenty of land at the site. Interior. Chris invites John and Mary to a rabbit stew dinner his wife has made. They eat outside in a tent. Chris's car had run out of gas. During the Great Depression many farmers who lost their land got in their cars and drove looking for work until they ran out of gas. Interior. Bedtime.

The idea of a cooperative farm is introduced. Signs: "Wanted 10 men with trades." Cars pour into the farm. John has the men line up. Some have trades like carpentry or masonry, others are a violinist and pants presser, but John realizes he needs everyone and they form the cooperative. Louie (Addison Richards), a tough-looking guy, says he'll run the tractor. The last person interviewed is an undertaker, bringing a deep sense of reality to the group.

At night everyone sits and listens to John getting everyone excited about what he calls "a common pot." Fire lights the scene. Diverse ideas are expressed. Chris proposes that they make John the boss.

Men marching and singing. Plows with a horse. Other men plow themselves, with cars, a motorcycle—fade to black. Building houses. Tracking skills. The violinist gives lessons to a kid for shoes from the shoemaker. A bad guy tries to take away another man's land. Louie comes over and knocks the guy out.

Houses built. Community. Things begin to grow. Chris says, "It's coming up"—a crowd forms. Frank the Carpenter (Henry Hall) gives a prayer with his arms raised up, "Our daily bread." A baby boy is born to the pants presser and his wife. Night. A band plays. People dance. Notice—the farm is for sale. Fade to black—fade up. A man holds an auction. Bid $1.85. The men from the cooperative stop others from bidding. The Sherriff (Harrison Greene) tries to stop the proceedings because he is outraged. He says the land is worth $4,000. A man in the crowd explains to him that legally the amount the cooperative is bidding is lawful. Fade to black.

Men give the farm to John. Knock. A movie stereotype, a blonde woman with loose morals enters. Her name is Sally (Barbara Pepper). Rain. They go to help the man she was with. Outside, Louie says he's dead.

John and Mary's house. Sally in a black dress goes into a room. Louie caught a guy stealing. Sally plays blues/jazz records. Mary listens.

Wipe. A communal meal. Sally sits next to Louie and mentions John is going to give her a beauty parlor. Louie retorts: "That guy's married and you lay off." Louie talks to Chris and shows him a wanted poster: he is a criminal and there is a $500 reward for his capture. Louie has a plan to be turned in

and give the money to the collective. Chris is against this plan and tears up the poster. Fade to black. Sally talks to John, and they take a walk. Wipe.

Among trees—John is upset about the lack of food. Sally gives him a check for $500 and a letter from Louie. Fade to black. Corn grows, but there is a lack of rain. Louie—the judge told about him giving money to the farm and the law will go easy on him. Drought montage—long, white, expressive letters spell out the word "drought" over the montage images. The corn is dying. Mary and Chris. Money almost gone. John in the community areas looks down; everyone gives him dirty looks. No future here. John is fed up and wants to quit. Sally playing music—Mary confronts her. Sally means more to John than his wife. Mary tells her to go. "John's going with me," Sally tells Mary. John and Mary are tense. They talk. He leaves. She tried to talk to him. Car—John and Sally. He has a vision of Louie in a prison uniform, which is shown in a **double exposure**. While driving, he swerves the car. John tells Sally to drive. Once out of the car John hears that the power station is back up and the water will be back flowing again. Sally tries to kiss him but John runs back to the farm.

Night. Late. John rings a large, circular metal ring by banging it with a metal rod. Everyone comes running out. John gives an impassioned speech about the water. Everyone is angry with him. Mary looks on. John appeals to Chris, who agrees to the plan, and the community now joins in.

They start the ditch with picks and shovels. They clear trees. A line of men. Men clear rocks. They plot the course. Chopping trees. A tree is pulled out from its roots when pulled by a car with a connecting chain. **Dissolve** to men digging.

Night. Women serve coffee. Close-ups. Sparks. Day. Chop trees. Wipe. A bridge is built, finished with tin advertisement sheets. A line of men dig in synchronization. A man is down; another man helps him up and holds onto him as they walk. Smoke—dissolve to men digging. This is an organic use of dissolve, a magical result. The choice of the two images, the smoke and the men digging, when combined appear to look as if they were one image. This transition implies the men were inside the cloud of smoke that cleared to reveal them. Women and children wait in anticipation. A large woman runs over to the line and uses a pick as the men do. A feminist statement, a moment that breaks the Hollywood stereotypes of women. The ditch is done, and the message is relayed from one man to the other spread over the area— one of these men is Vidor in a cameo appearance.

Water starts to flow and the men follow its path. A rock is in the way, and a strong man lifts it and gets it out of the path of the flowing water. Water overruns a turn—man lies down and stops this with his whole body. A leak in the bridge. John holds it up while another man repairs it. Men push dirt away to keep water flowing. Water enters the crop area. People rejoice. Men flip for joy. A motorcycle slides in mud and tips over. A farm wagon. John and

Mary and Chris celebrate triumphantly. This wide shot of them in the wagon that closes the film is epic. Corn is being picked by the people; John, Mary, and Chris are triumphant, having overcome great odds. This shot is an affirmation of Vidor's belief in the strength and good in people. The composition is framed by the clouds in the sky and the abundance of the corn they all have grown. It is the perfect ending for a movie that is rousing, humane, and fueled by the power of cinema.

Conclusion

The power of *Our Daily Bread* and King Vidor's work in general is that he was a realist who lived in challenging times, but he was in his heart and mind an optimist. *Our Daily Bread* presents personal and physical challenges to the characters and is set in one of America's darkest periods, the Great Depression. They meet the challenges with strength and unity. It was Vidor's beliefs and cinematic vision that most anything could be resolved if approached with an attitude that people are basically good, a belief in hope, to never waver from believing in the power of love, and that if everyone worked together and never gave up, they would succeed. Vidor was unique amongst his peers during the classical Hollywood studios era in that he always saw the glass full and not half empty.

Notes

1. The Great Depression was a severe worldwide economic depression that took place mainly in the 1930s originating in the United States. In most countries it started in 1929 after the stock market crash and run on the banks in the United States and lasted until 1941. Personal income, profits, and prices dropped. International trade was severely affected and unemployment rose dramatically.

2. *Esquire* is an American men's magazine founded in 1933 that flourished during the Great Depression. Political and social articles and literary works were part of the contents. Some of the literary lights who contributed to *Esquire* include Ernest Hemingway and F. Scott Fitzgerald.

3. Judge Willis Brown (1881–1931) lectured on boy's reformation during the decade of the 1910s as a judge of the Utah court. By 1917 he founded the Boy's City film company in Culver City—part film studio, part homeless shelter. He is best known in film circles for giving director King Vidor his first job.

4. Andrew Sarris (1928–2012) was an American film critic who was a leading proponent of the auteur. He practiced his craft and presented his theories in a column in *The Village Voice*. His book *The American Cinema: Directors and Directions 1929–1968* was first published in 1968 and is considered a landmark in cinema literature. It was highly debated and became a bible for American auteurists.

5. Raoul Walsh (1887–1980) was an American film director and actor. He is known for many films including *The Big Trail* (1930) that featured John Wayne's first leading role, *High Sierra* (1941), and *White Heat* (1949).

6. William Wellman (1896–1975) was an American film director notable for his work in the crime, aviation, adventure, and action genres. In 1927 he directed *Wings*, the first film to win the Academy Award for Best Picture. His films include *The Public Enemy* (1931), *Wild Boys of the Road* (1933), and *The Ox-Bow Incident* (1943).

7. The Motion Picture Production Code was a set of moral guidelines put forth by the industry that was in effect from 1930 to 1968. The major studios accepted the code written to cover violence, sex, obscene language, and other areas in detail to rid the movies of any perversity and to present life in the most wholesome manner possible.

For Further Study

Screen

Brother Can You Spare a Dime?
The Crowd
Grapes of Wrath
The Plow That Broke the Plains
Sullivan's Travels

Read

The Forgotten Man: A New History of the Great Depression by Amity Shlaes
The Great Depression: America 1929–1941 by Robert S. McElvaine
King Vidor by Nancy Down and David Shepard
King Vidor, American by Raymond Durgnat and Scott Simmon
King Vidor's The Crowd: The Making of a Silent Classic by Jordan Young

Tempo, Content, and Directorial Style

Pickpocket

This French film that can be classified as a crime\thriller concerns a young man who lives a life primarily alone until he meets a young woman who loves him. He supports himself by picking the pockets of people on the Metro and on the street. The police know about him and eventually he is arrested and put in prison, but he reaches a higher spiritual plane because of his love for the young woman and her love for him.

Robert Bresson was born in France, educated at the Lycée Lakanal close to Paris and turned to painting after graduation. Catholicism was very important to him. He was a prisoner of war during World War I and initially became a photographer. He made his first film, *Public Affairs*, in 1934. He directed only 13 feature films and was meticulous in his approach. He was unconventional and not interested in commercial success. Bresson used nonactors for his films, calling them models; he told them exactly what to do in each shot.

Bresson was a spiritual filmmaker and explored this in his films. His themes of spirituality came from his own religious beliefs. In an interview reported by Heather King on the Catholic Education Resource Center website, he once said, "There is the feeling that God is everywhere, and the more I live, the more I see that in nature, in the country. When I see a tree, I see that God exists. I try to catch and to convey the idea that we have a soul and that the soul is in contact with God. That's the first thing I want to get in my films." Bresson was often isolated from his crew; his wife and, at times, assistant director Mylene van der Mersch, would pass on his instructions to the crew.

Pickpocket (1959) was photographed in black-and-white. Michel (Martin LaSalle) writes on a page in his journal. We hear his **voice-over** with the same text. This technique was also employed by Bresson in his film *Diary of a Country Priest* (1954).

Narrative and Cinematic Analysis

Racetrack. A man with a newspaper. Michel watching. Stands behind a woman, she turns. Blank expression on Michel's face. By minimizing the expression of his actors Bresson was able to show and capture their inner souls. Opens bag. Puts hand in. He has what he wants and leaves. Elated. A police car behind him. Headquarters. Michel gives the money back, but the police can't prove anything. Back to his small flat, exhausted. Sleep. Day. Trolley. Goes to see his mother (Dolly Scal) who is ill. Sees Jeanne (Marika Green), a beautiful French girl who takes care of his mother. Gives money for his mother, then leaves. **Dissolve**. Michel meets his friend Jacques (Pierre Lemarie). Goes up to the chief inspector (Jean Pélégri). Talented men, genius should be allowed to work at their craft, Michel tells him. Jacques is Michel's only friend. He is a lonely man. Many film critics and scholars feel that Bresson was inspired by Dostoevsky's *Crime and Punishment* although *Pickpocket* is an original script written by Bresson.

Michel goes into the Metro (subway). He can't face returning to his room. Dissolve. On the train. A man with newspaper robs another man. In his flat Michel practices what he saw. Hands shaking. The man he targeted gets off train. Picks another. He looks one man in the eye. Folds paper and leaves. On a bench; he has the wallet and money.

Café. Friends talk. The chief inspector is there. Michel changes routes. Gets off the subway. After a week only has slim pickings. A man confronts him—after staring at Michel, the pickpocket gives the man his wallet back and quickly leaves the station. Michel's flat—there's a man outside. He watches Michel. Michel enters the flat and finds that the door was open. He sits on his bed. Michel lives in the most minimal of quarters. Bresson keeps the framing sparse. This is a place for thinking and dealing with moral and spiritual matters. Jacques and Jeanne enter—Michel's mother is very ill. Michel asks Jacques to go with Jeanne. The street. Michel's walks and catches up with a master pickpocket (Kassagi). Michel gets on a trolley after him. A bar. They become friends in 15 minutes.

Montage. The master pickpocket shows Michel all his pickpocket techniques. Michel exercises his fingers with a coin. Playing on a pinball machine exercises the fingers. Even though this training is for criminal enterprise, it has a magical quality, and the viewer learns the secrets of the trade. Dissolve. Michel goes home only to sleep. There is a note under his

door from Jeanne—"Come quickly." Goes to mother's apartment, enters this time. Kneels at her bed. She tells him she is dying. Michel is confronted with real life, which enters his world as a pickpocket who needs to study and prepare for his work. It's these confrontations that cause a spiritual crisis within him.

Church funeral mass. Jeanne and friends are there. He tells Jeanne, "I believed in God for three minutes." At a table in an establishment Michel sees that many people put their briefcases on the counter. The Master Pickpocket comes in, and they split the take from what they have stolen. Michel comes into his flat and finds Jacques there looking through his personal items, trying to get him to see what is right and wrong. Michel is reading a book on a legendary pickpocket from the past. Playing pinball. Any action that makes the fingers nimble is absorbed by the pickpocket. The chief inspector looks at a book Michael brought to him. He won't keep it. Dissolve.

His flat. Michel checks his room and the money hidden in a secret place. Michel steals a watch by grabbing a man's arm in crosswalk. Michel practices stealing watches. All this practicing shows diligence and patience. Michel is dedicated to a craft that will get him in legal trouble. Jacques arrives. Jeanne downstairs. Outside a café. "You're not in the real world." Jacques and Jeanne leave. Michel leaves the table. They come back. Dissolve. His flat. Michel is running and then falls. He cleans himself up. Jacques comes up to flat. He saw Jeanne home. Michel thinks his friend and Jeanne are in love. Writing and voice-over continue to be dominant in the film as a manner of entering Michel's mind, heart, and soul.

A woman with luggage. Michel is behind her. He switches her bag for a newspaper. Terminal. Uses a newspaper to steal a man's money. Michel is behind a man and steals his wallet. Police assistant in area. A tree man teamwork together. Police summons. Terminal. The Master Pickpocket is being arrested. His flat. The chief inspector comes in—he had been in the flat before and saw dust on a book. Michel was supposedly studious. A complaint was filed against Michel a year ago, then withdrawn. He stole from his mother as a young man. The chief inspector had the flat searched. Michel tries to bluff him. Michel leaves without telling the chief inspector his plans. Music. Jeanne is upset. Knowing a deed is wrong doesn't stop you. Michel asks Jeanne if he's a thief. She says "Yes." She embraces him. Music. Money in his hiding place. He leaves the flat. Taxi. Dissolve. Michel is accelerating his pickpocket activities. He is mentally and physically challenging people and the authorities to catch him.

Michel enters a train. Paris, Milano. Writing, voice-over. Music. Made good earnings but lost them on women. Back to his flat. Child on the floor— Jeanne didn't marry—didn't love him enough. Michel says he'll look after the kid. Fade to black.

Fade in. Music. Bar. Michel takes out money and gives it to Jeanne. Dissolve. Bar. A man reading papers. Track. A man makes him think he's a thief, but when Michel goes to steal his money, that man cuffs him—he's with the police. Michel lives in a world of deception, never knowing if he is watched or will come in contact with the police.

Michel in a jail cell. Jeanne visits. "You're all I have." He goes back to the cell. Why go on living? Jeanne didn't come back. **Fade out, fade in.** Jeanne back to visit. Goes into him. She kisses his hand. "Oh Jeanne, to reach you at last. What a strange path I had to take." They kiss. Close-up. Music. End. The last line of *Pickpocket* is also in *American Gigolo* (1980) directed by Paul Schrader (see note in Chapter 3) an ardent admirer of Bresson and this film, as well as the director's entire catalogue. He introduces *Pickpocket* on the Criterion[1] DVD. These words are filled with poetry and romantic yearning. They ring out from the film. It is the last line and reveals that his feelings for Jeanne were even deeper than revealed earlier.

Conclusion

Bresson's detractors complain his films are too slow in pace, delivering the narrative, and developing the characters. If a viewer is not engaged in a Bresson film, it can appear slow. If a viewer is engaged in it, the pacing and narrative development will appear perfect for the film and not at all slow. The detractors often used Hollywood films that often move rapidly with many edits, fast dialogue, and constant action as a standard. To a Bresson admirer these American films may seem too fast and unable to be logically comprehended.

Most films in general modulate the pace by presenting some fast, some medium, and some slower scenes. Bresson's films are not overly edited. Many of his shots are long **takes** that may have one pace or one modulated within that pace. The content and the point of view of the director impacts on the pace of a film. Bresson always examines these elements with an intensity towards the story and to find the spirituality within the narrative.

Morality is a principal theme in Bresson's films. He is considered a Catholic filmmaker because he puts his characters into situations that test their moral fortitude. In Hollywood films, often the rules of right and wrong are clearly defined and the audience is made aware of what the rules are. Bresson examines morality not from the outside but from the inside. The soul is all important in a Robert Bresson film. The impact on mind and body is photographed and materializes on film in detail.

Although some of the performers in Bresson films have gone on to become professional actors, such as Dominque Sanda[2] and Anne Wiazemsky,[3] all of the people in Bresson films including those two actresses started out as non-actors. He told his performers to do as little as possible, especially in terms of

expressions on their faces. He also told them precisely what to do and when. Other film directors such as John Cassavetes[4] have used nonactors extensively, but gave them more leeway to create their characters and perform on screen. Bresson put his "models" in the frame and left nothing to chance.

Bresson did not like the conventional scores of European and American films. He used classical music to great emotional effect. In *Pickpocket* he selected Jean-Bastiste Lully[5] and Johann Caspar Ferdinand Fischer.[6] The music also spoke to an earlier time while the film takes place in modern times.

There were two godfathers of the **French New Wave**: Jean-Pierre Melville and Robert Bresson. Melville[7] for his style, and Bresson because they admired the purity of cinema he produced. Bresson created himself—his films show little to no influence from other filmmakers. His deliberate pace put the viewer into a spiritual space.

Pickpocket is a film in which the main character lacks spirituality and is hollow inside. He comes alive when he is stealing from others, and through love. Ironically, by showing the act of picking a pocket and stealing in such detail, *Pickpocket* also functions as documentary on the dark art. In the end the film is about what all Robert Bresson films are about—the human face and the soul.

Notes

1. Criterion is an American home video distribution company that licenses essential and historic classic and contemporary movies and markets them to film lovers.

2. Dominque Sanda (1948–) is a French actress who has appeared in noted European films of the 1970s such as *Garden of the Finzi-Contini* (1970), directed by Vittorio de Sica; *The Conformist* (1970) and *1900* (1976), both directed by Bernardo Bertolucci; and *Beyond Good and Evil* (1977), directed by Liliana Cavani.

3. Anne Wiazemsky (1947–2017) was a French actress and novelist. She made her cinema debut at age 18 playing the lead in Bresson's *Au Hasard Balthazar* in 1966. She went on to appear in several Jean-Luc Godard movies including *La Chinoise* (1967), *Weekend* (1967), and *One Plus One* (*Sympathy for the Devil*) (1968).

4. John Cassavetes (1929–1989) was an American actor, screenwriter, and film director. He was a pioneer of **independent film**, performing in other people's movies to finance his own films in which he had total control. His films include *Faces* (1968), *A Woman Under the Influence* (1974), and *Opening Night* (1977).

5. Jean-Batiste Lully (1632–1687) was an Italian-born French composer, instrumentalist, and dancer. He spent most of his life working in the court of Louis XIV of France. He is considered a master of the Baroque style.

6. Johann Caspar Ferdinand Fischer (1656–1746) was a German Baroque composer, considered to be one of the finest keyboard players of the day. He brought the French influence to the Baroque style. He influenced both Handel and Bach.

7. Jean-Pierre Melville (1917–1973) was a French filmmaker who adopted the last name of the American author whom he greatly admired. His films include *Bob le Flambeur* (1956), *Le Samourai* (1967), and *Army of Shadows* (1969).

For Further Study

Screen

American Gigolo
Diary of a Country Priest
L'Argent
A Man Escaped
The Pickpocket King

Read

Bresson on Bresson: Interviews, 1943–1983 by Robert Bresson and Myleen Bresson
Notes on the Cinematograph by Robert Bresson
Robert Bresson by James Quandt
Robert Bresson: A Spiritual Style in Film by Joseph Cuneen
Transcendental Style in Film: Ozu, Bresson, Dreyer by Paul Schrader

CHAPTER SEVENTEEN

Nonlinear Structure
Pulp Fiction

Two hitmen go on a job for their gangster boss to kill a man. The gangster convinces a fighter to take a dive. One of the hitmen shoots heroin, then drives to meet his boss's wife, and they go to a 1950s-themed restaurant. She thinks he has cocaine and snorts it, but it is really heroin—she overdoses but is revived. Later the gangster is raped. The hitmen escape a shootout and see it as a religious miracle. While eating at a diner they run into a couple who rob the establishment. In the end the robbers get away with the money and the hitmen get to keep a briefcase.

In January 1992 Quentin Tarantino directed *Reservoir Dogs*, inspired by the **nonlinear structure** of Stanley Kubrick's (see Chapter 2) *The Killing* (1956). In 1994 he became a sensation with *Pulp Fiction* (1994).

Kubrick's *The Killing* is a crime film, the robbery of a race track. Many give Kubrick the credit for telling this exciting story in a nonlinear structure, in which the **narrative** would move back and forth in time. The reality is that the **structure** came directly from the novel *Clean Break* by Lionel White,[1] from which *The Killing* is adapted. The time jumps in *Pulp Fiction* are **flashbacks** and **flashforwards**. Flashforwards had appeared in films prior to *The Killing*, but they were not common. Flashbacks were more prevalent in older films, used to reveal why something happened or how it happened. The term *nonlinear storytelling* means telling a story out of chronological order. In literature it goes as far back as 1756 with *The Life and Opinions of Tristram Shandy*, a novel written by Laurence Sterne.[2]

The Power and the Glory (1933), which influenced *Citizen Kane* (1941), told a cinematic story in a series of flashbacks. Akira Kurosawa's[3] *Rashomon* (1950) boldly applied a nonlinear structure in which characters have different recollections of an event. This manner of storytelling was also seen in

D. W. Griffith's *Intolerance* (1916), in *Napoleon* directed by Abel Gance (1927),[4] in surrealist films, and in works by Russian filmmakers. These all came before *The Killing*, but it was Kubrick's film that influenced young filmmakers from the 1960s and 1970s.

The major thematic influence on the films of Quentin Tarantino, especially *Pulp Fiction*, is pop culture. As a kid, Tarantino endlessly watched television, listened to all sorts of music, and played board games. He worked at Video Archives in Manhattan Beach, California, where he saw traditional American movies, **kung-fu movies**, foreign films, horror, science fiction, **blaxploitation, American New Wave** films, everything he could get his hands on. All of these influences together formed the Tarantino cinema style.

The title *Pulp Fiction* references the pulp magazines and hardboiled novels popular in the middle of the 20th century. The film contains many monologues with characters talking about a number of subjects, many of them arcane. *Pulp Fiction* manages to combine humor and excessive violence. It originally was turned down by Columbia Tristar as "too demented." Ultimately, it became the first film fully financed by Miramax.

Tarantino employs flashbacks and flashforwards to create a constantly changing universe of connected narratives and characters to tell a story in a manner that would not only influence many filmmakers but would create a new narrative standard of nonlinear storytelling that would change the way that films would be structured and how they unfolded.

Narrative and Cinematic Analysis

Dictionary definition of Pulp Fiction on screen. Couple at coffee shop booth, talking about robbing banks and liquor stores. Very talky, fast-paced dialogue, a trademark of Quentin Tarantino, who wrote *Pulp Fiction* in his own vocal cadence. The man, Pumpkin (Tim Roth) asks for coffee "Garçon," French for boy servant, but here the server is female. He is British. So is his partner Honey Bunny (Amanda Plummer). They kiss and exchange love messages. Then both pull guns and yell into the room about a robbery. **Freeze frame**.

Surf guitar. Miramax. A Band Apart, Tarantino's production company, is a reference to and a tribute to *Bande à part* (*Band of Outsiders*) directed by Tarantino's **French New Wave** hero Jean-Luc Godard (see Chapter 3). Sally Menke (1953–2010), Tarantino's longtime editor, made a lasting contribution on this film by carefully structuring the movie along with the director. This is a particularly challenging movie from an editing standpoint because the time-altering structure was written into the film by Tarantino. Finalizing the experimental nature of the narrative structure involved translating that editorially by reading the film as it was shot, which is already an interpretation of the script presenting its own challenges.

Jungle Boogie is just one of the pop songs used in the song score. This approach provides more than music but also commentary from the lyrics as well as comments on the period while providing a sonic atmosphere. Jules (Samuel L. Jackson) and Vincent Vega (John Travolta) are in a car. Vincent talks about his trip to Amsterdam. Beer at McDonalds. Royale with Cheese—what a cheeseburger at a McDonald's is called there. Mia Wallace (Uma Thurman), the wife of Marsellus Wallace (Ving Rhames), was in an unsold pilot as an actress. Schooling by Jules about the television pilot system. Tarantino is constantly providing pop culture information. His interjections are comparable to the footnotes in a nonfiction book. Continued very talky. Tarantino is able to present a flow of dialogue captured in a lively cinematic style. Elevator. Hall. They walk and talk about a foot massage incident, then stop, then go. Not time yet. They pass the door of an apartment still talking about the foot massage incident. A man was thrown out of a window because he gave Mia a foot massage. Back to door. More talk about what it means to give someone else's wife a foot massage. There is a moral code here that appears to be a bit harsh. Marsellus is out of town. He told Vincent to take Mia out, but not on a date.

Door opens, they enter. One of the men inside, Brett (Frank Whaley), is eating fast food. Jules tells him they represent their business partner, Marcellus Wallace. Brett eats a Big Kahuna Burger. Jules asks if he can try it. The guy who let them in is standing against a door. There's a guy lying on a couch who says that what they are looking for is in the cupboard. There Vincent finds a briefcase. In a tight close up he runs the security code and opens it. Vincent reacts, but the camera doesn't show what is inside. He confirms to Jules that they have it. Brett says they are sorry that things with Mr. Wallace went wrong, that they went into it with the best intentions. Jules shoots the guy on the couch. Jules gets into a tirade with Brett over what Marsellus looks like. Finally Brett describes Marsellus Wallace, and Jules says does he look like a b**** because you tried to screw him. Lots of four-letter words and slang in the film. Tarantino created his own linguistic patter. Brett is shot in the arm. Jules recites a quote from the Bible about vengeance. Both Jules and Vincent fire many bullets at Brett. Slow **fade out** to black. There is a lot of violence in the film, most of it is unrealistic and cartoonish.

Pulp Fiction has chapter headings like in a novel. There is precedent for this technique. Most likely Tarantino was influenced by his movie hero Godard, who often applied this to his work.

Vincent Vega and Marsellus Wallace's Wife

Bar. Basement. Marsellus is talking. Butch (Bruce Willis) is staring. Very long take. Marsellus talks about boxers and Butch's career. It's over. Fighters are unrealistic. Holds up an envelope. Butch pushes it away. Then he goes to

take it and Marsellus holds onto it, then lets go. Marsellus is seen from behind. There is a Band-Aid on his neck. Butch is a boxer. This is a deal to throw Butch's next fight in the fifth round. Butch accepts the deal. A man opens the door and lets Jules and Vincent into a bar. Jules has the briefcase. They sit at the bar. On the opposite side, Marsellus talks to Butch. At the bar there is talk about Vincent taking Mia out. Butch comes to the bar and gets into a staring situation with Vincent. Vincent indicates to Butch that he is washed up. On the other side Marsellus and Vincent greet and hug each other. Butch stares over at Vincent. Fade out to black.

Fade in from black. Jody (Rosanna Arquette) and another woman talk about piercings. Vincent asks her why her tongue is pierced—she says it's sexy, a sexual reference. Lance (Eric Stoltz), a redhead, longhaired guy, calls Vincent Vincenzo. They go into a room. Lance sells heroin. He says cocaine is dead and that heroin is coming back big. Vincent buys a bag. Lance heats up the drug. Vincent shoots up. Flashforward of him driving high, **intercut** several times with the shooting-up process. Black. Surf music. The cocaine-heroin issue represents a change in underground culture.

Vincent walks to house to pick up Mia. There is a note on a glass door. As he reads the note there is **voice-over** of Mia saying the words of the note out loud. Microphone intercom. She tells Vincent to make himself a drink. "Son of a Preacher Man" plays. Security camera. This home is a moviegoer's image of a drug dealer's digs, ostentatious and in bad taste. He makes a drink. She sets up and snorts cocaine. Record. Car. They go to Jack Rabbit Slim's eatery. Red car. A man who looks like Ed Sullivan.[5] Interior. Restaurant. A waiter is dressed like Zorro, the masked vigilante character of literature and television who captured bad guys and was known for his mastery of the sword. A Marilyn Monroe look-a-like is a waitress. James Dean is a waiter. Old movie posters are on the brick walls. Customers are seated and served in tables made from vintage cars. Buddy Holly is their waiter. A short bell boy in a red jacket says, "Call for Philip Morris," a reference to an iconic 1950s television commercial. The Durward Kirby[6] Burger is on the menu. Vincent is wearing a Western tie. He orders a bloody-as-hell steak. This menu item is named after the director Douglas Sirk, a master of melodramas and the woman's film. Tarantino delights in film history references. She calls him Vince. They order a Vanilla Coke and five-dollar shake. He takes a sip of her shake. Mia plays with the cherry in her mouth. There is silence between them, which she says means they are comfortable with each other. He makes a joke about it. She goes to the bathroom. Marilyn's dress goes up as an homage to *The Seven-Year Itch* (1955). Mia snorts cocaine in the bathroom's line of women. "What did you think happened to Antoine?" he asks her, referring to the mysterious foot massage incident. She replies, "Foot massage." She denies that a man was thrown out of a window for touching a wife's feet. Twist dance contest. Mia raises her hand and they enter the competition. Old school dance moves. Reference to Travolta being a dancer, most notably in *Saturday Night*

Fever (1977). They win the trophy. Fade to black. This scene is memorable because it takes place in a movieland of pop culture and movie memories. The dance is entertaining and the dialogue further reveals the character. The characters in *Pulp Fiction* are fast talking, full of culture references, witty, clever, and hip.

Back at Mia's house. She has the trophy. She goes to a reel-to-reel tape recorder to put on music. Vincent announces he's going to the bathroom. Reel-to-reel tape plays "Girl, You'll be a Woman Soon." She dances. Vincent is talking to himself in the bathroom about having one drink and then going home without being rude. Back to Mia. Vincent talking to himself about morality. She smokes a joint. The coat she has on is Vincent's. She reaches into a pocket and pulls out the bag of Vincent's heroin. He continues to work out his plans. She sets up the heroin thinking she is going to snort cocaine again. She takes off her jacket and snorts the white powder. She immediately gets a nosebleed and her eyes turn upward and become glassy. Mia is losing consciousness. **Fade to black**.

Mia is bleeding from her nose, drooling, head back. Vincent panics and picks her up. Car. Vincent driving wildly. Mia is unconscious, Vincent yells to her not to die on him. This is not totally humanitarian, he is worried about what Marsellus would do to him if she overdoses. He dials his cell phone. Lance is in his house in bed watching TV. Eventually Lance gets up and answers the phone. Vincent says there is big trouble and that he is coming to Lance's house. Lance tells him not to bring her to his house. Vincent arrives, crashing the car into Lance's house. They argue, eventually they bring Mia into the house. Jody gets out of bed. Mia is in an overdose. She is laying on the floor. Lance gets his little black medical book. Jody and Lance argue. Lance says they have to give her an adrenalin shot. Huge needle. The spot where the needle should go is determined with a red magic marker. Has to get through her breastbone into her heart. Vincent stabs her on the red spot with the needle and Mia suddenly comes to consciousness. She jumps up. The needle is still in her chest. This is all high theater, not realistic and played to the hilt by all. At her house they vow to keep this incident secret by shaking hands. She goes into her house. Vincent blows her a kiss. He goes home. Fade out to black.

Television. *Clutch Cargo*. "The Arctic Bird Giant" episode. Image of an animated Eskimo. This series ran from 1959 to 1960. It was **limited animation** and used Synchro Vox optical technique to put human lips moving to the dialogue on to the mouths of the animated characters. Interior of a house. A little boy is watching the show. Captain Koons (Christopher Walken) accompanied by the boy's mother enters the room. The boy shuts the set off. Mother tells him Captain Koons was in a prisoner of war camp with his daddy. He stands in front of the boy and talks to him. Vietnam. They were in the camp for a long time. Boy is Butch who grows up to be the boxer played by Bruce

Willis. Captain Koons has something for him. He has a watch. During World War I, his great grandfather had the watch. For War World II his Grandad got the watch. He was killed. The watch was delivered to his son who was an infant. Watch was on father's wrist when he was in Vietnam. Captain Koons had the watch up his behind. He gives little Butch the watch.

Grown Butch the fighter jumps up in a room. A man says its time. Fade out to black.

The Gold Watch

Alley. Esmeralda Villa Lobos (Angela Jones) is listening to the radio in her cab. The announcer says that the other fighter in the bout with Butch is dead. Butch did not throw the fight even though he was paid to take the dive in the fifth round. Butch jumps out a window onto a roof. Esmeralda peels out. Vincent and the man who was behind the bar in the earlier scene when Butch accepted the deal walk through a hall. They knock on a door. Marsellus is seen again from behind. Mia is standing near the doorway. There is a man on a table. Butch is in the cab and he takes off his boxing uniform. The woman listening to the radio is driving a cab. Butch first learns the other fighter is dead. She wants to know what it's like to kill a man. He doesn't feel the least bad about what he has done. He talks to someone named Scotty in a phone booth. He's going to be rich and prosperous. Butch gets out of the cab. Gives Esmeralda money and she is not to say she drove him.

Butch in room. Woman on bed. She is Fabienne (Maria de Medeiros), Butch's girlfriend. He gets into bed with her. She gets on top of Butch. They kiss. She asks if everything went as planned. Retiring. They kiss. She knows they are in danger of being killed. They want to be together forever. Fade to black.

Butch is in the shower. Fabienne dries her hair and brushes her teeth. He dries off with a towel. She has an accent. He lays on bed. Fade to black.

Fade up from black. He jumps up in bed—motorcycle movie on the TV. She gets him out of bed. Says what she wants to eat for breakfast—blueberry pancakes. She gets him up and out of bed. Butch can't find his watch. Reminded her to get his watch. Says his father went through a lot to get him that watch. She's sorry. She's not sure if he told her to bring the watch. Butch goes berserk, throws the TV and other items in the room around. He apologizes. He tells her he has to go back to his apartment to get the watch. Gives her cash for breakfast. This connects to the previous chapter.

Car. Butch is angry out loud at her forgetting his watch. At Butch's place. He walks along the side of building. Through a lot. Walks into a doorway and along a balcony. Key in the door. Inside the apartment. Gets the watch, puts it on. Looks in the kitchen. Finds a gun with silencer on counter. Vincent walks out of bathroom. Butch shoots Vincent. Butch hears beeping, goes

into bathroom. Vincent is in bathtub bloody and dead. Butch wipes finger-prints from the gun, then leaves.

Butch walks outside and into a car and drives off. He stops for a traffic light. Marsellus is in the crosswalk. They see each other. Butch runs Marsellus over with his car. Fade out to black.

People standing over Marsellus on the ground. He gets up. Bystander (Kathy Griffin) points out who hit him with a car. Marsellus pulls out a gun and the crowd quickly disperses. Butch bleeding in crashed car. Marsellus aims gun but shoots female bystander. He chases Butch on foot, both are injured.

Interior of a pawn shop, Butch runs in. Man behind the counter. Marsellus comes running in and they begin to fight. Butch has Marsellus on the floor punching him hard. Butch pulls Marsellus's gun and points it at him. The counterman pulls a rifle and aims it at the two of them. Tells Butch to toss his weapon, which he does, and tells him to get his foot off of Marsellus whom he identifies with the N word. He orders Butch to put his hands behind his head. The counterman hits Butch with the butt of his rifle and knocks him out. He makes a call. Fade to black.

Basement. Both men are tied up in chairs with balls in their mouths. Gasoline is poured on them. Doorbell rings. Counterman goes upstairs. Cop comes down. Sits in chair opposite the two. Counterman goes into back room and takes out man with hood. Cop decides who is going in the back by pointing to them back and forth by reciting a racist version of a children's rhyme. Picks Marsellus. Puts Marsellus in back. A man with a black hood and leather outfit is chained in front of Butch. The backroom door closes. The counterman and the cop are with Marsellus. Butch gets his hands free, knocks out the man in leather. Butch goes upstairs and gets the key and goes to the front door. He hears the noises coming from the back room. He decides not to leave by himself. He finds a hammer, puts it down and picks up a baseball bat, drops that and picks up a chainsaw, puts that down and takes a sword down from the wall. He goes back down to the basement and goes to the backroom door. Butch opens the door. Marsellus is being anal raped by the cop. Butch slashes the counterman. He holds the cop at bay with the sword, challenging him to go for his pistol. Marsellus is now free and has the rifle, and blows the cop away. Marsellus is going to call his crew to plier and blow torch these guys. Butch and Marsellus are cool together—don't tell anyone about this—leave town tonight and stay gone. Butch agrees and leaves. Motorcycle. Butch drives off. He drives to his girlfriend and she cries. She gets on the motorcycle. They ride off. Fade to black. Tarantino has been roundly criticized for using the N word here and in many of his films. It can be read that the characters saying the word are people who are deeply prejudiced and would say it. Heavy use of the word can appear suspect and insensitive.

The Bonnie Situation

This is the same sequence as earlier when Jules and Vincent go into the apartment to retrieve the case for Marsellus. The perspective has changed. It starts with a guy in the bathroom with a pistol, and through the door he can hear Jules reciting the Bible verse as he did earlier. Now the room with Jules finishing up the verse and again shooting Brett. This time there is an intercut to the man in the bathroom. Marvin (Phil LaMarr) is sitting on the floor traumatized about the killing. Guy from the bathroom comes out shooting, then runs out of bullets. Vincent and Jules look down. They have not been hit. They both blow him away. There are bullet holes in the wall behind them. Jules says it wasn't luck, it was divine intervention. A miracle. God came down from heaven and stopped the bullets from hitting them. We should be dead, it was a miracle, Jules says. They leave and let Marvin out. Tarantino is constantly playing with time in this film and the ways a scene can be presented in terms of **point-of-view**.

Marvin is in the back seat of a car. Front seat, Vincent and Jules talking. Jules is driving. Jules says he's retiring, telling Marsellus today he is through. Vincent asks Marvin his opinion about what they are talking about when Vincent's loaded gun accidently goes off and kills Marvin. There is blood all over them and the car. The two men argue over the incident. Jules calls his partner Jimmie (Quentin Tarantino). They are now in a house trying to clean the blood off their hands and faces. They argue again, this time over Vincent getting blood all over a towel. Vincent and Jules in Jimmie's kitchen drinking coffee. Jimmie is in a robe. Jimmie doesn't want to hear about how good his coffee is but about the dead, he uses the N word, in his garage. Both Vincent and Jules are a bloody mess. Jimmie says the N word a lot. Here it is the writer-director of *Pulp Fiction* saying this **on-screen**, directly associating himself with the racial epithet.

Jimmie is very angry. Jimmie's wife is coming home in an hour and a half. He doesn't want her to see a dead body in their garage. He says she will divorce him if she does. He tells Jules to make some phone calls. Marsellus is on the phone talking to Jules. Fantasy sequence of a black female nurse (Jimmie's wife) walking in on them carrying a dead body. Back to reality. Marsellus is outside at a seaside table talking to Jules. Mia walks over with a drink and sits next to him. Tells Jules that the Wolf should be coming directly. Jules calms down when he hears the Wolf is coming and hangs up the phone in Jimmie's bedroom.

Outside. The Wolf (Harvey Keitel) is on a bed on phone taking information. There are a lot of people in his home in the other room. Marsellus gives the impression that he already talked to the Wolf, so this is a flashback. He says he'll be there in 10 minutes.

Lower area of the screen: "nine minutes thirty-seven seconds later . . ." another literary device injected into this highly cinematic work.

The Wolf's car speeds from very far back in the frame to a close up and stops. The Wolf is at Jimmie's house. He talks to the boys; tells them he solves problems. They have 40 minutes. Asks for a cup of coffee. The Wolf ask Jules a series of questions about the car. The Wolf tells them to put the body in the trunk. Asks for cleaning products and to clean the inside of the car. Then scoop up all the little pieces of brain and skull, wipe down the upholstery. Soak up all the blood. Tells Jimmie he needs bedding to camouflage the back seat of the car. The Wolf tells everyone to go to work. Vincent wants a "please." The Wolf tells them time is of the essence. Camouflage. The Wolf is on the phone saying the car will be there in 20 minutes. Jimmie has the bedding but tells the Wolf it's their best and was a present from relatives. He established that they weren't rich but Marsellus is. He gives Jimmie cash. Jules and Vincent clean the car. They argue about cleaning the mess up. The car is cleaned. The Wolf inspects it. Clean. Vincent and Jules strip because they are covered with Marvin's blood. Jimmie gives them garbage bags. The Wolf washes them down with a hose. Towels. Fade to black. Fade up from black. They have T-shirts on. All through this scene the Wolf is dressed in a black tuxedo, white shirt, and black bow tie, indicating that he left a party. Apparently the Wolf is available at any time for his highly specialized skills. Dead body in trunk with a bag of bloody clothes on top. The Wolf tells them the driving plans. He'll be driving the car with the body. Monster Joe's Used Auto Parts. The Wolf is with Raquel (Julia Sweeney), the daughter of the owner. The Wolf drives off fast. Jules suggests they call a cab. The go off to breakfast.

Exterior. Grill. Breakfast. Coffee shop from the beginning. Jules and Vincent eat breakfast and talk. Miracle. Jules says he felt the touch of God that morning when the bullets didn't hit them. Jules thinking about quitting the life. He says he will give the case to Marsellus then walk the earth. Reference to television show *Kung Fu*. Repeat of Pumpkin, also known as Ringo, saying "Garcon." Vincent goes to the bathroom. Robbery starts again and continues. *Pulp Fiction* is in a time continuum. This is not a straight continuation of the early scene, so Tarantino uses an alternate linear structure to present different perspectives and views of action. Honey Bunny, known as Yolanda, and Pumpkin, who has a gun, run around the place menacing people. Pumpkin tells the manager to talk to the customers, he has his gun on him. Vincent still in bathroom. Wallets out. They are collected in a garbage bag. Jules has his gun out hidden below the table—Pumpkin sees the suitcase, takes the case, and opens it. Bright light emanates from it. This is not explained. Jules grabs him, holds his gun on Pumpkin. Honey Bunny holds her gun on Jules. Jules says they should be like three little Fonzies (a reference to the character the Fonz, played by Henry Winkler on the hit television series *Happy Days*)— be cool. Gun on Pumpkin. Pumpkin goes into the bag and finds Jules's

wallet, says Bad Mother F*****. Vincent out of the bathroom and holding gun on Honey Bunny. Jules gives him $1,500 of his own. Buying your life. Didn't know what the passage of the Bible he had recited meant, but now he understands. Trying real hard to be the shepherd. The two crooks leave. Jules and Vincent say let's leave. Once again Dick Dale plays surf guitar. Jules and Vincent put their guns in their shorts. Black.

Conclusion

Jules's presentation of biblical verse is supposed to be Ezekiel 25:17. It is not an accurate reading but a reworking; in fact some of the themes he incorporates are reworked from other parts of the Bible. The recitation works for the character of Jules and the situations he found himself in. The dialogue is not a biblical quotation that is theologically correct, but eloquent words that connect a personal interpretation of the holy book with a man looking for salvation.

Quentin Tarantino has a cinematic vision culled from a lifetime of absorbing and being delighted by pop culture. *Pulp Fiction* certified Tarantino as a superstar director and a favorite for those 30 and under who saw him as their voice in the movies. As stated Quentin Tarantino did not invent nonlinear structure in motion pictures, but he did find a new and inventive way to achieve it. After *Pulp Fiction* many films followed suit including *Lone Star* (1996), *Lost Highway* (1997), *Gummo* (1997), *Run Lola Run* (1998), *eXistenZ* (1999), *Aratat* (2002), and *Elephant* (2003). Nonlinear structure in movies takes the classical **linear storytelling** and makes it hypercinematic, presenting the audience an exciting and memorable experience that is pure film.

Notes

1. Lionel White (1905–1985) was an American journalist and crime writer. Several of his works were adapted into movies. His books include *The Snatchers* (1953) filmed in 1968 as *The Night of the Following Day*, *Operation–Murder* (1956), and *Steal Big* (1960).

2. Lawrence Sterne (1713–1768) was an Irish novelist and an Anglican clergyman. He published many sermons, wrote memoirs, and was involved in local politics. He also wrote *A Sentimental Journey Through France and Italy*, a novel first published in 1768 as Sterne was facing death.

3. Akira Kurosawa (1910–1998) was a Japanese film director and screenwriter who was highly influential in the history of film. He directed 30 films in a career that spanned 57 years. Many considered Kurosawa a Japanese director who was very Western. He made period and modern-day films, films about Japanese culture, and adaptations of classic novels. His motion pictures include *The Idiot* (1951), *Seven Samurai* (1954), and *Ran* (1985).

4. Abel Gance (1889–1981) was a French film director, producer, writer, and actor. A pioneer in the theory and practice of **montage**, Gance was an experimentalist who used radical visual technique to create a film narrative. His work includes *J'accuse* (1919), *Lucrezia Borgia* (1935), and *Lumière* (1953).

5. Ed Sullivan (1901–1974) hosted *The Ed Sullivan Show*, a vaudeville-like show for television that presented a wide range of acts for the whole family. It was broadcast by the CBS Television Network from 1948 to 1971.

6. Durward Kirby (1911–2000) was an American television host and announcer best associated with *The Gary Moore Show* during the 1950s and *Candid Camera*, which he cohosted with the creator and participant in the stunts, Alan Funt, from 1961 to 1966.

For Further Study

Screen

Amores Perros
Elephant
EXistenZ
The Hours
The Killing

Read

Quentin Tarantino by Jami Bernard
Quentin Tarantino by Wensley Clarkson
Quentin Tarantino: The Cinema of Cool by Jeff Dawson
Shoot Like Tarantino: The Visual Secrets of Dangerous Storytelling by Christopher Kenworthy
Story: Substance, Structure, Style, and the Principles of Screenwriting by Robert McKee
Unraveling Non-Linear Storytelling: Case Studies by Nobayah Modh Suki

CHAPTER EIGHTEEN

The Camera as Instigator
Seconds

Directed by John Frankenheimer and photographed in black-and-white by master Hollywood veteran James Wong Howe, and starring the then middle-aged superstar Rock Hudson, *Seconds* (1966) is by no means a certifiable horror **genre** movie, but ranks as one of the scariest movies ever made.

John Frankenheimer began his career directing live television at the CBS network. During the 1950s Frankenheimer directed over 140 episodes of programs such as *Playhouse 90*,[1] *Climax!*[2] and *Danger.*[3] He was known to be fast and very inventive with the camera and live editing. He moved into directing feature films in 1957 with *The Young Stranger*, and directed six more films including *Birdman of Alcatraz* and *The Manchurian Candidate*, both released in 1962, before helming the groundbreaking *Seconds*.

Rock Hudson was perfect in the role of an older man who we see as a youthful male after experimental operations transform him from middle age to the prime of life. Hudson was a matinee idol: tall, dark, and handsome, and an experienced actor. Frankenheimer was taking a huge risk with the casting because Hudson was known as a heartthrob starring in lighter fare, such as his movies with Doris Day in *Pillow Talk* (1959), *Lover Come Back* (1961), and *Send Me No Flowers* (1964). His performance in *Seconds* was amplified by the audience's surprised reaction to the superstar playing in such a dark, off-beat, dramatic film.

Seconds is about a man who is dissatisfied with his life and wants a new one. He is contacted on the phone by an old friend who leads him to a company that will give him a new body, a new name, a brand-new face and lifestyle.

Actor John Randolph plays Arthur Hamilton, a middle-aged man who's long married in a passionless relationship. He withholds information from

his wife about secret phone calls he has been getting and decides to explore the process of becoming a new, younger person by listening to that voice on the phone and heading to New York's teeming Grand Central Station from his Westchester home.

The cinematography in *Seconds* features brilliant experimental camera-work that is inventive and groundbreaking. Howe had accomplished what experts consider superlative work in many movies throughout his career including *The Adventures of Tom Sawyer* (1933), *King's Row* (1942), and *Body and Soul* (1947), but the Grand Central Station sequence in *Seconds* is a tour-de-force of innovative camera movement including application of unusual angles, floating **handheld camera** shots, and optical distortion that would have made any back-in-the-day Hollywood movie mogul scream to have the director of photography and the director fired on the spot. *Seconds* looks like it was shot by a young, risky cinematographer who really knew lenses, but Howe was born in 1899 in China. He settled in the United States in 1904. As a child he was given a Kodak Brownie camera, which sparked his interest in photography. He considered becoming a bantamweight boxer, hoped to go to aviation school but ran out of money, and had several odd jobs in Los Angeles including as a delivery boy for a commercial photographer. Howe met a boxing friend who was photographing a Mack Sennett[4] short. He landed a job at the film lab at Famous Players–Lasky Studios.[5] Later he was called to the set of *The Little American* (1917) to work as an extra clapper boy, which brought him to director Cecil B. DeMille.[6] The legendary director was taken by this diminutive Asian boy smoking a cigar; he kept him on and eventually made him a camera assistant, which led to Howe's sterling career as a leading Hollywood director of photography.

The title sequence in *Seconds* is a masterpiece of the cinematographic art, imagined and realized by the creative vision by Saul Bass, best known not only for his work with older directors like Alfred Hitchcock,[7] Otto Preminger,[8] and maverick independent Robert Aldrich (see Chapter 6) but also for being adopted by **American New Wave** giant Martin Scorsese (see note in Chapter 3), the elusive and brilliant Stanley Kubrick (see Chapter 2), and African American director John Singleton on *Higher Learning* (1995). The *Seconds* main title sequence has a distorted, liquid quality that sets up the viewer for a unique and startling cinema experience. It contains tight, contorted moving shots of the face, slowly moving from one feature to another in a series of angles, pulsing with the rich application of black and white, all to music by Jerry Goldsmith[9] that is gothic and unnerving.

As the story progresses it is established that Hamilton had been recommended to a clandestine company that provides people youth and new identities through radical surgery and psychological reprogramming. Hamilton wants to say no, but the company drugs him and puts him into a simulated situation that they film to blackmail him into thinking he may have raped a

young woman. Forced to comply, he is turned into a young, very handsome man, Tony Wilson, at which point Rock Hudson takes on the leading role in one of the most challenging, surprising, and exciting parts of his successful career.

Mavericks remain mavericks regardless of their age—it's the way they see the world and their art. Howe always found the camera style that fit the story of the film being made. Because of the unusual nature of *Seconds*, which was adapted from a novel by David Ely, Howe instinctually knew he would have to pull out all the cinematographic stops to create the right style for what would become an experimental horror/drama. His palette included lenses that distorted the image, erratic moving camera work, high-contrast lighting, and inventive compositions. Hidden cameras were used to achieve realism and to work in public spaces and tight close-ups explored human terror. Howe's astounding work on *Seconds* was nominated for an Academy Award.

John Frankenheimer was a man of strong morals who had despised the Hollywood Blacklist[10] that by 1963 had done its major damage, although it managed to exist until the end of the decade. To make a statement, Frankenheimer embraced many who had been victims of that witch hunt including John Randolph, Will Geer, and Jeff Corey, and gave them significant parts in *Seconds*. Some film critics and movie scholars posited that the main character's reluctance to get a recruit for the company that transformed older men into handsome younger men was a metaphor for those brave souls that resisted the House Un-American Activities Committee (HUAC) during the Hollywood Blacklist era, which insisted those called to be interviewed name names of others who they felt were communists in order to save themselves.

Narrative and Cinematic Analysis

Twisting eye, stretching images of features of a face—moves into a mouth. Church organ. Ear. Titles. Face in gauze. Distortion clears. Grand Central Station. Arthur Hamilton (John Randolph) is followed by a mysterious man. Low follow shot. Handheld camera. Hamilton walks in track area. Follower partly seen in a cut-off composition. Hamilton is handed a piece of paper by this man, then gets on the train. Doing crossword puzzle—distracted. Opens paper, there is an address on it. Skillful hand-held camerawork. Sweating. View out window direction changes. Scarsdale, a suburb of New York in Westchester County. Station wagon. His wife Emily Hamilton (Francis Reid) picks him up and they drive home. Has a daughter. Emily asks him about the phone call last night. Paper reads 34 Layfette Street. Night—phone. Charlie Evans (Murry Hamilton) proves who he is. Gives details. Tennis picture. Tennis trophy. What do you have now? Referring to Arthur's current life. Study. Arthur in bed with wife. She questions him. Ted Haworth,

a Hollywood master, created and executed the progressive production design. Separate beds (still complying with the Production Code's insistence that married couples in a movie sleep separately, not in a single bed that could imply that they may have sex). Emily is in a nightgown. She sits on his side with him. Kisses him, but he's not responding. Lights out. His eyes are still open.

Arthur Hamilton works at a bank. He has trouble dictating a letter to his secretary. Dry cleaners: an old man pressing clothes. Introduces himself as Wilson. He was told by his friend to use that name. Edgy. Leaves, then the old man finally speaks and gives him a new address because they moved. Meat factory. He arrives, a man knows his name. He is given a hat and butcher's coat. He is led to a large truck. Meat Packing Company. Short ride. Directs him to an elevator. Hall. A woman greets him by name. Arthur drinks a beverage and becomes out of sorts. He is now moving in a distorted room where a beautiful young woman with long hair in a black negligee is in a bed and frightened as he approaches. Arthur wakes up back in the office. Walks out. The elevator has no buttons or floor markers. Goes in room where many other men are waiting. Arthur tries to get out. Man in a white coat calls and tells him to go to the end of the corridor. Greeted by Mr. Ruby (Jeff Corey, who became a well-respected acting coach after he was blacklisted). Sits in chair. Mr. Ruby sits behind his desk. Service costs $30,000 which is over $200,000 in 2018 dollars. Ruby discusses the details and circumstances of Arthur Hamilton's death. Dinner brought in. Ruby suggests an accident carefully staged. In the midst of these details, which are very troubling to Arthur, Ruby remarks that the kitchen bakes cheese into the chicken so it's crispy. Hotel room fire is the death selection. Reverse side of room is an Old Man (Will Geer) who says he's a trustee. Money will go to his wife and daughter and to him in his new life. Arthur is reluctant to sign. The Old Man shows Arthur the film of him ravaging the woman from earlier. Insurance. The Old Man tells Arthur that he doesn't want to go back. Two shot (a shot containing two people). Money for a new life. Arthur says he's going to be president of the bank he works at. He talks about his wife wistfully. This is a very long, single take. The Old Man tells him about the dreams of youth and that he and his wife can't help each other anymore. Arthur signs the contract.

Operation. John Randolph is in the movie for approximately 35 minutes. Graphic details of operations. Drawing plans of Arthur Hamilton's face to Rock Hudson's face. Newspaper clip of Hamilton's death. Dr. Innes (Richard Anderson, who later ironically starred in the television series *The Six Million Dollar Man*, which concerned a man who was rebuilt) masterminds the surgical transformation. Hudson's face is covered in bandages. Later the bandages are removed. Rock Hudson is seen from behind the doctor. He is turned towards a three-part mirror. Scars. Hamilton looks totally different, younger, and very handsome. Hudson is now a rebuilt version of Hamilton.

Montage of physical conditioning. Guidance. Audio tape made under medication. He is told he can now be a painter with a certificate of study. To be supplied with paintings every once in a while. Absolved of all responsibilities. Plane ride. Painting studio in California. Freedom.

Voice-over. Airplane attendant smiles at him as he becomes frightened and runs to the bathroom. Luggage. Arthur Hamilton's name is now Tony Wilson. Off the plane. A man with a beard and wearing a plaid hat calls Wilson by name. John (Wesley Addy) is his manservant. Wilson enters his home on a beach. Pool. Goes into the studio. Only artist in neighborhood. Professional men. Painting. Outside table, drinks coffee. John suggests a cocktail party. John tends to flowers and watches Tony walking on the beach. He doesn't want to meet anyone just yet. Shaving. Painting. Dinner alone. Night. Beach. Water. In bed. Day. Walking on beach. Stops, sees a woman dressed in a hooded jacket. Her name is Nora Marcus (Salome Jens). He walks away after calling out to her with no response. Then she goes up to him and they walk together. She runs into the ocean. Slow **dissolve**. Nora was married and had two kids but left them four years ago. Inside Tony's house. Rain. She reads his tea leaves. She determines he is tentative, reserved, a key unturned.

Driving, she's at the wheel. Santa Barbara. Festival. They go together. Walking in a field, on roads. Drinking wine. Couples kissing. Grapes. Thrown into vat. Woman takes off her clothes and goes into the vat. Men and women take off their clothes. Stomp grapes. Guitar tambourine. Tony uncomfortable. Handheld camera. Lots of nudity. Nora dances with a man. Headdresses are made of vine. Nora tries to get Tony into the vat. She takes off her clothes and gets into vat. Guys grab Tony, take off his clothes and get him in vat. They dance. Fuzzy image. **Slow motion. Freeze frame. Dissolve**. This scene was ahead of its time. There had been nudity in movies before, but so many characters, male and female, are involved here and the action contains a lot of body movement. There is some full-frontal nudity, very uncommon in Hollywood movies at this time. Frankenheimer himself was a handheld cameraman on this sequence and at one point the revelers pulled the director, who was only wearing swim trunks, into the vat.

On the beach. Tony gives in to the notion of cocktail party. At the party he is getting very drunk. He is introduced to people. He is told by Nora to slow down. They go into the back of his house. She tells him to ease up on the drinking and to give people a chance. "I think I love you," he tells her, and they kiss. Long-held close-up. Tony meets a lawyer. He continues to drink. Lawyer takes Nora away. Tony talks to an older lady. She is in a group that changes sects every month. Tony is very drunk. Tells people he paints naked. Spills a drink on the dress of a wife of a guest. John quickly comes over and tends to it. Nora and men at the party gather together. They are angry at the way Tony is acting. He is drunk. He says Arthur Hamilton's name. The men carry him to a bed. Handheld camera shot. Tony talks about his daughter.

They continue to hold him down. The men are called "reborns" by the company. Tony calls for Nora, who is very angry with him.

Phone. Charley calls. Dangerous. Nora works for the company, she's an employee. Don't throw it all away. Airport. Reborns follow. Tony goes back to his home in Scarsdale. Maid goes to get Mrs. Hamilton. Tony looks around on main floor. On the mantle is a picture of Arthur Hamilton, then Tony's reflection comes into the picture. Emily comes down. Met your late husband. Painter. Tony says he admired Arthur's watercolors and would want one as a memento. The garage was cleaned out. Tony tells Emily her husband talked a lot about home and family. Wants to do painting of him. Quiet man. Silences, she tells him, never talked a lot, like a stranger, nothing touched him. He had been dead a long time before that hotel fire. Tony leaves. She gave him a trophy. Voice-over. Car. John gets out. Tony wants to go back and start again, begin again.

In a room with Mr. Ruby. Can you sponsor someone? Photos. Bright lights. Room with many men waiting. Tray of pill cups. Wilson sits down. Charlie sees him. Wide angle. Charlie comes over to Wilson. Didn't recognize him. Waiting. Phoned from this room. Tied together. Buzzer. The doctor comes in. Charlie is called. You're going to make it this time.

Ruby is angry that Tony can't sponsor anyone. High angle. Ruby phones someone—take him to the next stage. Dark room light hospital room. Old Man talks to Tony. Some fellows make it, some come back. Company makes mistakes. Men strap him to a transport table. Change is important. Down hall. A man says he is a minister of every faith. In the next stage we meet the creator. Tony struggles. They silence him with a ball in his mouth. Minister reads from the bible. Tony Wilson screams and shakes violently from side to side. Operating room. Age 51, Cadaver use. Accident. Dr. Innes. You were my best work Mr. Wilson. Light. Relax, old friend. Cranial drill. White out. Beach. Man carrying child on his shoulders. Dissolve to credits.

Conclusion

Seconds is a pre-American New Wave film made by a 36-year-old man who started in television, at that time a medium that was looked down upon by cineastes. More surprising, his cameraman James Wong Howe was 61 years old and came out of the traditional studio system. *Seconds* is ahead of its time in content and cinematic style. The narrative is dark and deals with themes such as aging, transformation, happiness/sadness, and what is human. Frankenheimer and Howe used everything in their toolboxes to tell this cinematic story. *Seconds* also featured a brilliant use of actor Rock Hudson, presenting his male beauty as an example of the perfect man and John Randolph as a worn-out, middle-class, unhappy person. *Seconds* is also a science fiction film because of the transformation sequence and concept, but ultimately it is a

contemporary horror picture because it reveals mankind with the power to make people into something they're not, and to get rid of them when it doesn't work out.

Notes

1. *Playhouse 90* was a television anthology program that aired on CBS from 1956 to 1960. Episodes were broadcast live and ran for 90 minutes. The series featured actors who were established and coming up. It also was a proving ground for directors like Sidney Lumet and others who would go on to have solid careers in filmmaking. The producers included Fred Coe, John Houseman, and Arthur Penn. The writers included Rod Serling. Some of the programs include *Requiem for a Heavyweight*, *The Helen Morgan Story*, and *Judgement at Nuremberg.*

2. *Climax!* was an American anthology television series that aired on CBS from 1954 to 1958, hosted by William Lundigan and later cohosted by Mary Costa. Many of the episodes were broadcast live, and it was one of the few CBS shows produced in color. It also featured established and up-and-coming actors and directors. Programs include *The Lou Gehrig Story*, *The Valiant Men*, and *Journey into Fear.*

3. *Danger*, an American anthology television series, first aired in 1950. The writers included Gore Vidal, and the directors Yul Brynner. Episodes include *The Dark Curtain*, *The Last Duel in Virginia City*, and *The Birds.*

4. Mack Sennett (1880–1960) was a Canadian-born American director and actor known as an innovator in slapstick comedy. He founded Keystone Studios in 1912, the first totally enclosed film stage and studio ever constructed. Considered to be the comedy and master of the short film, Sennett produced a staggering 1,115 films between 1908 and 1956, including *For Lizzie's Sake* (1913), *On His Wedding Day* (1913), and *Tillie's Punctured Romance* (1914).

5. Famous Players–Lasky Studios was an American motion picture and distribution company created in 1916 from the merger of Famous Players Film Company and the Feature Play Company. Major films that came out of this studio include *The Sheik* (1921), *The Ten Commandments* (1923), and *Wings* (1927).

6. Cecil B. DeMille (1881–1959) was an American film director and producer known for biblical and historical epics. He was a grand showman who worked in many genres including social drama, comedies, Westerns, farces, and morality plays. His films include *The Virginian* (1914), *The Crusades* (1935), and *The King of Kings* (1927).

7. Alfred Hitchcock (1899–1980) was an English film director and producer who made films in England in the early part of his career and then in Hollywood for the rest of his career. He was a highly influential filmmaker who worked in the thriller genre. He created his own camera language that reinvented cinema narrative storytelling. His many films include *The 39 Steps* (1935), *Psycho* (1960), and *The Wrong Man* (1956).

8. Otto Preminger (1905–1986) was an American theatre and film director and actor originally from Austria-Hungary. Known for his courageous fight against film censorship, he took on controversial topics such as drug addiction, rape, and homosexuality. His films include *Laura* (1954), *The Man with the Golden Arm* (1956), and *Porgy and Bess* (1959).

9. Jerry Goldsmith (1929–2004) was an American film and television music composer and conductor. A legend and innovator in the field, he created a vast amount of work. His credits include *Planet of the Apes* (1968), *Patton* (1970), *Star Trek: The Motion Picture* (1979), *Chinatown* (1974), and *Alien* (1979).

10. The Hollywood Blacklist was the practice of denying work and firing screenwriters, actors, and others in the film industry during the late 1940s, the 1950s, and into the 1960s because they were believed to have been members of the Communist Party or communist sympathizers.

For Further Study

Screen

The Conversation
The Manchurian Candidate (1962)
Peeping Tom
Repulsion
Shock Corridor

Read

The Cinema of John Frankenheimer by Gerald Pratley
John Frankenheimer: A Conversation by Karl Thiede and Charles Champlin
John Frankenheimer: Interviews, Essays, and Profiles edited by Stephen B. Armstrong
A Little Solitaire: John Frankenheimer and the American Film by Murray Pomerance and R. Barton Palmer
Pictures about Extremes: The Films of John Frankenheimer by Stephen B. Armstrong

The Graphic Novel Comes Cinematically Alive

Sin City

A graphic novel is a long-form story presented in comic book style and format. In Frank Miller's graphic novel series *Sin City*, the first story, *The Hard Goodbye*, concerns a man's obsessional revenge for his one-time sweetheart's death. The third, *The Big Fat Kill,* is about a man trapped in a street war between prostitutes, a group of mercenaries, the police, and the mob. The fourth, *That Yellow Bastard*, follows an aging police officer who protects a woman from a deranged and disfigured serial killer. The stories are linked by the short story *The Customer Is Always Right*, which is collected in *Booze, Broads, & Bullets*, the sixth book in the series.

Robert Rodriguez burst onto the national and international movie scene in 1992 by writing and directing the feature film *El Mariachi* for only $7,000. He went on to great successes, especially with the *Spy Kids* franchise, before teaming up with Frank Miller on *Sin City* (2005).

Frank Miller's storied career in comics includes work on *Dr. Strange*, *The Punisher, Wolverine, Batman: The Dark Knight*, and *Watchmen*. Robert Rodriguez made a short film from Miller's epic graphic novel series *Sin City* of the story *The Customer Is Always Right*, which pleased Miller and led to the creation of the *Sin City* feature film.

Rodriguez asked Miller to codirect the film, which produced startling results. The original graphic novel panels were used as storyboards. The visualization of the movie adapts the drawn vision of the graphic novel into a live action interpretation, complete with the cinematic equivalents of the artist/writer's creation. The combination of the two talents produced a live

action movie that looked like a graphic novel come to life with a new set of motion picture aesthetics.

Sin City is a **neo-noir** story by Frank Miller first published in the *Dark Horse Presents Fifth Anniversary Special* in April 1991 and continued in *Dark Horse Presents #51–62* from May 1991 to June 1992, serialized in 13 parts. The intertwining stories with frequently recurring characters take place in Basin City, a fictional town in the American west. It was later published in seven separate volumes: Volume 1: *The Hard Goodbye*, Volume 2: *A Dame to Kill For*, Volume 3: *The Big Fat Kill*, Volume 4: *That Yellow Bastard*, Volume 5: *Family Values*, Volume 6: *Booze, Broads, & Bullets*, and Volume 7: *Hell and Back*.

Neo-noir takes the classic film noir formula—a doomed man, bad guys, and a femme fatale who brings the antihero down—and places it in contemporary times rather than the 1940s or 1950s. Film noir movies were in black-and-white. Neo-noirs are in color. *Sin City* was photographed in a high-contrast black-and-white style to capture the look of a pen and black ink graphic novel. Because *Sin City* is noir, scenes take place at night and large shadow areas create tension and dread. The images in *Sin City* are in black-and-white with elements of bright comic book color placed strategically in a shot. The concept of adding color to the black-and-white of the movie comes from the graphic novel where it was done on a highly selective artistic basis. In the graphic novel they were applied to the drawings; in the film *Sin City* they were accomplished in postproduction using a digital application.

Narrative and Cinematic Analysis

Black-and-white. Big city. Terrace. The Customer (Marley Shelton), a blonde woman with short hair in a red dress. Film noir style **narration**. *Sin City* proves that the film noir style can be applied to many forms: movies, television, theater and comic books and graphic novels. Jazzy music. Speaker is The Salesman (Josh Hartnett). He offers her a cigarette and she takes it. She talks about being bored. He says he didn't come for the party but for her. Her lips are colored with red. Throughout this film the contrast between black-and-white and color is striking. Color is selective and added digitally. This is a trope of this graphic novel. He compliments her eyes, which turn to green then back to black-and-white. She turns back to the view in front of her. Storm brewing. He continues to romance her. She turns around and faces him again. Silhouette of them kissing. This extreme form of black-and-white has been attempted in movies before. Here it is not a reference to that technique but to the source material. It begins to rain. Back to black-and-white movie style. They kiss again. Narration. He tells her he loves her. He shoots her with a silencer. He is a hit man. He doesn't know what she was running from. He continues to hold her. In narration he says he'll cash her check in the

morning, giving the impression that she hired her own death. Pull back, camera turns until it is in a **full shot**.

The city buildings are lit up, spelling out the **main title**. *Sin City*. It turns bright red. Images from the original graphic comic *Sin City* appear. Credits. Quentin Tarantino (see Chapter 17) is a special guest director.

Detective John Hartigan (Bruce Willis) is on his last day as a police officer. Driving. Sports car. He is the narrator now. There is voluminous **voice-over** throughout *Sin City*. Changing the speaker in a noir or otherwise is not common, but has been done before. Here there are multiple stories, also not common in earlier movies. Retirement. Not his idea. Doctor says he has angina. He has a helpless young girl in the hands of a lunatic to save. Stops the car when he sees his partner Bob (Michael Madsen) in the road. Hartigan gets out of car and argues with Bob about saving 11-year-old Nancy Callahan; Bob tells him to think about his wife Eileen who is at home waiting for him. Hartigan turns and tells Bob that maybe he is right. He knocks Bob out with one punch.

Nancy Callahan at age 11 (Makenzie Vega) is tied to a chair and her captor stands above her. Hartigan is walking quickly to find Nancy when he has a heart attack. Two thugs stand over a car. Hartigan watches them, then approaches the men and knocks them out with a tire iron. Heart attack persists. Twin men. They leave the room and Nancy Callahan is left with another man, Roark Jr., (Nick Stahl), a serial child murderer and the son of a U.S. Senator. Hartigan takes a pill. He collapses to the ground. He pulls his gun and gets up. Twin men pull their guns on him. He shoots them both. Roark Jr. shoots Hartigan in the back while holding the girl. Hartigan gets up on his feet. Roark Jr. runs with the girl, gets to the end of a dock surrounded by water. Hartigan reaches him. Hartigan shoots Roark Jr. in the ear. Nancy gets away from Roark Jr. Hartigan tells Nancy to cover her eyes. He shoots Roark in the testicles. Bob appears and shoots Hartigan in the back. Cut to black. Hartigan says, "Hell of a way to end a partnership." Violence and difficult subject matter is nothing new to contemporary movies, but graphic novels have more leeway. The drawings are often very realistic, but in live action even stylized ones like in *Sin City* have a direct and disturbing impact on the viewer.

Fade in from black on Hartigan, stalling for the back-up to arrive. He tells Nancy to run for her life. Bob shoots Hartigan many times. White blood, an unrealistic touch to stylize the action. Things go dark. He's happy the girl is safe now. Nancy snuggles with him. Fair trade: old man for young girl. **Fade out** to black.

Goldie (Jamie King), a blonde woman in a red dress. Marv (Mickey Rourke). Many of the characters including Marv are played by actors wearing extensive make-up so they appear to have the exaggerated faces of the graphic novel characters they are playing. This was done in *Dick Tracy*

(1990), setting a precedent. That picture was a challenge, and this one takes on faces that are further distorted from real life. Red, heart-shaped bed. Goldie. Narration by Marv. They have sex. Close-up of her face and hair in color, a startling variation that makes her hyperreal. Shots of them laying on bed. Kevin (Elijah Wood), a man with white lens glasses, is in the open doorway. Cut to black. Cut into a **top shot** looking down at the couple on the bed. This view goes back to the musicals of Busby Berkeley during the 1930s and 1940s. Martin Scorsese transferred this dynamic of looking directly down at the world image especially in *Taxi Driver* (1976), a neo-noir. Goldie is murdered. Room. Cops drive downstairs. Marv puts on his leather jacket. Cops run up the stairs and burst through the door, Marv sends them flying with a swing of his arm. He jumps over the railing and falls several flights, then grabs a railing to stop his fall. He crashes through a window and onto a pile of garbage bags. A police car drives towards him, hits him, and he goes feet first through the windshield. He punches out both cops, and drives off with the police car. His hands and face are bleeding. Marv drives off a dock into the water. He swims underwater, into a drainpipe, and up and out to the street.

Room. Lucille (Carla Gugino) is startled in bed. She gets a gun and goes toward the noise at the door. Lots of Band-Aids on Marv. She patched him up. Lucille is his parole officer. She puts on a robe and they talk. He is fired up, ready for violence—the old days are back. She warns him against it. He's out of prison now and knows exactly what he has to do. Roof. Night. Alleys. Marv jumps out window to the street. Marv's narration. Guy pushes another man through a door. Marv grabs the man's head with both hands and squeezes his skull while both of his thumbs are in the man's eyes. Marv enters a dive bar. Female dancer performing. It's Nancy Callahan grown up (Jessica Alba) doing a pole dance. The place is jammed with low-lifes. Marv sits at the bar. Close-up of Nancy, a light hits her long hair and makes it look very blonde or white. A waitress Shellie (Brittany Murphy) approaches Marv. Marv tells her to keep the drinks coming. She then approaches a booth where Dwight McCarthy (Clive Owen) is sitting. She puts down a drink at his table. McCarthy, in narration, speaks about Marv. He says people think Marv is crazy, but McCarthy feels Marv was just born in the wrong century. Should have been in the Roman Gladiator era. Nancy dances. Marv drinks a lot. Two guys tell Marv he has to leave. They take him outside to a brick walled area. He beats up the two guys and shoots one of them for his coat. Cut to black. Back to Marv and man he shot. Marv is looking for information on a killer. He gives Marv information. He shoots him again. Marv puts on the coat. A woman who looks like Goldie is watching Marv. She's says, "Bastard, you are going to pay for what you did to me." She has a gun. Marv pushes guy's head down a toilet and grills him for information. A gross action that can be seen in lower-class B movies. The man says he was set up by another man. Marv

drives his car fast, holding onto that man, dragging him on the ground. Narration: Marv says "Connelly talked, they all talk."

Church steeple, pull back to reveal entire church. Priest hears his confession. "I killed three men tonight." Pulls gun in confessional. Wants a name from the padre. Priest gives a little information but is uncooperative and nasty. Marv kills him. Top of steeple. Marv has the keys to the priest's Mercedes. Car comes speeding at Marv. He pulls his gun. It's Goldie. She hits him with her car. He goes flying and lands on the ground. She takes another run and hits Marv again and again; he spins up into the air and lands on the ground. She fires a volley of shots at him. She leaves. He takes pills.

Driving. He says that wasn't Goldie. He gets to the farm the priest told him about. Gets out of the car and walks the grounds. A bad place. Angry dog. The dog attacks Marv who punches the canine out. Kevin appears. Marv and Kevin fight. Martial arts applied to Marv. Story, story, story, key in a good movie. The plotting here, adapted from the graphic novels, is intricate and relies on old crime movie tropes. Kevin's fingernails are weapons and draw blood, which shows red. Marv hurt, tells Kevin that he killed Goldie. Kevin hits Marv with a sledge hammer. Black. Marv on the floor in a room. His face is covered with blood. Marv sees that there are women's heads on the wall. Lucille is in the corner of a cell. She tells Marv that Kevin saves the heads and eats the rest. One of the many heads is Goldie. By seeing the result of Kevin's savagery and not seeing him in this scene, the viewer is appalled by what this homicidal maniac can do, and seeing the heads builds the fright in the viewer's mind.

Marv takes off his long leather coat and covers Lucille. Kevin outside in the night. She tells Marv Goldie was a prostitute. Marv looking outside sees a car. Person in the car calls Kevin, who runs up to it. Marv pulls out a barred window. Police helicopter. Marv and Lucille are outside running. Gang of men approaches. Marv aims his gun to shoot them but is hit over the head by Lucille. She takes his gun. She walks to the leader and hands over the gun. She is killed by a succession of bullets. Marv picks up an axe and fights the group. The gang leader shoots a police officer dead.

Helicopter shot. A technique used to get an aerial angle or to represent the **point-of-view** of someone in a helicopter. Here it's another shot angle to diversify the directorial style. Night. City. Narration by Marv. The leader Marv killed was a cop. Marv is walking on a bridge in pouring rain. A man known as someone who could have been president but chose to serve God was the name Marv got from the policeman. Torrential rain. Patrick Henry Roark (Rutger Hauer) became the most powerful man in the state. He brought down mayors and governors. Statue of the Cardinal as images fade in and fade out. He made his rotten brother a U.S. senator. Face of Senator Roark (Powers Boothe). Man of the cloth brought down in the name of a dead prostitute. Marv not well, drops to his knees, concerned he could be wrong. Without

Lucille he can't get medicine. May have imagined all of this. Walks. Reaches Old Town. Prostitutes walk the streets. Marv asks various women about who may have killed Goldie. A woman who looks like Goldie shoots Marv. He says, "You can't be Goldie" to her, Goldie's dead. Marv falls back into a vortex. Historically movies have visualized a character who feels trapped with life swirling in around them. By using special effects or camera moves, the result is cinematic and is tied to the character's state of mind. Marv in a room, tied with rope. She smacks him in the face while other women of Old Town look on. She is revealed to be Wendy, Goldie's twin sister, also played by Jaime King. She continues to smack him. His white tank top shirt is full of blood. He tells her he's a fall guy, didn't kill Goldie. He tells her to shoot him or to get out of his way. She points her pistol at him and then brings it down to her side. Gail (Rosario Dawson) is in the room. Three other women look on. Marv picks up the gun and the axe. Needs handcuffs. Gail has a collection.

Wendy and Marv are in a car driving. He tells her Cardinal Roark is behind this. He thinks this is crazy, but Wendy says it isn't. Goldie had a connection with clergy. They exchange a cigarette. He tastes Wendy's lipstick and becomes attracted to her, thinking of Goldie. Marv goes to a hardware store and buys rope, razor wire, a hacksaw, and special gloves. Driving. Wendy wants to know why he's doing this. She was nice to me, he tells Wendy. Marv tells her to pull over. He gathers the killing tools and tells her if he is not back in 20 minutes to get out of the area. She tells him to kill him good. He goes through the woods and reaches a house in the distance. He lays wire down on the ground. He sees Kevin through a window. Marv throws a firebomb into the house and it ignites. Kevin jumps out a window. Marv fires his gun at Kevin. Kevin charges at him. The building explodes. Explosions are a violent act and a device to ramp up the action. Marv puts handcuffs on. Kevin jumps over a trip wire. Yellow fire. Martial arts applied to Marv. Marv cuffs Kevin to his own arm, punches him. Red blood flies out of Kevin's mouth. Marv is soaked in red blood. Wendy appears, pointing a gun at Kevin. Marv punches Wendy out and puts her in her car. Flashback images of Kevin and what Marv did to him. Silhouette shot, **flashback** of dog eating at Kevin's cut-off legs while Marv watches. Flashback—he grabs a saw to finish the job. Marv carries Wendy into the dive bar where the adult Nancy Callahan dances and drinks beer. He talks to Nancy. He hot-wires a cab. Drives to the church. Guard at gate. Marv gives him a strangle hold. Cardinal in bed, a noise wakes him up. Marv brings in Kevin's head and shows it to the Cardinal. Said Kevin spoke to him. Dead because of one stupid whore. Tells him not to talk about Goldie in that way. Kevin was a tormented boy when he came to the Cardinal. Kevin didn't just eat their bodies; he ate their souls. The Cardinal joined in. They were all whores. Nobody cared for them. Nobody missed them. Goldie almost ruined everything. This is a savage narrative attack on these characters and the religious connection.

Goldie. **Flashback**. She is in color, everything else is in black-and-white as she walks into a bar. Marv is there drinking. He sees her and is touching her. Present. Cardinal telling story. Flashback, black-and-white. Police with guns drawn are moving through a hallway. Marv throws a guard off of a balcony. He crashes into a police car as earlier. Present. Cardinal telling a story. He tells Marv to eliminate him if it will give him satisfaction. The Cardinal lifts up Kevin's head and tells him that they are going home. Cops arrive at destination, the previous shot of them going through hall might not have been a flashback. This is real time. Marv strangles the Cardinal. Blood spurts. Narration. Marv speaks to departed Goldie, telling her he has avenged her murder. Cops come in door and shoot Marv repeatedly with fast action weapon. The character of Kevin and his ghoulish actions give *Sin City* a horror movie element and a connection to Grand Guignol, a drama that embraces the horrible and macabre.

Operation in progress. Narration. Marv feels this is a waste of time. Later. Marv in a hospital bed connected to bags of fluid. Now a group of cops beat Marv hard with sticks. Assistant attorney tries to get Marv to sign a confession or they'll kill his mother. Marv breaks the D.A.'s arm. They charge Marv with many murders including Lucille, the heads of women he found, and Goldie. Judge throws the book at him. Execution only a few hours away. Only Wendy's hair is in color. She says Marv can call her Goldie. She holds him tight. Top shot. Two together. They strap Marv into the electric chair. Switch thrown. He's alive. Switch. Dead. **Zoom** into Marv's eye—heart-shaped bed in red. There appears to be Marv and Goldie. Black. The electric chair has been in countless crime movies and triggers myriad reactions in audiences from justice served to inhumane treatment. Although *Sin City* has many contemporary qualities, it is constantly looking back to tropes from Hollywood crime movies of the past.

Guy outside room knocking. Shellie says she is not letting him in. Jackie Boy (Benicio Del Toro) is outside the door talking to her. He had beaten her up in the past. She calls him a loser. Tells him to get help. Dwight enters the room with no shirt on and tells Shellie to open the door. Now it's revealed that Jackie Boy's gang is behind him. Dwight calls Jackie Boy a drunk and knows by their breathing that he has four guys with him. She opens the door. They all walk in. Dwight walks into the bathroom. Jackie Boy slugs her, shown in shadow images. She tries to pull a knife but falls to the floor. Jackie Boy goes into the bathroom. Dwight gets Jackie Boy from behind him. Dwight pushes Jackie Boy's head into the toilet and holds it under water—he hadn't flushed. This is another film noir trope. Gross, it involves an everyday object turned vulgar and repulsive. Dwight leaves the bathroom. Jackie Boy whips his head out of the toilet. He pulls a gun, walks up to Shellie, and tells the gang to get out of the apartment.

They all get into a blue car. Dwight is standing outside a window. Shellie puts her head out. Dwight jumps from a ledge and in slow motion eventually

lands on the ground. He gets into a red car. Dwight is now the narrator. He speeds after them. Cops. Siren. Jackie is at the wheel. He has his head totally out the window. Car swerves. Gang member pulls him back in. Police car passes Dwight. Old town. Women on the street. Car passes by. Police turn around. The women are all packing guns. Narration by Dwight. Jackie boy driving and drinking out of a bottle. Woman walking next to Jackie's car is Becky (Alexis Bledel). Jackie Boy propositions her. She turns him down.

Pan up building. One of the women is there. Dwight sneaks up from the side of the building. His gun is drawn. Gail stops him with a large automatic gun. She tells him everything is under control. Gail asks Dwight about Shellie. He says Jackie Boy is no longer Shellie's boyfriend and is out of control. Miho (Devon Akoi) is on a roof with swords. Becky tells Jackie Boy he is surrounded. Her eyes are colored blue. One of the women closes an iron gate. Gail and Dwight. He says Jackie Boy and his crew didn't kill anyone. Gail says that they won't. Back and forth with Becky and Jackie Boy. She says, "You can't handle a woman." Gang member eggs Jackie Boy on. Jackie boy taunts Becky. She fires back a retort. Jackie Boy pulls his gun and points it at Becky. He is trying to get her in the car. Miho throws a metal shuriken, which takes off Jackie Boy's gun hand. Miho leaps off the building roof with two swords raised upwards. White blood is pouring out of Jackie Boy's hand. Miho lands on the top of the car and stabs her sword through the roof, which penetrates one of the gang members. She continues to attack the other gang members. Jackie Boy crawls on the ground and finds his hand, then bites it to dislodge his gun. He has the pistol and is aiming it at Miho. Gail and Dwight watch. Dwight draws his gun and moves behind Jackie Boy. Dwight is behind him, razzing him by saying "Watch your step, Jackie Boy." Jackie Boy slips on something and falls to the ground. Gail approaches with her gun. Jackie Boy crawls to the hand. He has the shuriken in his back. Dwight is telling him to give up. Miho flings something that gets stuck in the barrel of Jackie Boy's gun. Dwight warns him. Jackie Boy turns and points the gun at Dwight. He shoots and it backfires into his forehead. The others stand around him. Miho finishes Jackie Boy off with her sword. The women go through his clothes. His wallet shows he was a cop, a hero cop. White blood. Old Town will be wide open. This elaborate and well-choreographed sequence has martial arts elements but it is reminiscent and in the tradition of a shootout in an old Hollywood Western, the good guys versus the bad guys, back and forth violent interchange, all for the protection of the town and its inhabitants.

Raining. Hide the bodies. Dwight takes Jackie Boy's wallet. Flashback to Shellie yelling out the window, the helicopter drowning her out. Back to Dwight. She said cop. He finds Jackie Boy's badge. Gail looks at it. He was Iron Jack, a hero cop. This is now a fact, but if Jackie boy was an undercover police officer, why was his behavior so outrageous and criminal? In the world

of *Sin City* anything goes. Dwight narration. The women have a truce; the cops stay out. That keeps the women free to keep the pimps and the mob out. Jackie is bleeding white blood, this unreality continues. Some bleed red, some white, which dehumanizes them. There will be a war because they killed a cop when they were supposed to send cops back alive. Becky says things are going to go back to the way they used to be. Gail says no. She says they have guns and they'll fight the cops and anyone who tries to move in. War. Dwight asks for a car, he'll hide the bodies. Gail says the cops know Rafferty (Jackie's name) was here. Gail says they'll search the river, he says he'll take them to the pits. Dwight and Gail have a passionate kiss. They had been together for one night in the past. Bodies lined up in the street. A car drives up. Gail tells Becky she can go home but not to say anything about what happened that night. In order to get the bodies in the trunk, Dwight tells Miho to chop them into small pieces, which she does. Becky on pay phone. Two women come up to her. She says not to tell Gail. She just wants to hear her mom's voice.

Car driving in rain. Night. Dwight sitting next to the body of Jackie Boy. Lightning, a dramatic effect constantly used in crime and horror movies. Jackie Boy has the barrel of a gun sticking out of his forehead. Dwight is driving. Jackie Boy moves his head and starts talking. This is the scene that Quentin Tarantino directed. Jackie Boy is alive. Jackie Boy tells Dwight the hookers let him down. The gas gauge is just about on empty. Dwight is looking at and talking to Jackie Boy. Keep your eyes on the road. Dwight almost drives into an oncoming car, swerves to avoid it. Green, blue, yellow, lights flashing one after another. Dwight says he's sure he's imagining that Jackie Boy is talking. Sure he's dead. Motorcycle cop pulls Dwight over. Dwight stops on a dime. Jackie Boy is thrown forward into the dashboard. Gun barrel in his forehead hits it first. Motorcycle cop sees Jackie Boy and thinks he's drunk. Motorcycle cop says Dwight is driving with a busted tail light—"I'll let you off with a warning." Dwight runs out of gas a quarter-mile from The Pits. Pushes car in area with large models of dinosaurs. Dangerous. Dwight is shot. Man on top of one of the large dinosaur models with a rifle did it. Dwight falls to the grass. Lightning. Whether Jackie Boy is a hallucination or actual, it can be interpreted as an outrageous assault on the remaining reality of the story.

Gail on the phone. Going on lockdown. African American man Manute (Michael Clarke Duncan) grabs her from behind. Tells her soon the truce between the girls and the police will be ended. "You'll all be slaves," he tells her. He wants her to negotiate the terms of surrender of Old Town. Everyone will be under the control of his boss. He tells her by now Dwight is surely dead. Gail tells him her man Dwight always finds a way.

Dinosaur area. Dwight appearing to lie on the ground dead. Three men and a woman with guns approach. Rain continues. They have Irish accents.

The woman sees Jackie Boy, apparently dead in the front seat of the car. One of the men finds the police badge. Dwight pulls his gun and shoots the man. He shoots another man. Then Dwight shoots Jackie Boy in the head. Shootout. He hits the woman. Shoots the guy next to her. Mercenaries. Grenade. Car blows up. Dwight and car blown into the water. Black. Death comes slow in *Sin City*, and revival or proof of life is a continuous occurrence. Injected into the story now is another possible political angle. This group may be foreign mercenaries.

Dwight in the water. His eyes are closed, then open. Irish man talking about delivering Dwight. They are all alive, even though Dwight shot them. One of them holds up Jackie Boy's head with the gun barrel in his forehead. Silhouette of Dwight as he sinks below into the water. Miho floats down, grabs his wrist, and pulls Dwight up. The car is pulling a body. Two men with arrows between their eyes lay on the grass dead. Rain. Dwight talks to two Old Town women. One tells him they got Gail. The other is Miho. She points to a hanged man. He has a knife in him. Car speeding. Dwight and two women in the car. Speeding. Car crash. Jackie Boy's head flies out the window. Shoot out. The driver is shot. It is the Irish guys. One grabs Jackie Boy's head, which was lying on the ground. Miho flies through the air, throws something at one of the shooters and the top of his head flies off. The constant appearance of Jackie Boy's violated head is theater of the absurd. If an altered reality is firmly established with logic, the audience will follow, which is in play here. Miho gets blown up into the air. Dwight shoots at guy with the head but he slips down into a manhole. Dwight jumps into it, shooting all the while. He lands in the water, there is a tunnel behind him. He holds the Irish man at gunpoint. Irish man presses detonator and Dwight blows up in the water. Miho appears. She stabs the Irish man. Dwight takes a cell phone and says they have to rescue Gail. Old Town.

Manute squeezes Gail's face. Becky is standing by watching, tells Gail to just give them what they want. Gail is tied up with a rope. Becky walks over to her and says it's over. She tells her Dwight is dead (he isn't) and that the cops are going to mow them down. Misleading information complicates the story in an effective manner. Tells her to make a deal. Gail now realizes that Becky sold them out. They have a heated conversation. It was for money. Becky didn't want her mother to know she was a prostitute. Becky wanted a way out. Gail bites Becky's neck and spits out a red, bloody piece of it. Manute comes over and smacks Gail, who is tied to a chair. Two guys are ordered by Manute to kill Becky. One walks over with gun. He is shot with an arrow by Miho. Dwight sends a note. Wants a trade—Jackie's head for the woman out back. Manute and gang walk to back. Shooter with arrow in him still there. Miho shoots an arrow into his forehead. Dwight. Lightning. Dozens of armed gang members walk around back. Dwight is waiting. Gail is being held. He tells them they can have Old Town; he just wants Gail. Jackie's head is

talking. Fair trade. Manute lets Dwight have Gail. She runs to him. Dwight gives them the head. Dwight blows up the head with detonator. Gang is blown back. The girls show up on roofs shooting down at the gang. Gail and Dwight have guns and shoot at the gang. Becky is hit with a bullet. They kill them all. Boss will see what it cost to mess with the girls of Old Town. Dwight and Gail kiss. Becky escapes. The fire will burn us both. Fade to black.

Fade in to Hartigan in the hospital. He is hooked up to a lot of bottles with fluids. Senator Roark is standing at the foot of the bed smoking. Tells Hartigan what he did to his son Kevin in graphic detail. Kevin is in a coma. He could have become the president of the United States but you, Hartigan, have turned him into a freak. Says as he draws gun on Hartigan that he could pump him full of bullets and he wouldn't even be arrested. He wants Hartigan healthy. Will pay for surgery. Fix his heart condition. You will be convicted of raping little Nancy. Your reputation will be destroyed. Tell anyone the truth and you're dead. Fade to black. Nancy says they won't let her testify. She is a young teenager now. Talking in room. She was threatened. Still alive thanks to you. Full shot of hospital room, she walks up to Hartigan in bed. Stay away, they'll kill you. Hartigan tells her not to even write him. Nancy says she will write under another name. She leaves and says she loves him. Actors play many roles, and some are known for one particular one that the public identifies with. Powers Boothe plays Roark here with cruel specificity, a man drunk with power willing to do anything. This actor won an Emmy for playing the real-life Jim Jones, who was responsible for the slaughter of upwards of 1,000 people. Boothe's portrayal in *Guyana Tragedy: The Story of Jim Jones* was so convincing that it stuck with viewers, who may see elements of that legendary performance in the portrayal of Roark.

Guy punches Hartigan very hard repeatedly. His face is bloody. Puncher mentions the phrase "die hard," a reference to the movie *Die Hard* (1988) that starred Bruce Willis, who is now playing Hartigan. They are in a large room with a skylight. A man and a woman look on. Tammy (Lisa Marie Newmeyer) is dressed like a nurse. She was brought in from New Town. They want a confession. Hartigan sits in a very tall prison cell. Solitary. Letter from Nancy signed Cordelia. Sends a note every Thursday. His only friend. The daughter he never had.

Hartigan in the same jail cell. In narration he says eight years have passed. Thursdays pass—no letter. Another two months and no letter. He wonders if Nancy is alright, still alive. Top shot of Hartigan laying on the floor of a cell. Nancy is grown up, 19 years old. There is a really bad smell. A guy with a yellow head, arms and legs with everything else in black-and-white, is sitting in the cell. He punches Hartigan. On the floor is a bloody envelope with no letter, but there's a bloody index finger. Hartigan thinks its Nancy's. Got to get out. Parole. He tells them what they want to hear. Confesses to being a child molester so he can get out of prison. Snowing. His partner is there

waiting for him with a car. Yellow Bastard (Nick Stahl, who also plays Roark Jr.) is waiting in a car. Partner tells him his wife remarried four years ago and now has two kids. Snow. Driving at night. They are followed by Yellow Bastard driving behind them on right. They arrive at a large house. Hartigan gets out, partner drives off. Hartigan inside house. Nancy's house. Not a sound, no sign of life. Matches from a saloon. This all-yellow character is right out of the comic book/graphic novel world, taking the narrative into uncharted territory for most viewers.

Saloon. Hartigan stops a waitress walking by with a tray of drinks. It's Shellie. He tells her he's looking for somebody. Shellie tells him to look towards the stage. Nancy (Jessica Alba again) is doing a sexy dance on the stage, twirling a lasso. Hartigan is in disbelief. He moves closer towards her. Marv is drinking at the bar. He realizes they were bluffing about finding Nancy and now he's led them straight to them. Yellow Bastard is there. He has a gun. Hartigan turns to leave, to get Yellow Bastard to follow him outside. As he leaves Nancy recognizes Hartigan, jumps off stage, and kisses him. He tells her they have to get out of there. She thought he forgot about her and her dumb letters. He says her letters kept him from killing himself. They go outside, there is a car waiting. She drives. Gun under seat. She tells him she thought about him all the time. Yellow Bastard shoots at them from his car. Hartigan leans out of car pointing gun at Yellow Bastard. Hartigan aims carefully, he shoots and hits Yellow Bastard in the head. Yellow blood pours out of him. His car flips over. He tells her to stop the car so he can confirm the kill. Outside the two of them look over the scene. Yellow splattered on snow. The stink. Sirens. They get back in the car. In 1960 Hans Laube invented Smell-O-Vision, which released related scents into a movie theater to provide another sense to the movie-going experience. Here we are told about the stink and see reaction to it, which also taps into the sense of smell, but here through the memory of the viewer and perception of what it could be.

Motel. Yellow Bastard is still alive, he's in their car. She wants Hartigan to sleep with her. He says he's too old. Tries to kiss him. They kiss. He gets up. They love each other. He takes a cold shower. Yellow Bastard opens the curtain and punches him. Yellow Bastard keeps saying to Hartigan, Do you recognize my voice? Hartigan says he does recognize his voice—it's Jr. the senator's son. Black.

Hartigan has a noose around his neck. Yellow Bastard is injecting a yellow fluid into Nancy's neck. He makes a phone call, says he has the girl and wants a party set. If it's not perfect, he will call his dad, Senator Roark. Yellow Bastard tells Hartigan his father paid a fortune to grow back the equipment that Hartigan blew off. Side effects were yellow skin and distorted features. He's holding Nancy and is going to rape and torture her. He reveals he's a pedophile. Yellow Bastard kicks the table out from under Hartigan, and

he goes off with Nancy. Hanging, Hartigan says this is the end. Black. Close up of his eye. The rope is around his neck. He swings back and forth towards the window. Breaks the window, but there is no alarm as he had hoped. Has to cut the rope. This kind of action trope is reflective of a swashbuckler movie.

Car. Motel. Snow. Driving. Two guys get out of car in front of the motel. They go into room. One has gun drawn. Hartigan takes them over, gets the gun. Hartigan drives fast to the farm. Six miles from there he finds Nancy's car. Hartigan running in snow. His heart gives him pain. Says it can't be his heart, he was cured. Failure is a theme in *Sin City*, actions that happen or are supposed to happen fail. Farm. Slits the throat of a guard. Roark Jr. with the white-lens sunglasses sits and reads a black book with a white cross on it. Up the hill in a house Yellow Bastard is whipping Nancy, who remembers not to scream because that triggers Yellow's sex drive. He pulls out a large serrated knife. Hartigan is outside on the grounds. Yellow Bastard looks out the window and sees him. Two guards come up on him from behind. Hartigan turns, has a gun in each hand, and shoots both of the guards. Hartigan enters the building and sees Yellow Bastard coming down the steps holding onto Nancy with the knife under her chin. Hartigan collapses. Yellow Bastard throws Nancy aside. He has a knife ready to kill Hartigan but Hartigan stabs Yellow Bastard in the stomach, punching him repeatedly. He kills him and is covered in yellow blood. Hartigan takes Nancy out of the building. Fade out to black. Resolve of critical issues in *Sin City* are extended narratively to build tension beyond conventional limits.

Car. He wraps her to keep warm. Going to get evidence to put senator behind bars—they kiss. She gets into car. Narration. He says Nancy Callahan was the love of his life, never told her. Killed the senator's only son. Senator goes wild. He destroys his office. Nancy will never be safe as long as Hartigan is alive. One way to beat the senator. An old man dies, a young woman lives. In silhouette Hartigan shoots himself. Fair trade.

Becky in hospital. On the phone. She has a fractured arm. She gets into an elevator. The hit man dressed as a doctor is in the elevator next to her. He takes off his eye glasses. Calls Becky by her name. Offers her a cigarette. She signs off the call by saying, "Love you too, mom." Black. In narration he says "Anything" referring to what can be done in Sin City.

Conclusion

Countless movies have been adapted from short stories, novels, and plays. *Sin City* represents a new category for motion picture creation. Because graphic novels are so totally visual, they are an excellent venue for adaptation. The screenwriter can see the characters and the action and is empowered in their ability to create a script with dynamic, visual storytelling. Other

graphic novels that have been adapted into movies include *The Crow* (1994), *Hellboy* (2004), and *A History of Violence* (2005). Visual storytelling is vast and communicates universally. The graphic novel created a new form of telling stories that is limitless in narrative possibilities. Cinematic language is expansive and adaptive. *Sin City* further opened the door for new possibilities and new visions.

For Further Study

Screen

American Splendor
Ghost World
Road to Perdition
V for Vendetta
Watchmen

Read

The League of Extraordinary Gentlemen
Maus
Persepolis
Sin City (seven book series)
300

The Perfect Silent Film

Sunrise

This 1927 silent film has long been known as *Sunrise*. The full title stated on the film is *Sunrise: A Song of Two Humans* (1927).

A man and a woman live in a lakeside town with their young child. Another woman who is on vacation seduces the man. During a boat ride on a lake, the wife begins to suspect she is in danger from her husband and when they get to land, she runs away. They go all around the city, and he tries and eventually succeeds in making her happy. On the trip back to their home they encounter very bad weather and the small boat capsizes. The other woman goes to their house assuming the plan to kill the wife has succeeded. He comes to her house and begins to choke her. The wife has clung to a bunch of reeds and was saved by a local man. The man and his wife are back together, they kiss, and there is a happy ending.

F. W. Murnau was a German film director who by the age of 12 had read Schopenhauer,[1] Nietzsche,[2] Shakespeare, and Ibsen.[3] His parent's villa was often turned into a stage where the young Murnau directed plays. He studied philology (the study of language in historical literature) and art history in Berlin and literature in Heidelberg, where legendary theater director Max Reinhardt[4] saw him in a student performance and enrolled him in his acting school. During World War I, Murnau served as company commander at the Eastern Front. He joined the German air force two years later and survived eight crashes without injuries.

At the end of WWI Murnau returned to Germany and created his own movie studio with famed actor Conrad Veidt (*William Tell* [1934], *Storm over Asia* [1938], and *The Thief of Bagdad* [1940]). Murnau's first feature film was *The Boy in Blue* released in 1919, based on the Gainsborough[5] painting *The Blue Boy* (1770). He adapted the novel *Dracula* written in 1897 for the film

Nosferatu (1929). He was sued for copyright infringement by the wife of the book's author Bram Stoker and lost the suit. All prints of *Nosferatu* were to be destroyed, but bootleg prints survived. In 1924 Murnau directed *The Last Laugh*, which is considered a **German Expressionist film** in which the director experimented with cinematic technique to great effect. His last German film was *Faust* (1926). He arrived in Hollywood in 1926 were he was hired by the Fox Studio and directed *Sunrise*.

The silent film was the earliest form of motion pictures presented to audiences. Silent films were not exhibited without any sound. Music was provided, usually by a live orchestra or piano player on stage while the film ran. **Sound effects** could be part of the experience, with a person using props to create mostly realistic sound effects. While a silent film was being projected, an operator hand-cranked the movie at various speeds depending on the scene. Mostly the speed simulated normal movement, but action scenes or scenes of danger could be made to appear faster or romantic scenes could be made to appear slower yet by altering the cranking speed. Actors had to communicate their feelings by mouthing the words and by moving their faces and bodies in an expressive manner. There were **intertitles** that had either narrative information or the text of dialogue, which informed what the actors were doing or saying. These were **intercut** into the movie when necessary. Silent films were far from crude, an all too common notion. The great majority showcased great cinematic skill and technique. Visual storytelling became a real art, without sound to provide or support narrative information.

Sunrise has arguably been considered the greatest silent film ever made. Certainly King Vidor's (see Chapter 15) 1928 *The Crowd*, released just one year after *Sunrise*, would also be on that short list. The artistic style of *Sunrise* is expressionist. Great atmosphere is created with artistic lighting and expressive set design. The story is compelling and emotional. No character has a name in the film, which is intended to give the story a universality. *Sunrise* takes place in contemporary times for when it was made, but imagined through a German Expressionist prism, creating a hyperreality. Silent film acting in general is deliberately overexpressive and relies much on facial expressions to communicate interior feelings. In 1929, Janet Gaynor, who plays the wife, was the first actress to win an Academy Award for Best Actress in three films, *Sunrise*, *7th Heaven*, and *Street Angel*. All the acting in *Sunrise* is naturalistic and compelling by nature of the contemporary story, but the characters and narrative reach out beyond the individual to make a statement about human interaction. Intertitles in *Sunrise* are minimal and are used to impart important dialogue or comments on the story. They were hand drawn in a stylized and expressive manner and also made comments on the story by a change of size or made to move via animation. There are selective sound effects to counterpoint the images.

Narrative and Cinematic Analysis

Sunrise is an American film with strong European German Expressionist influences that transform it into an artistic experience. This is a black-and-white silent movie with an added orchestral musical score.

Intertitle, which states this story can happen anywhere anytime; life is sometimes bitter, sometimes sweet. The story about to unfold here is stated as a song, not as in a vocal presentation but as poetry. Life is the same as always. There is a sunrise and a sunset. Life can be bitter. Life can be sweet.

Summertime, vacation time. Line drawing of a train moving out of the station **dissolves** to live action. Two shots in which there are two separate images, one on the right and one of the left, joined to form one shot with a soft overlay edge. The first is a moving train on either side of the frame. The second is a beach scene on one side and a large boat filled with people on the other. There are several shots establishing a cottage and a town just off the water. There are vacationers. One is the Woman from the City (Margaret Livingston), who is stylish and has dark hair. She wears a flapper hat. She has stayed there long beyond the season.

Dusk—the Woman from the City walks. Whistles. The Man (George O'Brien) is in a cottage. He walks to the door. The Wife is blonde, petite, and very dear. She sets the table. Outside, whistles again. The Wife brings out a hot bowl of food. Sad. Two women outside talk about the couple when they were once happy. They explain that he has had dealings with moneylenders and lost some of their farm.

This shown in **flashback**. The couple are outside with the Boy (Robert Parrish, who became a noted film editor and film and television director). They are very happy.

Also presented in backstory is a shot of the Man watching as his cattle are being taken away.

Back to present. The Wife goes to the Boy, who cries. Night. Moon. Field. Trees. Fence. Walks. The camera follows footsteps in the mud to reveal the Woman from the City. Camera movement in *Sunrise* is expressive and interpretive. She waits for the Man. Moon. Grass. He comes to her—they kiss and embrace. Wife and the Boy. She is crying; she knows there is something wrong.

Back to present. The Man walks in a field. The camera follows him relentlessly. He arrives at the spot where the Woman from the City waits. They kiss in a field. She wants him to leave his wife and come with her to the city. She suggests drowning her. Intertitle over cloud imagery. Letters from words in an intertitle are animated to express drowning. The Man pushes the Wife over the boat into the water—a visualization of what he sees in his mind. The Woman and the Man struggle, but he submits to her. Letters in an intertitle about the city grow in size to express a place far away from the town. Another shot that combines two images: they sit in the field looking out and

the City lays before them. There is an expressionist series of shots. A city created through painterly images, moving lights, a split image shot: dancers on a striped floor joined to an image of a brass band playing rigorously by a soft edge transition, **dissolve** to brass band and bass drummer faded image above the Man and the Woman from the City. She dances. She wants him to marry her and live in the city. Camera follows footprints in the mud. The music is ominous. They are revealed to be hers. She picks bulrushes for him to use after shoving his wife in the water to her death. The Man comes home holding the bulrushes. The Boy is sleeping. The Man hides the bull rushes in the barn.

The Man comes into the cottage looking mentally tortured. Double beds. The Wife is sleeping. He collapses into his bed. **Superimposition** of the Man and threatening waves. This image represents the Man's thoughts of drowning his wife. Sound of a bell. Full shot of water, bell rings, pan up to town. The Wife gently covers him. He gets up with a start and sees the bulrushes on the bed. There is a rapid push into the bulrushes which is how he sees them, startled. Outside. Wife feeds chickens. Superimposition of Woman from the City over him kissing and touching him. Multiple images of the Woman from the City around him. She is ghost-like and is conjured up by his mind. He gets up. Meets the Wife at the doorway and talks to her. She looks at him longingly.

Going on a trip to the city across the water. The Man holds his head. Repeat of him throwing the Wife off a boat. He is tormented, in a somnambulistic state. Holds the bulrushes. She puts on a pretty hat. A woman is there to take care of the Boy. They walk on the pier to boat. The bulrushes are wrapped up. The Wife comes to the boat, sits down. They push off. Dog barking. Dog swims to the boat. The Man turns boat around. He walks the dog back home. The Man comes back to the boat. A bell rings. They push off. He rows like he has a grim purpose. Seagulls fly off the water. She watches him. He stops rowing. He puts down the oars. She stares at him, he stares at her. He looks at her with an evil expression. He gets up and lumbers towards her. She folds her hands, almost as if she were praying. He is repelled by his thoughts and actions. His arms cover his face. Bell. Rows as fast as he can. Works oars to navigate a stop, puts rope around on tree stump. The Wife runs away. "Don't be afraid of me," he says. She runs and gets on a trolley, he follows.

City. Cars. People. The Wife is very upset. The Man stands over her. "Don't be afraid of me." She runs off the trolley into traffic. He runs up to her and guides his wife out of traffic. The city scenes are rendered in a more realistic style than the early scenes in the film. Restaurant: he holds her, they sit at a table. Glass panels. The Wife is despondent. When they don't respond to a waitress trying to take their order, the Man walks off and brings her a plate of cake slices. She looks up and takes a piece of cake, then collapses

onto the table. She gets up; he follows. Outside. Busy street. The Man buys her flowers, she cries, then he buys more flowers for her. She can't stop crying. He tries to console her. Church bells. Street traffic. She calms. Sees a bride going into the church. Interior: a church marriage ceremony underway. They go in and watch. "Trust—be her protector," the priest says to the groom. Close up of the Man crying. "Will thy love her?" says the priest. The Man cries in the lap of the Wife. "Forgive me." She holds him. Bells ring. She kisses him. They come out of church looking like they were just married. She still holds the flowers. People watch. They walk through cars on the street without looking, then they are walking through a field. They kiss and it is revealed that this was pictured as to how they felt, but the reality was that they were in the middle of the street with drivers yelling at them for holding up traffic.

Photography shop. They look at wedding pictures and photos of children. Barber shop in a large space. The Man gets a shave. The Wife is put in another chair but doesn't want her hair cut. A lady manicurist looks at his hands and flirts. He says no. The Wife smiles. A man sits next to the Wife on a bench. He gets too close to her. He takes one of her flowers for his lapel. The Man comes over and steps on his foot, pulls out a folding knife. He looks menacing but cuts out the flower from the man's lapel. The Man leaves and the man sweats. **Fade to black**. Photographer: standing pose. Sees the Wife holding flowers and thinks she is a bride. They laugh. Shot from inside camera: the image is upside down. They kiss; he takes the shot without them aware. Tree backdrop. Photographer goes to develop the print. She sits on a couch. Statue with no head. They find a ball with face on it and put it on the statue. What would become Alfred Hitchcock's musical theme for his television series, Gounod's *Funeral March of a Marionette*, plays. They leave. Photographer sees the ball on the statue and laughs. Outside they open pictures and laugh at the one of them kissing.

The Woman from the City marks a newspaper ad to sell the farm and move to the city. Spinning wheel with shimmering lights. To the contemporary viewer it looks like computer animation, but this is 1927. Eventually this becomes the centerpiece of an amusement park/entertainment center. The design of the park speaks to art deco and abstract expressionism. Long lines to get in. Roller coaster. Fountain. Restaurant. Dissolve. Midway. Piggy roll contest. Dancing area with orchestra. The Wife wants to dance. The Man wants to throw balls. Pig escapes. Sound effects. While they are at this crowded place where everyone is enjoying themselves, a pig gets loose and runs wild. The Man chases the pig. Kitchen. Cook drinking liquor. Sees and hears pig now covered with a sheet and drops the bottle, and it breaks on the floor. Pig drinks, gets drunk. The Man comes into kitchen and catches the pig. Everyone applauds him. He is deemed a hero. A band plays *The Peasant Dance*. The Wife starts to dance and the crowd claps. The Man takes off

his jacket and they start to dance. Intercut with a woman watching them dance. A strap comes down from her dress. A man standing next to her fixes it. He holds it in place while she claps, then it falls down again. He fixes it and then pulls both down. She slaps him. The Man and the Wife were dancing all through this. Loud applause for the dancers. Sound of them clapping and cheering; voices and whistles can be heard.

At a dining table. The Man pours a drink for the Wife. A superimposition above the dancers that pictures people spinning on a large horizontal ring above them. They disappear when the waiter walks over to their table for the check to be paid. The Wife is tipsy from drinking. They leave after the check is paid. A moving camera follows them out, then reveals the expanse of the restaurant, then past a flowing fountain, then picks up the couple as they leave the area. Fireworks. Crowd. Ride with flying cars. Roller coaster. Night. They run to a trolley. He lifts her on. Fade to black.

Boat on the water. Barge fire. Smoke. Music. People dance. The Wife dances in place. The Man and the Wife kiss. Intercut of the city. Back to the boat. She falls asleep on him. Intercut of the city. Lightning. Wind. Rain. Fade to black. Music creates sounds like lightning and thunder. City people run for shelter. Boat. Wind. City. Bad storm. People running. Boat. He takes off his jacket. He takes down the sails and rows the boat. She's up and puts on his coat. Lightning. Cottage in distance—holds her and rows. Child wakes up in cottage. He pulls out the bulrushes and ties them to her. Caretaker and child. Lightning. Waves. Cottage. Wind. Storm calms down. Fade to black. Moon. Rocks. He holds onto a rock, then swims. Climbs up rocks. Calls out sound for help to her, which is musical in nature.

Woman from the City sleeping. A man with a lantern. She wakes and looks out the window. People run outside towards dock. She dresses and runs out. The Man asks a group of people for help. The Woman from the City watches. Boats. Searching. There is a cut to black that holds for many beats, and then we see the Wife floating on the bulrushes. The Man. Boat. Lantern. He makes a musical voice in hopes his wife will hear him. She floats away from the bulrushes. He sees loose bulrushes. The Man takes off his hat. The others with him bow their heads, signaling they believe the Wife has drowned. They pull the Man from edge of the boat. Boats and lanterns. People wait at the shore in hope. The boat comes back without her. The Man is walked up the road. The Woman from the City. They take him into his cottage. Shot on the woman watching the Boy. They are both crying. People leave, and the door is closed. He goes into bedroom. Collapses and kneels on bed.

Bells. Sunrise. A man has rescued the Wife. The Man strangles the Woman from the City, then stops. Horn. The Wife is alive and smiling. She holds her husband. Locals didn't give up hope. Flashback of man recovering the Wife. Black. Sunrise over village. The Woman from the City leaves the community. Sunrise over cottage. Wife in bed with child and husband. The Woman from

the City leaves the town to go back to the city. The Man and the Wife kiss. A graphic symbolizing the sun, rises—End.

Conclusion

Sunrise is a prime example of the art of the silent film. Every frame is expressive visually and the acting emotional and captivating. There are film historians and scholars who feel that the art of cinema died with the introduction of the sound film, heralded by *The Jazz Singer* starring Al Jolson[6] in 1927. Also, that most of what could be done in film was accomplished in this era. Sound was destined to come to the movie theater in terms of dialogue, sound effects, and other sonic areas, but from the 1890s to the late 1920s audiences learned about the very art of filmmaking with more lessons to come.

Notes

1. Arthur Schopenhauer (1788–1860) was a German philosopher best known for his 1818 work *The World as Will and Representation*, in which he says the world is a product of a blind and insatiable metaphysical will.

2. Friedrich Nietzsche (1884–1900) was a German philosopher, social critic, composer, poet, and physiologist. He made a radical critique of truth in favor of perspectivism, made a genealogical critique of religion and theories of master-slave mortality. He also believed humans had a will to power. After his death his work became associated with fascism and Nazism, but later scholars refuted this. He is considered to be the most influential and important philosopher of his time and beyond. His views touched on a myriad of subjects including science, art, history, tragedy, and culture.

3. Henrik Ibsen (1828–1906) was a Norwegian playwright referred to as "the father of realism" and one of the fathers of modernist theater. His plays include *An Enemy of the People* (1882), *Hedda Gabler* (1891), and *The Master Builder* (1892).

4. Max Reinhardt (1873–1943) was an Austria-born theatre and film director and theatrical producer. He was known for his innovative productions in Germany and the United States. They include *The Miracle* (1924), *The Eternal Rode* (1937), and *Sons and Soldiers* (1943). In 1935 *A Midsummer's Night Dream*, codirected by William Dieterle and Reinhardt, was released. The production was created in Hollywood and distributed by Warner Bros.

5. Thomas Gainsborough (1727–1788) was an English portrait and landscape painter who was known for his light palette and easy brush strokes. His works include *Frances Browne, Mrs. John Douglas* (1783–1784), *Johann Christian Bach* (1776), and *Landscape in Suffolk* (1748).

6. Al Jolson (1886–1950) was an American singer, comedian, and stage and film actor. Often considered the world's entertainer of his time, he had more

than 80 hit records and widely toured the United States and internationally. He was beloved and took his place in history as being the first actor to sing or speak in a talking movie. He also appeared in *Hallelujah, I'm on a Bum* (1933), *Rose of Washington Square* (1939), and *Swanee River* (1939).

For Further Study

Screen

The Cabinet of Dr. Caligari
The Crowd
The General
Greed
Intolerance

Read

American Silent Film by William K. Everson
100 Essential Silent Film Comedies by James Roots
The Parade's Gone By . . . by Kevin Brownlow
Silent Movies: The Birth of Film and the Triumph of Movie Culture by Peter Kobel
Spellbound in Darkness: A History of the Silent Film by George Pratt

Tatami Camera Style
Tokyo Story

In *Tokyo Story* (1953) an elderly couple travels to Tokyo to visit with their children, but once there they are disappointed with their attitudes, complaints, and general indifference. *Tokyo Story* is a bittersweet but enlightening meditation on family, relationships, and mortality.

Yasujirō Ozu was born in Tokyo in 1903. At the age of 12 he skipped school often to watch movies such as *Quo Vadis?* (1913). In 1917 he saw *Civilization* (1916) and decided he wanted to be a film director. At 17 he was thrown out of his school dormitory and later took the exam to be a teacher, but failed. In 1922 he was able to work as a substitute teacher. It was a long journey from the school to the movie theater he visited to watch more films. His uncle helped him get a job at the Shochiku Film Company as an assistant in the cinematography department in 1923. In 1924 he started a year of military service and finished as a corporal. In 1926, back at the studio, he became a third assistant director. In 1927 he directed his first film, *Sword of Penitence*. Ozu began using the low camera position that has become his trademark. He continued to direct films until 1937 when the studio became unhappy with the lack of box office sales his films brought in. In that year he was conscripted into the Imperial Japanese Army and spent two years in the Second Sino-Japanese War and other battles. In July 1939 his conscription ended. He continued to make films, but was back in the army in 1943 and was sent to Singapore. He got to see and was very impressed with *Citizen Kane* (1941). He returned to Japan in February 1946 and reported to work at the Ofuna Studios where he directed *The Record of a Tenement Gentleman* (1947) after working on what was called the Noriko trilogy, which concluded with *Tokyo Story*.

Ozu had a distinctive visual style and approach to creating his films. He didn't use **dissolves** for transitions. He would cut to a static shot or shots and hold them beyond what the viewer expected; then he would go to the next scene. He rarely utilized music, only during the transition shots. He did not move the camera much. He did not use the Hollywood staple, the **over-the-shoulder shot**, but instead would shoot the actors in a dialogue scene straight on with them appearing to be looking in the camera, which made the viewer feel as if they were in the center of the scene. His most noted cinematic element was putting the camera very low, perhaps one or two feet from the floor. It was like the **point-of-view** of a person sitting on a tatami mat, the traditional Japanese flooring. This was done in scenes where the characters are sitting but also when shooting someone from down a hallway. He also violated the **eyeline match** theory used extensively in Hollywood movies where the actors and camera were positioned so it looked as if the characters were looking at each other.

Ozu is a singular figure in the history of Japanese cinema. In content and visual style he stood out as an original voice in his time. No other director made films like Ozu. Akira Kurosawa came out of a Western tradition and worked in many **genres** not always traditional to Japanese cinema. Kenji Mizoguchi made genre works, **remakes** of **German expressionism**, and adaptations of Eugene O'Neill[1] and Leo Tolstoy.[2] Masaki Kobayashi spent from 1959 to 1961 directing *The Human Condition*, a trilogy on the effects of World War II on a Japanese pacifist and socialist. The total of the trilogy is almost 10 hours, making it one of the longest films ever made. Mikio Naruse directed films that were bleak and pessimistic. He primarily made working-class dramas featuring a female protagonist. Some compare him to Ozu because they both made family dramas, but that's where the comparison ends. Ozu's films had a spirituality expressed in the writing, acting, and in his direction. There is a meditative quality to Ozu's films, and in a field of great Japanese directors, he stands out as a unique artistic figure.

Narrative and Cinematic Analysis

Black-and-white. Dramatic score over credits. Shots of Tokyo—long takes. Train goes by. House, trees. Shūkichi Hirayama (Chishū Ryū) and his wife Tomi Hirayama (Chieko Higashiyama) are retired, have children and grandchildren. They are sitting on the floor in the home. Daughter Kyōko (Kyōko Kagawa) leaves. "You don't have to see us off." Exterior. She walks off. The parents are leaving today to see all their children who live in Tokyo. Smokestacks. Train platform.

Sign: Dr. Hirayama–Internal Medicine and Children's Diseases. Interior home. Fumiko Hirayama (Kuniko Miyake) cleans up. All interior shots from floor level. The doctor's older boy Minoru (Zen Murase) asks if grandparents

have arrived. Room for a doctor examination. He walks around to his room and finds that his desk has been moved. Mother tells him she moved it to make room for his grandparents. The boy is angry. The parents arrive. Their eldest son, Kōichi Hirayama (So Yamamura), a pediatrician, is with them. The eldest daughter Shige Kaneko (Haruko Sugimura) is also there to greet her parents. Pillows for the floor. They all sit down. The doctor's youngest son Isamu (Mitsuhiro Mōri) is also sitting on the floor. The boy runs away. It's been a long time. Some use hand fans. Boys in the room. Crackers are served. Introduces boys to grandparents. The boy runs away. Kuniko joins them. Planning meal. Sukiyaki.[3] The daughter-in-law Noriko (Setsuko Hara) missed her train, now arrives, bows. Exterior. Minoru in exam room studying, has his cap on. Kitchen shot from other room. Parents and eldest children sit and talk. Plans for tomorrow. Here at last.

Landscape, sky. Smokestacks. Ooh La La Beauty Parlor. Shige and her husband Kurazō Kaneko (Nobuo Nakamura) eat breakfast. She thinks the parents will stay only a few days.

Fumiko gets her two boys ready to go out. The doctor gets dressed. Taking parents to a department store. Minoru is asked to see if the parents are ready to leave. A man comes to the door to tell the doctor his child is sick. The doctor says he must go and see the child. The parents say they will wait for him. The doctor tells his wife he will be a long time—that she can't take them to the department store because someone has to stay in the home/office. The older boy is angry; the little one sits, won't come to grandparents, and then leaves.

Examination room. Fumiko talks to her boys. Grandma walks in and suggests a walk, but the older boy is adamant against this. Grandma takes the little one out of the room. Mother tells the older son to go with them. She leaves the room. The older boy sits and stews, then gets up, walks across the room, and throws something to the floor. He sits in a chair and spins around.

Father is in the downstairs room. Fumiko enters with tea and sits with him. They talk about the boy being stubborn. Father says his son, the doctor, was stubborn too. Father looks out of window and in the distance sees his wife and grandson in the distance. Closer. Grass. The boy won't talk. Long shot of them. On Shūkichi as he is sitting on floor with a hand fan, looking at them through the window.

Beauty parlor. Women set up for customers including Shige Kurazō, the owner of the shop. Shige's husband comes in and sits on the floor. He says he bought some expensive cakes for her parents. Shige says that these cakes are too expensive for them. She asks him if he will take her parents out tomorrow; he says he will be busy then. He suggests where to take them, but there is no one to take them. They eat cakes. Mother sits on the floor. Kurazō suggests going to the baths. Father outside. Ice cream on the way back is suggested. Shige says, "Use my sandals, the old ones." The parents and Kurazō

leave. Shige calls Noriko to ask a favor, which is to take the parents some-
where, because she is too busy to take them anywhere. Noriko is in an office.
She asks the boss if she can take off tomorrow. She goes back to the phone
and tells Shige yes.

Tour bus through Tokyo. **Voice-over** of the guide. Ride through city.
Building. Steps. Noriko points out where everyone lives. Wide shot of the
city. Wide shot of a building. Interior: Noriko borrows some sake from a
female neighbor. The parents are looking at a photo of their deceased son
Shōji who had been married to Noriko. He was in the military. Noriko goes
to a neighbor to borrow cups. The lady also gives Noriko stewed green pep-
pers. Parents thank her for the tour. The father smokes a cigarette. She serves
him sake. Noriko remarks about the amount of sake. Mother says, "He likes
to drink." Asks her if their son drank. Noriko says yes. Her husband has not
been alive for eight years. Father tells Noriko he is afraid the son caused her
problems. Food is delivered. Noriko serves them and fans them as they eat.
Fans have long been part of Japanese culture. Patterns on them can symbol-
ize wealth and a path from life guiding the user through life. They represent
tradition and create a gentle wind to cool the one using it or respectfully on
another for comfort. Even though Noriko is not a blood relative, she is the
most kind, caring, and sweet-hearted of everyone in the family. She treats the
parents as if they were her own. They love Noriko but at times are overly
blunt concerning their deceased son and the fact that Noriko is alone.

Shige's husband says that the parents are late to arrive at their place. They
don't know how long they will be in Tokyo. There's a plan to send them to a
hotel. It costs money wherever we bring them. Everyone is busy. The hotel in
mind is inexpensive. Exterior, people sitting. Landscape. House. Spa. Mother
and father drinking at a table. They talk about the spa. Wide shot of the
sea. Room with female staff. Men and women playing a card game. Hallway.
People fanning themselves. Two pairs of shoes in front of a room, another
Japanese custom. Father and mother lie in bed fanning themselves. Noisy. A
musical group performing. They can't sleep. Loud voices. The mother and
father in their room, still can't sleep. Father sits up, then mother sits up in
bed. Shot of two pairs of shoes as before. Ozu revisits images to capture the
routine of life.

Landscape view out of the window. Women cleaning in the hall, singing.
Mother and father sitting on the ledge of a wall overlooking the water. They
talk about not being able to sleep last night. He says she did, he heard her
snoring. They talk about the spa being for a younger generation. Mother and
father sitting on a wall. He wants to go home. They've seen Tokyo. Mother
agrees. He gets up and walks on the ledge of the wall, but the mother can't
get up. Says she felt dizzy, okay now, then gets up and walks. He says it's
because she didn't get enough sleep, but this is a foreshadowing of an event
that will have a powerful impact on the family. In a Hollywood movie

foreshadowing may appear overly dramatic and obvious; here it is natural and understated.

Hallway. Landscape, window view. Smokestacks. Beauty parlor. Shige works with a customer. The parents are back. Shige says you should have stayed longer, is visibly disappointed. They go to their room. Shige tells the customer she is ashamed of her parents. *Tokyo Story* is direct and honest about familial relationships and the underlying issues that cause tension in the family. The assistant takes over her customer, and Shige goes to her parents. They talk about the spa. They tell her they want to go home. Shige says it's been a long time since they've been here to Tokyo. She gives an excuse why they sent them to the hotel. She is having a large meeting of other hairdressers in her house that night, which is why she suggested the hotel. Says she should have told them. Shige seems to want it both ways, telling the parents they haven't been in Tokyo for a long time while saying she should have explained why the hotel was suggested. The mother and father don't know what to do. He suggests his wife go to Noriko's apartment. They both can't say there. He says he'll visit the Hattoris. He jokes. "We're really homeless now." They pack their bags. The journey to Tokyo was planned and expected, but what has happened with the family shuffling them around creates a new adventure.

Exterior. The mother and father sit on grass. They walk. He tells her she has forgotten her umbrella. She goes back and gets it. He tells her she is so forgetful. They walk to a wall and look out. He remarks how big Tokyo really is. The significance of a big city in relation to the smaller areas of Japan is how large it is and how opposite it is to the simple life the parents have been living. He points out the differences between the elders and the children. They walk again. The musical score for *Tokyo Story* by Takanobu Saitō is lyrical and heartwarming as well as sad. Strings are dominant in this music. They walk. Sign in front of store: "Hattori–Professional Scribe." Father sits with a friend and his wife. They talk about the old neighborhood. Father tells them the place where the couple had lived wasn't too close to the bomb. The dropping of atom bombs on Japan during World War II is never far from the minds of these Japanese people. They reminisce about better times. The friend says he rents to a law student who is a playboy and never studies. Talk about the old police chief who now lives nearby. The two men go to see him.

Sign on a round paper lantern. Interior. The men sit and drink sake. Talk about a geisha from the past. They talk about war and that they had enough of it. Loss of sons. Low table. A place to drink. Street signs. Drinking at the bar. All three are getting drunk. One of the friends claps his hands and asks for more sake. No response. He gets up and goes off.

They are now at a different establishment. A female bartender serves them. They are very drunk. They say the bartender looks like a young geisha from their past. One of the other friends says she looks like his wife. The

bartender tells them they should leave, that they have had enough to drink. The friend tells the father he is lucky to have such nice children. He says his son is not good. He lies about his son's job. He criticizes young people. The father agrees with the friend that he's not satisfied with today's young people. This conflict resembles what was called "The Generation Gap" in America during the 1960s. The father said he thought his son was doing better, but now that he is in Tokyo he sees the son is just a neighborhood doctor. He tells his friend that we can't expect too much from our children. Times have changed and this has to be expected. The woman bartender tells them it's 12 o'clock—time to leave. The two friends are bent over and have their heads on the bar.

Exterior. Back alley. The daughter-in-law gives mother a massage. She says she's a burden to everyone. The mother says she will be sleeping in the dead son's bed. Feels sorry for the daughter-in-law. Tells her to be free to get married again. "You had trouble after marrying him." She says she's happy. The girl smiles, then changes expression. She lies in bed thinking. This is another conflict in old ways of thinking—the woman seems to have adjusted to her life after losing her husband and she says she is happy.

Shige and her husband are sleeping. Police officer brings them home, father and friend both extremely drunk. They stumble to the beauty parlor chairs and fall into them. She is tough with them. Talks with the husband. The father used to drink all the time and upset her mother. He drank until the youngest daughter was born, then he stopped drinking and was a new man. Now he has started up again. She tells her husband to sleep upstairs and prepares their bed for them. She's most angry that the father came back this night. Fixes the bed. The two men continue to sleep in beauty parlor chairs. This examination of possible alcoholism puts the father in a different light. His backstory presents a less stable man.

Exterior. Building. The daughter-in-law prepared something in another room that she then brings to her apartment. The mother gets ready to leave. She looks almost into the camera as she talks to the mother. Gives mother spending money. At first the mother doesn't want to take the money, but she is convinced and takes it. She is moved to tears over the young woman's generosity. She hopes the mother will come again but the old woman quickly says she won't be coming back, either a foreshadowing of what is to come or her reaction to the difficulties during their stay. The mother was going to leave something behind, but the daughter-in-law caught it. The mother says she's getting very forgetful. They leave. An umbrella almost left too. Camera stays on the empty room. Because it is mentioned more than once, the mother's forgetfulness seems to be linked to a winding down occurring in her life.

Sign. Terminal. Everyone's here to see them off. The mother says the children live far away and that they might not see her again. Again does she mean what she says? Boarding. Terminal. Exterior. Large building. Train

wires. Train tracks. Their son Keizō (Shiro Ōsaka) tells a fellow train company worker that his parents weren't supposed to get off the train, but the mother got sick on the train. She's feeling better now. The tone of the conversation conveys that he thought it was a bit of a to-do and needed to talk about it to someone.

Parents in a room. The train was crowded. The mother takes powered medicine. Says she feels fine and is ready to leave. The father wants to stay over one more night for a less crowded train. They both feel the earlier crowded train got her sick. They are in Osaka seeing their son Keizō who works in the train office. The father is surprised how children change. He says that Shige used to be much nicer. Lucky. He's happy their children are better than most.

Clothes hanging. The doctor's wife cleaning house. The doctor tells her that the mother got sick on the train. He's reading from a letter. The trip was too much for her. She was satisfied and will remember Tokyo for a long time. Phone rings. He answers and says he hasn't gotten a telegram. Shige is on the phone talking to her brother the doctor. Telegram says the mother's dying. On doctor, the letter to him was from the father. He tells her they got off the train because the mother was ill. Telegram delivered to the doctor's home. His wife goes to the door and gets the telegram. She brings it to the doctor who is still holding the wire. It is from Onomichi, which is a city in Japan. The mother is critically ill. It's from Kyoko. He gets back on the phone and tells Shige that he got the telegram. Shige says she'll be right over. The wife suggests to call Noriko. She leaves the room, leaving him alone. The sound of dialing. He waits while he whistles and gestures his hand. *Tokyo Story* has taken a dramatic turn, a fact of life that will impact all.

Yoneyama Trading Company. A man picks up the phone and tells the caller to wait a minute. The daughter-in-law gets up from her desk. She picks up the phone and finds out that the mother is very ill. She goes back to her desk and sits. She is very sad and contemplates what has happened.

Two shots of construction in progress. Doctor's office. Shige and the doctor. The talk is about the mother being critically ill. She thought it would be the father first. She mentions that she felt strange about the mother's remark when they were at the train station, as if she knew something was going to happen. She wants to go see her mother. The doctor says he has to make many arrangements. Shige says she does as well. They talk about taking mourning clothes, if they'll need them. They'll meet at the train station. They both leave the room.

Bell rings. Landscape shots. Daughter and father attend to the mother who is ill. The daughter is fanning her. Gong rings. The daughter says to the father that she is going to meet the train to pick up family from Tokyo. He tells his wife that the children are coming to see her. The mother is breathing very heavy. Father continues to fan her. He tells her that she will get well.

Boats on the water. A bug on the ceiling lamp. The family sits around the mother, who is lying on the floor in a coma. Shige fans her. The doctor son examines her and finds her reactions to be weak. Shige ask her husband where Keizō is, that he is late. He did not answer the telegram informing him that the mother was gravely ill. The doctor asks to see his father and Shige. They all get up and walk into another room. He tells them he doesn't like the mother's condition. They all kneel. Discussion as to whether the trip to Tokyo caused her condition. The doctor says it may have. He tells them that she may not live until tomorrow. Shige cries. The father is coming to grips with the fact that his wife will die. The doctor predicts by daybreak. He gets up and walks into the room with his mother, leaving the other two who are stunned at the news. The others continue to sit in vigil. The father and Shige who continues to weep into her handkerchief. The father says that it seems that Keizō, the youngest son, won't be in time. The father gets up and goes back to his wife. He is very somber. Music.

Covered area. Water. Boats. House. Train tracks. These poetic linking sections throughout *Tokyo Story* signal that life continues while the characters live their lives. Mother's room. Crying. Shige contemplates that life is so short. Feels the mother knew this was going to happen soon. Knowing the mother's death is near and what caused it is complex and part of the density of this film. Shige may be right, but she is simplifying what occurs. Shige is glad her parents went to Tokyo and that she got to see her mother alive. The daughter-in-law and the other daughter are asked if they have mourning clothes, and they say no. She criticizes them. Shige says they'll have to borrow them. Shige says the mother died peacefully and full of years. Keizō arrives. At the door he takes off his shoes and learns the mother has died. He realizes he wasn't on time, something he was afraid of. He enters the room where his mother has passed on. They all exchange bows. He apologizes for being late. The mother's face is covered with a cloth. They all sit in front of the body. She died at 3:15 in the morning. Keizō is told to look at her to see how peaceful she is. He gets up and walks over to his mother, he takes off the cloth covering her face, and asks her forgiveness for being late. They look for the father. One of the daughters sees that he is outside looking off, and she goes to him. He is told that Keizō is here. The father says it is a beautiful dawn sky. They walk back in. The others continue to cry and mourn.

Outside buildings. Funeral service. Chanting and drum. There is a large group of family and friends. Many shots of individuals and groupings as the chanting and drums continue. Keizō goes outside and looks at the cemetery. The daughter-in-law comes out. They both go back in. Headstones. The daughter-in-law comes out to see what's wrong with him. He says he hates the sound of the chanting and drumming, a rebellion against traditional Japanese ways. He feels mother is getting smaller and smaller. He says he wasn't

a very good son. He says no one can serve their parents beyond the grave. He walks back in, and she follows. Shots of the headstones.

Water, boat. Outside the home. Inside the home, everyone is around the table. Memories. They all reminisce about good family times in the past. The father gets up and goes outside. Everyone eats and drinks. Shige wishes that the father had gone first. Feels if the daughter who lives with him gets married, he'll be all alone, and if he had died first they could have taken care of the mother in Tokyo. Shige wants the mother's clothes as a keepsake. The father is back. She abruptly stops talking. The father says it is all over now and thanks them all for coming. He praises the doctor for tending to the mother. He mentions the dizziness episode during the trip. Shige says that he should have told them, but the doctor says it wouldn't have mattered, the mother was overweight and the illness spread quickly. The illness is never defined, making death a more mysterious process. Shige and the doctor decide they have to leave on the night train. They discuss the group's plan. Shige tells her father he's going to be lonely. He says he'll get used to it. Talk of train tickets. Everyone goes back to eating. Shige is concerned about the father drinking too much. The father realizes that everyone will be going home.

Lanterns, landscape in background. Empty room. The father outside tending to plants. The daughter-in-law in the kitchen cleaning up. The daughter dressing. The women are now in a room together and talk about leaving and about coming to Tokyo to visit. The daughter who lives with the father is glad the other women stayed longer and criticizes the others for leaving so quickly. The daughter calls them selfish and doesn't like how they have behaved. The daughter-in-law explains that children drift away from parents. They have their own lives and mean no harm. Family life is disappointing. The daughter leaves for work. They say goodbye. The daughter-in-law cleans up the house. She tells the father she's leaving today. He thanks her for everything and for being kind to the mother. He tells her the mother was worried about her. He wants her married, to forget about her dead husband. Talk about the dead son. She says she is not all they think. He doesn't want her to think of the dead son. She assures him she isn't always thinking of him. She is concerned what will become of her. Loneliness. Selfish. Father doesn't agree. Couldn't say it to the mother. He says she's a good woman; she says not at all. He gives her his wife's watch. She cries. She's done the most and is not even a blood relative.

Outside school. Interior of school. Children walk into school. Classroom. Kyōko watches over the students as they work. She looks at her watch twice. Looking out the window, a train passes by. Train exterior. Train interior. The daughter-in-law on the train looks at her gift watch. She remembers her mother-in-law. Train whistle. Houses, water. The father alone. A neighbor talks about his wife and that he will be lonely. He fans himself. He says if he

knew of this situation, her death, he would have been nicer to her. Lonely. Boat on water. He fans himself in a full shot. Boat, water, Closer. Music. Fade to black—End.

Conclusion

Ozu's *Tokyo Story* is about family, the individual, relationships, and the great city itself. In 2002 it was voted the best film of all time in a poll of directors by *Sight & Sound* magazine. The film is so imbued with Japanese culture that Ozu found it difficult to export this film because those companies involved found the film "too Japanese." *Tokyo Story* is a canonical work, a timeless film from one of Japan's greatest filmmakers, and is a mirror of the customs and traditions of that country, one in which there is a lot to learn about life.

Notes

1. Eugene O'Neill (1888–1953) was a towering American playwright and Nobel Laureate in literature. He was an early realist playwright and was interested in characters on the fringe of society as they struggle to maintain their dreams but ultimately fall into disillusionment and despair. His works include *Mourning Becomes Electra* (1931), *The Iceman Cometh* (1940), and *Long Day's Journey into Night* (1956).

2. Leo Tolstoy (1828–1910) was a Russian writer best known for his novels *War and Peace* (1869) and *Anna Karenina* (1877) and for the realistic intensity achieved in his fiction. He achieved both scope and detail and developed many themes and approaches to genres. Other novels include *Childhood* (1852), part of his "autobiographical trilogy"; *The Cossacks* (1863); and *Resurrection* (1899).

3. Sukiyaki is a Japanese food dish that consists of thinly sliced beef slowly cooked at the table alongside vegetables and other ingredients in a shallow iron pot in a mixture of soy sauce, sugar, and mirin. The ingredients are usually dipped in a small bowl of raw beaten egg after being cooked in the pot, then eaten.

For Further Study

Screen

An Autumn Afternoon
Early Summer
The End of Summer
Late Spring
Stories of Floating Weeds

Read

The Cinema of Ozu Yasujiro: Histories of the Everyday by Woojeong Joo
Japanese Cinema by Stuart Galbraith IV and Paul Duncan
Japanese Cinema: Film Style and National Character by Donald Richie
Ozu: His Life and Films by Donald Richie
Tokyo Story: The Ozu/Noda Screenplay by Yasujiro Ozu and Kogo Noda

The Tall Tale

The Treasure of the Sierra Madre

Feature films are made up of moments; although scenes are essential elements of a movie, it is the memorable moment that we most remember and keep with us long after seeing a movie. A moment in a movie can be a range of incidents, actions, moves, looks, and many other events. In the annals of movie moments there are those that rise above all the rest: Gene Kelly dancing and singing in the rain in the 1952 movie *Singin' in the Rain*; the boy in the red trunks being eaten by the shark in *Jaws* (1975); Harrison Ford and Kelly McGillis and their romantic dance to the Sam Cooke classic, "Don't Know Much about History," in *Witness* (1985) (see Chapter 25); the car flying over the Grand Canyon with Thelma and Louise in the front seat in the 1991 movie that bears their names; James Cagney falling to the floor in his family home doorway after he had been murdered by his own ilk in *The Public Enemy* (1931); and John Wayne framed in a dark doorway at the end of *The Searchers* (1956), then walking off alone as the door closes. Those are but a few great moments in American cinema.

It is 1925 in a Mexican oil town. Fred C. Dobbs (Humphrey Bogart) and Bob Curtin (Tim Holt) are two down-on-their-luck Americans when they meet Howard, an old prospector (Walter Huston). They agree to set up a camp to dig for gold, which they find. Another American finds their camp, and they feel compelled to kill him. A group of Mexicans posing as Federales arrive and see the gold operation. Later when Howard is called to cure a sick boy, paranoia over the "goods," which is what they call the gold they have mined, runs high. The bandits come back, Dobbs is killed, and the goods become sand blowing in the wind.

Director John Huston was the son of legendary actor Walter Huston who appeared in the films *Dodsworth* (1936) and *Yankee Doodle Dandy* (1942) and who won an Academy Award for his supporting role in *The Treasure of the*

Sierra Madre. John Huston dropped out of high school for two years to become a professional boxer. At 15 he was a top-ranking amateur lightweight in California, but his career ended with a broken nose. Then he was involved in many things including abstract painting, ballet, English and French literature, opera, and horseback riding. Living in Los Angeles he fell in love with the movies as an observer. He moved to New York where he saw his father on stage and decided to become an actor. John Huston became a magazine writer and landed a screenwriting contract with Samuel Goldwyn Productions. After six months of not receiving assignments, he quit to work at Universal and began by writing dialogue for a number of films. Eventually he got to Warner Bros. and cowrote *Jezebel* (1938), *The Amazing Dr. Clitterhouse* (1938), *Juarez* (1939), *Dr. Ehrlich's Magic Bullet* (1940), and *Sergeant York* (1941). He then wrote the hit movie *High Sierra* (1941), and Warner Bros. gave him a shot at directing the film that became *The Maltese Falcon* (1941), where he would direct Humphrey Bogart for the first of five times. In 1942 he served in the U.S. Army and made powerful **documentaries** during WWII as part of the Army Signal Corps. After the war he returned to directing at Warner Bros. with *The Treasure of the Sierra Madre* (1948), for which he won the **Oscar** for best screenplay and director.

B. Traven was the author of the book *The Treasure of the Sierra Madre*. His real identity was never learned because this was a pen name. He was believed to be a German novelist, but much about him has been disputed by literary scholars. Most agree he was Ret Marut, a German stage actor and anarchist who left Europe for Mexico in 1924. Others feel he was Otto Feige, born in Poland.

The Treasure of the Sierra Madre was published in 1927 and is classified as an adventure novel. The context of the Mexican Revolution from 1910 to 1920 informed the plot of *The Treasure of the Sierra Madre*. In all, B. Traven wrote 11 standalone books, a combination of short stories and novels. Thirteen of his works were adapted into motion pictures or television shows.

The Treasure of the Sierra Madre (1948) is an American tall tale. A tall tale is a story with larger-than-life characters and narrative portrayed as if they were true and factual. The exaggeration of the tale is what attracts the reader. Some legendary tall-tale characters include real historical people such as Johnny Appleseed, Jim Bowie, Davy Crockett, Calamity Jane, and Casey Jones, while others such as Pecos Bill or Paul Bunyan are entirely fictional. These grand adventures are convincing because viewers want to believe that the characters are greater than us. Humphrey Bogart has never been better, and he takes the viewer into his maniacal view of the world.

Narrative and Cinematic Analysis

The film is both an adventure story and a Western. The quest for gold embraces the adventure **genre**. Prospecting and the conflicts caused by Mexican banditos speak to the Western. Credits. Rousing music by Max Steiner

(see Chapter 9). Winning lottery numbers are put up. Fred C. Dobbs (Humphrey Bogart) checks to see if he has one—he doesn't. Humphrey Bogart has played so many memorable characters, such as Rick Blaine in *Casablanca* (1942) and Charlie Allnut in *The African Queen* (1951), and Fred C. Dobbs ranks among his best creations. Audiences relate to the characters and the actor for his ability to create distinctive characters. Dobbs runs into an American in a white suit (John Huston) on the street and asks him for a handout. The director was also a fine actor. He had worked with Bogart so many times that audiences associated them together, and here they are both on the screen, not just one in front of the camera and the other behind it. The man gives him a coin. Dobbs is in a bar. A young Robert Blake[1] as a Mexican boy comes in and tries to sell Dobbs a lottery ticket. He throws his drink at the boy but finally buys 1/20th of a ticket. Dobbs meets Bob Curtin (Tim Holt) on a park bench. Complains about never getting a job from another man. The American in the white suit is having his shoes shined while he is reading a newspaper. As there is another beg for a handout, he lowers the newspaper, sees Dobbs, and hands him another coin. Barber shop. Dobbs gets a shave and a haircut. He follows a pretty woman. Dobbs sees the man in white suit again and hits him up once more. The man is smoking a big cigar, chews him out, and gives him two pesos this time, just to get rid of him.

Dobbs goes to a bar. Pat McCormick (Barton MacLane) offers him a job at $8 a day. Ferry. Meets Curtin there. Night. Day. Men working hard. Dobbs and Curtin are told pay is $16 to $18 a day, plus a bonus. Mexico, Tampico. Men to be paid off on a ferry. Ferry lands—the agent doesn't show. McCormick gives Dobbs a couple of bucks. They are to meet McCormick at a bar. A man tells them they've been had. Drinking beer. Dobbs and Curtin go through most of the $10 they got from McCormick.

They get blankets and pillows. An area with beds. Talk of gold. Howard (Walter Huston) talking a blue streak to other men. Dobbs speaks to Howard, who says, "Been all over the world. I know what gold does to a man's soul." The three make a plan to share expenses. Howard knows all the angles. Dobbs goes to sleep. Walter Huston had long been considered one of America's greatest actors. When he comes on screen, older and in a colorful character role, the audience is assured this will be a good movie and looks forward to his interaction with the other actors. Dobbs and Curtin on a bench. Blessing as a curse. Lobby. McCormick is seen with a woman. They go into a bar. McCormick is all dressed up and tells Dobbs and Curtin that the money didn't pay off yet. McCormick breaks a bottle over Curtin's head. They both fight him. They knock McCormick down. Curtin can't see. After beating him to a pulp they take $300 off of McCormick. They throw the rest of the money on him. They wash their faces clean in a fountain. The fight is very rough and tumble. Huston had boxed professionally in his early days and his

knowledge and sense relationship with Ernest Hemmingway, a writer who explored issues of masculinity, paid off here.

Dobbs, Curtin, and Howard agree to be partners. They'll need $300. If they need weapons that takes it up to $600. The Mexican boy comes in—he sold the winning lottery ticket—a prize of 250 pesos. He gives Dobbs his share, and Dobbs gives the kid a tip. Now they have the money. Dobbs puts up Curtin's share. Crowded train carrying the three men. The train stops suddenly—banditos. They shoot at them from the windows. Men on horseback. Dobbs gets a look at one bandito in a big hat. Soldiers ride to the train.

At their destination they pick out burros. Howard takes care of the deal, speaking in fluent Spanish. Windy and dangerous. The thematic musical score enhances the adventure theme of the film. Walking through rough trails. Dobbs and Curtin are exhausted. The old man keeps climbing steadily. Dobbs thinks he sees gold, calls Howard. Dobbs pours water on a rock. Howard says its fool's gold and that water is precious—sometimes more precious than gold. Wind storm. They are moving through a jungle using a machete. Howard plays the harmonica, a pocket instrument associated with Westerns as well as other genres.

The next day Dobbs wants to quit. Howard talks fast. Tells him they are dumb. Howard starts to dance. There is gold beneath their feet. There is a hill where they have to go. Howard's dance performed by Walter Huston, as his son watched from behind the camera, is one of the greatest moments in American film history. It is free and joyous with abandon. He moves freely like a great dancer, laughs heartedly while swinging his arms and speaks out a lively patter as the boys stare at him dumfounded.

They set up a mining operation. They have $5,000 in a tent at night. Dobbs says each guy is responsible for their own goods. He doesn't call it gold but *goods*, a term defined as materials that satisfy human wants and provide utility. Curtin wants to split it up when they get paid. Howard says he's the most trustworthy, the one with the most experience. They all decide to divide it up each night. Gold. They have to hide it each night—each man in his own place. Hard work. Mine collapses on Dobbs. Curtin calls out, walks away, then goes back and in to save Dobbs, who was knocked out. Calls Howard. He looks at Dobbs on the ground.

Night. Dobbs goes off to hide his goods. Curtin wants to raise peaches, sing, play guitar music, and be a fruit grower. Dobbs wants a Turkish bath, dozens of everything, clothes, all that is on a restaurant menu and have them send it back even if it was good. It is suggested they limit what they can earn to $25,000. Dobbs wants $75,000 to $100,000. Howard says that would take a year. Like Howard, Curtin says $25,000. Angry, Dobbs says he put up the money, he's insulted. They give him gold; Dobbs throws it in fire. Says he just doesn't like being called a hog. Greed is the central theme of *The Treasure of*

the Sierra Madre. The mood swings of Dobbs increase; he is becoming more erratic.

In the middle of the night he checks the burros, comes back. Dobbs checks his goods. Curtin goes after him. Dobbs comes back. Curtin checks his goods and comes back with guns. Trust is another central theme here.

Day. Dobbs is talking to himself out loud, goes to town. Paranoid. Bogart transmits this phase of the character with frightening realism. A lizard goes under rock. Curtin gets a stick. This is where Dobbs has hidden his goods. Dobbs pulls a gun on Curtin. They go at each other. When Howard turns the rock over there is a Gila monster on Dobbs's goods. They have a gun on Dobbs, and they shoot the lizard dead.

Banditos and soldiers march out. American James Cody (Bruce Bennett) goes up to Curtin and follows him into a store. Curtin tells Cody he is a professional hunter. Cody knows gold. The burros are packed up. Cody follows Curtin to the camp. Dobbs tells him to leave in the morning. Howard gives him something to eat. Cody doesn't believe the hunting story.

Curtin and Howard go to bed. Dobbs in tent. They take turns watching Cody, who camps across the way. Morning. Cody makes coffee with their water. Dobbs punches Cody out. Cody tells them he will start digging for gold. He tells them they can kill him, or he can inform on them for a nice reward, or they all can become partners. They discuss it. Majority decides. They decide to kill him. They walk up the mountain and approach Cody. They look down the hill—banditos. Cody looks out. They get into positions. They take down the tent and put out their camp fire. Banditos on road. They arrive on horseback. Dobbs has his rifle. He recognizes the man with the big hat from the train robbery. Dobbs calls them out and fires. They move back. Two of the men come forward again. They want to buy the gun from him. Howard shoots, and they leave.

Shootout. Cody has a rifle. Quiet. Three get together. Calls Cody. Curtin goes to Cody while the other two provide cover fire. Curtin comes back and Cody is dead—shot right through the neck. The story demonstrates a deep sense of irony: first the three were going to kill Cody but the intervention of the banditos levels the playing field. Banditos leave **off-screen**. Dobbs takes his rifle and sees something, and the Federales chase the banditos. Cody's wallet has a picture of his wife. Howard starts to read from Cody's wife. Cody had a son. He wanted to strike it rich. He said this was his last chance. She writes about the pain of a long separation. Orchards. Hope he strikes it rich.

Dissolve. They dig a grave for Cody. Dobbs wants to pack it in. They get their gear together. Howard tells them they should put mountain back the way it was. Pack burros. Goods are each man's responsibility. Each man thanks the mountain. Camping. Curtin says, "Let's give a fourth of the goods

to Cody's widow." Howard says yes, Dobbs no—excessive greed again. Indians come late at night. One of the men stands and speaks in Spanish. Howard speaks to them. A little boy fell in the water and won't revive. Howard goes off with them.

Surrounded by a large gathering of Indians, Howard tries to revive the boy. He listens to his heart. He puts a piece of mirror under the boy's nose to see if he is breathing. Howard pumps the boy's arms up and down. He lifts him up and the boy moans. Eyes open. Everyone takes their hat off. Day. Howard tells them the boy was in shock. Howard's common sense approach is interpreted as magical powers by the Indians.

Later Indians ride up. They believe they must pay off their debt or angels will be angry. Howard has to go with them. The two go to Durango. They have the goods. On the trail back. Dobbs drinks water and wants Curtin to handle Howard's burros. They argue. Can't go any further. Started something that they have to finish, Night. Camp. First time without the old man. Dobbs laughs. Dobbs plans to take Howard's goods and go a different route. Paranoid. Dobbs thinks Curtin wants to kill him and take old man's goods. Curtin gets Dobbs's gun. Gives him the gun back. Dobbs still thinks Curtin wants to kill him. Bet on who will fall asleep first. Dobbs pulls his gun on Curtin and beats him. Campfire. Curtin falls asleep. Dobbs wakes Curtin up and has his gun on him. Didn't like taking orders. They walk into forest with shots heard off-screen. Dobbs comes back paranoid about whether he killed him and goes back to check. Curtin lies there. Dobbs puts his gun next to him. Dobbs talks to himself in a manner that projects a growing madness. Curtin moving. He tries to get up. Flame from fire rises high. Indians. Curtin crawls to them. Dobbs gets ready to leave. Decides not to bury Curtin. It's right not to bury him. Goes back to bury him without clothes so the bugs and creatures will get to him. Dobbs comes back, Curtin is not there. Dobbs talks to himself.

Dissolve. Howard lounging in a hammock fanned by a pretty girl. Drinks. Gifts. Pig. Fruit. Two Indians come to talk to him. Howard has a hat. Dissolve. Curtin brought there. Howard bandages him. Dobbs taking goods and going different direction. Howard understands what gold does to men. Howard in white. Howard, Curtin, banditos are looking for Dobbs. They see his dead horse. Dobbs alone falling, a dirty mess. He finds water, drinks, splashes it on his face. A bandito's reflection in the water. Dobbs sees him and two others. Durango. Selling burros. Money. Two men from town. A bandito recognizes Dobbs. Spanish. Something fishy. Doesn't believe others are coming. Hides. Pulls a pistol on mean guy. Shoots, no bullets. Knocks him down. Takes his things. Dobbs up. They all run after the burros. Banditos search the burros. Other team keeps coming. Town. They sell hides. A kid sees a brand on the animals. A man checks the burros. One bag emptied. Spanish.

Banditos arrested. Dissolve. Federales. Three men dig their graves. Firing squad.

Howard and Curtin and men come into town. Dobbs is dead. Good safe in an office. A boy talks to Howard. Spanish. A bandito thought they were bags of sand to protect the hides. They ride out. Sand. On Horses. Sound of wind. A bag on the ground. Another. Howard sees empty bags. Laughs and throws a bag. It's a great joke played on us. Everyone laughs. Gold back to where we found it. Laughing continues, wind. Howard gives Curtin money to go see Cody's widow. Howard rides off. Curtain rides off the other way. Empty bag stuck to cactus. End. The tall tale has a logical ending with the odd twists and turns it presented. An oral storytelling could have presented this, but this is a movie—an unforgettable one, perfectly told and cinematically illustrated.

Conclusion

John Huston won two Academy Awards for *The Treasure of the Sierra Madre*, for the adapted screenplay and directing, and his father won for his performance. Thus they became the first father and son to win the Oscar. The film has been greatly admired by generations of film directors. Stanley Kubrick (see Chapter 2) said it was his fourth favorite film of all time. Sam Raimi[2] ranked it as his favorite film of all time. Paul Thomas Anderson (see Chapter 13) watched it at night before bed while he was writing *There Will Be Blood* (2008). *Breaking Bad* creator Vince Gilligan emulated a scene from *The Treasure of the Sierra Madre* in the "Buyout" episode, which was the sixth in the fifth season of the series. The greatness and importance of *The Treasure of the Sierra Madre* lay in John Huston's total approach to the novel's adaptation. The story is lively with action; the psychological portrait of Dobbs keeps the viewer wondering what the maniacal character will do next. The cinematic style that unfolds the narrative without getting in the way is sublime.

Notes

1. Robert Blake (1933–) is an American actor who began in movies as a child, notably appearing in the *Our Gang* series of short films for MGM from 1939 to 1944) and the *Red Ryder* film franchise. As an adult he was in the television series *Baretta* on the ABC television network from 1975 to 1978 and appeared in the feature films *In Cold Blood* (1967), *Electra Glide in Blue* (1973), and *Lost Highway* (1997), directed by David Lynch (see Chapter 4).

2. Sam Raimi (1959–) is an American filmmaker, actor, and, producer famous for creating the cult horror *Evil Dead* series, the original *Spider-Man* film, and the 1990 superhero film *Darkman*.

For Further Study

Screen

A Connecticut Yankee in King Arthur's Court
John Huston and the Dubliners
Moby Dick
Tall Tale
Tall Tales & Legend

Read

The Hustons by Lawrence Grobel
An Open Book by John Huston
The Secret of Sierra Madre: The Man Who Was B. Traven by Will Wyatt
The Treasure of the Sierra Madre by B. Traven

The Essential Road Movie

Two-Lane Blacktop

Some film scholars and critics trace the roots of the **road movie** film **genre** as far back as Homer's[1] epic *The Odyssey*, written around 800 BC, and Virgil's[2] *The Aeneid*, written between 28 and 19 BC.

Although filmmakers had made road movies in the early years of American film, it did not become an accepted genre until the late 1960s, especially due to the impact of the initial releases of *Bonnie and Clyde* (1967) and *Easy Rider* (1969). Both of these landmark films bore the themes of traveling across the country and self-discovery.

The narrative of a road movie involves a road trip of some distance. Two or more characters take this journey. The journey takes the characters from one place to another—either to one destination or many. The physical trip is usually the background for the narrative and character development. The essence of the road movie is the emotional, spiritual, and psychological journey taken by the characters. Change, personal evolution, and how the characters relate to each other and their environment are the key objectives of this genre.

Interviews with actors and other film personnel reveal that those who worked on road movies did not necessarily know they were working in this specified genre; they played characters and followed the story, but it was critics and scholars who identified and categorized this new genre, just as the French did with **film noir**. It was up to the film artists to shape what became the road movie into a film form where the road was a metaphor for the distance traveled to discovery.

Just some of the uncategorized road movies made before the late 1960s include *It Happened One Night* (1934), *You Only Live Once* (1938), *Stagecoach*

(1939), *They Drive by Night* (1940), *Sullivan's Travels* (1941), *Detour* (1946), *They Live by Night* (1949), and *The Wild One* (1953), which starred Marlon Brando as the leader of a motorcycle gang; this film especially heavily influenced the road movies of the 1960s, 1970s, and beyond.

It was during the 1970s, a decade that was emotionally depressed and spawned the development of religious cults and transformation movements, that set the tone for the creation of some of the best and most important road movies ever made. The country's economic downturn, disillusionment, individual lack of identity, and the search for the real America were all elements that helped shape this very American genre, with the country's love for cars, speed, and travel all contributing to the emergence of the road movie.

Some notable films of the era include *Vanishing Point* (1971), *Badlands* (1973), the appropriately named *Road Movie* (1974), and *Mad Max* (1979). German director Wim Wenders was so influenced by American films that in the 1970s he created a road movie trilogy: *Alice in the Cities* (1974), *The Wrong Move* (1975), and the epic *Kings of the Road* (1976).

Monte Hellman had established himself as a fine film editor, cutting many of his own pictures as well as those for other directors, including *Head* (1968), *The Wild Angels* (1966), and *The Killer Elite* (1975). As a director Monte Hellman "graduated" from the Roger Corman (see note in Chapter 12) school of **low-budget filmmaking**. Before directing *Two-Lane Blacktop* and earlier films, Hellman made two revisionist Westerns, both starring Jack Nicholson and released in 1966: *The Shooting* and *Ride in the Whirlwind*, which became cult classics. He would do the same for the road movie—reinvent it.

From early in his career Monte Hellman was fascinated with existentialism. Although he was a film director, he also mounted a theatrical production of Samuel Beckett's[3] *Waiting for Godot*, an icon of the philosophy. Most scholars agree that existentialism began with Kierkegaard,[4] but it is principally associated with Jean-Paul Sartre,[5] who stated that "existence precedes essence." Individuals must see themselves as individuals. Films in the existential vein include *Paths of Glory* (1957), *The Seventh Seal* (1957), *High Noon* (1952), *Taxi Driver* (1976), *Fight Club* (1999), and *Groundhog Day* (1993). *Two-Lane Blacktop* (1971) is an existential road movie that unfolds as it could have been written by Samuel Beckett.

In *Two-Lane Blacktop* two young men, the Driver and the Mechanic, drive around the country in a souped-up car, racing for money. They meet a young woman known as the Girl and then a middle-aged man driving a Pontiac GTO known as GTO, a term referring to a car built to racing specifications, and enter into a long race where the winner will get the pink slip for the other car.

Hellman made the decision to cast two notable musicians in pivotal roles in the film. James Taylor, the singer/songwriter who had released the iconic

album *Sweet Baby James* in 1970 and had gained recognition as a musician, played the Driver. Dennis Wilson, the drummer for the Beach Boys, played the Mechanic. They weren't exploited for their fame as much as cast for believability in their character portrayals. Their performances are realistic. Only popular music fans knew who was playing these two roles. Neither of them performs music in any fashion during *Two-Lane Blacktop*.

Laurie Bird played the Girl, a hippie chick who seems to personify that lifestyle prevalent in the 1960s that had largely vanished in the 1970s. All three were nonactors. The practice had been established in Hollywood and independent films. These are performers with no formal acting training and often no **on-screen** experience. The nonactor can be genuine and naturalistic, free of affectation.

Warren Oates, a seasoned pro with a smile that made him look like a jackal, played GTO. Oates was supercool, and a man weathered by his experiences in the world. Prior to acting in *Two-Lane Blacktop*, Oates had appeared in Sam Peckinpah's *Major Dundee* (1966) and *The Wild Bunch* (1970), Hellman's *The Shooting* (1966), and a long, long list of appearances on television shows that showed his versatility and capabilities. Oates was a generous and personable actor whose presence was always well felt.

After the mega-success of *Easy Rider* in 1969, the studios put a major effort into finding young filmmakers and projects that spoke to the youth audience. Universal was one of the studios that went after that demographic. Ned Tanen, a young executive at Universal Pictures, gave Hellman $850,000 to make *Two-Lane Blacktop* and promised him the director's Holy Grail—the Final Cut.

Narrative and Cinematic Analysis

Cars revving up. Race in progress. Line-up of cars. Street lights. Signal lights. Cops—they all leave. Car sounds. **Main title**. Radio. Driving. day. Stop car. 1955 custom Chevy. Benches. Trunk pulls out. Betting on races. Gas station. High test. Kid can't find the gas tank. Driving. Dinner, The Driver and the Mechanic eat. Hippie van outside. The Girl takes her things and goes into the Chevy. They get in, back up, and drive off with her in it. Going east. They don't respond to the Girl talking. The Mechanic responds minimally. The driver doesn't. GTO passes. The Girl gives the Mechanic a neck massage. The first actual example that there may be any kind of romance between the Girl and the two boys. Explains to her who to race. They let her out to hustle people for change. Street scene is improvised with real people shot from a distance for realism.

Night. Racing competition. Rudy Wurlitzer, the co-screenwriter of *Two-Lane Blacktop*, plays the driver of a green car. $300 bet. They win. Later the

Mechanic drives off with the Girl. In a motel he lies on the bed as she pulls down the bedding. Bar. Song. The Driver drinks a shot of rye and a beer. This appears to be the set up for a sex encounter.

Motel room: the Mechanic and the Girl make love **off-screen**. In a cinematic era where nude and sex scenes are common, Hellman goes old school and leaves it to the imagination. Bar. Red wallpaper. Wurlitzer's character agues with woman as the Driver looks on. She leaves. Driver outside motel. Sounds of lovemaking from inside. He sits on sidewalk and waits. Leaving it to the imagination of the viewer pays off, and empathy goes out to the Driver.

Day. GTO picks up a hitchhiker. Inside GTO makes up a story. He is an unregenerate liar and tells a different life story to everyone he meets, so no one really knows who he is. He doesn't really know who he really is. Identity is an important theme in this film. GTO puts on a cassette with country music. No conventional score. The tapes throughout the film provide atmosphere and commentary on the characters and action. Trouble with the Chevy. The Mechanic works on their car. GTO asks the boys if they want to race him. Interior. Car. After a comment by the Mechanic about the car's rear end, the Girl complains that no one is paying attention to her rear end, a simple but provocative and funny line of dialogue. There is a naturalistic quality to all the performances, due to the work of nonactors. GTO drives into a gas station. His hitchhiker goes into the bathroom. The boys drive into the station. GTO checks out the girl as she goes to the bathroom. Once there she opens the door and the hitchhiker is in there, another touch of humor in a serious drama with philosophical overtones. GTO calls out the Driver. The Girl and the Driver sit on a fence. Driver talks about cicadas. The Girl gets into GTO's car. They talk about where he could drive her. "Me and Bobby McGee" plays on the soundtrack, a classic road song by Kris Kristofferson,[6] which links narratively to the film referencing driving, the road, and those who ride it. GTO checks out their car. The Driver talks to the Girl; she gets out of GTO's car and gets back into the Chevy. The boys offer GTO a race for pink slips to Washington, DC. GTO lies about where he's headed. They all look at a map as the Mechanic gives GTO the details on the run. The winner will take ownership of the other man's car. Now there are three possibilities for romance with the Girl.

GTO. "Maybelline" plays in his car. He gives another guy a ride, this time an Oklahoma hitchhiker (Harry Dean Stanton). He gets in, relaxes, and after a minute puts his hand on GTO's knee—"I'm not into that." Heavy rain. The Girl out in rain. "Sweetheart." She gets back in. Night. The ride is going poorly in GTO's car, "Get your paws off of me." "I ain't moving—it's raining." "First town, you're out." Park. Police pull over GTO. The Chevy drives up and

stops. They tell the cops he is dangerous. They peel out. Night driving. Horn. GTO stops them. Angry. We're all in this together. He told the police his wife was having set of twins—one of his many lies. They give GTO a hard-boiled egg. Trunk. Bar setup. Drugs. "Here's to your destruction." Now GTO says he's scouting locations for film on fast cars. The Girl is now in GTO's car. He asks her to ride with him. "Not right now." She kisses him. "You'll probably lose the race." GTO says, "You can never go fast enough." GTO and the Driver in the Chevy—the Girl and the Mechanic are in the GTO. The Chevy wins this short race.

Day. Town. Rain. Mobil station. Restroom closed. GTO relieves himself outside. The Mechanic takes the license plates off of someone's car and puts them on the Chevy. GTO drinks from a flask. Driver looks for the Girl, and finds her. The Mechanic in GTO's car. The Driver teaches the Girl to drive. The car stalls. He puts his hand on hers to switch gears. She tries again. "You're right, you can't do it." They make out. Physicality in *Two-Lane Black-top* is limited. The characters are all starved for physical contact. They are lonely and emotionally detached.

Driver goes to auto parts shop. The Mechanic puts in a part for the GTO. Arkansas. The Chevy and the GTO meet. Dinner. The Mechanic, the Girl, and the Driver are eating. GTO enters. "Are we sill racing?" She sings "Satis-faction" by the Rolling Stones. Ironically she sings not particularly well, and the real singers, Taylor and Wilson, never sing in the picture, something viewers might have expected. A local guy comes up to them. Where are you from? GTO tells them he is their manager. He tells them they have the best track. "You wouldn't be hippies?" GTO tells him these are good boys and that he takes care of them. "We have boys here that can shut you down." The guy leaves. This scene echoes *Easy Rider* (1969) with its fear/hatred of hippies and alternate lifestyles and that a dark change is coming to the country.

Day. Driving. Dodge Charger. Accident. The Dodge goes into a ditch and the Chevy makes it around. Bloody scene. The driver has broken neck. There is a strangeness to this sequence, a surreal atmosphere that is reminiscent of Jean-Luc Godard's (see Chapter 3) *Weekend* (1967). It is stylized and unexpected.

A hippie man gets into GTO's car. "It doesn't matter what we do, we have 30, 40 years. Stop the car, I just want to get out." The Mechanic needs to check parts on the Chevy. GTO picks up an old lady with a child who are going to a graveyard. "Her folks are buried there." "They were killed by a city car," she keeps repeating. GTO opens his umbrella and helps the woman and child out to the cemetery. GTO is an Old World gentleman living in chaotic times.

Race lot. Announcer. GTO shows up. The Girl goes to the grandstand. A series of quarter-mile races. Night. The Girl sleeping in the car. GTO. The Mechanic works on the Chevy. The Girl in back of the car. The Driver in.

Going against a Corvette. The Mechanic leaves to fix the valves. The Driver says, then we'll go to Florida. The Girl packs her duffel bag and leaves. Goes to GTO car. Race. Chevy wins. GTO says he's got a lead on them, they are not going to get me now; I'm going to New York. The boys go after GTO. Florida. The Chevy is at a speedway. Later GTO drives up to the speedway.

Day. GTO uneasy. Stops at gas station diner. A hippie at counter. GTO and the Girl sit a table. Chevy. The boys realize they passed GTO five miles back and turn around. Diner. GTO and the Girl eating breakfast. Boys pull up. They sit at table. The Driver tells the Girl that they are going to Columbus, Ohio, to get some parts for the car. After a long pause she says, "No good." The hippie pays his check. He turns and puts on his jacket as he and the Girl look at each other. He leaves. She gets up takes her duffle bag and leaves. She goes to the Hippie, leaves behind her duffle bag, gets on his motorcycle with him, and they drive off. GTO comes out of the bathroom and sees what happened. The Driver and the Mechanic leave. GTO leaves. Outside they try to hustle a guy into a race. GTO drives away. GTO in car. He picks up two soldiers and says he won the GTO car in a pink slip race, in which he was driving a Chevy he built from scratch. In this lie, GTO has reversed the main narrative of *Two-Lane Blacktop*. A major character, the Girl, has left the film. Viewers watching the film with a traditional cinematic sensibility may think she will come back. She doesn't, and in the end it doesn't really matter because the characters in the film are drifting aimlessly. They are basically emotionally hollow inside and difficult to become attached to.

A two-lane blacktop with white lines on the road. Race track. Chevy. Driver. Opponent. Quiet. **Slow-motion** sound. Starter. From behind driver, slow-motion image. Down the line, the image stops, **freeze frame**, the single frame burns. End of movie.

Conclusion

There are many ways to interpret or "read" the last moments of *Two-Lane Blacktop*. Hellman wanted to end on a **self-referential** moment. The viewer is reminded that they are watching a movie, when the film catches in the projector gate and burns away from the heat of the machine's hot bulb.

The Driver is literally burned out from the endless driving and racing on the road. The slow motion symbolizes his energy running down, and the burning of the frame is to visually say he can't go on any further. The movie cannot go on any further. There is nothing more to learn on the road about themselves or the country, but the ending to *Two-Lane Blacktop* is open ended. It has to be interpreted by the viewer because there are no tangible answers presented. There is no life-ending crash or resolution to the lives of the four main characters. Hellman's fascination with existentialism has embraced the genre of the road movie.

The road movie taps into America's obsession with cars. Driving is mostly an everyday experience for most Americans, but the road trip is an occasion for inspection of the psyche. *Two-Lane Blacktop* is a cult classic, a legend among American road movies, because it is searching for the story and soul of the United States at what was a point in time that is now part of a continuing search for who we are.

Notes

1. Homer (850–800 BC) is the name ascribed by the ancient Greeks to the legendary author of *The Iliad* and *The Odyssey*, two epic poems that are the central works of ancient Greek literature.

2. Virgil (70–19 BC) was an ancient Roman poet of the Augustan period. He wrote three of the most famous poems in Latin literature: *The Eclogues* (or Bucolics), *The Georgics*, and the epic *Aeneid*. He is ranked as one of Rome's greatest poets.

3. Samuel Beckett (1906–1989) was an Irish avant-garde playwright, theatre director, poet, and novelist. His vision was a bleak and tragic outlook on human existence. He wrote with black comedy and gallows humor. He is considered the last of the modernist writers and a key figure in the theatre of the absurd. His plays include *Krapp's Last Tape* (1958), *Footfalls* (1976), and *Happy Days* (1961).

4. Søren Kierkegaard (1813–1855) was a Danish philosopher, theologian, poet, social critic, and religious author. He wrote critical texts on organized religion, morality, ethics, and psychology. His works include *Two Upbuilding Discourses* (1843), *The Concept of Anxiety* (1844), and *Christian Discourses* (1848).

5. Jean-Paul Sartre (1905–1980) was a French philosopher, playwright, novelist, political activist, biographer, and literary critic. He was one of the key figures in existentialism, and one of the key figures in 20th-century French philosophy and Marxism. His works include *Nausea* (1938), *The Age of Reason* (1945), and *No Exit* (1944).

6. Kris Kristofferson (1935–) is an American singer-songwriter and actor. He has written and recorded many songs including "Sunday Morning Coming Down" and "Help Me Make it Through the Night." As an actor he has appeared in films including *Pat Garrett and Billy the Kid* (1973), *Alice Doesn't Live Here Anymore* (1974), and *Heaven's Gate* (1980).

For Further Study

Screen

Easy Rider
Kings of the Road
Mad Max

Thelma & Louise
Vanishing Point

Read

Driving Visions: Exploring the Road Movie by David Laderman
James Taylor by Herbert Weiss and Leo Alfassy
Monte Hellman: His Life and Films by Brad Stevens
On the Road by Jack Kerouac
The Road Movie Book edited by Ina Rae Hark and Stephen Cohan

The 45 Minute and 56 Second Shot

Wavelength

The art of filmmaking is in its second century. Outside the traditional history of film is an alternative cinema that challenges the commercial film industry by reinventing the notion of time, space, content, visuals, audio, and music, proving the cinematic medium is an artistic endeavor just as painting and the other arts and does not solely exist for traditional entertainment purposes.

This type of work is largely called **avant-garde film**, but during a Golden Age in the 1960s and 1970s, it was better known as **experimental filmmaking**. Different styles, movements, and genres developed. A major field that blossomed during the late 1960s and into the 1970s was the **structural film**, identified and named by theorist and professor P. Adams Sitney. In his article "Structural Film" published in *Film Culture* magazine, Sitney states that the four characteristics of the structural film are "a fixed camera position (fixed from the viewer's perspective), the **flicker effect** (strobing), **loop printing** (the immediate repetition of shots, exactly and without variation), and re-photography off a screen." In a rejoinder he concludes that it is rare that any one film will contain all four characteristics, as there are also those structural films that avoid the common elements. Simply stated, in a structural film, the structure is the content.

A group of filmmakers worked in structural film, but the person most identified with the structural film movement is Michael Snow. Snow also created the film most associated with structural film, *Wavelength*, which was completed and first shown publicly in 1967.

Michael Snow was born in Toronto, Canada, on December 10, 1929, and was trained as an artist at Upper Canada College and the Ontario College of Art. Throughout his career he has worked in many mediums: painting, sculpture, installation art, photography, holography, drawing, and music, in addition to video and film. Beginning in the fine arts, he applied his sensibilities to his influential work as a filmmaker when he was offered a job at Graphic Films by one of the former members of the famed National Film Board of Canada.[1]

The word *wavelength* is defined as "the distance in the line of advance of a wave from any one point to the next point of corresponding phase." A sine wave,[2] which is heard throughout the majority of the film, is a mathematical curve that describes a smooth, repetitive oscillation.

Wavelength was photographed with a movie camera over the course of one week in December 1966 from one end of a second-story, 80-foot New York City loft. To conceive and prepare for the project, Snow took pencil to paper, making notes for the better part of one year. He wanted to make a film that was "a summary of my nervous system, religious inklings and aesthetic ideas." He wanted to create what he called "a time monument in which the beauty and sadness of equivalence would be celebrated," Snow said in the Canyon Cinema catalog. He was obsessed with the notion of pure film and attempted to capture the medium's very essence of time and space. Like Stan Brakhage (see note in Chapter 12) he wanted to document the concept inherent in Brakhage's film *The Act of Seeing with One's Own Eyes*, probably the most important thought of all that would give *Wavelength* its cinematic importance, to balance illusion and fact. Snow describes the film as a 45-minute zoom that travels from its widest to its smallest field. Although *Wavelength* is usually referred to as a 45-minute film, it actually runs for 45 minutes and 56 seconds and as a continuous zoom shot; it was created to appear to be that, but actually is not.

As a painter, Michael Snow would have been interested in, as Elizabeth Legge states in her enlightening volume *Wavelength*, "a vestigial cone of deep vanishing-point perspective, which is achieved by the placement of the camera, and the angle at which it produces a raking of the floorboards and receding lines of the ceiling."

When Snow conceived of a film with a "continuous" zoom, he began to ponder where the traveling lens could end. One of the windows in the loft seemed convenient, but that choice would affect the vanishing point negatively. A nude image from artist Tom Wesselmann[3] would reflect the contemporary art scene, Billie Holiday[4] would represent jazz, the image of a child in Snow's mind would make the film a "Catholic movie," a calendar image of Northern Ontario in the fall would signify Canadian identity. He did decide on an image of ocean waves, which would be hung on a wall of the loft, one

of 30 photographs Snow shot of the Atlantic Ocean for a sculpture piece. He liked that the photograph was not very dramatic and the waves weren't splashing violently.

Snow was not just interested in using the tools of the trade like the **zoom lens**, but also understanding the Zen[5] of the apparatus to apply to his vision. Music was an influence in that classical music is involved with systems and variations within them. A particular influence was Wanda Landowska's[6] 1950 recordings of J. S. Bach's[7] *Goldberg Variations*. Snow's thinking was to state a theme in the film and follow it with a series of variations. He then came up with a particular length for the film's running time, which was 45 minutes.

Exploring the symbolism of the number 45 reveals it has several meanings. It represents the cosmic solidarity expressed in human beings. A compass opens at 45 degrees, which reveals that matter is not completely dominated—there isn't perfect balance between the forces of the spirit and the matter. The numbers 44, 45, and 46 are the trinity of life.[8]

The camera and Angéniux zoom lens were borrowed from fellow experimental filmmaker Ken Jacobs,[9] who also gave Snow a number of rolls of Kodak film stock that were old and most likely out of date. Once film stock exceeds its stated shelf life date, it becomes destabilized in terms of color accuracy, density, and purity of image. There is no way to know what the results will be until the stock is exposed and printed—this random selection is part of the magic of *Wavelength*. Although there was no control of the image quality during the shooting, it was the selection process during **postproduction** where the film was shaped into the final result.

Snow used 100-foot rolls of 16mm film. He estimated he would need 16 to 18 rolls. He also defied Kodak by shooting indoors with their outdoor film rated to be exposed to sunlight, not artificial light, a practice the company said would drastically alter the color balance. There are fluorescent lights mounted on the ceiling of the loft. No traditional movie lighting instruments were used to shoot the film.

To gauge the timing and focal length of the zoom lens, Snow placed a piece of white tape on the lens. The tape was then divided in equal sections, then subdivided into increments Snow could follow as he operated the zoom lens by hand. He also applied a number system to the rolls of film stock.

The camera was placed on a platform for height and to produce the view of the room Snow wanted. The zoom was operated by hand to achieve nuance—Snow liked the unevenness of the zooming. The idea of a continuous zoom was compromised when, on the first day of shooting, the lens was practically in the middle of its intended journey—partly out of convenience for the availability of experimental filmmaker Hollis Frampton,[10] who was playing the man who dies in the loft. The film was then shot out of sequence,

and Snow then knew where that roll would be on the marked tape on the lens. Snow came to realize his calculations concerning the zoom lens were flawed for the last 10 minutes of the film. The final approach to the waves photograph, an iconic moment in experimental filmmaking, was no longer shot with a zoom lens but by a **handheld camera** and is framed more directly head on than if the zoom had been timed properly and was used from beginning to end to totally photograph the loft from far to near. This result became more dramatic, putting the viewer directly in front of and immersed in the image.

Scholar Elizabeth Legge speculates that the use of the zoom in *Wavelength* can be interpreted in a number of metaphors: "Perceptual processes, chronological measurement, directional movement, line of sight, teleological history or a narrative of any kind."

Originally Snow thought he could create *Wavelength* without editing. He marked out where in the zoom's travel he would be for a particular roll, but ultimately he did have to employ the editing process. Some of the editing was simply to join the reels together, but Snow also edited out parts of the lens movement, so again it's not a continuous zoom.

Snow was not pleased with the color produced by shooting different film stocks as well as utilizing filters and plastic material over the lens. During the postproduction process a B roll, a second roll of film, was employed for the color changes that in the final print are superimposed in select portions of *Wavelength*, and to hide the **splices** in the 16mm movie. The color changes transform the entire atmosphere of the room, making it cold or hot or in between at any one time. Light flashes in a number of colors at times appear over the images. They don't emerge as a strobe light but as a celestial event generated by the room or an unseen force within or without the room. Snow also used superimpositions for several moments in *Wavelength*: the phone call, frames of the opening shot placed much later in the film, and the final camera moves on the wave photograph. Also in the editing, images of the zoom moving ahead were positioned and superimposed with frames of the zoom further back, with the two eventually catching up. Toward the end of the film further forward camera movements on the waves were superimposed over frames from an earlier camera position as the final framing of the waves occurs.

Audiences of traditional films are not accustomed to changes of exposure during the running of a shot or scene, except in rare cases. Here Snow changes exposures to make the room darker or lighter, but more importantly to add a new dimension to the natural light streaming through the loft's windows. Experimental filmmakers of this era often incorporated the end of a film roll on which white dots appear. This is to indicate that you are watching a film, a **self-referential** trope, but Michael Snow goes further and works this image into the textual fabric of *Wavelength*.

Like many (but not all) experimental films, *Wavelength* is a sound film. The soundtrack consists of the varying volume of street noise coming from outside the window, **sound effects** for the supposed break in, the music, and the sine wave that begins minutes into the film, starting at a low 50 cycles per second and ending at a very high-pitched 12,000 cycles per second. Like the zoom that travels across the loft over the running length of the film, the sine wave also takes the viewer on a journey from the beginning of a spectrum to the end.

Especially in the late 1960s and early 1970s, commercial film audiences were used to seeing shots made with a zoom lens. They may move fast or slow, but they were almost always steady and continuous. Their length was rarely longer than a non-zoom shot in a film. Due to his planning and execution, this zoom in *Wavelength* is hesitant and moves in controlled spurts. The murder mystery/horror aspect of *Wavelength* is curious. The man's death occurs in an arena of light and sound that precedes and follows the event. Because of the overall action, subjective and objective, the audience follows this happening but soon doesn't expect a resolve. The superimpositions transmit a ghostlike sense to the film, a magical manipulation of the imagery that has to do with, again, time and space. At the conclusion of *Wavelength* when all we can see are the waves—the room is gone—the sound fades out and the film ends.

Narrative and Cinematic Analysis

Some experimental films tell a story, just not a traditional one. *Wavelength* has four moments that could be considered plot, and the rest is what experimental film scholar Scott MacDonald identifies as being closer to the "geometric sense" of the term.

Wavelength begins with sunlight entering the loft space and it concludes at night. The four "plot" points begin when a woman enters with two men carrying a bookcase. The second is later when that woman and a female friend enter and at one point listen to the Beatles song "Strawberry Fields Forever" on the radio. The third and probably most dramatic is the breaking of glass and stumbling noises as a man, played by structural filmmaker Hollis Frampton, enters, collapses on the floor, and is presumed dead. The fourth comes near the end of the film when a woman discovers the man and concludes that he is dead as she talks to someone on the telephone. None of this is explained as it would be in a traditional film. They are just presented as moments that the viewer can connect and elaborate or just take as is. The two women in the film are played by noted film critic Amy Taubin and experimental filmmaker Joyce Wieland who was married to Snow.

Are the four human mini-scenes there because Snow felt he needed a diversion from the tedium of the audience watching a slow, 45-minute zoom and listening to a sound rise from low to very high? He says not, but more questions are raised about the loft and its use. When we see the men carrying in an empty bookcase, does it signal that the woman is moving in? Who is the unidentified man? His violent entrance is *Wavelength*'s biggest mystery. Is he a robber breaking in? There is the sound of glass breaking—are there windows on the other side of the camera? Is the breaking glass part of his demise? *Wavelength* is a mystery, not like the kind Hollywood released, but more of a real-life mystery that may not be solved. Together these moments represent the skeleton of a narrative plot that is part of an investigation into the physicality and spirituality of the loft space and the time the film is running.

In his notes Snow pursued other "movie actions" such as reading, putting on makeup, dressing up, putting on a record, exercising, opening and closing a window, and even masturbating. This points to the fragmented nature of the narrative moments.

While watching *Wavelength* the viewer is experiencing the space, light, and the human engagement that occurs. The film is challenging because the narrative film viewer wants to know where we are, why are we moving constantly forward, what is causing the color changes, the superimpositions, and what they mean. Where are we going on this cinematic trip, and why do we end in the image of waves? Those familiar with watching experimental films process them as an experience and are less likely to question the film as it unrolls rather than to engage with them.

Wavelength is a film that allows the viewer to explore the space they find themselves in. The visual changes in color moments where there are flashes of light on the image are spiritual and metaphysical. A lot of attention is given to where the zoom and viewer are headed. The pictures on the wall can be spotted almost immediately, but identifying them is a challenge until the camera lens gets closer, becoming a trope that pays off at the very end of the zoom. When it becomes clear that one of the pictures on the wall is of ocean waves, the idea of space in the film goes from a building on the ground to being afloat in an infinite space.

The waves image has been long talked about, analyzed, theorized, and criticized. The mystery aspect of the film in terms of how did the man die or who killed him is not solved by the last shot of *Wavelength*, because that is not what this film is about. *Wavelength* is about time and space and the nature of cinema, so the importance of the waves then comes into focus. One image can have a multitude of contexts. The nature of the photograph is one of *Wavelength*'s many layers. The waves photograph is shown over time, presenting it as part of the loft and later as a still image. The waves can be seen as a metaphor

involving mortality and death. For a long time, the waves are unrecognizable because the camera and zoom lens are too far away to decipher it, creating an element of recognition and discovery. Michael Snow has said the conclusion of *Wavelength* is "a coming" to the final framing. "Climax, that's what I thought."

Conclusion

The first showing of *Wavelength* wasn't a married print that contained picture and sound. The soundtrack was on a reel-to-reel tape separate from the picture, which was on a projector. Later, when Snow was asked by Jonas Mekas (see note in Chapter 12), if he was going to a film festival in Belgium, he realized it was impractical to show the film double system (the name for presenting a film's track and picture separately). Mekas, long considered the patron saint of experimental filmmakers and a practitioner himself, found the money to make an **optical track** for *Wavelength* that was positioned beside the film image, making projection and presentation easier and achieving an industry standard. The new married print was sent to Belgium, where *Wavelength* won first prize.

Snow didn't think there would be an audience for *Wavelength* with the exception of the Film-Makers Cinematheque, founded by Jonas Mekas in the early 1960s in New York to exhibit experimental films. Upon completion of *Wavelength* Snow arranged a small screening, which among others included Amy Taubin,[11] Richard Foreman,[12] Jonas Mekas, Shirley Clarke (see note in Chapter 12), Bob Cowan,[13] Nam June Paik,[14] and Ken and Flo Jacobs (actress and Ken's wife), which was held in May 1967. Ironically over the decades *Wavelength* has become one of the most celebrated, written about, and screened experimental films made in the late 1960s.

In the age-old argument as to whether a particular experimental film is narrative or **nonnarrative** Michael Snow's *Wavelength* presents a challenge in that it is both narrative in the four peopled sequences and it is nonnarrative during the rest of the film in which the viewer is alone with the loft, the zoom, the optical changes, and the soundtrack. Complicating the argument further is that the so-called nonnarrative aspects of *Wavelength* are really narrative—a new narrative—a story about what takes place in a loft beyond narrative and what causes our view to constantly move through the ever-changing loft space. What do the celestial changes in the images mean, and finally, again, what do the waves really mean?

Michael Snow, *Wavelength*, and his other works have received much attention and many awards, one of the most prestigious and exclusive being the Independent Film Award given by the bible of experimental film, *Film Culture* magazine, the brainchild of filmmaker and critic Jonas Mekas.

Wavelength is a challenge to the viewer's experience with traditional Hollywood films that are for the most part designed to tell a story with a beginning,

middle, and end, with a series of scenes containing shots through which the director employs framing and compositions that guide the audience where they want them to look. Snow wants the viewer to travel along with the movement of the zoom as he directs the eye from large to small. Because of the wide shot composition throughout most of the film, the eye tends to wander around the room looking at details, looking for clues to the meaning of the film. The more disciplined viewer is looking at the entire frame as one as it travels from far to near. The human episodes are specifically eye-guided, as are the changes in color. Eventually the interested viewer realizes that this is a cinematic experience, legendary in its simplicity and impact. The viewer is always aware that time is passing based on the fact that the camera/zoom/**point-of-view** is constantly changing. All films contain the passage of time—a Hollywood movie convention—but *Wavelength* more than any other film is *about* the passage of time.

In the world of experimental films, Michael Snow's *Wavelength* is legend. Throughout his career Snow has been obsessed with movement and the travel arc of an image. *Wavelength* is iconic because it defines the purpose of avant-garde films—to break all Hollywood traditions and to present a pure sound and image experience.

Notes

1. The National Film Board of Canada is a public film and digital media producer and distributor. It produces and distributes documentary films, animation, web documentaries, and alternate dramas. In total it has produced over 13,000 productions, which have won over 5,000 awards. It reports to the Parliament of Canada through the minister of Canadian heritage.

2. A sine wave is a mathematical curve that describes a smooth, repetitive oscillation, a continuous wave named after the sine function of which it is the graph.

3. Tom Wesselmann (1931–2004) was an American artist associated with the Pop Art movement who worked in painting, collage, and sculpture. His series *Great American Nude*, started in 1961, first brought him to prominence.

4. Billie Holiday (1915–1959) was an American jazz musician and singer-songwriter. Her vocal style was inspired by jazz instrumentalists and pioneered a new way of creating phrasing and tempo. Some of her recordings include: "Strange Fruit" (1939), "I've Got My Love to Keep Me Warm" (1937), and "God Bless the Child" (1941)

5. Zen is a school of Mahayana Buddhism that asserts that enlightenment can be attained through meditation and intuition rather than through faith and devotion.

6. Wanda Landowska (1879–1959) was a Polish/French harpsichordist whose performances, teachings, recordings, and writings played a large role in reviving the popularity of the harpsicord in the early 20th century.

7. Johann Sebastian Bach (1685–1750) was a German composer and musician of the Baroque period. He is known for instrumental compositions such as the *Brandenburg Concertos* and the *St Matthew Passion*.

8. These and many other findings about the number 45 can be found at ridingthebeast.com.

9. Ken Jacobs (1933–) is an American experimental filmmaker. He is the creator of *Tom, Tom, the Piper's Son* (1969), a landmark structural film that manipulates and recontexualizes found footage from 1905. His film *Star Spangled to Death* (2004) is a nearly seven-hour film consisting largely of found footage. Other films include *Blonde Cobra* (1963), *The Georgetown Loop* (1996), and *Little Stabs at Happiness* (1960).

10. Hollis Frampton (1936–1984) was an avant-garde filmmaker, photographer, writer/theoretician, and pioneer of digital art. He is known for long series of short films with a common theme such as *Zorns Lemma* (1970), which explored the alphabet in a new way. The *Hapax Legomena* series is made up of seven films exploring the relation between sound and cinema. Other works include: *Lemon* (1969), *Traveling Matte* (1971), and *Winter Solstice* (1974).

11. Amy Taubin (1939–) important film critic who reviews traditional, nontraditional, and experimental films. She has written for *The Village Voice, Sight & Sound*, and *Film Comment*. She also contributed to *The Millennium Film Journal* and *Artform* and at one time was curator of video and film at the nonprofit experimental performance space, *The Kitchen*.

12. Richard Foreman (1937–) is an American playwright and avant-garde theatre pioneer. He is the founder of the Ontological-Hysterical Theatre, which used a stripped-down stage and static tension with minimal style with complex and theatrical themes. He sought to make work that unsettles and disorients received ideas and opens the door for alternative models of perception, organization, and understanding.

13. Bob Cowan (1930–2011) was an underground film actor. He was a regular collaborator and performer with George Kuchar and Mike Kuchar, best known as the Robot Xar in *Sins of the Fleshapoids* (1965). In the 1960s and 1970s he was one of a few underground film superstars.

14. Nam June Paik (1931–2006) was a Korean American considered to be the founder of video art. His works include: *Electronic Superhighway: Continental U.S. Alaska, Hawaii* (1995), *TV Buddha* (1974), and *Video Fish* (1975).

For Further Study

Screen

Back and Forth
Free Radicals: A History of Experimental Film
La Région Centrale

Masterworks of American Avant-Garde Experimental Film 1920–1970
Treasures IV: American Avant-Garde Film 1947–1986

Read

Michael Snow: Sequences: A History of His Art by Bruce Jenkins and Michael Snow,
 edited by Gloria Moure
Michael Snow: Wavelength by Elizabeth Legge
The New American Cinema edited by Gregory Battock
The Selected Writings of Michael Snow by Michael Snow and Louise Dompierre
Visionary Film: The American Avant-Garde, 1943–2000, Third Edition by P. Adams
 Sitney

Stranger in a Strange Land: Exploring the Possibilities of the Detective Film

Witness

Witness (1985) is a one-of-a-kind detective film. It does have good guys, bad guys, and a murder, but it also has elements that make it special as a film that is more than it appears to be on the surface.

The murderer is a cop. The witness to this crime is a young Amish boy, and a considerable part of the film takes place in Amish country among the people who live as if in a time long past. The screenplay is winning in every way—story, characters, and action. Audiences enjoyed the drama and humanity of *Witness*. The film contains moments that define it and stay in the mind of the viewer. *Witness* is memorable for the Amish boy's escape from a train station bathroom, the raising of a barn, and a romantic nighttime dance between an Amish woman and a non-Amish detective on the lam.

A good **screenplay** is necessary to make a good movie. In the case of *Witness*, the story and screenplay were not written by seasoned Hollywood pros. The story is so ingenious and unique to the crime genre that when the film was released to acclaim, it was assumed the screenplay came out of the Hollywood system. In fact, the writers and story creators were William Kelley, Earl W. Wallace, and Pamela Wallace. Producer Edward S. Feldman had a first look development deal with 20th Century Fox, and in 1983 he received the *Witness* screenplay with the title *Home*, the Amish word for death. It ran 182 pages, which added up to three hours of screen time. It

had been circulating around Hollywood for years and was based on a *Gunsmoke* (the popular, long-running CBS television Western) episode Kelley and Earl Wallace had written in the 1970s. Feldman liked the script but felt there were too many Amish details, which took away from the thriller aspects of the narrative. He offered Kelley and Earl Wallace $25,000 for a one-year option and one script rewrite, and promised an additional $225,000 if the film were made. In less than six weeks they delivered the revised script to Feldman, who sent it to Fox. Joe Wizan, the head of production, rejected it saying Fox didn't make rural movies. Feldman sent the script to studio after studio, and it was rejected until he sent it to Paramount. Feldman wanted Peter Weir (*Picnic at Hanging Rock* [1975], *The Last Wave* [1977], and *The Year of Living Dangerously* [1982]) for director, but he was busy. Director John Badham (*Saturday Night Fever* [1977]) said it was just another cop movie and passed.

The movie director Peter Weir was working on was *The Mosquito Coast*. The financing fell through at the time, so he became free to direct *Witness* after all, which would be the Australian director's first American film. They had to start shooting immediately, because a Directors Guild of America strike was imminent. Harrison Ford read the script and was ready to commit to it.

Witness was photographed on location in Philadelphia and the towns of Intercourse, Lancaster, Strasburg, and Parkesburg, Pennsylvania. Many local Amish folks were utilized as carpenters and electricians but declined to appear on film, since being photographed was against their beliefs.

The Amish aspect of the film was a big part of the appeal of *Witness*. Their morality urged them to help people, but they were totally against guns and violence, which was a major element of the crime/murder story. It also included a romance between an Amish woman and the urban detective who was hiding from corrupt detectives who were out to kill him. The Amish are not supposed to have relationships outside of their sect, so this forbidden romance was an additional commentary about this society and the two main characters.

The Amish were not generally known to the movie-going public when *Witness* was released in 1985. In the 21st century there was a wave of television shows, mainly in the reality genre, concerning the Amish including *Breaking Amish*, *Amish Mafia*, and *Return to Amish*.

Narrative and Cinematic Analysis

Ethereal music. **Main Titles. Fade in.** Green field, blue sky. Amish men and women walk ahead. Horse and buggy. Straight on shot coming through a field. Buggies. Pennsylvania. 1984. Approaching house. Sad faces. Rachel (Kelly McGillis) just lost her young husband. People cry. A minister speaks

over a casket. Kitchen. Men talk. Ladies together. Daniel (Alexander Godu-
nov) tells Rachel he's sorry. A field blowing in the wind. House. Farm. Sunset.
A cart pulling hay bales. The look and feel here appears to be a period movie,
but the audience will prepare to enter a world in current time where time has
basically stopped.

A buggy with Eli Lapp (Jan Rubles), Rachel, and Samuel (Lukas Haas).
Road. A truck and cars behind buggy. Rachel and Samuel take a train ride.
Daniel comes to see them off. They board train with the English, which is
what the Amish call the outsiders. A romance is building between Rachel
and Daniel. The train starts moving, and he is on the other side standing in
his moving cart, demonstrating his masculinity. Philadelphia train station.
Water fountain. Samuel sees a man with long beard from behind. He walks
around in front of him—he is not Amish but Jewish. The boy begins to
understand he is entering a different world. Samuel goes to the bathroom. A
man is washing his face. Samuel goes into a stall. McFee (Danny Glover) and
another man enter the bathroom. McFee puts his shirt over man's head and
stabs him to death. Samuel sees the murder through an opening in the stall.
He makes a noise. McFee pulls a gun and checks each stall. Samuel locks his
stall and slips out to another stall, grabbing his hat. Samuel stands on the
toilet to avoid detection. Rachel and Samuel on a bench. Detective John Book
(Harrison Ford) explains that the man who was killed was a policeman. Two
men, a black man, a big guy. This scene starts what will be a journey into
police corruption and a clash of cultures.

In a police car, the police radio sounds. Book's partner is Carter (Brett
Jennings), an African American. Rachel is upset. Book and Carter are in a
bar looking for the suspect. Book pulls an African American man out onto
the street, pushes his face into the car window, and asks Samuel if that was
the man. The boy says no. Book's sister Elaine's (Patti LuPone) house. He
brings Rachel and Samuel to stay there. Book is condescending. Rachel and
Samuel in a room. Samuel says prayers. Book brings them to the police sta-
tion. Look at a lineup, no recognition by the boy. Book takes them to lunch.
Samuel eats hot dogs. Praying. Book is uncomfortable. Elaine says he's not
married, afraid of responsibility, and thinks he's right about everything.
"Whacking people" is Elaine's term for Book's violent street behavior. This
romance begins with a cop with brusque manners and a proper religious
woman. Unlikely clashes of cultures are inherent in this clever and well-
crafted story.

Back at the police station. Samuel looks at pictures in mugshot books.
Phone call for Book. A woman calls Samuel over, offers the boy a cookie, but
Samuel says no. A handcuffed man. Samuel walks to a display case with tro-
phies and a newspaper article with picture of McFee as a hero cop. Camera
zooms in on the newspaper. Book still on the phone. Samuel catches Book's
eye, and he walks over. Samuel points to the picture of McFee. Book pulls

Samuel's finger down and nods. The music is almost otherworldly. Movies are made up of moments, and this one is special and revealing.

Book sees his boss Schaeffer (Josef Sommer) at home and tells him about McFee. The boy has to be moved. An underground garage. McFee appears suddenly and shoots at Book. A shootout occurs, then McFee drives off. Book has been hit. Elaine wakes up Rachel and Samuel. Book is in the other room—not safe in Philadelphia. He telephones and wakes up his partner: "Watch your back, Schaeffer is in this too."

Schaeffer comes to Elaine's house, says John is in trouble. Book borrows her car and drives to Amish country. Drives. His horn rings out as he smashes into a bird house. Movies are constructed out of plot points. This one puts Book in an alien environment and he has no choice to leave. Book is bleeding. Eli Lapp (Jan Rubes), the head of the family, goes to the crashed car. They get Book out and take him to their house. The bullet is removed by an Amish neighbor. They pull the car into a barn by a horse. Book is in bed. Rachel treats his wound, and they hold hands. He's cursing without realizing it, which is against the Amish beliefs. Lamp. She sits with him. He looks at her. She looks at him. Schaeffer is on the phone to local officer. There are many Lapps in the area, and the Amish don't believe in telephones. Schaeffer tries to locate Rachel's house. Elders come. Samuel finds the gun in a drawer. Book sees him. He is bandaged around the waist. Book takes out the bullets, gives the gun back to Samuel. Rachel comes in and sees Samuel with the gun—respect our ways. Eli talks to the boy about guns. Amish people are against war. He's seen bad men. Gun and bullets are on the table.

Because his clothes are stained with blood, Rachel brings Book her husband's clothes, making a connection between the two men. Public phone. Strasburg. Book and Rachel have an attraction. Book dresses Amish. Need my gun—in cabinet—bullets in can with flour. They ride a horse-drawn cart into town. Other Amish see him. Book walks funny from his injury. He calls his partner from a pay phone. Later Rachel is canning. He gives her the bullets back and tells her not to put them in the peaches. Silo. Corn. He works on his car.

An old man with lantern wakes up Book at 4:30 am. Time for milking. He sits on a stool and squeezes. Rachel rings a bell. Prayers. Breakfast. Daniel in a field. Came to see Rachel. Book fixes the bird house. Rachel comes to him. Lemonade. Drinks it in one gulp. Daniel went home; he's like a son to Eli. Night. Eli says, "You are a carpenter." Book is, in a sense, converted into an Amish man.

Book is working on the car—Rachel there. Radio. "(What A) Wonderful World" recorded by Sam Cooke in 1960, featuring the line "Don't know much about history," plays on the radio. Book recognizes it immediately and begins to "perform" it for Rachel. They almost kiss. Stop. Look, almost kiss. This dance sequence is a classic set-piece that allows the actors to open up their characters. Romance is building. Harrison Ford is terrific in the scene,

working every beat, every moment. Rachel is taken with him and feels liberated. Stylized and special. Eli comes in, angry. Rachel stands up to him: "I'm not a child." This sort of romance is forbidden.

Schaeffer: "I know he's with the Amish." The raising of a barn. Rachel and Book arrive. Daniel works on Book—he is in competition for Rachel's heart. Book meets the men. Raising the frame with ropes. Full shot of barn structure going up. Hammering. Lemonade. Daniel passes it on to Book, showing his fairness as well a sign of challenge for Rachel. Hand drill. Children play with wood and tools. Music. Whole frame together. Rachel looks up at Book. Lunch. Prayers. Women serve the men. Rachel is looking at Book. Women quilt. A woman tells Rachel that everyone knows about her and Book. This sequence bonds Book to the community and to Rachel. The action of the barn raising reveals the Amish work ethic and the beauty of building a structure. Night. Storm. Book sits on a swing watching Rachel inside. She washes herself. He watches her, she sees him. He sees her naked from the waist up— an erotic moment for Book and reveals the desire in Rachel. **Dissolve.** Exterior of the house. Rachel with chickens. Book tells her that if they made love, she would have to leave the Amish. Phone booth. Book calls Carter and learns that he died in the line of duty. Phones Schaeffer, whose wife answers, Schaeffer goes to his study. Angry. Schaeffer hangs up.

In a buggy with Eli. Townie puts ice cream on Daniel's face. Book gets out of the buggy and beats him up. Visitors see a man they believe is Amish employing violence on another, which is against their beliefs. Later the boy plays with wooden game Book made for him. Harrison Ford is an expert carpenter in real life, a fact many moviegoers knew. He's leaving tomorrow. Going back to his world. Rachel and Book kiss and hug. Synthesizer music throughout *Witness* brings a spiritual quality to the atmosphere of the film.

Road. A car stops and the lights are put out. Backs up. Guns in the trunk, ammunition. They load up. Rifles. They break into the house. Police officers. "It's Book we want." Eli yells out "Book!" Locks himself and Samuel in. Eli tells Samuel to go to someone's house. Book can't get his car started, climbs up the silo. He releases the corn down on a bad guy who is choking and can't get out. Schaeffer calls for his men. Eli signals to Samuel to ring the bell hard. Book digs out the bad guy's rifle. Book kills McFee. Samuel rings the bell. Schaeffer grabs Rachel as a hostage. The locals come running to the house. Everyone watches. The Amish stand as witnesses—the title now has a double meaning. Samuel is a witness and now all the Amish there are also. Book takes Schaeffer's rifle. Rachel looks out of the window. Book and Samuel in a field. Boy says "Goodbye, John Book." Rachel comes out. They look at each other as he walks to a car. Eli comes out. "Be careful among the English." Book drives up the road. Daniel, walking down to the house, waves to Book. Film ends.

Conclusion

What Peter Weir especially brought to *Witness* was the heightened religiosity of Amish life and its effect on John Book. Weir was the perfect choice to direct this modern classic film, because there is a river of spirituality running through all of his films that he balances with adroit storytelling.

The crime drama was given a renovation with Peter Weir's *Witness*. The basic elements are there—a crime, bad guys, a cop, and a woman. It's the culture of the Amish people that thrilled audiences when the film was released, and beyond. Audiences were exposed to a new world and new tensions because the sacred life of the Amish was invaded by the specter of crime. *Witness* also sent a message to the movie studios who always relied on seasoned pros and a seasoned formula. *Witness* broke the Hollywood mold, and opened the door for the endless possibilities within the genre of the crime film.

For Further Study

Screen

Between Two Worlds: The Making of Witness
Gallipoli
The Last Wave
Picnic at Hanging Rock
The Truman Show

Read

Filmmakers Series: Peter Weir by Marek Halof
The Last New Wave: The Australia Film Revival by David Stratton
New Australian Cinema and the Films of Peter Weir by Jonathan Raynor
Peter Weir: A Creative Journey from Australia to Hollywood by Serena Formica
Peter Weir: Interviews by John C. Tibbetts and David Thomson

Glossary

Note: terms in **bold** have their own separate definition.

adult films
Movies that feature explicit sexual activity for their content.

AFI
American Film Institute. An organization that educates filmmakers and honors the heritage of motion pictures in the United States.

American New Wave
A movement from the mid- to late 1960s to the early 1980s when a new generation arrived in the United States making films for the under-30 audience. They include Francis Ford Coppola, Martin Scorsese, and Brian De Palma.

art film
Films very different from commercial Hollywood movies that stress aesthetics and content.

auteur theory
Theoretical concept formulated in the pages of *Cahiers du Cinéma* magazine in the 1950s by **French New Wave** filmmakers and critics and later in the United States by film critic Andrew Sarris in the magazine *Film Culture* and in the *Village Voice*. The theory states that the film director is the sole author of a film. These filmmakers are identified as auteurs.

autobiographical film
Movies that embrace the filmmaker's own life experience or life history.

avant-garde film
An early term used to describe the movement of filmmakers who rebelled against Hollywood in content, theme, style, and approach by creating films whose prime goal is art and not commercial narrative storytelling. Also known as **experimental filmmaking**.

B movie
Usually refers to low-budget films with exploitative content. The original mean-ing was during the **classical Hollywood film** era: a B movie was the bottom half of a double bill. The A picture had major stars and talent and was in color, and the B movie was most often in black-and-white with a minor cast.

biopic
A movie about a person's life, most often a celebrity, historical figure, or one in the arts. Biopics are usually period films because the life studied comes from the past, near or far.

bi-pack
The process of loading two reels of film into a camera so that they both pass through the camera gate together.

blaxploitation movies
Films produced in the 1970s that were exploitation films featuring African-American casts. They often took place in urban settings and made heroes out of roles that had previously been of stereotypes.

blood squib
A small device containing fake blood that is attached to the body of an actor so they are not seen and can be triggered on cue when the cameras roll. They then explode and release fake blood so it looks like a bullet hit.

Cahiers du Cinéma
A French film magazine founded in 1951 by André Bazin and others. Members of the **French New Wave** were writers that contributed to the **auteur theory** and a reevaluation of **classical Hollywood film** directors. An English-language version was later published. The original magazine is the oldest film publication in existence.

cameo
A brief role or appearance performed by a recognizable actor, person, or celebrity.

choreography
The art of composing a dance or a camera movement by arranging patterns and steps.

cinema of transgression
A term coined by filmmaker Nick Zedd in 1985 to describe a New York under-ground film movement of like-minded artists using shock value and humor in their work.

cinéma vérité
A **documentary** film form developed in France during the 1950s and 1960s that attempts to film real life as it really is without cinematic manipulation or interference.

classical Hollywood film
The American film style that began in 1917 and ran to the mid-1960s. These films came out of the studio system, which had extensive rules on how a film should be written and produced, and were created utilizing a factory method.

compression
An editing technique that compresses an event into a shorter space of time than it would take in real time. Although the basis of most editing is to compress time, the editor can drastically alter real time when it is dramatically necessary for a scene.

continuity
What must be maintained during the shooting of a film. Everything in a shot should be the same or matched in a scene; everything on the actors—clothes, hairstyles, jewelry—all props, furniture, candles burning, cigarettes, and so on. Mistakes in continuity break the reality of a scene. The job of maintaining continuity goes to the script supervisor.

coverage
Footage that duplicates or compliments the **master shot** from a different angle or size, thus allowing the editor to make a match or move the film editorially.

crosscutting
Editing technique whereby shots or scenes are cut together in alternate sequence to create a dramatic relationship. Also called **intercutting**.

direct cinema
The American interpretation of **cinéma vérité**, in which the camera is nonobjective and as invisible as possible, in the manner of the French school but in which films are tightly structured during the editing process.

dissolve
Optical process whereby one shot **fades out** as the next shot **fades in**.

documentary
A **nonfiction film** dealing with facts that attempts to presents reality as it is.

dolly shot
A wheeled cart on which the camera is mounted and pushed to capture a moving shot.

double exposure
The **superimposition** of two exposures to create a single image.

DVD
An abbreviation of digital video disc or digital versatile disc. An optical disc storage format invented and developed by Phillips and Sony in 1995. Used to hold many media, especially feature films.

experimental film
Nonnarrative filmmaking created in opposition to the commercial nature of the Hollywood studio film. A term used in the 1960s and 1970s to identify individual nontraditional filmmakers with artistic intentions often employing abstract concepts, imagery, and techniques. Can also be called **avant-garde films**.

exploitation films
Movies that feature drug use, nudity, gore, the bizarre, destruction, mayhem, sex, and rebellion. They are usually considered **B movies** and are lower in quality and budget than traditional Hollywood films.

extreme low angle
An angle positioned lower than the average **low angle** shot and looking upward.

eyeline match
Filming an actor so their gaze will match that of another actor who is looking at them.

fade in
Optical effect or digital transition in which an image appears from black or a solid color field.

fade out
Optical effect or digital transition in which an image disappears into black or a solid color field. Also known as a "fade to black."

film noir
A Hollywood film style in the post–World War II era of the 1940s and early 1950s identified by French critics. These black-and-white crime films featured a doomed man and a femme fatale responsible for his downfall. The characters were cynical and disillusioned. Most scenes took place at night, and the atmosphere was doom-laden. The visual style of film noir, which literally means "black film," featured squalid settings and deep shadows.

film within a film
a second film that emerges within the main movie. It can be part of a film being made by those in the main movie or another film that in some way is directly related to it.

flash cut
A couple of frames of an image different than what came before it cut into a shot to surprise the viewer or interrupt the action with a sudden jolt.

flashback
A scene that occurs earlier in time than the one that precedes it.

flashforward
A scene that jumps ahead out of relation to the time frame that has been established.

flat
A flat piece of theatrical scenery that is painted and positioned on a sound stage, often with others to give the appearance of a room, building, or other forms of background. Also used for stage plays.

flicker effect
A film created with alternating bright and dark frames edited in a rapid sequence causing a strobe effect.

footage
Raw, unedited material as originally filmed by a motion picture, video, or digital camera to be edited into a finished film or human figure to place it in its surrounding.

freeze frame
A single frame of a motion picture image repeated for a desired length of time, appearing to be a still image.

French New Wave
A group of French filmmakers, many of whom were also film critics, including Jean-Luc Godard, Francois Truffaut, and Jacques Rivette, whose work rejected the literary style of the past for a more lively cinematic approach. Known in French as *La Nouvelle Vague*.

full shot
Also known as a long shot, or a wide shot that typically shows the entire object, person, or location.

genre
The organization of films according to type: musical, crime, Western, action, film noir, and science fiction films are all examples of film genres.

German expressionism
A modernist movement originating in Germany at the beginning of the 20th century. It presented the world solely from a subjective perspective distorting it radically for emotional effect in order to evoke moods or ideas.

grain
The random optical texture of processed photographic film due to the presence of small particles of a metallic silver or dye clouds developed from silver halide that have received enough photons.

grainy
When the film **grain** in a motion picture print is enlarged due to a photographic blow-up and can be seen clearly by the eye.

handheld camera
Technique in which the camera is held and operated by the camera operator without a tripod or dolly, or Steadicam.

high-key lighting
An application of bright light with little or no shadows.

independent film
A feature film produced outside the major studio system. Also called an *indie*.

intercutting
Editing technique whereby shots of scenes are cut together in alternate sequence to create a dramatic relationship. Also called **crosscutting.**

intertitles
Cards with text information concerning the scene or moment to support and enhance the film. They were widely used in silent films to present dialogue and background details and to establish time and place. In sound films intertitles provide information or comment on the content of the film.

iris
Controls the amount of light that comes through the lens.

iris transition
An old-fashioned editing transition in which a circular masking closes around an image until there is a black screen. A way of ending a shot or scene.

jump cut
A jump in the action caused by removing part of a continuous shot or by joining two shots that don't match in **continuity.**

kung-fu movies
Subgenre of martial arts films set in contemporary times and featuring realistic martial arts. Many of these films were produced in Hong Kong.

limited animation
Process in which frames are redrawn and others are reused, which produces a less fluid movement and one that is far less detailed.

linear storytelling
A narrative that utilizes a consecutive timeline without **flashbacks** or **flashforwards**.

loop printing
A section of film printed so it repeats its imagery.

low angle
A shot from a camera angle position low on the vertical axis, anywhere below the **eyeline**, looking up.

low-budget film
A motion picture produced with little or no funding from a major studio but usually by private investors. These films are produced for a fraction of the amount spent on Hollywood pictures.

main title
The name of the movie that appears at the beginning or end of a motion picture.

master shot
Continuous shot that includes the entire action of a scene.

matte painting
A painted representation of a landscape, set, or distant location that allows filmmakers to have the illusion of an environment that was not present in a location when it was shot. Originally they were executed on glass, then later produced digitally.

maverick filmmaker
One who goes against the grain of Hollywood moviemaking in every way: content, style of acting, cinematography, editing, production design, sound, and use of music.

metafiction
Narrative technique where a fictional work is self-conscious or openly draws attention to the fact that it is imaginary. It poses philosophic and critical questions about the relationship between fiction and reality by applying irony and self-reflection.

Mickey-Mousing
A technique where the music syncs with the actions on the screen in an obvious manner.

miniatures
When scale models are used to create **special effects**.

montage
The French word for editing. The early Russian cinema style in which a collision effect was achieved between shots designed for their graphic, narrative, social, and political purpose. In the **classical Hollywood film** studios model, a series of shots that established the passage of time or compressed an action or event. A contemporary filmmaking style that employs a multitude of individual shots and details as the main communication source of storytelling.

Motion Picture Editors Guild
Created in 1937, MPEG represents freelance and staff motion picture and television editors and other postproduction professionals.

Moviola
A mechanical device used to edit film. It was invented in 1924 by Iwan Serrurier. The Moviola was employed to cut most every Hollywood film from the 1920s to the late 1990s.

multiple cameras
When two or more cameras are used to film a scene, capturing various angles and image sizes to achieve **coverage** in an economical manner in terms of the budget and time schedule.

narration
Words spoken by an **off-screen** voice either by an unidentified speaker or one of the characters in a film. Theorists have classified the text of a narrator as being reliable or unreliable as part of a narrative strategy.

narrative
A series of connected events presented in sequence. Also known as the *story*.

narrator
Person who speaks **off-screen** in a film, presenting parts of the story.

neo-noir
A **film noir** created after the **classical Hollywood film** post–World War II period, often in color and often set in an unidentified contemporary time and place.

newsreel
A form of short **documentary** common between 1910 and 1960 shown in movie theaters that covered news stories of the day.

nonfiction film
A motion picture that is based in fact. Another term for **documentary**.

nonlinear structure
A narrative that does not follow a consecutive timeline and moves forward and back in time, place, action, and events.

nonnarrative film
Term used to describe an **experimental film** that has no discernible story or plot, often employing abstract or nonfigurative images.

off-screen
Anything, either image or sound, referenced but not shown within the frame.

on-screen
Characters, objects, or sets that are seen on camera.

optical printer
One or more film projectors mechanically linked to a movie camera. It allows the rephotographing of one or more strips of film. Used for editing transitions such as **dissolves, fade-ins, fade-outs,** and **special effects**.

optical track
Sound that is physically recorded and positioned alongside the image it accompanies. It can be seen as an optical image and plays in sync with the picture when projected.

Oscar
Another name for the Academy Awards given out annually by the Academy of Motion Picture Arts and Sciences for excellence in many fields related to motion picture creation.

over-the-shoulder-shot
A shot of someone taken from the perspective or camera angle from behind the shoulder of another person in the scene.

overture
Instrumental orchestral music played prior to the beginning of a film. Usually a series of themes from the film score. They were run in theaters during the studio era, usually over an image related to the film and before the main credits. Later found on video tapes and **DVD**s. Overtures were on epics and high-profile films that were first shown in key cities.

pan
When the camera is swiveled from a fixed position. This motion simulates a person turning their head from left to right or right to left. When this is done very quickly, it is called a *swish pan*.

personal filmmaking
The creation of filmmaking that relates to the thoughts and feelings of the film artist and tackles sensitive and personal subjects.

point-of-view
Also known as *POV*, a shot in which the viewer sees what a character is seeing.

postproduction
The time in which a film is edited; also includes sound design, music scoring and recording, rerecording, mixing, making of the film or digital print, advertising, and release.

production designer
Person who is the head of the art department and is responsible to help the director create the look of a film.

protagonist
The leading or major character in a movie.

rack focus
When the focus point within a shot changes from one character or object to another. One is in focus and the other is in soft or out of focus, then it changes so that the first element is in soft focus and the second is out of focus. This also can be applied to shots of object or landscapes.

reboot
A new version of a prior film in which the filmmakers revamp and reinvigorate the material to attract a new audience.

reimagining
A film that is a **remake** that is not directly identical to the original.

remake
A film that is based on an earlier work and tells the same or a very similar story, much closer to the original than a **reboot**.

rewind table
Originally a table with two rewind units turned by hand to rewind a roll of film to an empty reel, so the result would rewind that roll to the beginning or heads. Later they became mechanized and operated by an electronic control.

road movie
A genre that takes place during an automotive trip, which becomes a metaphor for the search to find soul and purpose, often ending in self-discovery, disappointment, and despair. Road movies embrace the mythic quest, the eternal search for identity and home that traces back to Homer's *The Odyssey* and Jack Kerouac's *On the Road*.

scene missing card
Text card inserted into a film during the editing process to indicate that the scene that will go in that spot is not now available.

screen direction
The direction that objects, actors, or vehicles move on a screen from the **point-of-view** of the camera and the audience. A film grammar and editing rule that states that movement from one shot to the next must maintain the consistency of screen direction to avoid confusion by the viewer.

screenplay
A screenplay is a document that contains narrative information about the plot, characters, and dialogue. Known also as a *script*, a screenplay is used to guide the director, cast, and crew in making a film. A screenplay can be an original work or adapted from a novel or other media.

second unit
A team of filmmakers who film shots or **sequences** on a film that do not involve the main or first unit. The second unit will often be shot simultaneously with the main unit, allowing the filming of a production to completed faster.

self-referential film
A movie in which the content refers to itself. The viewer is aware that they are watching a film.

sequel
A film that continues a story or expands upon some earlier work.

sequence
A series of scenes that form a distinct narrative unit often connected either by unity of location or time.

shock cut
Also called a *smash-cut*. When there is an abrupt, sudden, jarring, unexpected change in a scene or image to another in order to surprise the audience.

shooting ratio
The amount of **footage** shot for a film against the length of a finished film. A shooting ratio of 2:1 means twice as much footage is shot than the finished film.

slate
Also called a *clapperboard*. A chalkboard with a clapstick used to identify a shot and maintain synch when shooting a **take**. Also can be electronic or digital.

slow motion
Commonly abbreviated as slo-mo or slow-mo. An effect in which time seems to be slowing down.

sound designer
Person responsible for the concept and execution of a film soundtrack so that the audio expresses the visual aspects of the movie.

sound effects
Artificially created or enhanced sounds used in a film to emphasize the story or mood.

soundstage
The area in a movie studio suitable for recording sync-sound dialogue.

special effects
Also abbreviated as SFX, SPFX, or FX, visual tricks and illusions created for a motion picture. Usually categorized as optical, mechanical, or digital. Also called *visual effects*.

Spike Lee shot
Named after the accomplished African American film director. The camera is mounted on a dolly. Then an actor is put on another dolly, standing on a small board mounted to a track. The two dollies are moved at the same time. The board is pushed forward as the camera is pushed away. The result is the actor appears to be floating toward the camera.

splice
To join two pieces of film together either by glue or clear tape. In digital film-making a splice is done electronically.

split-screen
When a full screen becomes a series of defined panels, often with different images appearing or multiple images of one.

stag film
Inexpensively made film shot on 8mm, Super 8mm, or 16mm, often in black-and-white, that features explicit sex or female striptease.

Steenbeck editing table
The film runs through a series of gates and is brought to the screen by a prism. A controller moves the film forward or back, normal speed or high speed. Also known as a flatbed.

stock footage
Film reused from one film to another. Often stock **footage** is of a historic nature, scenes of a past event. Usually used in **documentaries** but not exclusively. Stock footage is film that is not shot for the production it is now in. Also known as *archival footage*.

stop-motion
An animation technique whereby an object is physically manipulated so it appears to move on its own. The object is manipulated in small increments and photographed a frame or so at a time to create this illusion.

structural film
Term coined by P. Adams Sitney in the 1970s, referring to film artists who pursued the shape of a film and emphasized the use of structure in creation of the work.

structure
A film can have a three-act structure comprising Act I: Set up, Act II: Confrontation, and Act III: Resolution, or a nonlinear structure in which the narrative moves out of **continuity** using **flashbacks** and **flashforwards**.

superimposition
When one image is laid on top of another image.

sync-sound
Sound recorded at the time of the camera during the filming of a movie.

take
A single recorded performance.

take ratio
An established number of **takes** a director will shoot of a shot. A ratio of 10 to 1 means up to 10 takes will be photographed for each shot.

top shot
A shot in which the camera is positioned high above a set or location, looking straight down on the action.

tracking shot
When the camera on tracks or rails moves alongside a person or object that it is filming.

VHS
Video Home System. Consumer-level analog video recording on tape cassettes released in Japan in late 1976 and in the United States in early 1977. Feature films and other motion picture formats were transferred onto VHS tape and sold or rented in various stores including video shops.

voice-over
An asynchronous voice spoken over a scene in a film. May or may not be directly connected to any characters on the screen. Also known as *VO*.

wipe
A film transition where one shot replaces another by traveling from one side of the frame to the other.

wrap
Phrase used by the director to signal that shooting of the entire film is complete.

zoom lens
A mechanical assembly of lens elements for which the focal length and the angle of view can be varied.

Bibliography

Aberdeen, J. A. *Hollywood Renegades: The Society of Independent Motion Pictures Producers*. Los Angeles: Cobblestone Entertainment, 2000.

Affron, Charles, and Mirella Jona Affron. *Sets in Motion: Art Direction and Film Narrative*. New Brunswick, NJ: Rutgers University Press, 1995.

Albers, Josef. *The Elements of Color*. New Haven, CT: Yale University Press, 1971.

Albrecht, Donald. *Designing Dreams: Modern Architecture in the Movies*. New York: Harper & Row in collaboration with the Museum of Modern Art, 1986.

Allon, Yoram, Del Cullen, and Hannah Patterson, eds. *The Wallflower Critical Guide to Contemporary North American Directors*. London: Wallflower, 2000.

Altman, Rick, ed. *Sound Theory, Sound Practice*. New York: Routledge, 1992.

Ball, Phillip. *Bright Earth: Art and the Invention of Color*. Chicago: University of Chicago Press, 2003.

Barnouw, Erik. *Documentary: A History of the Non-Fiction Film*. Second revised edition. New York: Oxford University Press, 1993.

Barsham, Richard. *Looking at Movies: An Introduction to Film*. New York: W. W. Norton, 2004.

Barson, Michael. *The Illustrated Who's Who of Hollywood Directors: The Studio System in the Sound Era*. New York: Noonday, 1995.

Battock, Gregory, ed. *The New American Cinema: A Critical Anthology*. New York: E. P. Dutton, 1967.

Bazelon, Irwin. *Knowing the Score: Notes on Film Music*. New York: Arco, 1975.

Bazin, André, and Hugh Gray, eds. *What Is Cinema? Vol 1*. Berkeley: University of California Press, 1967.

Bazin, André, and Hugh Gray, eds. *What Is Cinema? Vol 2*. Berkeley: University of California Press, 1971.

Beaver, Frank. *Dictionary of Film Terms: The Aesthetic Companion to Film Analysis*. Revised and expanded edition. New York: Twayne, 1994.

Begleiter, Marcie. *From Word to Image: Storyboarding and the Filmmaking Process*. Studio City, CA: Michael Wiese Productions, 2001.

Berg, Chung, and Tom Erskine. *The Encyclopedia of Orson Welles*. With John C. Tibbetts and James M. Welsh, series eds. New York: Checkmark, 2003.

Billips, Scott. *Digital Filmmaking*. Studio City, CA: Michael Wiese Productions, 2000.

Biskind, Peter. *Easy Riders, Raging Bulls: How the Sex-Drugs-and-Rock 'n' Roll Generation Saved Hollywood*. New York: Simon & Schuster, 1998.

Blacker, Irwin R. *The Elements of Screenwriting: A Guide for Film and Television Writing*. New York: MacMillan, 1986.

Block, Bruce. *The Visual Story: Seeing the Structure of Film, TV, and New Media*. Woburn, MA: Focal, 2001.

Bluestone, George. *Novels into Film: The Metamorphosis of Fiction into Cinema*. Berkeley: University of California Press, 1957.

Boorstin, Jon. *The Hollywood Eye: What Makes Movies Work*. New York: Cornelia & Michael Bessie Books, 1990.

Bordwell, David. *Ozu and the Poetics of Cinema*. Princeton, NJ: Princeton University Press, 1988.

Bordwell, David, Janet Staiger, and Kristin Thompson. *The Classical Hollywood Cinema: Film Style & Mode of Production to 1960*. New York: Columbia University Press, 1981.

Brady, Frank. *Citizen Welles: A Biography of Orson Welles*. New York: Charles Scribner's Sons, 1989.

Bresson, Robert. Translated by Jonathan Griffin. *Notes on Cinematography*. New York: Urizen, 1977.

Brody, Richard. *Everything Is Cinema: The Working Life of Jean-Luc Godard*. New York: Metropolitan, 2008.

Brown, Royal S. *Overtones and Undertones: Reading Film Music*. Berkeley: University of California Press, 1994.

Buscombe, Edward. *The Searchers*. London: BFI, 2000.

Card, James. *Seductive Cinema: The Art of Silent Film*. New York: Knopf, 1994.

Champlin, Charles. *John Frankenheimer: A Conversation with Charles Champlin*. Burbank, CA: Riverwood, 1995.

Chion, Michel. *Audio-Vision: Sound on Screen*. New York: Columbia University Press, 1994.

Chion, Michel. *David Lynch*. London: BFI, 1995.

Compo, Susan. *Warren Oates: A Wild Life*. Lexington: University Press of Kentucky, 2009.

Cunneen, Joseph. *Robert Bresson: A Spiritual Style in Film*. New York: Continuum, 2003.

Curtis, David. *Experimental Film: A Fifty-Year Evolution*. New York: Universe, 1971.

Dixon, Wheeler Winston. *The Exploding Eye: A Re-Visionary History of the 1960s American Experimental Cinema*. New York: State University of New York Press, 1997.

Dowd, Nancy, and David Shepard. *King Vidor: A Director's Guild of America Oral History*. Metuchen, NJ: Scarecrow, 1988.

Durgnat, Raymond, and Scott Simmon. *King Vidor, American.* Berkeley: University of California Press, 1988.

Estrin, Mark W., ed. *Orson Welles: Interviews.* Jackson: University Press of Mississippi, 2002.

Evans, Mark. *Soundtrack: The Music of the Movies.* New York: Da Capo, 1979.

Field, Syd. *Screenplay: The Foundations of Screenwriting.* New York: Dell, 1984.

Fielding, Raymond. *A Technological History of Motion Pictures and Television.* Berkeley: University of California Press, 1983.

Flint, David. *Babylon Blue: An Illustrated History of Adult Cinema.* London: Creation, 1999.

Gabler, Neal. *An Empire of Their Own: How the Jews Invented Hollywood.* New York: Crown, 1988.

Gibbs, John. *Mise-en-Scène: Film Style and Interpretation.* London: Wallflower, 2002.

Godner, Orville, and George E. Turner. *The Making of King Kong.* London: Tantivy, 1975.

Grant, Barry Keith, ed. *Film Genre Reader.* Austin: University of Texas Press, 1986.

Hart, John. *The Art of the Storyboard: Storyboarding for Film, TV, and Animation.* Boston: Focal, 1999.

Horak, Jan Christopher. *Lovers of Cinema: The First American Avant-Garde 1919–1945.* Madison: University of Wisconsin Press, 1995.

Hughes, David, Jim Smith, and James Clarke. *The Complete Lynch.* London: Virgin, 2002.

Hulkrans, Andrew. *Forever Changes: 33 1/3.* New York: Continuum, 2003.

Huston, John. *An Open Book.* New York: Da Capo, 1994.

James, David E. *Allegories of Cinema: American Film in the 1960s.* Princeton, NJ: Princeton University Press, 1989.

James, David E., ed. *To Free the Cinema: Jonas Mekas & the New York Underground.* Princeton, NJ: Princeton University Press, 1992.

Josephson, Matthew. *Life Among the Surrealists.* New York: Holt, Rinehart & Winston, 1962.

Katz, Steven D. *Film Directing Shot by Shot: Visualizing from Concept to Screen.* Studio City, CA: Michael Wiese Productions, 1991.

Konigsberg, Ira. *The Complete Film Dictionary.* Second edition. New York: Penguin, 1997.

Kostelanetz, Richard, ed. *12 From the Sixties: The Decade's Most Provocative and Significant Writers.* New York: Dell, 1974.

Kozloff, Sarah. *Invisible Storytellers: Voice-Over Narration in American Fiction Film.* Berkeley: University of California Press, 1998.

Laderman, David. *Driving Visions: Exploring the Road Movie.* Austin: University of Texas Press, 2002.

Leaming, Barbara. *Orson Welles: A Biography.* New York: Viking, 1985.

Lee, Spike, and Kaleem Afttab. *That's My Story and I'm Sticking to It.* New York: W. W. Norton, 2005.

Legge, Elizabeth. *Wavelength*. Cambridge, MA, and London: Afterall, 2009.

Levy, Emanuel. *Cinema of Outsiders: The Rise of American Independent Film*. New York: New York University Press, 1999.

Lindsay, Vachel. *The Art of the Motion Picture*. New York: Modern Library, 2000 (originally written in 1915).

LoBrutto, Vincent. *The Encyclopedia of American Independent Filmmaking*. Westport, CT: Greenwood, 2002.

LoBrutto, Vincent. *Stanley Kubrick: A Biography*. New York: Donald I. Fine, 1997.

Lynch, David. *Catching the Big Fish: Meditation, Consciousness, and Creativity*. New York: Jeremy P. Tarcher, 2006.

MacCabe, Colin. *Godard: A Portrait of the Artist at Seventy*. New York: Farrar, Straus and Giroux, 2003.

MacCann, Richard Dyer, ed. *Film: A Montage of Theories*. New York. E. P. Dutton, 1966.

MacDonald, Scott. *A Critical Cinema 2: Interviews with Independent Filmmakers*. Berkeley: University of California Press, 1992.

MacDonald, Scott. *Avant-Garde Film: Motion Studies*. Cambridge: Cambridge University Press, 1993.

Manoogian, Haig P. *The Filmmaker's Art*. New York: Basic Books, 1966.

Marie, Michel. *The French New Wave: An Artistic School*. Malden, MA: Blackwell, 2003.

McDonough, Jimmy. *Big Bosoms and Square Jaws: The Biography of Russ Meyer, King of the Sex Film*. New York: Crown, 2005.

Mekas, Jonas. *Movie Journal: The Rise of a New American Cinema, 1959–1971*. New York: Collier, 1971.

Merritt, Greg. *Celluloid Mavericks: A History of American Independent Film*. New York: Thunder's Mouth, 2000.

Miller, Frank. *Sin City: Book 2: A Dame to Kill For*. Milwaukie, OR: Dark Horse, 1993.

Milne, Tom, translation and commentary. *Godard on Godard*. New York: Viking, 1972.

Murch, Walter. *In the Blink of an Eye: A Perspective on Film Editing*. Second edition. Los Angeles: Silman-James, 2001.

Neupert, Richard. *A History of the French New Wave*. Second Edition. Madison: University of Wisconsin Press, 2002.

O'Connell, P. J. *Robert Drew and the Development of Cinéma Vérité in America*. Carbondale: Southern Illinois University Press, 1992.

Phillips, Gene D., ed. *Stanley Kubrick: Interviews*. Jackson: University Press of Mississippi, 2001.

Phillips, Gene D., and Rodney Hill. *The Encyclopedia of Stanley Kubrick*. With John C. Tibbets, James M. Welsh, series eds. New York: Checkmark, 2002.

Polti, Georges. *The Thirty-Six Dramatic Situations*. New York: William Morrow, 1984.

Pratley, Gerald. *The Cinema of John Frankenheimer*. London: A. Zwemmer; New York: A. S. Barnes, 1969.

Rainsberger, Todd. *James Wong Howe: Cinematographer*. San Diego, CA: A. S. Barners, 1981.

Rodley, Chris, ed. *Lynch on Lynch*. London: Faber and Faber, 1997.

Rosenbaum, Jonathan. *Essential Cinema: On the Necessity of Film Canons*. Baltimore, MD: Johns Hopkins University Press, 2004.

Roud, Richard. *Godard*. Bloomington: Indiana University Press, 1970.

Sarris, Andrew. *The American Cinema: Directors and Directions 1929–1968*. New York: Da Capo, 1996 (originally published in 1968).

Schrader, Paul. *Transcendental Style in Film: Ozu, Bresson, Dreyer*. New York: Da Capo, 1972.

Shipman, David. *The Story of Cinema: A Complete Narrative History from the Beginnings to the Present*. New York: St. Martin's, 1982.

Simon, Mark. *Storyboards: Motion in Art*. Second edition. Boston: Focal, 2000.

Sitney, P. Adams. *Visionary Film: The American Avant-Garde 1943–2000*. Third Edition. Oxford: Oxford University Press, 2002.

Sitney, P. Adams, ed. *Film Culture Reader*. New York: Cooper Square, 2000 (originally published in 1970).

Solnit, Rebecca. *River of Shadows: Eadweard Muybridge and the Technological West*. New York: Viking, 2003.

Sterritt, David. *The Films of Jean-Luc Godard: Seeing the Invisible*. New York: Cambridge University Press, 1999.

Thompson, Dave. *Black and White and Blue: Adult Cinema from the Victorian Age to the VCR*. Toronto, ON: ECW, 2007.

Tobias, Michael, ed. *The Search for Reality: The Art of Documentary Filmmaking*. Studio City, CA: Michael Wiese Productions, 1997.

Traven, B. *The Treasure of the Sierra Madre*. New York: Farrar, Straus and Giroux, 1963 (originally published in 1935).

Turim, Maureen. *Flashbacks in Film: Memory & History*. New York: Routledge, 1989.

Tyler, Parker. *Underground Film: A Critical History*. New York: Grove, 1969.

Usai, Paolo Cherchi. *Silent Cinema: An Introduction*. London: BFI, 2000.

Vidor, King. *King Vidor on Filmmaking*. New York: David McKay, 1972.

Vidor, King. *A Tree Is a Tree*. Hollywood, CA: Samuel French, 1953, 1981.

Wasson, Sam. *Fosse*. Boston: Eamon Dolan, 2013.

Wees, William C. *Light Moving in Time: Studies in the Visual Aesthetics of Avant-Garde Film*. Berkeley: University of California Press, 1992.

Weis, Elizabeth, and John Belton, eds. *Film Sound: Theory and Practice*. New York: Dover, 1970.

Winkler, Peter L. *Dennis Hopper: The Wild Ride of a Hollywood Rebel*. Ft. Lee, NJ: Barricade, 2011.

Wurlitzer, Rudolf, and Will Corry. *Two-Lane Blacktop*. New York: Award, 1971.

Youngblood, Gene. *Expanded Cinema*. New York: E. P. Dutton, 1970.

Index

Academy Awards, 17, 144, 185, 206, 224, 230
action films, 29
Act of Seeing with One's Own Eyes, The, 241
actors, 169
Adam, Ken, 15, 16, 17
adult films, 106
Aeneid, The, 232
Alba, Jessica, 194, 202
Alcott, John, 14, 17
Aldrich, Robert, 55, 56, 184
Aldrich Company, 56
Alien, 40
Allen, Woody, 6
All That Jazz, 1–12
Altman, Robert, 97, 134, 137, 140
American Film Institute (AFI), 40, 41, 42
American Gigolo, 169
American Graffiti, 3
American New Wave, 30, 96, 97, 122, 184, 188
Amish, 250, 251, 252, 253, 254
Amish Mafia, 251
Anderson, Paul Thomas, 131, 133, 134, 141, 230
Anderson, Richard, 186
Anderson, Wes, 6
Andrusco, Ritchie, 123
Anger, Kenneth, 122

animation, 90, 176, 206, 209
Antonioni, Michelangelo, 77
Apocalypse Now, 3
Armstrong, Robert, 85, 90, 93
Arquette, Rosanna, 175
art direction, 17
art film, 106, 107
art house theaters, 123
Arthur, Robert Alan, 3
Ashby, Hal, 97
Ashley, Ray (Raymond Abrashkin), 121
Associates, The, 56
Attenborough, Richard, 55
Audubon Films, 106
auteur theory, 27, 160
autobiographical filmmaking, 2, 4, 6
avant-garde, 28, 43, 240

Bach, J. S., 242
Badham, John, 251
Badlands, 233
Balin, Marty, 71
Bande à Parte (Band of Outsiders), 173
Barger, Sonny, 69
Barry Lyndon, 14–26
Bass, Saul, 184
Battleship, Potemkin, The, 28
Beach Boys, The, 234
Beatles, The, 244
Beckett, Samuel, 233

Behind the Green Door, 107
Belli, Melvin, 69, 70
Beltrani, Marco, 60
Berenson, Marissa, 22
Berkoff, Steven, 22
Bible, The, 145, 174, 181
Big Fat Kill, The, 191
Biograph Company, 122
biopic, 2, 15
Bird, Laurie, 234
Biroc, Joseph, 60
black-and-white films: *Eraserhead,* 37,
 42; *Hiroshima Mon Amour,* 76;
 King Kong (1933), 94; *Lickerish
 Quartet, The,* 107, 115, 117–118;
 Magnolia, 131; *Memento,* 143–155;
 Pickpocket, 167; *Seconds,* 183;
 Sin City, 192, 197; *Sunrise,* 207;
 Tokyo Story, 214
Blackman, Jeremey, 132
Blade Runner, 40
Blake, Robert, 226
B movies, 98, 194
BNC Mitchell motion picture camera,
 15
Bogart, Humphrey, 29, 224, 225, 226
Bogdanovich, Peter, 41, 47, 97, 122
Bonnie and Clyde, 97, 232
Boogie Nights, 131
Boothe, Powers, 195, 201
Booze, Broads, & Bullets, 191, 192
Borgnine, Ernest, 55
Bosch, Hieronymus, 108
Boston University, 67
boutique independent film studios,
 123
Bowen, Michael, 132
Brakhage, Stan, 103, 241
Breaking Amish, 251
Breathless, 27–34
Bresson, Robert, 166
Bretherton, David, 5
Breton, André, 40
Brewster, Richard, 123
Burns, Edward, 60

Cabaret, 4, 5
Cabot, Bruce, 86
Cahiers du Cinema magazine, 31
cameramen, 89
Canada, 241, 242
Cannes film festival, 43
Canonero, Milena, 15, 17
Canyon Cinema catalog, 241
Capra, Frank, 97
Cartwell, Herb, 40
Cassavetes, John, 170
Castle Rock, 123
Cathedral of Chartres, 47, 50
CBS (Columbia Broadcasting System),
 251
CFI lab, 41
Chadowjecki, Daniel, 16
Champion, Gower, 1
Chang, 89
Chaplin, Charlie, 55, 122
Chase, Barrie, 56, 58, 59
Cheeseman, Ed, 90
choreography, 2, 4, 48
cinema of transgression movement,
 122
cinematographers, 40
cinematography, 17, 48, 78, 123, 184,
 213
cinéma vérité, 67, 68
Citizen Kane, 3, 45, 46, 50, 213
Clarke, Shirley, 246
classical Hollywood sudio era, 29
Clockwork Orange, A, 14, 15, 17
close-ups, 31, 33, 112, 114, 167, 174,
 194
Cocteau, Jean, 85
Columbia Tristar, 173
comic book, 191
Coney Island, 121, 123, 124, 125, 126
Cooke, Sam, 253
Cooper, Merian C., 85, 86, 89, 90,
 93
Coppola, Francis Ford, 27, 97, 122
Corey, Jeff, 185, 186
costume designers, 15, 17

Coutard, Raoul, 33
Cowan, Bob, 246
Crabbe, Byron L., 85
Creation, 90
crime drama, 255
Criterion Collection, 47, 169
Cruise, Tom, 132
Customer Is Always Right, The, 191
Cutler, Sam, 69, 71

Dada, 40
Dali, Salvador, 38, 47
Dame to Kill For, A, 192
Dean, James, 96, 175
Deep Throat, 107
de Hory, Elmyr, 45, 46, 47, 48, 49, 50
Delerue, Georges, 79
Delgade, Marcel, 90
Del Toro, Benico, 197
DeMille, Cecil B., 184
De Palma, Brian, 97, 122
Deren, Maya, 122
detective film, 250
Detour, 233
Devil in Miss Jones, The, 107
diary filmmaking, 45
Diary of a Country Priest, 167
Dick Tracy, 193
digital filmmaking, 192
DiGuilio, Ed, 15
direct cinema, 67
Directed by John Ford, 47
director of photography, 60
Directors Guild of America (DGA), 251
Dirty Dozen, The, 55
Disney, Walt, 122
Dixon, Vernon, 16, 17
documentaries, 28, 45, 68, 73, 75, 89, 123, 225
dolly shots, 111
Dorn, Dody, 144
Dostoevsky, Fyodor, 167
double exposure shot, 50, 58, 70, 163
Dovshenko, Alexander, 28

Drew Associates, 67, 68
Duellists, The, 17
Duncan, Michael Clarke, 199
Dune, 41
Dunn, Linwood, 92
Dunning bi-packing, 92
Duras, Marguerite, 83
Duryea, Dan, 56
DVD, 47

Easy Rider, 97, 99, 100–101, 122, 131, 232, 234, 236
Edison, Thomas, 122
editing: *F for Fake*, 48, 49, 51; *Flight of the Phoenix*, 60, 67; *Hiroshima Mon Amour*, 75, 78; *King Kong* (1933), 93; *Last Movie, The*, 98–99; *Lickerish Quartet, The*, 107, 117; *Our Daily Bread*, 160; *Pulp Fiction*, 173; *Wavelength*, 243
8 ½, 3, 4, 98
Eisenstein, Sergei, 28, 78
El Mariachi, 191
Elmes, Fred, 40, 41
El Topo, 97
Empire State Building, 86, 89, 93
Engel, Morris, 121, 122, 123
Eraserhead, 36–43
erotic films, 106, 107, 114
essay filmmaking, 45
existentialism, 233
experimental filmmaking, 43, 85, 97, 106, 240, 242–244, 246, 247
exploitation films, 122
eyeline match, 110, 214

Fairbanks, Douglas, 122
Fake! The Story of Elmyr de Hory, the Greatest Art Forger of Our Time, 45
Family Values, 192
Feldman, Edward S., 250, 251
Feminism, 165
F for Fake, 45–51
Five and Two Pictures, 123
Fellini, Federico, 3, 5

Fight Club, 233
film critics, 159, 167
Film Culture magazine, 246
film editing, 75
film editors, 2, 106, 207
Film-Makers Cinematheque, 246
film noir, 32, 143, 144, 192, 232
film scholars, 167
film schools, 97
film within a film, 80, 97, 107, 108
Final Cut, 234
Finch, Peter, 56
Fisk, Jack, 42
flashforwards, 108, 110, 143, 172,
 173, 174
flicker effect, 240
Flight of the Phoenix, 54, 55, 60, 61, 62
Flight of the Phoenix, The, 54, 55, 56,
 57, 58, 59, 60
Flying Burrito Brothers, 71
Fonda, Peter, 96, 99, 122
Ford, Harrison, 251, 252, 253, 254
Ford, John, 97, 160, 161
foreign films, 106, 173
Foreman, Richard, 246
Fosse, Bob, 2, 3, 4, 5, 9, 12
400 Blows, The, 3
Fox Searchlight Pictures, 123
Frampton, Hollis, 242, 244
France, 29, 166
Francis, Connie, 56, 62
Frankenheimer, John, 183, 185
Frasier, Ronald, 55
freeze frames, 48, 56, 72, 173, 187,
 237
French films, 166
French New Wave, 27, 31, 75, 123,
 170, 173
French television, 46
Friedkin, William, 43
Fuller, Sam, 98, 101
Fusco, Giovanni, 79

Gainsborough, Thomas, 16
Garden of Earthly Delights, The, 108

Gaynor, Janet, 206
Geer, Will, 185, 186
Genres: action, 56, 61; adventure,
 225; crime, 25; erotic films, 106;
 film noir, 143; horror, 38; musicals,
 38; period films, 15; road movie,
 232–233, 237; self-referential films,
 107; Westerns, 98, 113
German expressionism, 206, 207,
 208, 214
Gibson, Henry, 137
"Gimme Shelter," 72
Gimme Shelter, 67–73
Glover, Danny, 252
Godard, Jean-Luc, 27–29, 30–32, 75,
 82, 123
Godunov, Alexander, 252
Goldberg Variations, 242
Goldsmith, Jerry, 184
Goldwyn, Samuel, 122
Graduate, The, 97, 134
Grand Central Station, 184
graphic novels, 191, 192, 193, 204
Grass: A Nation's Battle for Life, 89
Grateful Dead, The, 71, 72
Grauman's Chinese Theater, 93
Graver, Gary, 48
Griffin, Kathy, 178
Griffith, D. W. 54, 122, 173
Groundhog Day, 233
Gugino, Carlo, 194
Guillermin, John, 94

Haas, Lucas, 252
Hamilton, Gay, 19
Hamilton, Murray, 185
handheld camera, 184, 187, 243
Hard Goodbye, The, 191, 192
Harnett, Josh, 192
Hauer, Rutger, 195
Hawks, Howard, 97, 160
Haworth, Ted, 185
Head, 232
Heim, Alan, 2, 4, 5, 8, 9
Hell and Back, 192

Heller, Lucas, 56
helicopter shot, 195
Hellman, Monte, 233, 237
Hells Angels, 67, 69, 71, 72, 73
High Noon, 233
Hiroshima, Japan, 76, 77, 78, 79, 80, 81, 82
Hiroshima Mon Amour, 75–83
Hitchcock, Alfred, 54, 184, 209
Hoffman, Philip Seymour, 132
Hollywood: American New Wave, 27; blacklist, 185; classical Hollywood film style, 29; conventions to end a scene, 147; dramatic foreshadowing, 216–217; Grauman's Chinese Theater, 93; Hollywood studio system, 30; jump cuts, 28; musicals, 5; period scenes, 18; traditional films, 246–247
Hollywood Pictures, 123
Hollywood Studio System, 97
Holt, Tim, 224, 226
Homer, 232
Homicide: Life on the Street, 28
Hopper, Dennis, 96, 97, 122
Horden, Michael, 19
horror films, 38, 173, 183, 197
House Un-American Activities Committee, The (HUAC), 185
Howe, James Wong, 183
Hudson, Rock, 183, 185, 186, 188
Hughes, Howard, 45, 49, 50
Hunter, Meredith, 72
Huston, John, 224, 225, 226, 230
Huston, Walter, 224, 226, 227

Independent Film Award (*Film Culture* magazine), 246
Independent filmmaking, 56, 97, 106, 121, 122, 123
Internet, 60
intertitles, 206, 207
Irving, Clifford, 45, 49
It Happened One Night, 232

Jackson, Peter, 94
Jackson, Samuel L., 174
Jacobs, Flo, 246
Jacobs, Ken, 242
Jagger, Mick, 69, 70, 71, 72
Jaglom, Henry, 99
Janus Films, 106
Japanese cinema, 214
Jay, Ricky, 135
Jefferson Airplane, 71
Jennings, Brett, 252
Jodorowsky, Alexandro, 97
Johnson, Noble, 86
Joplin, Janis, 235
Jump cut, 27, 28, 29, 32, 102, 117
Junior, Mark Boone, 144

Kanter, Paul, 71
Kean, Mary, 19
Keene, Tom, 161
Keitel, Harvey, 179
Kelley, William, 250, 251
Kierkegaard, Søren, 233
Killer Elite, The, 233
Killing, The, 172, 173
King, Jamie, 193
King Kong (1933), 85–94
King Kong (1976), 94
King Kong (2005), 94
Kodar, Oja, 46, 48, 49, 50, 51
Koerner, Diana, 22
Korda, Alexander, 122
Kristofferson, Kris, 100, 235
Krüger, Hardy, 22, 55, 58
Kubrick, Stanley: Anderson, Paul Thomas, 133–134, 137; *Barry Lyndon,* 14–22, 24, 26; Bass, Saul, 184; cinematic time and space, 76; *Eraserhead,* 43; *Killing, The,* 172–173; *Treasure of the Sierra Madre, The,* 230
Kurosawa, Akira, 214

La Belle et la Bête, 86
Landowska, Wanda, 242

Lang, Fritz, 77
Lang, Mike, 70
Larrinaga, Mario, 85, 91
Last Movie, The, 96–103
Legge, Elizabeth, 241, 243
Legrand, Michel, 48
Leighton, Ava, 106
Lenny, 2, 4
lenses, 15, 72, 184
Lesh, Phil, 71
Levine, Joseph E., 47
Lickerish Quartet, The, 106–119
Little Fugitive, 121–126
Livingston, Margaret, 207
Liza with a Z, 4
Look magazine, 16
loop printing, 240
Lost World, The, 90
low-budget movies, 96, 122, 233
Lucas, George, 3, 97, 122
Lucasfilm, 123
Luciano, Michael, 60
Luck of Barry Lyndon, The, 17
LuPone, Patti, 252
Lynch, David, 6, 36–38, 40, 41, 42, 76, 122

MacDonald, Scott, 244
MacLane, Barton, 226
Macy, William H., 132
Madison Square Garden, 69, 70, 71
Madsen, Michael, 193
Magee, Patrick, 22
Magnificent Ambersons, 45
Magnolia, 131–141
Manchurian Candidate, The, 183
Mancini, Henry, 57
Mann, Aimee, 131, 141
Man with a Movie Camera, 28
Marquand, Christian, 56
matte paintings, 91
Maverick filmmakers, 55, 99, 185
Maysles, Albert, 67, 68, 69, 70
Maysles, David, 67, 68, 69, 70
Mazursky, Paul, 6

McGillis, Kelly, 251
"Me and Bobby McGee," 100, 235
Me and Bobby McGee (un-released film project), 101
Mekas, Jonas, 246
Melies, Georges, 28
Melville, Jean-Pierre, 170
Melvin, Murray, 22
Memento, 143–157
Menke, Sally, 173
Mercury Players, 50
Metzger, Radley, 106, 109, 112, 116–118
MGM studios, 121
Mickey-Mousing, 87, 89
Mighty Joe Young, 93
Miller, Frank, 191, 192
Minnelli, Liza, 4
Mirmax, 123, 173
Mizuguchi, Kenji, 214
Montages: *All That Jazz*, 3, 6, 9; *Gimme Shelter*, 72; *Hiroshima Mon Amour*, 77; *Lickerish Quartet, The*, 113; *Little Fugitive*, 125–126; *Our Daily Bread*, 161, 163; *Pickpocket*, 167; *Seconds*, 187; Soviet Cinema, 28, 78
Moore, John, 55
Moore, Julianne, 132
Morley, Karen, 161
Mosquito Coast, The, 251
Moss, Carrie-Anne, 146
Most Dangerous Game, The, 90
Motion Picture Production Code, 93, 161
Moviola, 48, 49
MTV, 4
multiple cameras, 4
Murnau, F. W., 205, 206
Murphy, Brittany, 194
Murphy, Michael, 136
music: *Barry Lyndon*, 18; *Eraserhead*, 38, 39, 40; *F for Fake*, 48; *Flight of the Phoenix, The*, 58; *Flight of the Phoenix*, 60; *Gimme Shelter*, 68;

Hiroshima Mon Amour, 79; *King
Kong* (1933), 86–87, 89, 92, 93;
Lickerish Quartet, The, 107; *Our
Daily Bread*, 161; *Pickpocket*, 170;
Seconds, 184; *Sunrise*, 206; *Tokyo
Story*, 217; *Wavelength*, 240, 242;
Witness, 254
musicals, 5
music videos, 4, 28

Nagasaki, Japan, 76
Nance, Jack, 41
narration: *Barry Lyndon*, 18; *Gimme
Shelter*, 67; *Hiroshima Mon Amour*,
79; *Magnolia*, 131, 132; *Memento*,
144; *Sin City*, 192, 194, 195, 197,
198
Naruse, Mikio, 214
Nashville, 141
National Film Board of Canada, 241
neo-noir, 143, 192
New Line Cinema, 123
New School for Social Research, 121
newsreels, 50
New York, Times Square, 86
New York Film Festival, 45
New York Times, 122
Nichols, Mike, 134
Nicholson, Jack, 233
Night and Fog, 75, 78
Nights of Cabaria, 5
nonactors, 170
nonfiction filmmaking, 45, 46
nonlinear structure, 69, 172, 181
non-narrative filmmaking, 242
Nosler, Lloyd, 160

Oates, Warren, 234
O'Brien, Willis H., 85, 90–93, 207
Odyssey, The, 232
Okada, Eiji, 79
O'Neal, Ryan, 19, 21
optical printer, 92
Orkin, Ruth, 121, 122
Oscars, 48, 57, 93, 159, 225

O'Sullivan, Arthur, 21
Otto, Miranda, 61
Our Daily Bread, 159–164
Owen, Clive, 194
Ozu, Yasujiro, 213, 214, 222

Paik, Nam June, 246
painting, 16, 241
Paper Moon, 41
Paths of Glory, 233
parallel storytelling, 131, 140
Paramount Vantage, 123
Parrish, Robert, 207
Pearce, Guy, 143, 144
Peckinpah, Sam, 100, 254
period films, 14, 17, 113
Philadelphia, Pennsylvania, 251, 253
Phillips, Michelle, 99
photographers, 16
photojournalism, 121
Photo League, 121
Picasso, Pablo, 27, 47, 50, 51
Pickford, Mary, 122
Pickpocket, 166–170
Pirandello, Luigi, 108–109, 117, 119
Plummer, Amanda, 173
Polglase, Van Nest, 85
porno chic movement, 107
postproduction, 31, 41
Preminger, Otto, 30, 32, 184
Presley, Elvis, 68
production designers, 15, 42, 186
Psycho, 54
Pulp Fiction, 172–181

Quaid, Dennis, 60
Qualen, John, 162
Quigley, Godfrey, 21

rack focus, 111, 112
radio, 46, 253
Radio City Music Hall, 93
Raging Bull, 3
Randolph, John, 183, 185–187
rear screen projection, 92

Rebel Without a Cause, 96
Redford, Robert, 122
Redmond, Liam, 20
Reid, Frances, 185
Reichenbach, François, 46, 50
Reicher, Frank, 86
Reilly, John C., 132
Reinhardt, Max, 205
remakes, 54, 94, 214
Remberg, Erika, 108
Renoir, Jean, 55
Reservoir Dogs, 172
Resnais, Alan, 75, 78, 123
Return to Amish, 251
Reynolds, Joshua, 16
Rhames, Ving, 174
Ribisi, Giovanni, 60
Richards, Keith, 69, 70
Ride in the Whirlwind, 233
Riva, Emmanuelle, 79
RKO Pictures, 55, 89
Road Movie, 233
road movies, 232, 233, 237, 238
Robards, Jason, 132, 138
Rodriguez, Robert, 191
Rolling Stones, The, 68, 69, 70, 72
Roseman, Leonard, 19
Rose, Ruth, 89–90
Roth, Tim, 173
Rotunno, Giuseppe, 3, 4, 6
Rourke, Mickey, 193
Rowan & Martin's Laugh-In, 28
Rubles, Jan, 252, 253

Saint Margaret, 112, 113
Salesman, 67
Samuel Goldwyn Productions, 225
Sanda, Dominque, 169
Sarris, Andrew, 160
Sartre, Jean-Paul, 233
Scheider, Roy, 2
Schoedsack, Ernest B., 85, 89, 90
Schrader, Paul, 27, 169
science fiction films, 173

Scorsese, Martin, 23, 27, 97, 122, 184, 194
Scott, Ridley, 40
screenplays, 17, 56, 90, 107, 208, 225, 250
screenwriters, 83
Seberg, Jean, 29
Seconds, 183–189
self-referential films: *Breathless,* 30; *F for Fake,* 47, 48; *Gimme Shelter,* 69; *Last Movie, The,* 98, 100; *Lickerish Quartet, The,* 107; *Two-Lane Blacktop,* 237; *Wavelength,* 243
Selznick, David O., 85, 90, 122, 128
sequels, 93, 94
Seventh Seal, The, 233
Shining, The, 14, 18, 22
Shrieve, Michael, 71
Shooting, The, 233
Sight & Sound magazine, 222
silent films, 205, 206, 207, 211
Sin City, 191–204
Singleton, John, 184
Six Characters in Search of an Author, 107
16mm film, 107, 242, 243
Slick, Grace, 71
slow motion, 100, 187, 237
Society of Independent Motion Picture Producers, 122
Soderberg, Steven, 54
Söderlund, Ulla-Britt, 15, 17
softcore films, 106, 107, 119
Sommers, Josef, 253
Son of Kong, 93, 94
Sony Pictures Classics, 123
sound design, 39
sound designers, 36
sound effects, 39, 93, 206
Soviet Union, 28
Smell-O-Vision, 202
Snow, Michael, 240–243, 245, 246, 247
special effects, 41, 90, 93
Spielberg, Steven, 122

Spivak, Murray, 92
Splet, Alan, 37, 41, 42, 43
split screen, 108
stag film: classic form, 108; definition;
 107; *Lickerish Quartet, The,* 109,
 111, 112, 113, 115, 116, 117, 118
Stagecoach, 232
Stahl, Nick, 193, 202
Stanton, Harry Dean, 235
Steenbeck editing table, 69, 70, 72
Steiner, Max, 92, 225
Stoltz, Eric, 175
stop-motion animation, 71, 91
storyboards, 181
"Strawberry Fields Forever," 244
structural film, 240
Sullivan's Travels, 233
Sundance Institute, 122
Sunrise (*Sunrise: A Song of Two
 Humans*), 205–211
superimpositions, 208, 210, 244, 245
surrealism, 36, 38, 40
Sweeney, Julia, 180
Sweet Baby James, 234
Sweet Charity, 5
"Sympathy for the Devil," 72

Tanen, Ned, 234
Tarantino, Quentin, 172–174, 179,
 181, 193, 199
Tarkovsky, Andrei, 76
Taubin, Amy, 244, 246
Taxi Driver, 194
Taylor, James, 233
Taylor, Mick, 69
television, 28, 47, 183, 251
Thackeray, William Makepeace, 14,
 18
That Yellow Bastard, 191, 192
Therese and Isabelle, 106, 199
They Drive by Night, 323
35mm film, 47
3D, 91
Thurman, Uma, 174
Tobolowsky, Stephen, 145

Tokyo, Japan, 213, 215, 216, 217
Tokyo Story, 213–222
top shot, 63, 194
traveling matte, 91
Traven, B., 225
Travolta, John, 174, 175
Treasure of the Sierra Madre, 103,
 224–230
Tristar Pictures, 123
Truffaut, Francois, 3, 27, 30, 75, 123,
 160
Truman, Harry, President, 76, 83
Turco, Paolo, 108
Turner, Tina, 70
Turner Entertainment, 123
20th Century-Fox, 53, 55, 60, 250,
 251
Twin Peaks: Fire Walk with Me, 41
Two-Lane Blacktop, 232–238
2001: A Space Odyssey, 14, 18, 19

Universal Studios, 97, 234
U.S. Army, 225

Vanishing Point, 233
Van Sant, Gus, 54
Verdon, Gwen, 5
Vertov, Dziga, 28
Vidor, King, 77, 159, 160, 161, 163,
 164, 206
Vierny, Sacha, 78
Vietnam War, 176, 177
Virgil, 232
Vitali, Leon, 22

Waiting for Godot, 233
Walken, Christopher, 176
Walker, Roy, 16, 17
Wallace, David Forster, 133
Wallace, Earl W., 250, 251
Walters, Melora, 132
Wanger, Walter, 122
Warner Bros., 17, 225
Warner Independent Pictures, 123
War of the Worlds, 46, 50

Waters, John, 43, 122
Watteau, Jean-Antoine, 16
Watts, Charlie, 69, 70
Wavelength, 240–247
Weir, Peter, 251, 255
Welles, Orson, 45–51, 122, 160
Wenders, Wim, 233
Wesselmann, Tom, 241
Westerns: *Breathless,* 29; *Last Movie, The,* 97, 98, 99, 100, 101, 102; *Our Daily Bread,* 160; *Sin City,* 198; *Treasure of the Sierra Madre, The,* 225, 227; *Two-Lane Blacktop,* 233; *Witness,* 251
Whaley, Frank, 174
"What A Wonderful World," 253
Whirlpool, 32
Wiazemsky, Anne, 169
Wieland, Joyce, 244
Wild Angels, 233
Wild Bunch, The, 100, 234
Wild One, 233
Wilson, Dennis, 234
Willis, Bruce, 174, 193
wipes, 161
Witness, 250–255

Wizan, Joe, 251
Wolf, Frank, 108
Wong, Victor, 86
Wood, Elijah, 194
Woodstock Music Festival, 73
World War I, 89
World War II: *Flight of the Phoenix,* 58; *Gimme Shelter,* 67; *Hiroshima Mon Amour,* 75, 76; *Lickerish Quartet, The,* 107, 109, 110, 112, 113, 114, 115, 116; *Little Fugitive,* 122; *Memento,* 143; *Tokyo Story,* 217; *Treasure of the Sierra Madre, The,* 225
Wray, Fay, 86, 90, 93
Wurlitzer, Rudy, 234
Wyman, Bill, 69

You Only Live Once, 232

Zeiss Company, 15
Zimmerman, Don, 60
Zoffany, Johan, 16
zoom lens, 15, 16, 18, 103, 114, 115, 197, 242–243
Zwerin, Charlotte, 67, 68

About the Author

Vincent LoBrutto is a film instructor in the Department of Film, Video, and Animation at the School of Visual Arts in Manhattan. He is the author of numerous books on filmmaking, including *Stanley Kubrick: A Biography* (Penguin, 1999), *Martin Scorsese: A Biography* (Praeger, 2007), and *Gus Van Sant: His Own Private Cinema* (Praeger, 2010). In 2010, LoBrutto received the Robert Wise Award for journalistic illumination of the art of editing from the American Cinema Editors.